Nikon D3200: From Snapshots to Great Shots

Rob Sylvan

Nikon D3200: From Snapshots to Great Shots

Rob Sylvan

Peachpit Press 1249 Eighth Street Berkeley, CA 94710 510/524-2178 510/524-2221 (fax)

Find us on the Web at www.peachpit.com To report errors, please send a note to errata@peachpit.com Peachpit Press is a division of Pearson Education

Copyright © 2013 by Peachpit Press All photography © Rob Sylvan except where noted

Senior Editor: Susan Rimerman Production Editor: Lisa Brazieal Copyeditor/Proofreader: Scout Festa Composition: WolfsonDesign

Indexer: James Minkin Cover Design: Aren Straiger Cover Image: Rob Sylvan

Interior Design: Riezebos Holzbaur Design Group

Notice of Rights

All rights reserved. No part of this book may be reproduced or transmitted in any form by any means, electronic, mechanical, photocopying, recording, or otherwise, without the prior written permission of the publisher. For information on getting permission for reprints and excerpts, contact permissions@peachpit.com.

Notice of Liability

The information in this book is distributed on an "As Is" basis, without warranty. While every precaution has been taken in the preparation of the book, neither the author nor Peachpit shall have any liability to any person or entity with respect to any loss or damage caused or alleged to be caused directly or indirectly by the instructions contained in this book or by the computer software and hardware products described in it.

Trademarks

Many of the designations used by manufacturers and sellers to distinguish their products are claimed as trademarks. Where those designations appear in this book, and Peachpit was aware of a trademark claim, the designations appear as requested by the owner of the trademark. All other product names and services identified throughout this book are used in editorial fashion only and for the benefit of such companies with no intention of infringement of the trademark. No such use, or the use of any trade name, is intended to convey endorsement or other affiliation with this book.

ISBN-13: 978-0-321-86443-7 ISBN-10: 0-321-86443-3

98765

Printed and bound in the United States of America

DEDICATION

For Paloma

I love you.

The camera used while writing this From Snapshots to Great Shots book was generously provided by B&H Photo.

www.bhphotovideo.com

ACKNOWLEDGMENTS

My deepest thanks go to Jeff Revell, the author of a number of books in the From Snapshots to Great Shots series and specifically the book on the D3100, which I had the honor and pleasure of updating for the D3200. Jeff is a tremendous photographer and gifted teacher. Thank you for providing such a sound foundation upon which to build.

Any book that has reached the final stage of being published is actually the work of many hands (eyes, brains, and hearts too) behind the scenes. I owe everyone at Peachpit a great deal of gratitude, but specifically Susan Rimerman, Ted Waitt, Lisa Brazieal, Scout Festa, WolfsonDesign, Aren Straiger, Sara Jane Todd, Scott Cowlin, and Nancy Aldrich-Ruenzel, who were instrumental in getting this book finished, looking so darn fantastic, and out into the world. Thank you all.

A special thanks to David Brommer and B&H Photo for help in securing the D3200 I used to write this book.

I am grateful for all that I have learned from my friends at the National Association of Photoshop Professionals, the Digital Photo Workshops, the fantastic instructors at Photoshop World, and countless numbers of fellow photographers. You all have taught and inspired me over the years.

I also want to thank my wife, Paloma, for being the love of my life and my number one supporter during this project; my son, Quinn, for assisting me on many shoots and being the model in many more; and my family, friends, and neighbors—Ea, Avery, Otis, Hayley, Mark, Adrienne, Emma, Julia, Paige, Ella, John, Kris, Sabrina, Cookie, Ed, Bryan, Max, Chris, Anna, Dan, Jaylin, Alden, Hayden, Quinn K, Josh—for being a part of the book in large and small ways.

I owe a deep debt of gratitude to Nikki McDonald, who took a chance on me a few years ago and invited me into the Peachpit family. This is all your fault. ①

Contents

INTRODUCTION	x
CHAPTER 1: THE NIKON D3200 TOP TEN LIST	1
Ten Tips to Make Your Shooting More Productive	
Right Out of the Box	1
Poring Over the Camera	2
Poring Over the Camera	4
1. Charge your Battery	5
2. Adjust Your Auto Off Timer Setting	6
3. Set Your JPEG Image Quality	7
4. Turn Off the Auto ISO Setting	9
5. Set Your Focus Point and Mode	11
6. Set the Correct White Balance	13
7. Set Your Color Space	16
8. Know How to Override Autofocus	17
9. Review Your Shots	18
10. Hold Your Camera for Proper Shooting	24
Chapter 1 Assignments	25
CHAPTER 2: FIRST THINGS FIRST	29
A Few Things to Know and Do Before You Begin Taking Pictures	29
A Few Things to Know and Do Before You Begin Taking Pictures Poring Over the Picture	29 30
Poring Over the Picture	30
Poring Over the Picture Choosing the Right Memory Card	30 32
Poring Over the Picture Choosing the Right Memory Card Formatting Your Memory Card	30 32 33
Poring Over the Picture Choosing the Right Memory Card Formatting Your Memory Card Updating the D3200's Firmware	30 32 33 34
Poring Over the Picture Choosing the Right Memory Card Formatting Your Memory Card Updating the D3200's Firmware Cleaning the Sensor	30 32 33 34 36
Poring Over the Picture Choosing the Right Memory Card Formatting Your Memory Card Updating the D3200's Firmware Cleaning the Sensor Using the Right Format: RAW vs. JPEG	30 32 33 34 36 37
Poring Over the Picture Choosing the Right Memory Card Formatting Your Memory Card Updating the D3200's Firmware Cleaning the Sensor Using the Right Format: RAW vs. JPEG Lenses and Focal Lengths	30 32 33 34 36 37 40
Poring Over the Picture Choosing the Right Memory Card Formatting Your Memory Card Updating the D3200's Firmware Cleaning the Sensor Using the Right Format: RAW vs. JPEG Lenses and Focal Lengths What Is Exposure?	30 32 33 34 36 37 40 45
Poring Over the Picture Choosing the Right Memory Card Formatting Your Memory Card Updating the D3200's Firmware Cleaning the Sensor Using the Right Format: RAW vs. JPEG Lenses and Focal Lengths What Is Exposure? Motion and Depth of Field	30 32 33 34 36 37 40 45 48
Poring Over the Picture Choosing the Right Memory Card Formatting Your Memory Card Updating the D3200's Firmware Cleaning the Sensor Using the Right Format: RAW vs. JPEG Lenses and Focal Lengths What Is Exposure? Motion and Depth of Field Chapter 2 Assignments	30 32 33 34 36 37 40 45 48 51
Poring Over the Picture Choosing the Right Memory Card Formatting Your Memory Card Updating the D3200's Firmware Cleaning the Sensor Using the Right Format: RAW vs. JPEG Lenses and Focal Lengths What Is Exposure? Motion and Depth of Field Chapter 2 Assignments CHAPTER 3: THE AUTO MODES	30 32 33 34 36 37 40 45 48 51
Poring Over the Picture Choosing the Right Memory Card Formatting Your Memory Card Updating the D3200's Firmware Cleaning the Sensor Using the Right Format: RAW vs. JPEG Lenses and Focal Lengths What Is Exposure? Motion and Depth of Field Chapter 2 Assignments CHAPTER 3: THE AUTO MODES Get Shooting with the Automatic Camera Modes	30 32 33 34 36 37 40 45 48 51 53

Landscape Mode	59
Child Mode	60
Sports Mode	61
Close-up Mode	62
Night Portrait Mode	63
Flash Off Mode	64
Guide Mode	66
Why You May Never Want to Use the Auto Modes Again	66
Chapter 3 Assignments	68
CHAPTER 4: THE PROFESSIONAL MODES	71
Taking Your Photography to the Next Level	71
Poring Over the Picture	72
P: Program Mode	74
S: Shutter Priority Mode	77
A: Aperture Priority Mode	82
M: Manual Mode	88
How I Shoot: A Closer Look at the Camera Settings I Use	92
Chapter 4 Assignments	96
CHAPTER 5: MOVING TARGET	99
The Tricks to Shooting Subjects in Motion	99
Poring Over the Picture	100
Stop Right There!	102
Using Shutter Priority (S) Mode to Stop Motion	105
Using Aperture Priority (A) Mode to Isolate Your Subject	108
Using Auto ISO the Right Way	109
Keep Them in Focus with Continuous-Servo Focus and	
AF Focus Point Selection	111
Stop and Go with 3D-Tracking AF	113
Manual Focus for Anticipated Action	114
Keeping Up with the Continuous Shooting Mode	115
A Sense of Motion	116
Tips for Shooting Action	118
Chapter 5 Assignments	122
CHAPTER 6: SAY CHEESE!	125
Settings and Features to Make Great Portraits	125
Poring Over the Picture	126
Automatic Portrait Mode	128
Using Aperture Priority Mode	128
Metering Modes for Portraits	131

Using the AE-L (Auto Exposure Lock) Feature	133
Focusing: The Eyes Have It	134
Classic Black and White Portraits	137
The Portrait Picture Control for Better Skin Tones	139
Detect Faces with Live View	139
Use Fill Flash for Reducing Shadows	141
Portraits on the Move	143
Tips for Shooting Better Portraits	144
Chapter 6 Assignments	153
CHAPTER 7: LANDSCAPE PHOTOGRAPHY	155
Tips, Tools, and Techniques to Get the Most Out of	
Your Landscape Photography	155
Poring Over the Picture	156
Sharp and In Focus: Using Tripods	158
Selecting the Proper ISO	160
Selecting a White Balance	162
Using the Landscape Picture Control	165
Taming Bright Skies with Exposure Compensation	166
Shooting Beautiful Black and White Landscapes	169
The Golden Light	170
Where to Focus	171
Easier Focusing	173
Making Water Fluid	175
Directing the Viewer: A Word About Composition	178
Advanced Techniques to Explore	181
Chapter 7 Assignments	189
CHAPTER 8: MOOD LIGHTING	191
Shooting When the Lights Get Low	191
Poring Over the Picture	192
Raising the ISO: The Simple Solution	194
Using Very High ISOs	196
Stabilizing the Situation	197
Focusing in Low Light	199
Shooting Long Exposures	201
Using the Built-In Flash	203
Compensating for the Flash Exposure	206
Reducing Red-Eye	209
Rear Curtain Sync	211
Flash and Glass	213

A Few Words About External Flash Chapter 8 Assignments	214 215
CHAPTER 9: CREATIVE COMPOSITIONS Improve Your Pictures with Sound Compositional Elements Depth of Field Angles Point of View Patterns Color Contrast Leading Lines Splitting the Frame Frames Within Frames Chapter 9 Assignments	219 219 222 224 224 226 226 228 230 230 232 233
CHAPTER 10: D3200 VIDEO: BEYOND THE BASICS Video and the D3200 It's All About the Lenses Using Accessories Getting a Shallow Depth of Field Giving a Different Look to Your Videos Tips for Better Video Watching and Editing Your Video	235 235 240 241 243 244 244 247
CHAPTER 11: ADVANCED TECHNIQUES Impress Your Family and Friends Poring Over the Picture Spot Meter for More Exposure Control Metering for Sunrise or Sunset Manual Mode Avoiding Lens Flare Using the Sun Creatively Macro Photography Active D-Lighting Customize Your White Balance Conclusion Chapter 11 Assignments	251 252 254 255 257 260 260 262 263 265 266
INDEX	269

Introduction

The D3200 is a wonderful bit of camera technology and a very capable tool for creating photographs that you will be proud to show others. The intention of this book is not to be a rehash of the owner's manual that came with the camera, but rather to be a resource for learning how to improve your photography while specifically using your D3200. I am very excited and honored to help you in that process, and to that end I have put together a short Q&A to help you get a better understanding of just what it is that you can expect from this book.

Q: IS EVERY CAMERA FEATURE GOING TO BE COVERED?

A: Nope, just the ones I felt you need to know about in order to start taking great photos. Believe it or not, you already own a great resource that covers every feature of your camera: the owner's manual. Writing a book that just repeats this information would have been a waste of my time and your money. What I did want to write about was how to harness certain camera features to the benefit of your photography. As you read through the book, you will also see callouts that point you to specific pages in your owner's manual (either the small printed manual or the more complete PDF found on the disc that comes with the camera) that are related to the topic being discussed. For example, I discuss the use of the AE-L button, but there is more information available on this feature in the manual. I cover the function as it applies to our specific needs, but I also give you the page numbers in the manual so you can explore it even further.

Q: WHAT ABOUT VIDEO?

While the focus of this book is on creating still photographs, I have devoted one chapter (Chapter 10) to helping you get started with the video functions of the D3200.

Q: SO IF I ALREADY OWN THE MANUAL, WHY DO I NEED THIS BOOK?

A: The manual does a pretty good job of telling you how to use a feature or turn it on in the menus, but it doesn't necessarily tell you *why* and *when* you should use it. If you really want to improve your photography, you need to know the whys and whens to put all of those great camera features to use at the right time. To that extent, the manual just isn't going to cut it. It is, however, a great resource on the camera's features, and it is for that reason that I treat it like a companion to this book. You already own it, so why not get something of value from it?

Q: WHAT CAN I EXPECT TO LEARN FROM THIS BOOK?

A: Hopefully, you will learn how to take great photographs. My goal, and the reason the book is laid out the way it is, is to guide you through the basics of photography as they relate to different situations and scenarios. By using the features of your D3200 and this book, you will learn about aperture, shutter speed, ISO, lens selection, depth of field, and many other

photographic concepts. You will also find plenty of full-page photos that include captions, shooting data, and callouts so you can see how all of the photography fundamentals come together to make great images. All the while, you will be learning how your camera works and how to apply its functions and features to your photography.

Q: WHAT ARE THE ASSIGNMENTS ALL ABOUT?

A: At the end of most of the chapters, you will find shooting assignments, where I give you some suggestions as to how you can apply the lessons of the chapter to help reinforce everything you just learned. Let's face it—using the camera is much more fun than reading about it, so the assignments are a way of taking a little break after each chapter and having some fun.

Q: SHOULD I READ THE BOOK STRAIGHT THROUGH OR CAN I SKIP AROUND FROM CHAPTER TO CHAPTER?

A: Here's the easy answer: yes and no. No, because the first four chapters give you the basic information that you need to know about your camera. These are the building blocks for using the camera. After that, yes, you can move around the book as you see fit because those chapters are written to stand on their own as guides to specific types of photography or shooting situations. So you can bounce from portraits to shooting landscapes and then maybe to a little action photography. It's all about your needs and how you want to address them. Or you can read it straight through. The choice is up to you.

Q: IS THERE ANYTHING ELSE I SHOULD KNOW BEFORE GETTING STARTED?

A: In order to keep the book short and focused, I had to be selective about what I included in each chapter. The problem is that there is a little more information that might come in handy after you've gone through all the chapters. So as an added value for you, I have written a bonus chapter: Chapter 12, called "Pimp My Ride." It is full of information on accessories that will assist you in making better photographs. You will find my recommendations for things like filters, tripods, and much more. To access the bonus chapter, just log in or join Peachpit.com (it's free), then enter the book's ISBN on this page: www.peachpit.com/store/register.aspx. After you register the book, a link to the bonus chapter will be listed on your Account page under Registered Products. Note: If you purchased an electronic version of this book, you're set—Chapter 12 is already included in it.

Q: IS THAT IT?

A: One last thought before you dive into the first chapter. My goal in writing this book has been to give you a resource that you can turn to for creating great photographs with your Nikon D3200. Take some time to learn the basics and then put them to use. I have been a photographer for many years and I'm still learning. Always remember that it's not the camera that makes beautiful photographs—it's the person using it.

Finally, don't forget to register your book at www.peachpit.com/NikonD3200 for updates and a free bonus chapter.

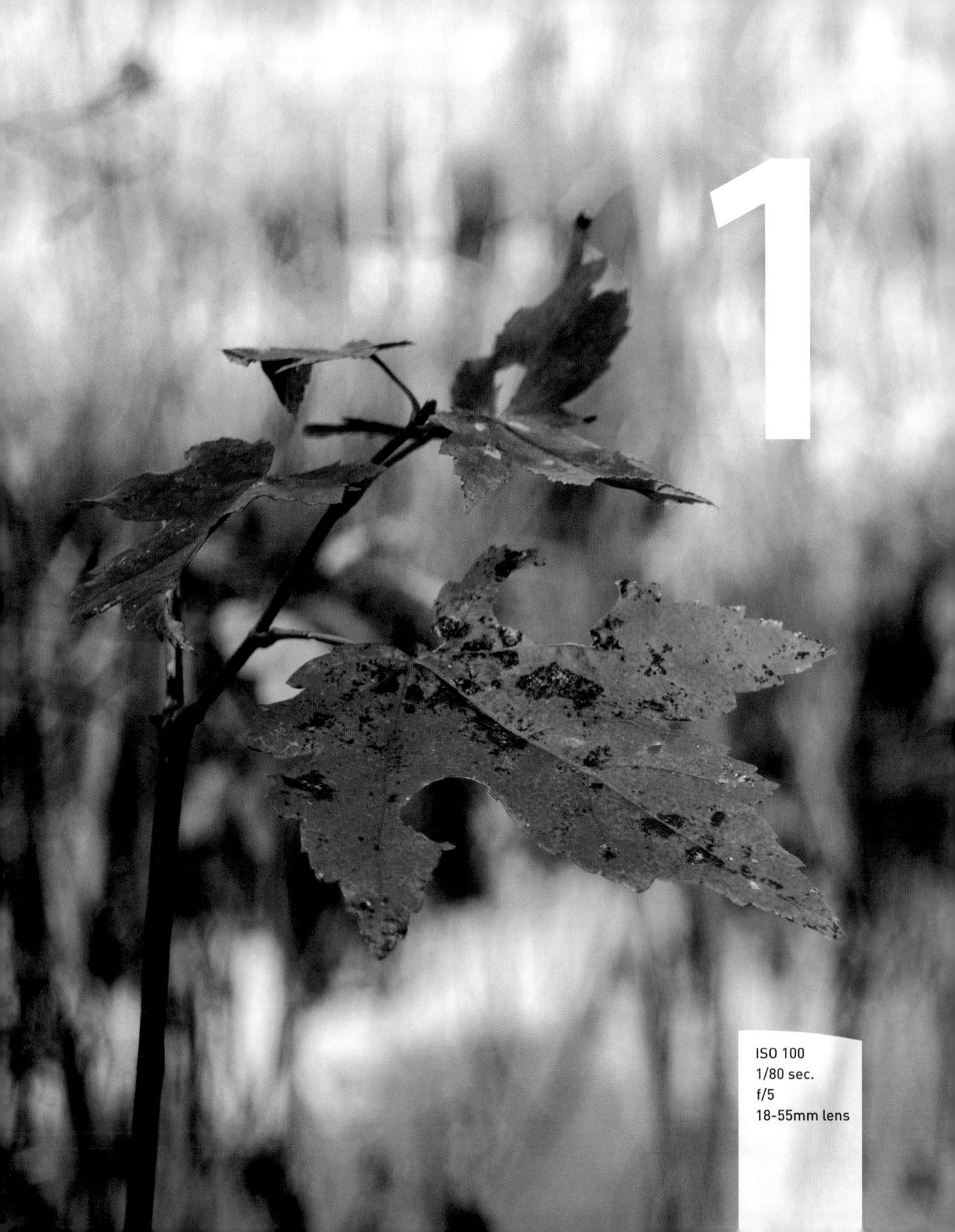

The Nikon D3200 Top Ten List

TEN TIPS TO MAKE YOUR SHOOTING MORE PRODUCTIVE RIGHT OUT OF THE BOX

Whenever I get a new camera, I am always anxious to jump right in and start cranking off exposures. What I really should be doing is sitting down with my instruction manual to learn how to use all of the camera features, but what fun is that? After all, we all know that instruction manuals are for propping up that short leg on the family room table, right?

Of course, this behavior always leads me to frustration in the end—there are always issues that would have been easily addressed had I known about them before I started shooting. Maybe if I had a Top Ten list of things to know, I could be more productive without having to spend countless hours with the manual. So this is where we begin.

The following list will get you up and running without suffering many of the "gotchas" that come from not being at least somewhat familiar with your new camera. So let's take a look at the top ten things you should know before you start taking pictures with your Nikon D3200.

PORING OVER THE CAMERA

CAMERA FRONT

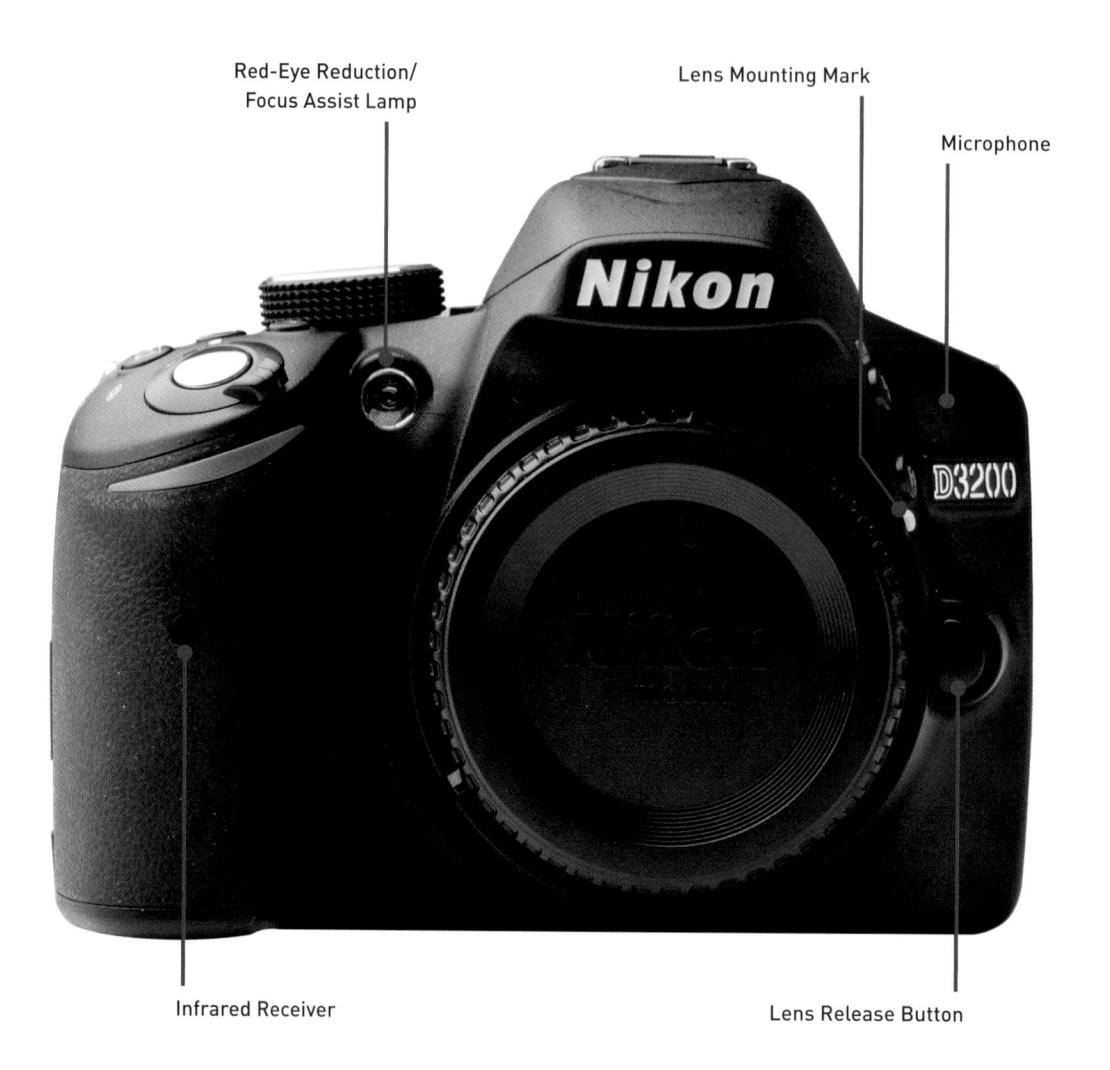

CAMERA BACK

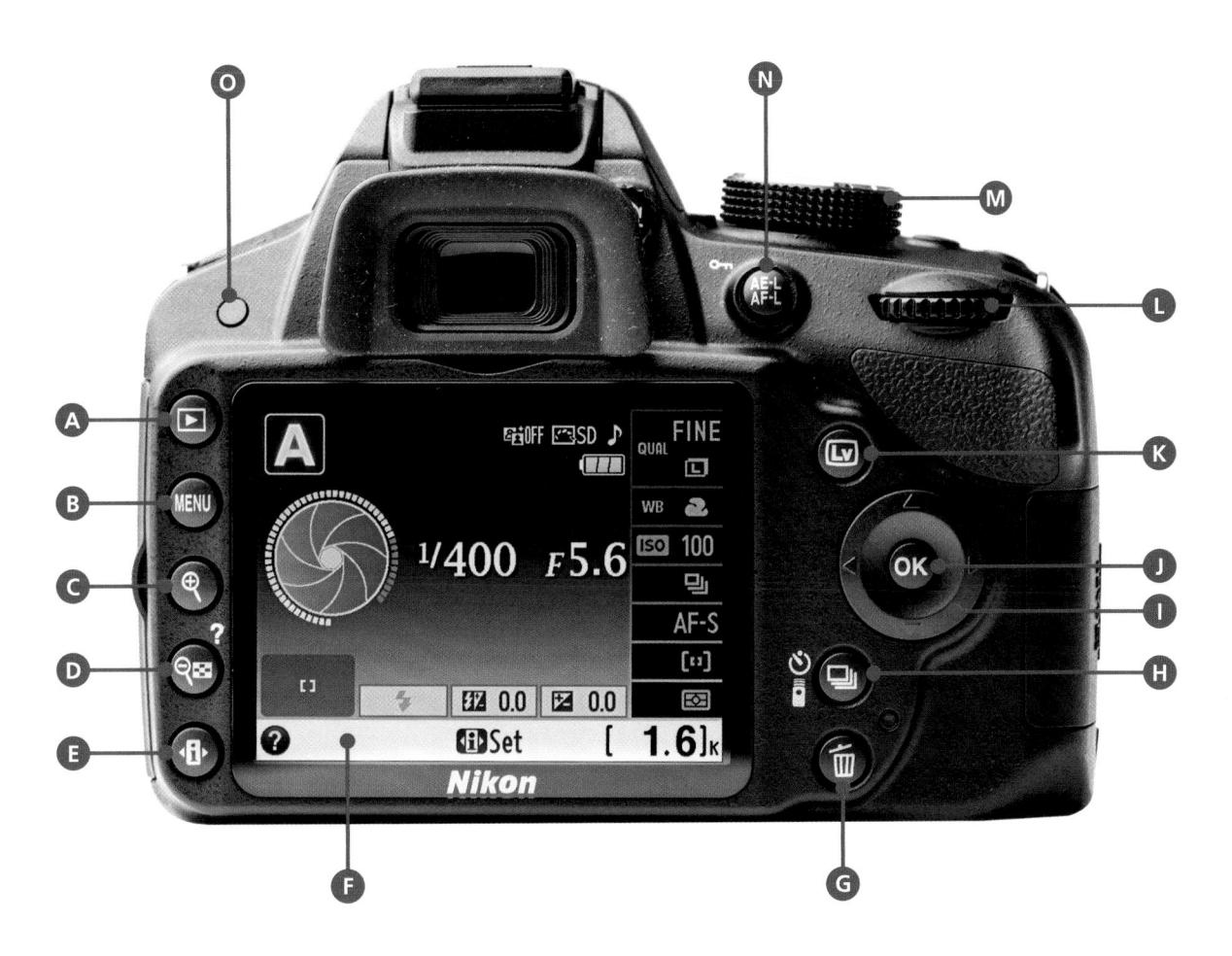

- A Image Playback Button
- B Menu Button
- C Playback Zoom In
- D Thumbnail/Playback Zoom Out
- E Information Edit
- F LCD/Information Screen
- G Delete Image Button
- H Release Mode/Self Timer/Remote

- | Multi-selector
- J OK Button
- K Live View
- L Command Dial
- M Mode Dial
- N AutoExposure/AutoFocus Lock Button
- O Infrared Receiver

PORING OVER THE CAMERA

CAMERA TOP

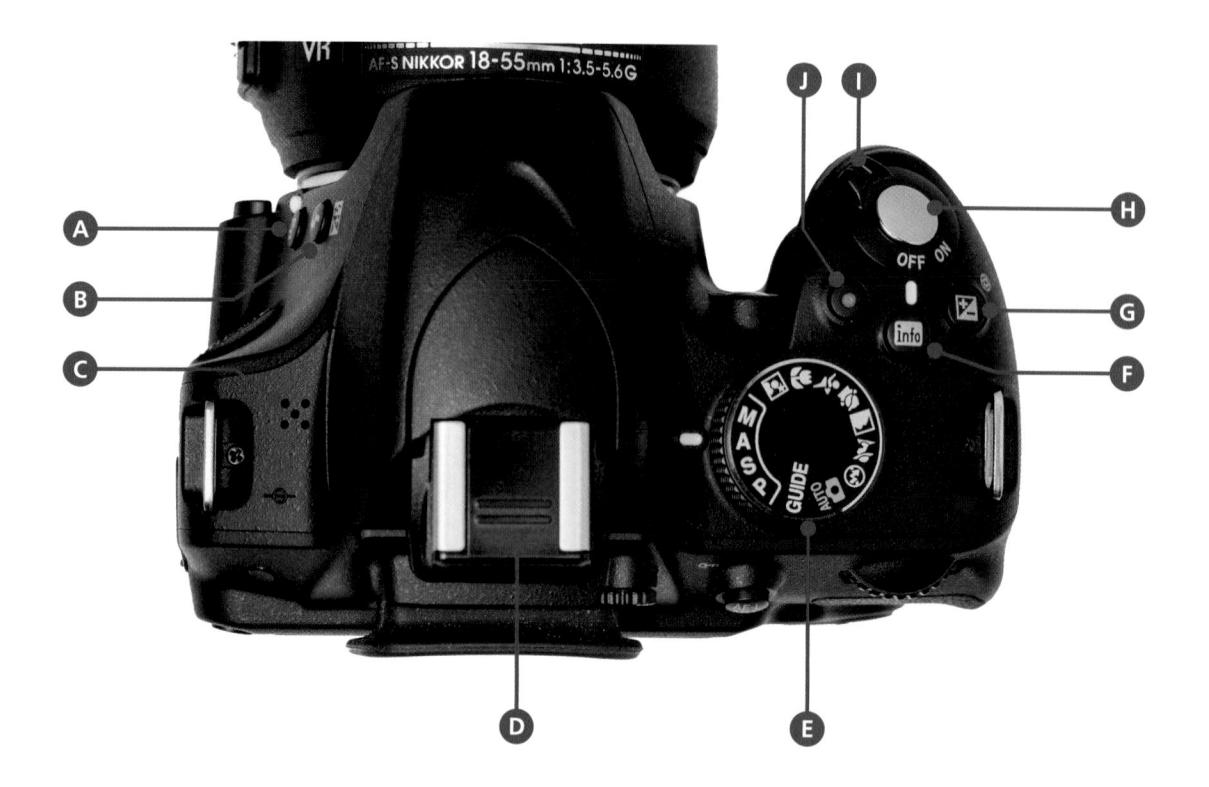

- A Function Button
- B Flash Mode/Flash Compensation
- C Speaker
- D Flash Hot Shoe
- E Mode Dial
- F Info Button
- G Exposure Compensation/Aperture Adjustment
- H Shutter Release Button
- I On/Off Switch
- J Movie-record Button

1. CHARGE YOUR BATTERY

I know that this will be one of the hardest things for you to do because you really want to start shooting, but a little patience will pay off later.

When you first open your camera and slide the battery into the battery slot, you will be pleased to find that there is probably juice in the battery and you can start shooting right away. What you should really be doing is getting out the battery charger and giving that power cell a full charge. Not only will this give you more time to shoot, it will start the battery off on the right foot. No matter what claims the manufacturers make about battery life and charging memory, I always find I get better life and performance when I charge my batteries fully and then use them right down to the point where they have nothing left to give. To check your battery's level, insert it into the camera, turn on the camera, and look for the battery indicator in the upper-right section of the information screen (Figure 1.1).

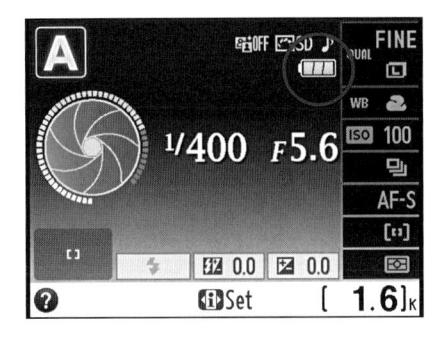

FIGURE 1.1
The LCD screen shows how much charge is left on your battery.

KEEPING A BACKUP BATTERY

If I were to suggest just one accessory that you should buy for your camera, it would probably be a second battery. Nothing is worse than being out in the field and having your camera die. Keeping a fully charged battery in your bag will always give you the confidence that you can keep on shooting without fail. Not only is this a great strategy to extend your shooting time, but alternating between batteries will help lengthen their lives. No matter what the manufacturers say, batteries do have a life, and using them half as much will only lengthen their usefulness.

2. ADJUST YOUR AUTO OFF TIMER SETTING

One of the things that really bugged me when I first began shooting with the D3200 was the short duration that the playback and menu screens stayed on while I was working with the camera. This can be very frustrating when you are trying to learn about the camera and its features and you have to keep pressing the Menu or Info button to bring the screen back to life. This is also the case when reviewing images on the screen after taking a picture. I don't know about you, but four seconds seems like a very short time when you are trying to assess whether or not you got your shot. The answer to this problem is to increase the timer setting to a longer duration. The D3200 has four different settings for the auto off function: Short, Normal, Long, and Custom. To make things easy, I set my camera to the Long setting, which gives one minute for playback/menus, 20 seconds for image review, and one minute for standby timer off. If you so choose, you can use the Custom setting to individually adjust each of these options.

SETTING THE AUTO OFF TIMERS

- 1. Press the Menu button and navigate to the Setup Menu tab.
- Select the Auto off timers item and press OK (A).
- Highlight your choice of timer settings (my preference is Long) and press OK a final time to lock in your change (B).

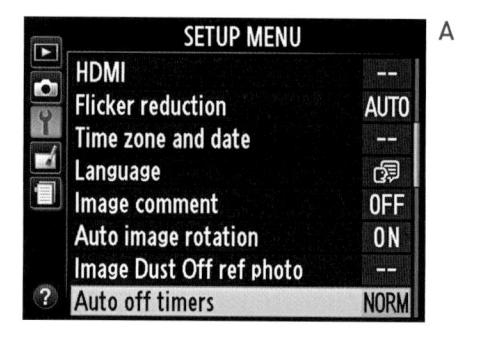

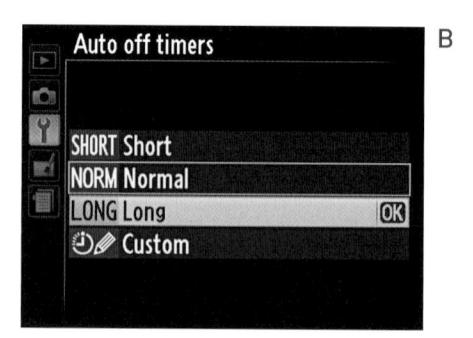

3. SET YOUR JPEG IMAGE QUALITY

Your new D3200 has a number of image quality settings to choose from, and you can adjust them according to your needs. Most people shoot with the JPEG option because it allows them to capture a large number of photos on their memory cards. The problem is that unless you understand what JPEG is, you might be degrading the quality of your images without realizing it.

The JPEG (Joint Photographic Experts Group) format has been around since about 1994 and was developed as a method of shrinking digital images down to a smaller size for the purpose of reducing large file sizes while retaining the original image information. (Technically, JPEG isn't even a file format—it's a mathematical equation for reducing image file sizes—but to keep things simple, we'll just refer to it as a file format.) The problem with JPEG is that in order to reduce file size, it has to throw away some of the information. This is referred to as "lossy compression." This is important to understand because, while you can fit more images on your memory card by choosing a lower-quality JPEG setting, you will also be reducing the quality of your image. This effect becomes more apparent as you enlarge your pictures.

The JPEG file format also has one other characteristic: To apply the compression to the image before final storage on your memory card, the camera has to apply all of the image processing first. Image processing involves such factors as sharpening, color adjustment, contrast adjustment, noise reduction, and so on. Many photographers now prefer to use the RAW file format to get greater control over the image processing. We will take a closer look at this in Chapter 2, but for now let's just make sure that we are using the best-quality JPEG possible.

The D3200 has nine settings for the JPEG format. There are three settings each for the Large, Medium, and Small image size settings. The three settings (Basic, Normal, and Fine) represent more or less image compression based on your choice. The Large, Medium, and Small settings determine the actual physical size of your image in pixels. Let's work with the highest-quality setting possible. After all, our goal is to make big, beautiful photographs, so why start the process with a lower-quality image?

SETTING THE IMAGE QUALITY

- 1. Press the i button (at the bottom left on the back of the camera) to activate the cursor in the information screen.
- 2. Use the Multi-selector to select the top image quality setting, then press the OK button (A).
- 3. When the option screen appears, use the Multi-selector to choose the Fine setting, and press the OK button (B).
- **4.** Now move the cursor down one step to choose the image size, and press OK to get to the options (**C**).
- 5. Select the L option to use the largest image size available, and press OK once more (D).
- 6. Press the i button again to return to shooting mode.

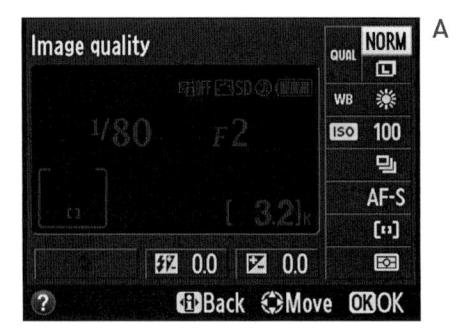

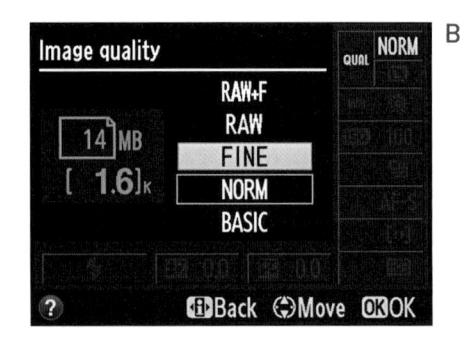

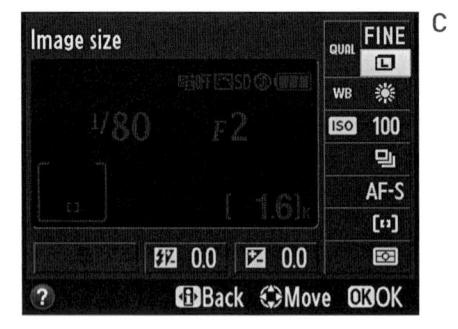

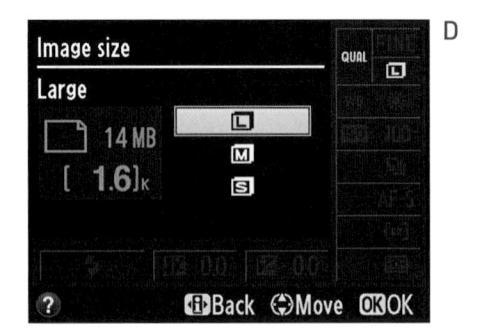

As you will see when scrolling through the quality settings, the higher the quality, the fewer pictures you will be able to fit on your card. If you have an 8 GB memory card, the quality setting we have selected will allow you to shoot about 509 photographs before you fill up your card. Always try to choose quality over quantity. Your pictures will be the better for it.

Manual Callout

For a complete chart that shows the image quality settings with the number of possible shots for each setting, turn to page 188 in your user manual. This is not the small printed manual but the PDF version that can be found on the Reference Manual CD.

4. TURN OFF THE AUTO ISO SETTING

The ISO setting in your camera allows you to choose the level of sensitivity of the camera sensor to light. The ability to change this sensitivity is one of the biggest advantages to using a digital camera. In the days of film cameras, you had to choose the ISO by film type. This meant that if you wanted to shoot in lower light, you had to replace the film in the camera with one that had a higher ISO. So not only did you have to carry different types of film, but you also had to remove one roll from the camera to replace it with another, even if you hadn't used up the current roll. Now all you have to do is go to your information screen and select the appropriate ISO.

Having this flexibility is a powerful option, but just as with the Quality setting, the ISO setting has a direct bearing on the quality of the final image. The higher the ISO, the more digital noise the image will contain. Since our goal is to produce high-quality photographs, it is important that we get control over all of the camera controls and bend them to our will. When you turn your camera on for the first time, the ISO will be set to Auto. This means that the camera is determining how much light is available and will choose what it believes is the correct ISO setting. Since you want to use the lowest ISO possible, you will need to turn this setting off and manually select the appropriate ISO.

Which ISO you choose depends on your level of available or ambient light. For sunny days or very bright scenes, use a low ISO such as 100. As the level of light is reduced, raise the ISO level. Cloudy days or indoor scenes might require you to use ISO 400. Low-light scenes, such as when you are shooting at night, will mean you need to bump up that ISO to 1600 or higher. The thing to remember is to shoot with the lowest setting possible for maximum quality.

SETTING THE ISO

- Press the i button on the back of the camera to activate the cursor in the information screen
- Use the Multi-selector to highlight the ISO sensitivity option and press the OK button (A).
- 3. In the option screen, select the appropriate ISO for the level of light you are shooting in and press the OK button to lock in the change (B).

You should know that the Auto ISO option is only enabled as a default when using one of the automatic scene modes. When using one of the professional modes (M, A, S, and P; we'll discuss these in Chapter 4), the Auto ISO feature will be automatically

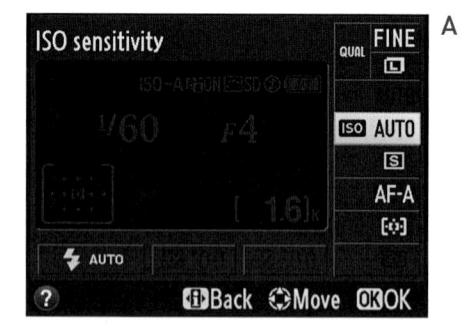

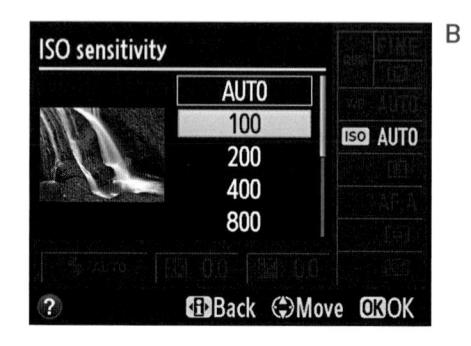

turned off. If you wish to use Auto ISO in one of these modes, you must activate it and set the auto parameters in the shooting menu. If you plan on shooting with the Auto or Flash Off modes, you cannot turn off the Auto ISO option at all.

NOISE

Noise is the enemy of digital photography, but it has nothing to do with the loudness of your camera operation. It is a term that refers to the electronic artifacts that appear as speckles in your image. They generally appear in darker shadow areas and are a result of the camera trying to amplify the signal to produce visible information. The more the image needs to be amplified—e.g., raising the sensitivity through higher ISOs—the greater the amount of noise there will be.

SET YOUR ISO ON THE FLY

You can also change the ISO without taking your eye from the viewfinder. Although there is no dedicated ISO button on the D3200, you can still change this setting on the fly by setting the Function button to handle ISO sensitivity. Simply use the Setup Menu item called Buttons to change the assignment of the Function button to ISO. Then, while you are looking through the viewfinder, just press and hold the Function button while turning the Command dial. You will see the ISO value change in your viewfinder display.

5. SET YOUR FOCUS POINT AND MODE

The Nikon focusing system is well known for its speed and accuracy. The automatic focus modes give you a ton of flexibility in your shooting. There is, however, one small problem that is inherent with any focusing system. No matter how intelligent it is, the camera is looking at all of the subjects in the scene and determining which is closest to the camera. It then uses this information to determine where the proper focus point should be. It has no way of knowing what your main emphasis is, so it is using a "best guess" system. To eliminate this factor, you should set the camera to single-point focusing so that you can ensure that you are focusing on the most important feature in the scene.

The camera has 11 separate focus points to choose from. They are arranged in a diamond pattern in the viewfinder, with ten points around the outside of the diamond and one in the center. To start things off, you should select the focus point in the middle. Once you have become more familiar with the focus system, you can experiment with the other points, as well as the automatic point selection.

You should also change the focus mode to AF-S so that you can focus on your subject and then recompose your shot while holding that point of focus.

SETTING THE FOCUS POINT AND FOCUS MODE

- 1. To choose a single point of focus, wake the camera (if necessary) by lightly pressing the shutter release button.
- 2. Press the i button on the back of the camera to activate the cursor in the information screen.
- 3. Use the Multi-selector to highlight the AF-area mode and press OK (A).
- 4. Select the top option, Single-point AF, and press OK (B).
- **5.** With the cursor still active, move up one item to the Focus mode option and press OK (**C**).
- Select AF-S for single focus mode, and press the OK button to lock in your change (D).
- 7. Press the i button to return to the regular information screen.

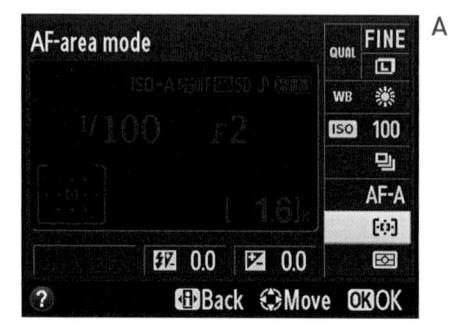

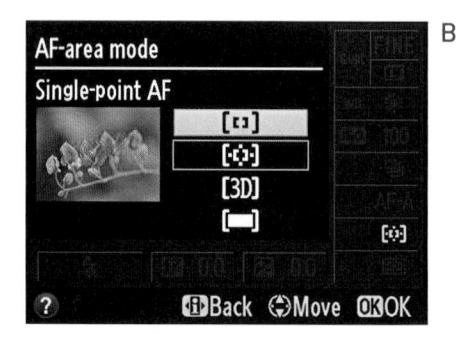

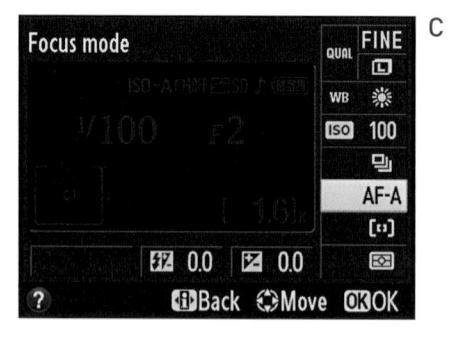

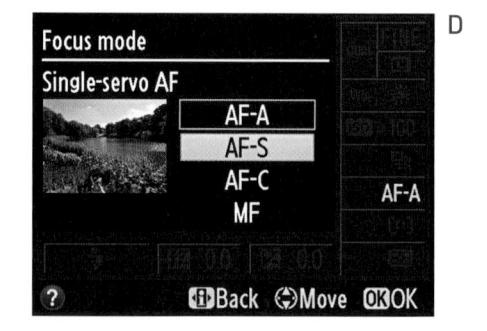

12

The camera is now ready for single focusing. You will hear a chirp (unless you've turned off the beep under the Setup Menu) when the camera has locked in and focused on the subject. To focus on your subject and then recompose your shot, just place the focus point in the viewfinder on your subject, depress the shutter release button halfway until the camera chirps, and without letting up on the shutter button, recompose your shot and then press the shutter button all the way down to make your exposure.

6. SET THE CORRECT WHITE BALANCE

Color balance correction is the process of rendering accurate colors in your final image. Most people don't even notice that light has different color characteristics, because the human eye automatically adjusts to changes in color temperature—so quickly, in fact, that everything looks correct in a matter of milliseconds.

When color film ruled the world, photographers would select which film to use depending on what their light source was going to be. The most common film was balanced for daylight, but you could also buy film that was color balanced for tungsten light sources. Most other lighting situations had to be handled by using color filters over the lens. This process was necessary for the photographer's final image to show the correct color balance of a scene.

Your camera has the ability to perform this same process automatically, but you can also choose to override it and set it manually. Guess which method we are going to use? That's right, once again your photography should be all about maintaining control over everything that influences your final image.

Luckily, you don't need to have a deep understanding of color temperatures to control your camera's white balance. The choices are given to you in terms that are easy to relate to and that will make things pretty simple. Your white balance choices are:

- Auto: The default setting for your camera. It is also the setting used by all of the automatic scene modes (see Chapter 3).
- Incandescent: Used for any occasion where you are using regular household-type bulbs for your light source. Tungsten is a very warm light source and will result in a yellow/orange cast if you don't correct for it.
- Cool-White Fluorescent: Used to get rid of the green-blue cast that can result from
 using regular fluorescent lights as your dominant light source. Some fluorescent
 lights are actually balanced for daylight, which would allow you to use the Daylight
 white balance setting.

- Direct Sunlight: Most often used for general daylight/sun-lit shooting.
- Flash: Used whenever you're using the built-in flash or a flash on the hot shoe. You should select this white balance to adjust for the slightly cooler light that comes from using a flash. (The hot shoe is the small bracket located on the top of your camera; it rests just above the eyepiece. This bracket is used for attaching a more powerful flash to the camera; see Chapter 8 and the online bonus chapter, "Pimp My Ride.")
- **Cloudy:** The choice for overcast or very cloudy days. This and the Shade setting will eliminate the blue color cast from your images.
- **Shade:** Used when working in shaded areas that are still using sunlight as the dominant light source.
- **Pre:** Indicates that you are using a customized white balance that is adjusted for a particular light source. This option can be adjusted using an existing photo you have taken or by taking a picture of something white or gray in the scene.

Your camera has two different "zones" of shooting modes to choose from. These are located on the Mode dial, and they are separated into automatic scene modes and what I refer to as the professional modes. All of the automatic modes, which are identifiable by small icons on the Mode dial, are automatic in nature and do not allow for much, if any, customization, which includes white balance. The professional modes, defined by the letter symbols M, A, S, and P, allow for much more control by the photographer (Figure 1.2).

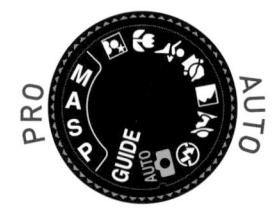

FIGURE 1.2

The camera's shooting modes are divided into the automatic scene modes and the professional modes.

SETTING THE WHITE BALANCE

- After turning on or waking the camera, select one of the professional shooting modes, such as P (you can't select the white balance when using any of the automatic modes).
- 2. Press the i button on the back of the camera to activate the cursor in the information screen.
- 3. Use the Multi-selector to highlight the White balance option and press the OK button (A).

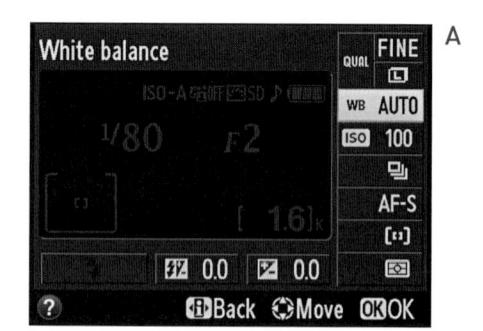

- **4.** Using the Multi-selector, select the appropriate white balance and then press the OK button (**B**).
- **5.** Press the **i** button to return to the regular information screen.

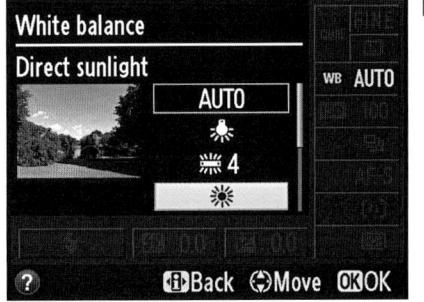

WHITE BALANCE AND THE TEMPERATURE OF COLOR

Different white balance settings in your camera correspond to a number–e.g., 5200K, 7000K, or 3200K. These numbers refer to the Kelvin temperature of the colors in the visible spectrum. The visible spectrum is the range of light that the human eye can see (think of a rainbow or the color bands that come out of a spectrum). The visible spectrum of light has been placed into a scale called the Kelvin temperature scale, which identifies the thermodynamic temperature of a given color of light. Put simply, reds and yellows are "warm" and greens and blues are "cool." Even more confusing can be the actual temperature ratings. Warm temperatures are typically lower on the Kelvin scale, ranging from 3000 degrees to 5000 degrees, while cool temperatures run from 5500 degrees to around 10000 degrees. Take a look at this list for an example of Kelvin temperature properties.

KELVIN TEMPERATURE PROPERTIES

Flames	1700K-1900K	Daylight	5000K
Incandescent bulb	2800K-3300K	Camera flash	5500K
White fluorescent	4000K	Overcast sky	6000K
Moonlight	4000K	Open shade	7000K

The most important thing to remember here is how the color temperature of light affects the look of your images. If something is "warm," it will look reddish-yellow, and if something is "cool," it will have a bluish cast.

7. SET YOUR COLOR SPACE

The color space deals with how your images will ultimately be used. It is basically a set of instructions that tells your camera how to define the colors in your image and then output them to the device of your choice, be it your monitor or a printer. Your camera has a choice of two color spaces: sRGB and Adobe RGB.

The first choice, sRGB, was developed by Hewlett-Packard and Microsoft as a way of defining colors for the Internet. This space was created to deal with the way that computer monitors actually display images using red, green, and blue (RGB) colors. Because there are no black pixels in your monitor, the color space uses a combination of these three colors to display all of the colors in your image.

In 1998, Adobe Systems developed a new color space, Adobe RGB, which was intended to encompass a wider range of colors than was obtainable using traditional cyan, magenta, yellow, and black colors (called CMYK) but doing so using the primary red, green, and blue colors. It uses a more widely defined palette of colors (or gamut) than the sRGB space and, therefore, contains colors farther toward the more saturated end of the spectrum than sRGB does, which can be preferable when printing.

A LITTLE COLOR THEORY

The visible spectrum of light is based on a principle called *additive color* and is based on three primary colors: red, green, and blue. When you add these colors together in equal parts, you get white light. By combining different amounts of them, you can achieve all the different colors of the visible spectrum. This is a completely different process than printing, where cyan, magenta, and yellow colors are combined to create various colors. This method is called *subtractive color* and has to do with the reflective properties of pigments or inks as they are combined.

The color space choice is applied only to the JPEG images produced by the camera. If you should choose to shoot RAW (discussed in Chapter 2), the color space is determined later when you are using software to process the photos. I typically use the Adobe RGB space when shooting JPEG because it has a wider gamut than sRGB, and it is always better to go from a wider color space to a narrower one when editing. That said, if you are shooting JPEG and sending photos straight to a printer or posting online without much (or any) editing, then sRGB is a fine choice.

SETTING THE COLOR SPACE

- 1. With the camera turned on, press the Menu button.
- 2. Using the Multi-selector, select the Shooting Menu, highlight the Color space option, and press the OK button (A).
- 3. Highlight your desired color space and press the OK button once again (B).
- **4.** Press the i button to return to the regular information screen.

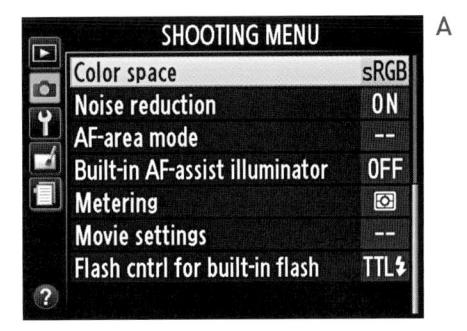

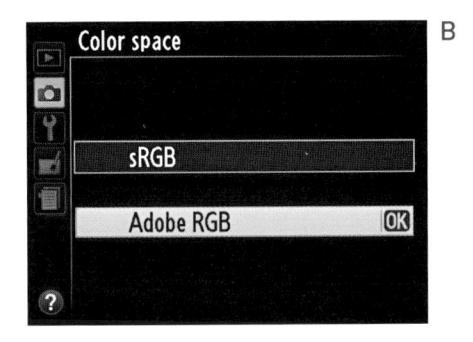

CHANGING SPACES

If you aren't sure about how you are going to be using your images, don't worry too much. The color space can always be changed later by using a photo-processing program.

8. KNOW HOW TO OVERRIDE AUTOFOCUS

As good as the Nikon autofocus system is, there will be times when it just isn't doing the job for you. Many times this has to do with how you would like to compose a scene and where the actual point of focus should be. This can be especially true when you are using the camera on a tripod, where you can't pre-focus and then recompose before shooting (as discussed earlier). To take care of this problem, you will need to manually focus the lens. I am only going to cover the kit lens that came with my D3200 (the 18–55mm VR), so if you have purchased a different lens be sure to check the accompanying instruction manual for the lens.

On the 18–55mm kit lens, you simply need to slide the switch located at the base of the lens (located on the lens barrel near the body of the camera) from the A setting to the M setting (Figure 1.3). You can now turn the focus ring at the end of the lens to set your focus. Now that you're in manual focus mode, the camera will not give you an audible chirp when you have correctly focused.

We'll cover more manual focus situations in greater detail in future chapters.

FIGURE 1.3 Slide the focus switch on the lens to the M position to manually focus.

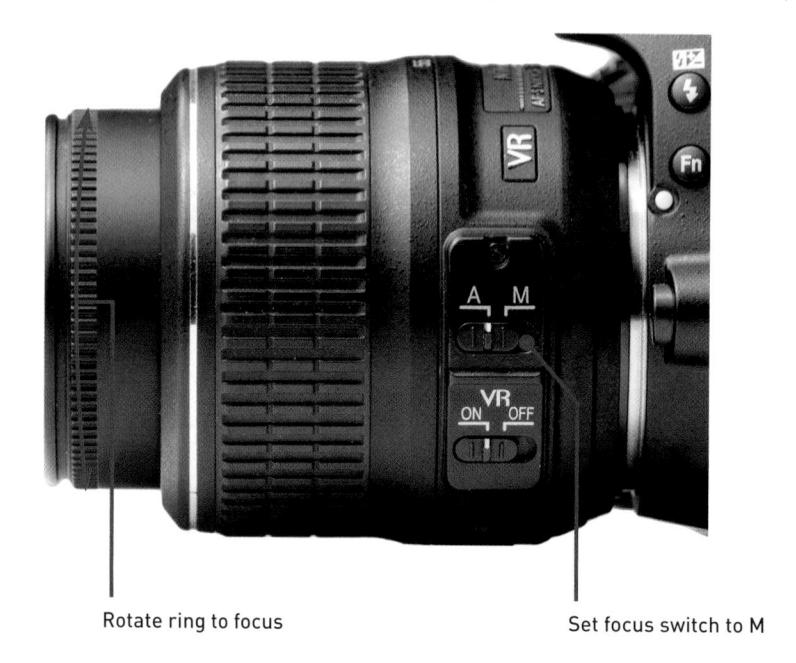

9. REVIEW YOUR SHOTS

One of the greatest features of a digital camera is its ability to give instant feedback. By reviewing your images on the camera's LCD screen, you can instantly tell if you got your shot. This visual feedback allows you to make adjustments on the fly and make certain that all of your adjustments are correct before moving on.

When you first press the shutter release button, your camera quickly processes your shot and then displays the image on the LCD display. The default setting for that display is only four seconds, which is why I change my review times (as discussed earlier). Since we have already adjusted the auto off timer, let's check out some of the other visual information that will really help you when shooting.

The default view (**Figure 1.4**) simply displays your image along with the image file name, date, time, and image quality setting.

There are other display options available that must be turned on using the camera menu. These options can be found in the Playback Menu under the Playback display options (Figure 1.5). With this menu option you can add display modes such as None (image only), Highlights (Figure 1.6), RGB histogram (Figure 1.7), Shooting data (Figure 1.8), and Overview (Figure 1.9).

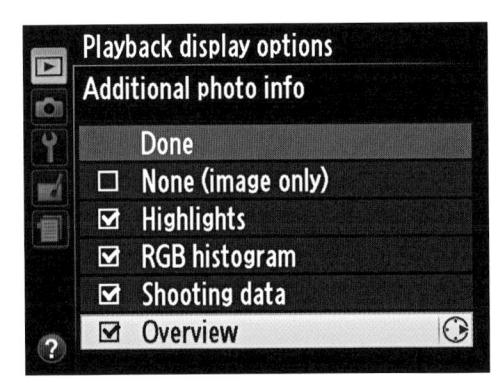

FIGURE 1.5
The Playback display options.

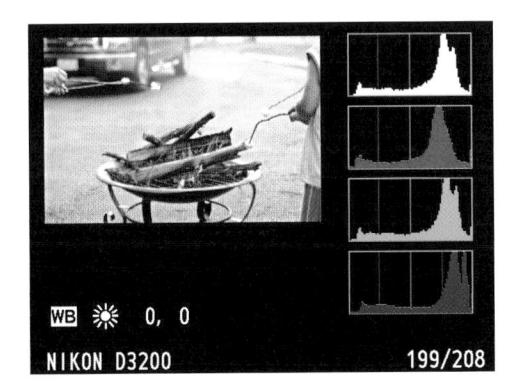

FIGURE 1.7
The RGB histogram display mode.

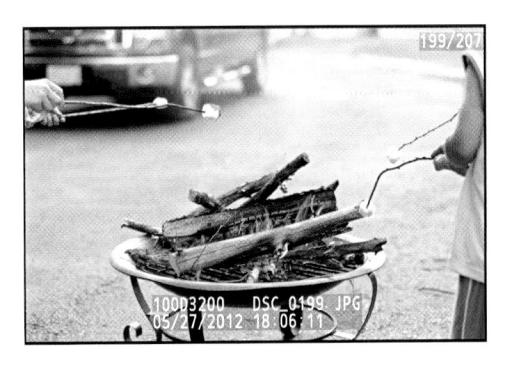

FIGURE 1.4
The default display mode on the D3200.

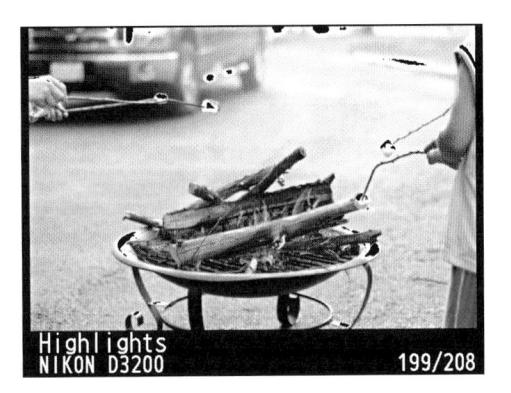

FIGURE 1.6 The Highlights display mode.

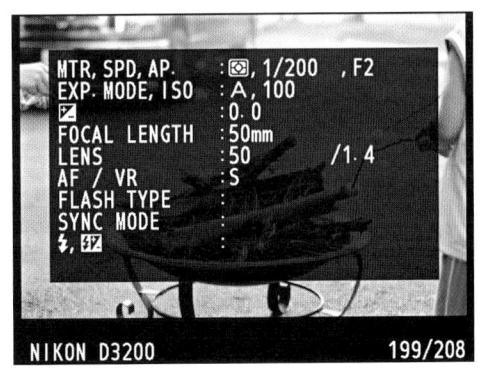

FIGURE 1.8
The Shooting data display mode.

FIGURE 1.9 Overview display mode gives you much more information.

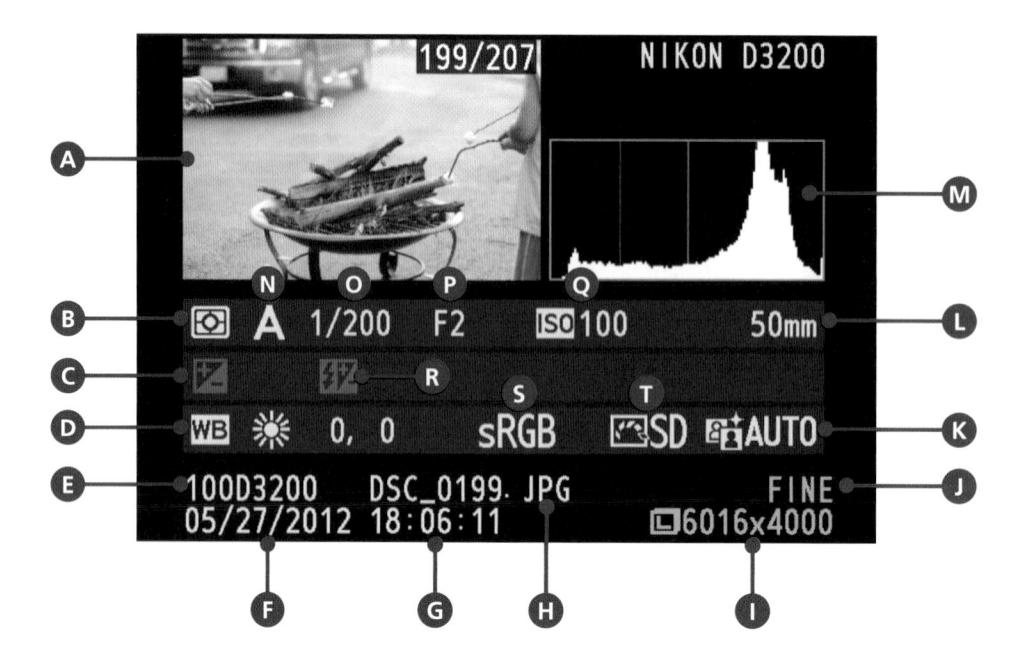

- A Image Thumbnail
- **B** Meter Setting
- C Exposure Compensation
- D White Balance
- E Folder Name
- F Date
- G Time

- H File Name
- I Image Size
- J Quality Setting
- K Active D-Lighting Status
- L Lens Length
- M Histogram
- N Camera Mode

- Shutter Speed
- P Aperture
- Q ISO
- R Flash Compensation
- S Color Space
- T Picture Control

I personally don't use the RGB histogram and Shooting data settings because this information does not offer me any visual information that I find critical during a photo session. I do, however, always have the Highlights option turned on so that I can always make sure I am not clipping any information from my image highlights. (Check out the "How I Shoot" section in Chapter 4 for more information about the Highlight display view and how to use it to improve your image quality.)

The display view called Overview provides the most visual feedback. This view mode not only displays the same information as the default view, but also includes camera settings such as aperture, shutter speed, lens length, white balance, exposure compensation, shooting mode, ISO, white balance setting, quality setting, any compensation settings, the active color space, and the picture control. The other noticeable item will be the histogram, which gives you important feedback on the luminance values in your image.

Because the image thumbnail is so small, you probably won't want to use this display option as your default review setting, but if you are trying to figure out what settings you used or you want to review the histogram (see the sidebar "The Value of the Histogram"), you now have all of this great information available.

DELETING IMAGES

Deleting or erasing images is a fairly simple process that is covered on pages 106–108 of the Reference Manual on the CD. To quickly get you on your way, simply press the Image Playback button and use the Multi-selector to find the picture that you want to delete. Then press the Delete button (its icon looks like a trash can) located on the back of the camera underneath the Multi-selector. When you see the confirmation screen, simply press the Delete button once again to complete the process.

Caution: Once you have deleted an image, it is gone for good. Make sure you don't want it anymore before you drop it in the trash.

THE VALUE OF THE HISTOGRAM

Simply put, histograms are two-dimensional representations of your images in graph form. There are two histograms that you should be concerned with: luminance and color. Luminance is referred to in your manual as "brightness" and is most valuable when evaluating your exposures. In **Figure 1.10**, you see what looks like a mountain range. The graph represents the entire tonal range that your camera can capture, from the whitest whites to the blackest blacks. The left side represents black; the right side represents white. The heights of the peaks represent the number of pixels that contain those luminance levels (a tall peak in the middle means your image contains a large amount of medium-bright pixels). Looking at this figure, it is hard to determine where all of the ranges of light and dark areas are and how much of each I have. I can see that the largest peak of the graph is in the middle and trails off as it reaches the edges. In most cases, you would look for this type of histogram, indicating that you captured the entire range of tones, from dark to light, in your image. Knowing that is fine, but here is where the information really gets useful.

A histogram that has a spike or peak riding up the far left or right side of the graph means that you are clipping detail from your image. In essence, you are trying to record values that are either too dark or too light for your sensor to accurately record. This is usually an indication of over- or underexposure. It also means that you need to correct your exposure so that the important details will not record as solid black or white pixels (which is what happens when clipping occurs). There are times, however, when some clipping is acceptable. If you are photographing a scene where the sun will be in the frame, you can expect to get some clipping, because the sun is

just too bright to hold any detail. Likewise, if you are shooting something that has true blacks in it—think coal in a mineshaft at midnight—there are most certainly going to be some true blacks with no detail in your shot.

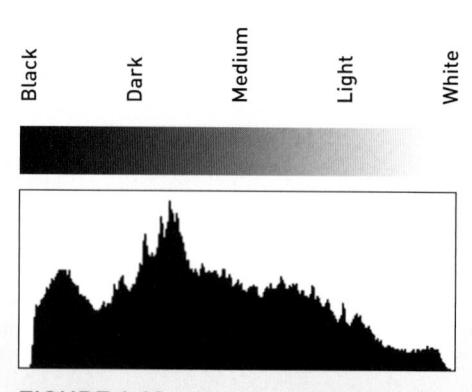

FIGURE 1.10

This is a typical histogram, where the dark to light tones run from left to right. The black-to-white gradient above the graph demonstrates where the tones lie on the graph and would not appear above your camera's histogram display.

The main goal is to ensure that you aren't clipping any "important" visual information, and that is achieved by keeping an eye on your histogram. Take a look at **Figure 1.11**. The histogram displayed on the image shows a heavy skew toward the left, with almost no part of the mountain touching the right side. This is a good example of what an underexposed image histogram looks like. Compare that to **Figure 1.12**, the histogram for the same image correctly exposed. Notice that even though there are two distinct peaks on the graph, there is an even distribution across the entire histogram.

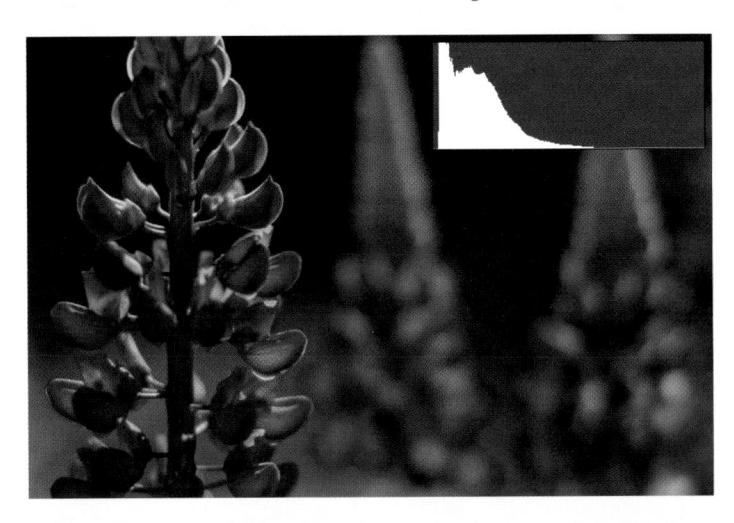

FIGURE 1.11
This image is about two stops underexposed. Notice that the histogram is skewed to the left.

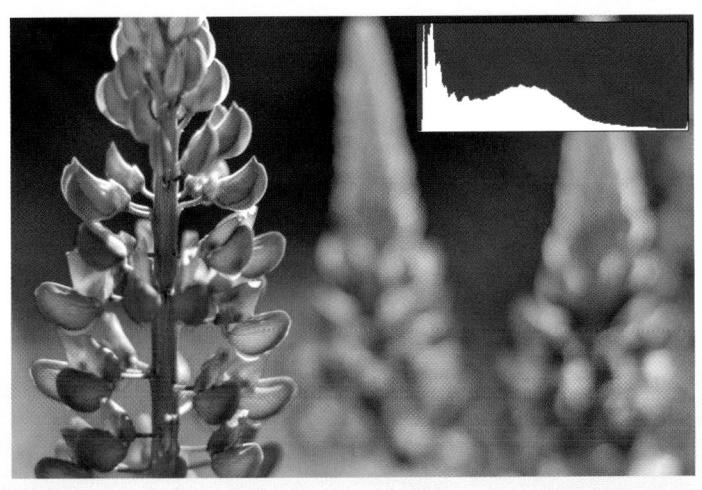

FIGURE 1.12 This histogram reflects a correctly exposed image.

10. HOLD YOUR CAMERA FOR PROPER SHOOTING

You might think that this is really dumb, but I hope that you take a few seconds to read this over and make sure that you are giving yourself the best chance for great images. I can't begin to tell you how many times I see photographers holding their cameras in a fashion that is either unstable or just plain uncomfortable-looking. Much of this probably comes from holding point-and-shoot cameras. There is a huge difference between point-and-shoots and DSLR cameras, and learning the correct way to hold one now will result in great images later. The purpose of practicing correct shooting form is to provide the most stable platform possible for your camera (besides using a tripod, of course).

DSLR cameras are made to favor the right-handed individual. The basics of properly holding the camera begin with grasping the camera body with the right hand. You will quickly find that most of the important camera controls are within easy reach of your thumb and forefinger. The next step is to create a stable base for your camera to rest on. This is accomplished by placing the camera body on the up-facing palm of your left hand (Figure 1.13). Now you can curl your fingers around the lens barrel to quickly zoom or manually focus the lens.

FIGURE 1.13 The proper way to hold your camera to ensure sharp, blurfree images.

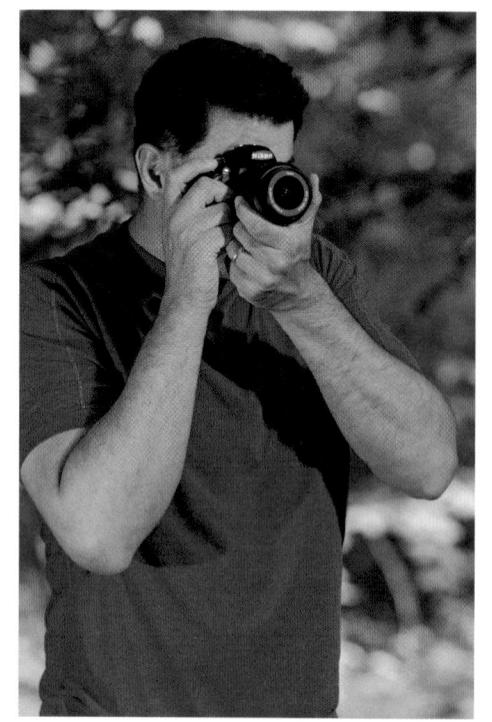

Now that you know where to put your hands, let's talk about what to do with the rest of your body parts. By using the underhand grip, your elbows will be drawn closer to your body. You should concentrate on pulling them in close to your body to stabilize your shooting position. You should also try to maintain proper upright posture. Leaning forward at the waist will begin to fatigue your back, neck, and arms. You can really ruin a day of shooting with a sore back, so make sure you stand erect with your elbows in. Finally, place your left foot in front of your right foot, and face your subject in a slightly wide stance. By combining all of these aspects into your photography, you will give yourself the best chance of eliminating self-imposed camera shake (or hand shake) in your images, resulting in much sharper photographs.

Chapter 1 Assignments

Let's begin our shooting assignments by setting up and using all of the elements of the Top Ten list. Even though I have yet to cover the professional shooting modes, you should set your camera to the P (Program) mode. This will allow you to interact with the various settings and menus that have been covered thus far.

Basic camera setup

Charge your battery to 100% to get it started on a life of dependable service. Next, using your newfound knowledge, set up your camera to address the following: image quality, Auto ISO, and color space.

Selecting the proper white balance

Take your camera outside into a daylight environment and then photograph the same scene using different white balance settings. Pay close attention to how each setting affects the overall color cast of your images. Next, try moving inside and repeat the exercise while shooting in a tungsten lighting environment. Finally, find a fluorescent light source and repeat one more time.

Focusing with single point and AF-S

Change your camera setting so that you are focusing using the single-point focus mode. Try using all of the different focus points to see how they work in focusing your scene. Then set your focus mode to AF-S and practice focusing on a subject and then recomposing before actually taking the picture. Try doing this with subjects at varying distances.

Evaluating your pictures with the LCD display

Set up your image display properties and then review some of your previous assignment images using the different display modes. Review your shooting information for each image and take a look at the histograms to see how the content of your photo affects the shape of the histograms.

Discovering the manual focus mode

Change your focus mode from autofocus to manual focus and practice a little manual focus photography. Get familiar with where the focus ring is and how to use it to achieve sharp images.

Get a grip: proper camera holding

This final assignment is something that you should practice every time you shoot: proper grip and stance for shooting with your camera. Use the described technique and then shoot a series of images. Try comparing it with improper techniques to compare the stability of the grip and stance.

Share your results with the book's Flickr group!

 ${\it Join the group here: flickr.com/groups/nikond 3200_froms napshots to great shots}$

First Things First

A FEW THINGS TO KNOW AND DO BEFORE YOU BEGIN TAKING PICTURES

Now that we've covered the top ten tasks to get you up and shooting, we should probably take care of some other important details. You must become familiar with certain features of your camera before you can take full advantage of it. Additionally, we will take some steps to prepare the camera and memory card for use. So to get things moving, let's start off with something that you will definitely need before you can take a single picture: a memory card.

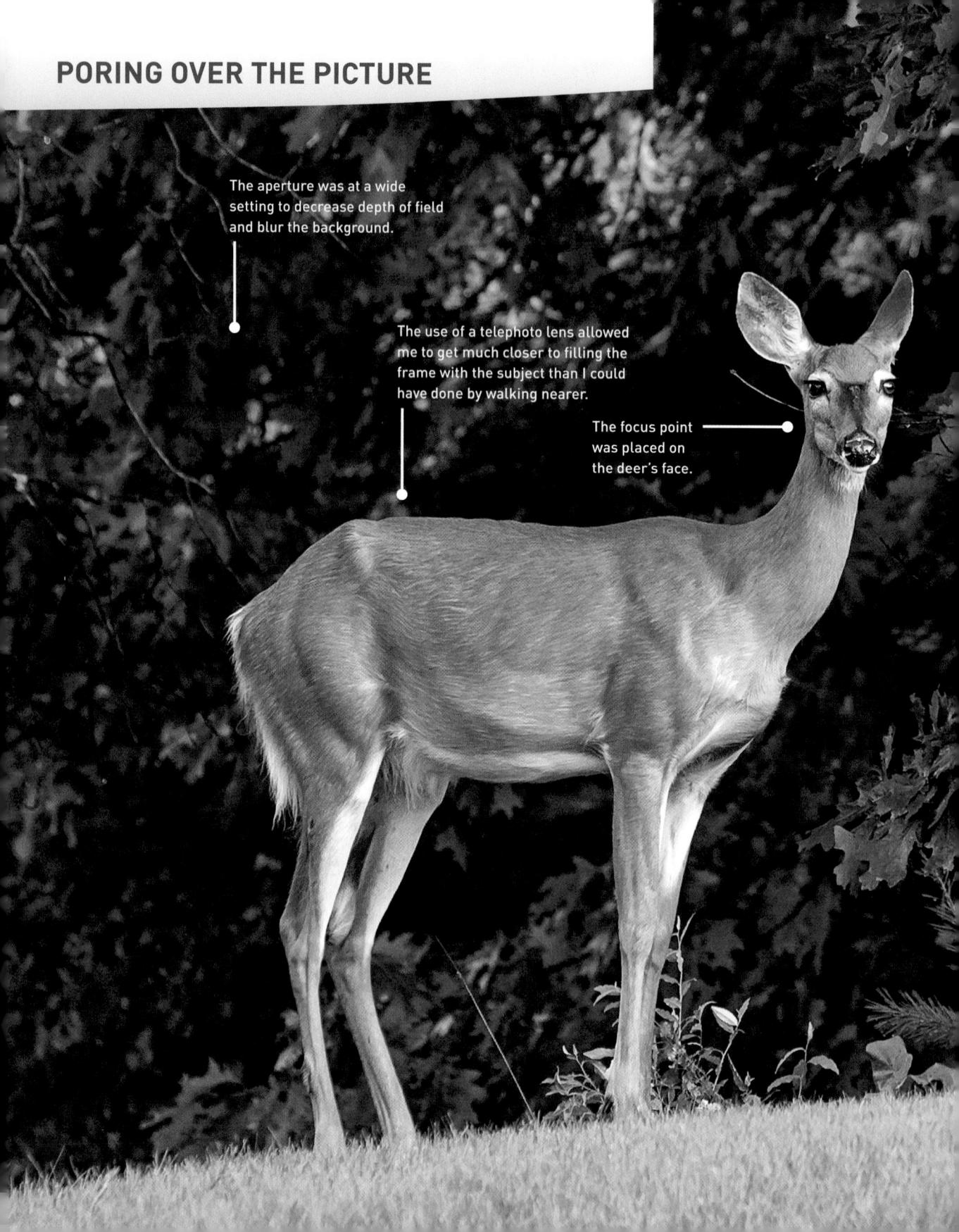

I grew up in a suburb of New York City and always dreamed of living someplace a little more rural where wild animals might just walk through your backyard. I've been happily living in New Hampshire for over 20 years now and count myself lucky when I get such great subjects as this white-tailed deer coming to call. Sure, they do occasionally nibble through the flower garden, but that seems a small price to pay. On this late summer afternoon I caught sight of this doe passing through, grabbed my camera with a 70-300mm lens, and walked as calmly as I could on a path to intercept her before she got lost in the woods. Thankfully, she paused for a moment to pose before vanishing into the dusk. The ISO was raised to allow for a fast enough shutter speed to decrease blur from camera shake while shooting without a tripod. ISO 640 1/160 sec. f/5.6 300mm lens

CHOOSING THE RIGHT MEMORY CARD

Memory cards are the digital film that stores every shot you take until you move them to a computer. The cards come in all shapes and sizes, and they are critical for capturing all of your photos. It is important not to skimp when it comes to selecting your memory cards. The D3200 uses Secure Digital (SD), Secure Digital High Capacity (SDHC), or Secure Digital Extended Capacity (SDXC) memory cards (Figure 2.1).

If you have been using a point-and-shoot camera, that has eno chances are that you may already own an SD media your photogrand. Which brand of card you use is completely up to you, but here is some advice about choosing your memory card:

FIGURE 2.1

Make sure you select an SD card that has enough capacity to handle your photography needs.

- Size matters, at least in memory cards. At 24.2 megapixels, the D3200 will require
 a lot of storage space, especially if you shoot in the RAW or RAW+JPEG mode
 (more on this later in the chapter). You should definitely consider using a card
 with a storage capacity of at least 8 GB.
- Consider buying High Capacity (SDHC) cards. These cards are generally much
 faster, both when writing images to the card as well as when transferring them to
 your computer. If you are planning on using the Continuous mode (see Chapter
 5) for capturing fast action, you can gain a boost in performance just by using an
 SDHC card with a class rating of at least 6. The higher the class rating, the faster
 the write speed.
- Buy more than one card. If you have already purchased a memory card, consider getting another. You can quickly ruin your day of shooting by filling your card and then having to either erase shots or choose a lower-quality image format so that you can keep on shooting. With the cost of memory cards what it is, keeping a spare just makes good sense.

Manual Callout

For a list of Nikon-approved memory cards for the D3200, you should check out page 62 in the user's manual.

FORMATTING YOUR MEMORY CARD

Now that you have your card, let's talk about formatting for a minute. When you purchase any new memory card, you can pop it into your camera and start shooting right away—and everything will probably work as it should. However, what you should do first is format the card in the camera. This process allows the camera to set up the card to record images from your camera. Just as a computer hard drive must be formatted, formatting your card ensures that it is properly initialized. The card may work in the camera without first being formatted, but chances of failure down the road are much higher.

As a general practice, I always format new cards or cards that have been used in different cameras. I also reformat cards after I have downloaded my images and want to start a new shooting session. Note that you should always format your card in the camera, not in your computer. Using the computer could render the card useless. You should also pay attention to the card manufacturer's recommendations with respect to moisture, humidity, and proper handling procedures. It sounds a little cliché, but when it comes to protecting your images, every little bit helps.

Most people make the mistake of thinking that the process of formatting the memory card is equivalent to erasing it. Not so. The truth is that when you format the card all you are doing is changing the file management information on the card. Think of it as removing the table of contents from a book and replacing it with a blank page. All of the contents are still there, but you wouldn't know it by looking at the empty table of contents. The camera will see the card as completely empty so you won't be losing any space, even if you have previously filled the card with images. Your camera will simply write the new image data over the previous data.

FORMATTING YOUR MEMORY CARD

- Insert your memory card into the camera (A).
- 2. Press the Menu button and navigate to the Setup Menu screen.

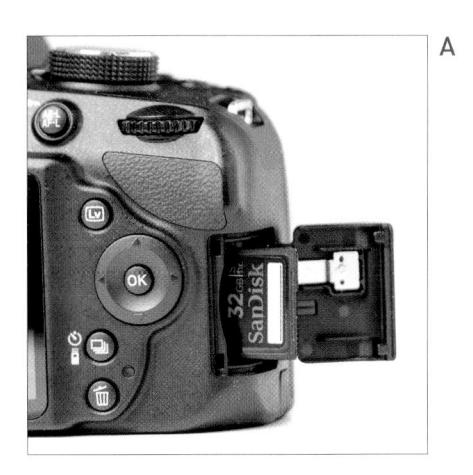

- **3.** Use the Multi-selector on the back of the camera to highlight the Format memory card option and press OK (B).
- **4.** The next screen will show you a warning, letting you know that formatting the card will delete all images (**C**). Select Yes and press the OK button.
- 5. The card is now formatted and ready for use.

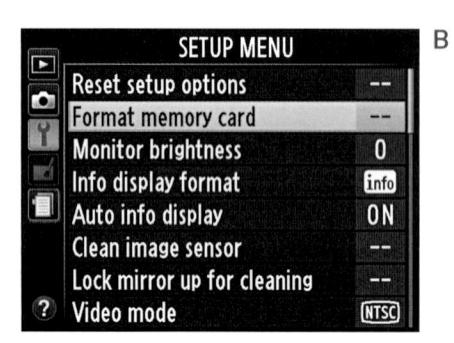

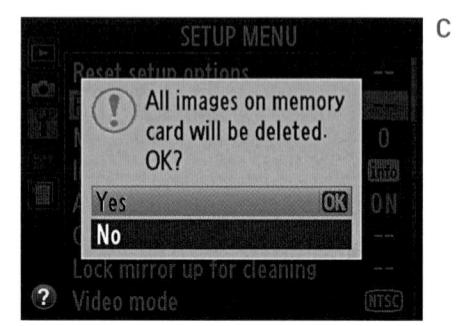

UPDATING THE D3200'S FIRMWARE

I know that you want to get shooting, but having the proper firmware can affect the way the camera operates. It can fix problems as well as improve operation, so you should probably check it sooner rather than later. Updating your camera's firmware is something that the manual completely omits, yet it can change the entire behavior of your camera operating systems and functions. The firmware of your camera is the set of computer operating instructions that controls how your camera functions. Updating this firmware is a great way to not only fix little bugs but also gain access to new functionality. You will need to check out the information on the Nikon firmware update page (http://nikonusa.com/Service-And-Support/Download-Center.page) to see if a firmware update is available and how it will afffect your camera, but it is always a good idea to be working with the most up-to-date firmware version available.

CHECKING THE CAMERA'S CURRENT FIRMWARE VERSION NUMBER

- 1. Press the Menu button and then navigate to the Setup Menu.
- 2. Use the Multi-selector on the back of the camera to highlight the Firmware version option and press OK (A).
- **3.** Take note of the current version numbers and then check the Nikon website to see if you are using the current versions (B).

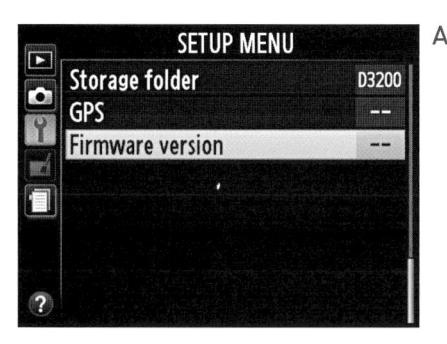

UPDATING THE FIRMWARE FROM YOUR SD CARD

- 1. Download the firmware update file from the Nikon website. (You can find the file by going to the Download section of the Nikon camera site, clicking the Current Firmware link, and then locating the firmware update for your camera and computer operating system.)
- 2. Once you have downloaded the firmware to your computer and extracted it, you will need to transfer it to your SD card. The card must be formatted in your camera prior to loading the firmware to it.
- 3. With a freshly charged camera battery, insert the card into the camera and turn it on.
- **4.** Follow the instructions listed above for locating your firmware version, and you will now be able to update your firmware using the files located on the SD card.

As of the writing of this book, there are no firmware updates available for the D3200. After you check your camera firmware version and the Nikon site for updates, continue to check back periodically to see if any updates become available.

CLEANING THE SENSOR

Cleaning camera sensors used to be a nerve-racking process that required leaving the sensor exposed to scratching and even more dust. Now, cleaning the sensor is pretty much an automatic function. Every time you turn the camera on and off, you can instruct the sensor in the camera to vibrate to remove any dust particles that might have landed on it.

There are five choices for cleaning in the camera setup menu: Clean at startup, Clean at shutdown, Clean at startup and shutdown, Cleaning off, and Clean now. I'm kind of obsessive when it comes to cleaning my sensor, so I like to have it set to clean when I turn the camera on and off.

The one cleaning function that you will need to use via this menu is the Clean now feature. This should be done every time that you remove the lens from the camera body. That is because removing or changing a lens will leave the camera body open and susceptible to dust sneaking into the body. If you never change lenses, you shouldn't have too many dust problems. But the more often you change lenses, the more chances you are giving dust to enter the body.

Every now and then, there will just be a dust spot that is impervious to the shaking of the Auto Cleaning feature. This will require manual cleaning of the sensor by raising the mirror and opening the camera shutter. When you activate this feature, it will move everything out of the way, giving you access to the sensor so that you can use a blower or other appropriate cleaning device to remove the stubborn dust speck. The camera will need to be turned off after cleaning to allow the mirror to reset.

If you choose to manually clean your sensor, use a device that has been made to clean sensors (not a cotton swab from your medicine cabinet). There are dozens of commercially available devices such as brushes, swabs, and blowers that will clean the sensor without damaging it. To keep the sensor clean, always store the camera with a body cap or lens attached.

The camera sensor is an electrically charged device. This means that when the camera is turned on, there is a current running through the sensor. This electric current can create static electricity, which will attract small dust particles to the sensor area. For this reason, it is always a good idea to turn off the camera prior to removing a lens. You should also consider having the lens mount facing down when changing lenses so that there is less opportunity for dust to fall into the inner workings of the camera.

USING THE CLEAN NOW FEATURE

- 1. Press the Menu button, then navigate to the Setup Menu.
- 2. Use the Multi-selector on the back of the camera to highlight the Clean image sensor option and press OK (A).
- 3. Highlight the Clean now option and press the OK button (B). The camera will clean the sensor for about two seconds and then return to the menu.

USING THE RIGHT FORMAT: RAW VS. JPEG

When shooting with your D3200, you have a choice of image formats that your camera will use to store the pictures on the memory card. JPEG is probably the most familiar format to anyone who has been using a digital camera. I touched on this topic briefly in Chapter 1, so you already have a little background on what JPEG and RAW files are.

There is nothing wrong with JPEG if you are taking casual shots. JPEG files are ready to use, right out of the camera. Why go through the process of adjusting RAW images of the kids opening presents when you are just going to email them to Grandma? Also, for journalists and sports photographers who are shooting nine frames per second and who need to transmit their images across the wire, again, JPEG is just fine. So what is wrong with JPEG? Absolutely nothing—unless you care about having complete creative control over all of your image data (as opposed to what a compression algorithm thinks is important).

As I mentioned in Chapter 1, JPEG is not actually an image format. It is a compression standard, and compression is where things go bad. When you have your camera set to JPEG—whether it is Fine, Normal, or Basic—you are telling the camera to process the image however it sees fit and then throw away enough image data to make it shrink into a smaller space. In doing so, you give up subtle image details that you will never get back in post-processing. That is an awfully simplified statement, but still fairly accurate.

SO WHAT DOES RAW HAVE TO OFFER?

First and foremost, RAW images are not compressed. (There are some cameras, like the D3200, that have a compressed RAW format, but it is lossless compression, which means there is no loss of actual image data.) Note that RAW image files will require you to perform post-processing on your photographs. This is not only necessary—it is the reason that most photographers use it.

RAW images have a greater dynamic range than JPEG-processed images. This means that you can recover image detail in the highlights and shadows that just isn't available in JPEG-processed images.

There is more color information in a RAW image because it is a 12- or 14-bit image (depending on the camera), which means it contains more color information than a JPEG, which is always an 8-bit image. More color information means more to work with and smoother changes between tones—kind of like the difference between performing surgery with a scalpel as opposed to a butcher's knife. They'll both get the job done, but one will do less damage.

Regarding sharpening, a RAW image offers more control because you are the one who is applying the sharpening according to the effect you want to achieve. Once again, JPEG processing applies a standard amount of sharpening that you cannot change after the fact. Once it is done, it's done.

IMAGE RESOLUTION

When discussing digital cameras, image resolution is often used to describe pixel resolution or the number of pixels used to make an image. This can be displayed as a dimension such as 6016 x 4000. This is the physical number of pixels in width and height of the image sensor. Resolution can also be referred to in megapixels (MP) such as 24.2 MP. This number represents the number of total pixels on the sensor and is commonly used to describe the amount of image data that a digital camera can capture.

Finally, and most importantly, a RAW file is your negative. No matter what you do to it, you won't change it unless you save your file in a different format. This means that you can come back to that RAW file later and try different processing settings to achieve differing results and never harm the original image. By comparison, if you make a change to your JPEG and accidentally save the file, guess what? You have a new original file, and you will never get back to that first image. That alone should make you sit up and take notice.

ADVICE FOR NEW RAW SHOOTERS

Don't give up on shooting RAW just because it means more work. Hey, if it takes up more space on your card, buy bigger cards or more small ones. Will it take more time to download? Yes, but good things come to those who wait. Don't worry about needing to purchase expensive software to work with your RAW files; you already own a program that will allow you to work with your RAW files. Nikon's ViewNX software comes bundled in the box with your camera and gives you the ability to work directly on the RAW files and then output the enhanced results. That said, you will have more control with dedicated RAW processing software such as Nikon's Capture NX2, Apple's Aperture, or Adobe's Photoshop or Lightroom.

My recommendation is to shoot in JPEG mode while you are using this book. This will allow you to quickly review your images and study the effects of the lessons. Once you have become comfortable with all of the camera features, you should switch to shooting in RAW mode so that you can start gaining more creative control over your image processing. After all, you took the photograph—shouldn't you be the one to decide how it looks in the end?

SHOOTING DUAL FORMATS

Your camera has the added benefit of being able to write two files for each picture you take, one in RAW and one in JPEG. If you have the RAW+JPEG setting selected, your camera will save your images in both formats on your card.

I think shooting RAW+JPEG is actually a good way to transition to shooting RAW. You get the ease and safety of the familiar JPEG, and the ability to compare the JPEG against your RAW processing experiences. Obviously this will take up more of the space on your memory card and hard drive, but think of it as a stepping-stone on the path to shooting only RAW in the future. It took me a little while to make the transition, and looking back there are some shots I took in JPEG mode that I now wish I had a RAW version of that I could try to improve. Live and learn.

SHOOTING IN RAW AND JPEG

- 1. Press the i button to activate the cursor in the information screen.
- Use the Multi-selector to highlight the Image quality setting located at the top right of the screen and press OK (A).

- 3. Press up on the Multi-selector to highlight the RAW+F option. (The F is for Fine.) (B)
- 4. Press the OK button to lock in your changes.

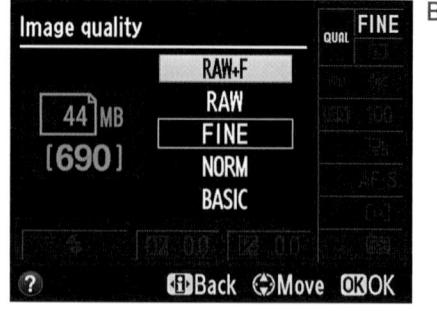

You will notice when you are in the selection screen that you will be able to see how much storage space each option will

require on your SD card. The RAW+F option will take up approximately 44 megabytes of space for each photograph you take (in practice I find that it requires less space than that).

LENSES AND FOCAL LENGTHS

If you ask most professional photographers what they believe to be their most critical piece of photographic equipment, they would undoubtedly tell you that it is their lens. The technology and engineering that goes into your camera is a marvel, but it isn't worth a darn if it can't get the light from the outside onto the sensor. The D3200, as a digital single lens reflex (DSLR) camera, uses the lens for a multitude of tasks, from focusing on a subject, to metering a scene, to delivering and focusing the light onto the camera sensor. The lens is also responsible for the amount of the scene that will be captured (the frame). With all of this riding on the lens, let's take a more in-depth look at the camera's eye on the world.

Lenses are composed of optical glass that is both concave and convex in shape. The alignment of the glass elements is designed to focus the light coming in from the front of the lens onto the camera sensor. The amount of light that enters the camera is also controlled by the lens, the size of the glass elements, and the aperture mechanism within the lens housing. The quality of the glass used in the lens will also have a direct effect on how well the lens can resolve details and the contrast of the image (the ability to deliver great highlights and shadows). Most lenses now routinely include things like the autofocus motor and, in some cases, a vibration reduction mechanism. There is one other aspect of the camera lens that is often the first consideration of the photographer: lens length. Lenses are typically divided into three or four groups depending on the field of view they deliver.

Wide-angle lenses cover a field of view from around 110 degrees to about 60 degrees (Figure 2.2). There is also a tendency to get some distortion in your image when using extremely wide-angle lenses. This will be apparent toward the outer edges of the frame. As for which lenses would be considered wide angle, anything smaller than 35mm could be considered wide.

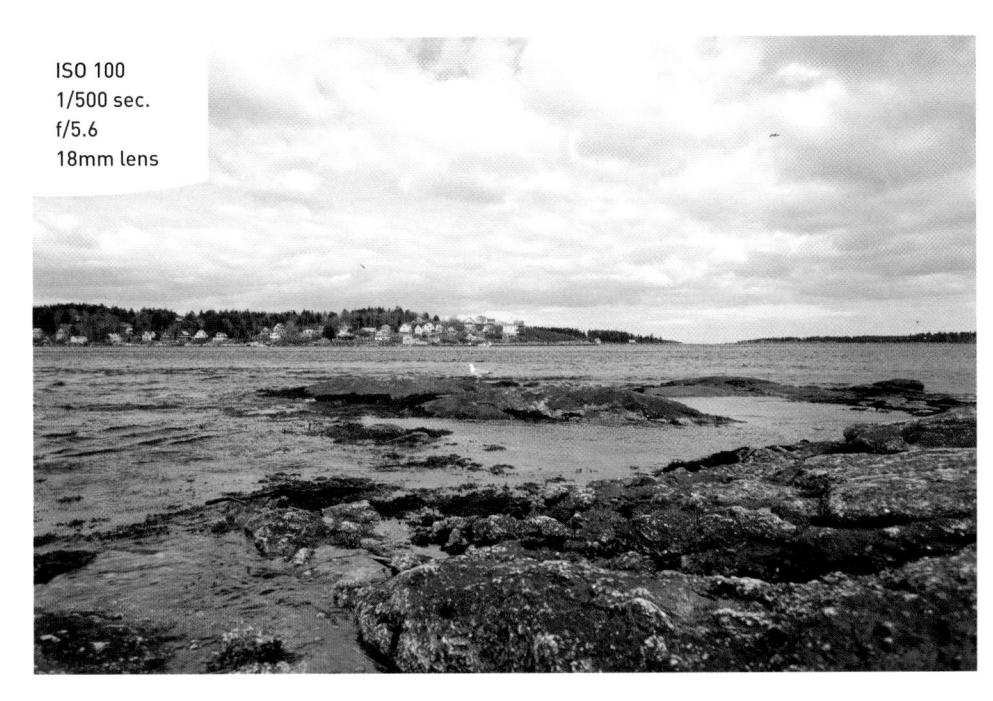

FIGURE 2.2
The 18mm lens setting provides a wide view of the scene but little detail of distant objects.

Wide-angle lenses can display a large depth of field, which allows you to keep the foreground and background in sharp focus. This makes them very useful for land-scape photography. They also work well in tight spaces, such as indoors, where there isn't much elbow room available (Figure 2.3). They can also be handy for large group shots but, due to the amount of distortion, not so great for close-up portrait work.

A *normal* lens has a field of view that is about 45 degrees and delivers approximately the same view as the human eye. The perspective is very natural and there is little distortion in objects. The normal lens for full-frame and 35mm cameras is the 50mm lens (Figure 2.4), but for the D3200 it is more in the neighborhood of a 35mm lens.

FIGURE 2.3 When shooting in tight spaces, such as indoors, a nice wide-angle lens helps capture more of the scene.

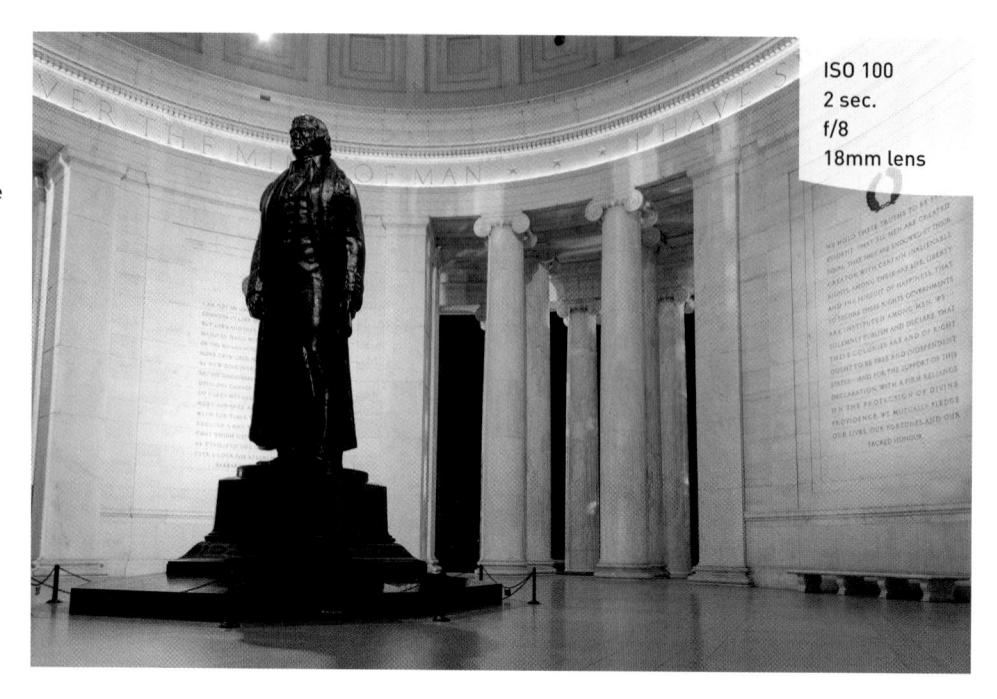

FIGURE 2.4

Long considered the "normal" lens for 35mm photography, the 50mm focal length can be considered somewhat of a telephoto lens on the D3200 because it has the same angle of view and magnification as an 80mm lens on a 35mm camera body.

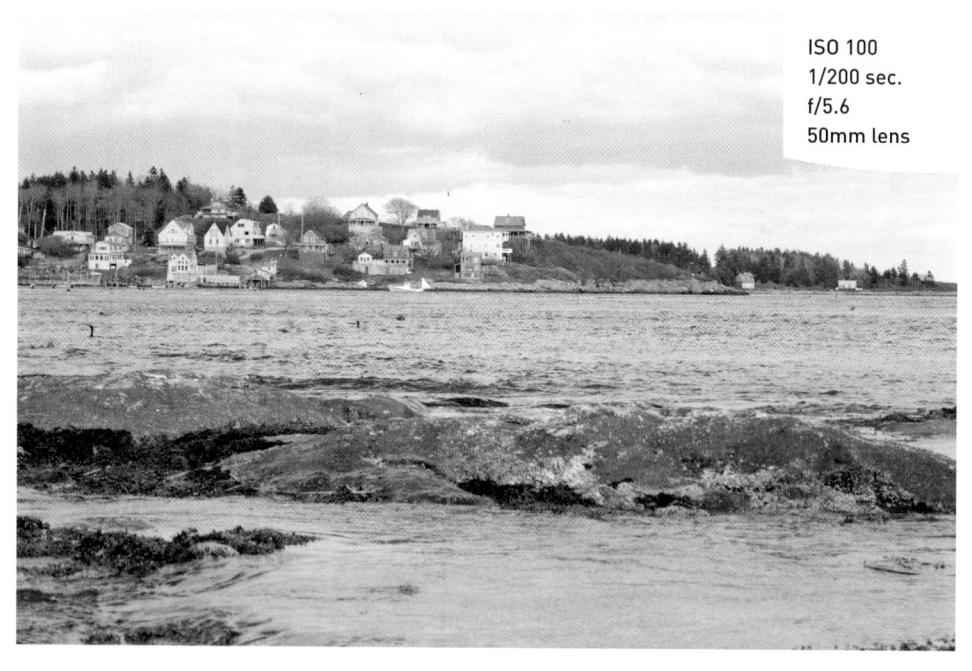

Normal focal length lenses are useful for photographing people, architecture, and most other general photographic needs. They have very little distortion and offer a moderate range of depth of field.

Most longer focal length lenses are referred to as *telephoto* lenses. They can range in length from 135mm up to 800mm or longer, and have a field of view that is about 35 degrees or smaller. These lenses have the ability to greatly magnify the scene, allowing you to capture details of distant objects, but the angle of view is greatly reduced (**Figure 2.5**). You will also find that you can achieve a much narrower depth of field. They also suffer from something called distance compression, which means they make objects at different distances appear to be much closer together than they really are.

Telephoto lenses are most useful for sports photography or any application where you just need to get closer to your subject (**Figure 2.6**). They can have a compressing effect—making objects look closer together than they actually are—and a very narrow depth of field when shot at their widest apertures.

FIGURE 2.5 By switching to my 200mm lens, I was able to bring the opposite shore right up close.

FIGURE 2.6
The compressing effect of the long telephoto lens makes the foreground rock, lighthouse, and moon look a lot closer together than they really are.

A zoom lens is a great compromise to carrying a bunch of single focal-length lenses (also referred to as "prime" lenses). They can cover a wide range of focal lengths because of the configuration of their optics. However, because it takes more optical elements to capture a scene at different focal lengths, the light must pass through more glass on its way to the image sensor. The more glass, the lower the quality of the image sharpness. The other sacrifice that is made is in aperture. Zoom lenses typically have smaller maximum apertures than prime lenses, which means they cannot achieve a narrow depth of field or work in lower light levels without the assistance of image stabilization, a tripod, or higher ISO settings. (We'll discuss all this in more detail in later chapters.)

Throughout the book, I will occasionally make reference to lenses that are wider or more telephoto than the 18–55mm zoom lens that comes on the D3200 as part of the kit because I have a multitude of lenses that I use for my photography. This doesn't mean that you have to run out and purchase more lenses. It just means that if you do this long enough, you are sure to accumulate additional lenses that will expand your ability to be even more creative with your photography.

WHAT IS EXPOSURE?

In order for you to get the most out of this book, I need to briefly discuss the principles of exposure. Without this basic knowledge, it will be difficult for you to move forward in improving your photography. Granted, I could write an entire book on exposure and the photographic process—and many people have—but for our purposes I will just cover some of the basics. This will give you the essential tools to make educated decisions in determining how best to photograph a subject.

Exposure is the process whereby the light reflecting off a subject reflects through an opening in the camera lens for a defined period of time onto the camera sensor. The combination of the lens opening, shutter speed, and sensor sensitivity is used to achieve a proper exposure value (EV) for the scene. The EV is the sum of these components necessary to properly expose a scene. A relationship exists between these factors that is sometimes referred to as the "exposure triangle."

At each point of the triangle lies one of the factors of exposure:

- ISO. Determines the sensitivity of the camera sensor. ISO stands for the International
 Organization for Standardization, but the acronym is used as a term to describe
 the sensitivity of the camera sensor to light. The higher the sensitivity, the less
 light is required for a good exposure. These values are a carryover from the days
 of traditional color and black and white films.
- **Aperture.** Also referred to as the f-stop, this determines how much light passes through the lens at once.
- Shutter Speed. Controls the length of time that light is allowed to hit the sensor.

Here's how it works. The camera sensor has a level of sensitivity that is determined by the ISO setting. To get a proper exposure—not too much, not too little—the lens needs to adjust the aperture diaphragm (the size of the lens opening) to control the volume of light entering the camera. Then the shutter is opened for a relatively short period of time to allow the light to hit the sensor long enough for it to record on the sensor.

ISO numbers for the D3200 start at 100 and then double in sensitivity as you double the number. So 400 is twice as sensitive as 200. There are also a wide variety of shutter speeds that you can use. The speeds on the D3200 range from as long as 30 seconds to as short as 1/4000 of a second. Typically, you will be working with a shutter speed range from around 1/30 of a second to about 1/2000, but these numbers will change depending on your circumstances and the effect that you are trying to achieve. The lens apertures will vary slightly depending on which lens you are using. This is because different lenses have different maximum apertures. The typical apertures that are at your disposal are f/4, f/5.6, f/8, f/11, f/16, and f/22.

When it comes to exposure, a change to any one of these factors requires changing one or more of the other two. This is referred to as reciprocal change. If you let more light in the lens by choosing a larger aperture opening, you will need to shorten the amount of time the shutter is open. If the shutter is allowed to stay open for a longer period of time, the aperture needs to be smaller to restrict the amount of light coming in.

HOW IS EXPOSURE CALCULATED?

We now know about the exposure triangle—ISO, shutter speed, and aperture—so it's time to put all three together to see how they relate to one another and how you can change them as needed.

STOP

You will hear the term *stop* thrown around all the time in photography. It relates back to the f-stop, which is a term used to describe the aperture opening of your lens. When you need to give some additional exposure, you might say that you are going to "add a stop." This doesn't just equate to the aperture; it could also be used to describe the shutter speed or even the ISO. So when your image is too light or dark or you have too much movement in your subject, you will probably be changing things by a "stop" or two.

When you point your camera at a scene, the light reflecting off your subject enters the lens and is allowed to pass through to the sensor for a period of time as dictated by the shutter speed. The amount and duration of the light needed for a proper exposure depends on how much light is being reflected and how sensitive the sensor is. To figure this out, your camera utilizes a built-in light meter that looks through the lens and measures the amount of light. That level is then calculated against the sensitivity of the ISO setting, and an exposure value is rendered. Here is the tricky part: There is no single way to achieve a perfect exposure, because the f-stop and shutter speed can be combined in different ways to allow the same amount of exposure. See, I told you it was tricky.

Here is a list of reciprocal settings that would all produce the same exposure result. Let's use the "sunny 16" rule, which states that, when using f/16 on a sunny day, you can use a shutter speed that is roughly equal to the ISO setting to achieve a proper exposure. For simplification purposes, we will use an ISO of 100.

RECIPROCAL EXPOSURES: ISO 100

F-STOP	2.8	4	5.6	8	11	16	22
1-3101	2.0	1	5.0				
SHUTTER SPEED	1/4000	1/2000	1/1000	1/500	1/250	1/125	1/60

If you were to use any one of these combinations, they would each have the same result in terms of the exposure (i.e., how much light hits the camera's sensor). Also take note that every time we cut the f-stop in half, we reciprocated by doubling our shutter speed. For those of you wondering why f/8 is half of f/5.6, it's because those numbers are actually fractions based on the opening of the lens in relation to its focal length. This means that a lot of math goes into figuring out just what the total area of a lens opening is, so you just have to take it on faith that f/8 is half of

f/5.6 but twice as much as f/11. A good way to remember which opening is larger is to think of your camera lens as a pipe that controls the flow of water. If you had one pipe that was 1/2" in diameter (f/2) and one that was 1/8" (f/8), which would allow more water to flow through? It would be the 1/2" pipe. The same idea works here with the camera f-stops; f/2 is a larger opening than f/4 or f/8 or f/16.

Now that we know this, we can start using this information to make intelligent choices in terms of shutter speed and f-stop. Let's bring the third element into this by changing our ISO by one stop, from 100 to 200.

RECIPROCAL EXPOSURES: ISO 200

F-STOP	2.8	4	5.6	8	11	16	22
SHUTTER SPEED	-	1/4000	1/2000	1/1000	1/500	1/250	1/125

Notice that, since we doubled the sensitivity of the sensor, we now require half as much exposure as before. We have also reduced our maximum aperture from f/2.8 to f/4 because the camera can't use a shutter speed that is faster than 1/4000 of a second.

So why not just use the exposure setting of f/16 at 1/250 of a second? Why bother with all of these reciprocal values when this one setting will give us a properly exposed image? The answer is that the f-stop and shutter speed also control two other important aspects of our image: motion and depth of field.

MOTION AND DEPTH OF FIELD

There are distinct characteristics that are related to changes in aperture and shutter speed. Shutter speed controls the length of time the light has to strike the sensor; consequently, it also controls the blurriness (or lack of blurriness) of the image. The less time light has to hit the sensor, the less time your subjects have to move around and become blurry. This can let you control things like freezing the motion of a fast-moving subject (Figure 2.7) or intentionally blurring subjects to give the feel of energy and motion (Figure 2.8).

The aperture controls the amount of light that comes through the lens, but also determines what areas of the image will be in focus. This is referred to as depth of field, and it is an extremely valuable creative tool. The smaller the opening (the larger the number, such as f/22), the greater the sharpness of objects from near to far (Figure 2.9). A large opening (or small number, like f/1.4) means more blurring of objects that are not at the same distance as the subject you are focusing on (Figure 2.10).

FIGURE 2.7 A fast shutter speed was used to freeze my son as he zoomed past in a go-kart.

FIGURE 2.8
The slower shutter speed coupled with a sturdy tripod helped me capture the smooth flow of the waterfall.

FIGURE 2.9 By using a small aperture, the area of sharp focus extends from a point that is near the camera all the way out to distant objects. In this photo, taken at "The Racetrack" in Death Valley, California, I wanted the rock closest to the camera to be in focus while maintaining good focus into the distance to show how far these mysterious rocks have traveled.

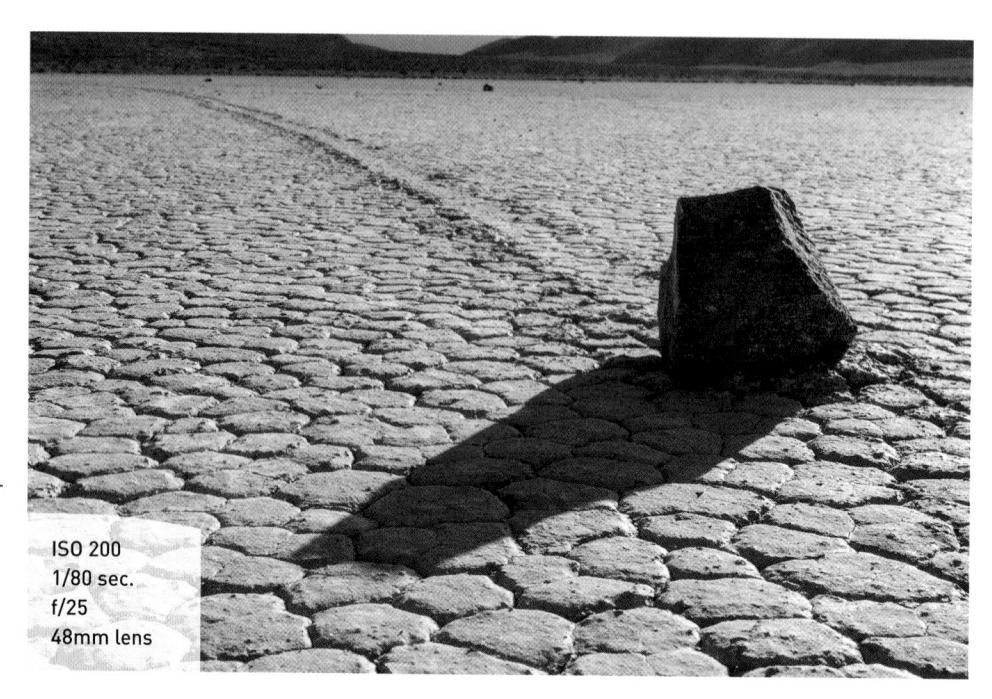

FIGURE 2.10 Isolating a subject is accomplished by using a large aperture, which produces a narrow area of sharp focus. The focus point is the top of the green egg.

As we further explore the features of the camera, we will learn not only how to utilize the elements of exposure to capture properly exposed photographs, but also how we can make adjustments to emphasize our subject. It is the manipulation of these elements—motion and focus—that will take your images to the next level.

Chapter 2 Assignments

Formatting your card

Even if you have already begun using your camera, make sure you are familiar with formatting the Secure Digital card. If you haven't done so already, follow the directions given earlier in the chapter and format as prescribed (make sure you save any images that you may have already taken). Then perform the Format function every time you have downloaded or saved your images or use a new card.

Checking your firmware version

Using the most up-to-date version of the camera firmware will ensure that your camera is functioning properly. Use the menu to find your current firmware version, and then update as necessary using the steps listed in this chapter.

Cleaning your sensor

You probably noticed the sensor-cleaning message the first time you turned your camera on. Make sure you are familiar with the Clean now command so you can perform this function every time you change a lens.

Exploring your image formats

I want you to become familiar with all of the camera features before using the RAW format, but take a little time to explore the format menu so you can see what options are available to you.

Exploring your lens

If you are using a zoom lens, spend a little time shooting with all of the different focal lengths, from the widest to the longest. See just how much of an angle you can cover with your widest lens setting. How much magnification will you be able to get from the telephoto setting? Try shooting the same subject with a variety of focal lengths to note the differences in how the subject looks, and also the relationship between the subject and the other elements in the photo.

Share your results with the book's Flickr group!

 ${\it Join the group here: flickr.com/groups/nikond 3200_froms napshots to great shots}$

3

ISO 200 1/320 sec. f/5.6 300mm lens

The Auto Modes

GET SHOOTING WITH THE AUTOMATIC CAMERA MODES

The Nikon D3200 is an amazing camera that has some incredible features. In fact, with all of the technology built into it, it can be a little intimidating for the person new to DSLR photography. For that reason, the folks at Nikon have made it a little easier for you to get some great-looking photographs without having to do a lot of thinking. Enter the scene modes. The camera modes on the automatic side of the Mode dial are simple, icon-labeled modes that are set up to use specific features of the camera for various shooting situations. Let's take a look at the different modes and how and when to use them.

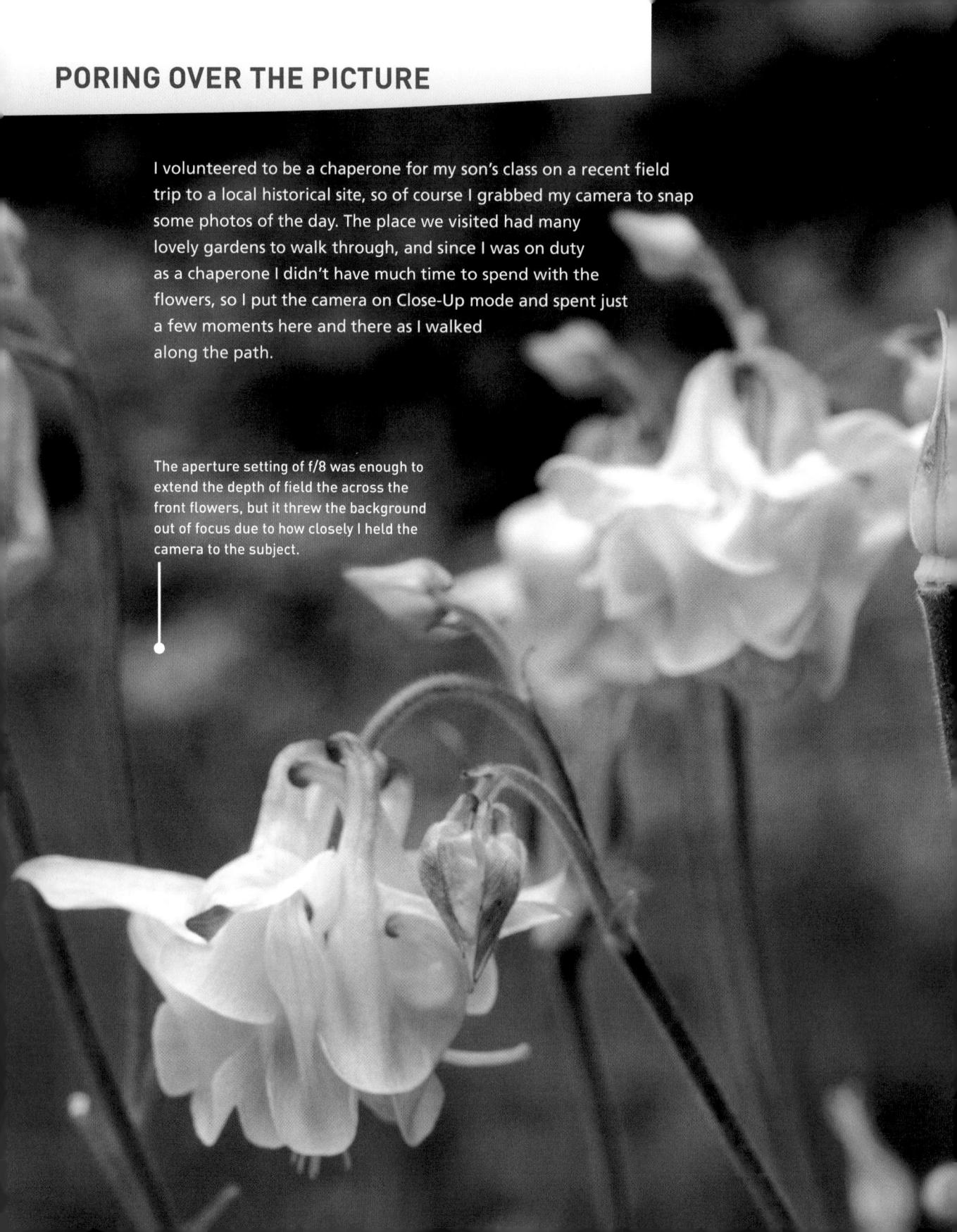

The Auto white balance did a pretty good job of rendering the correct colors in the scene. It was an overcast day, and the light was even and soft. The camera's focus mode was set to Auto, which did a good job of picking the correct focus distance. ISO 110 1/125 sec. f/8 50mm lens

AUTO MODE

Auto mode is all about thoughtfree photography (Figure 3.1). There is little to nothing for you

to do in this mode except point and shoot. Your biggest concern when using Auto mode is focusing. The camera will utilize the automatic focusing modes to achieve the best possible focus for your picture. Naturally, the camera is going to assume that the object that is closest to the camera is the one that you want to have the sharpest focus. Simply press the shutter button down halfway while

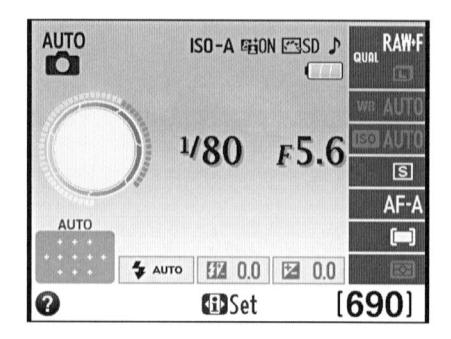

FIGURE 3.1 The Auto mode's info screen.

looking through the viewfinder, and you should see one of the focus points light up over the subject. Of course, you know that putting your subject in the middle of the picture is not the best way to compose your shot. So wait for the chirp to confirm that the focus has been set, and then, while still holding down the button, recompose your shot. Now just press down the shutter button the rest of the way to take the photo. It's just that easy (**Figure 3.2**). The camera will take care of all your exposure decisions, including when to use flash.

FIGURE 3.2 Auto mode works great when you just want to snap some shots and not think too much.

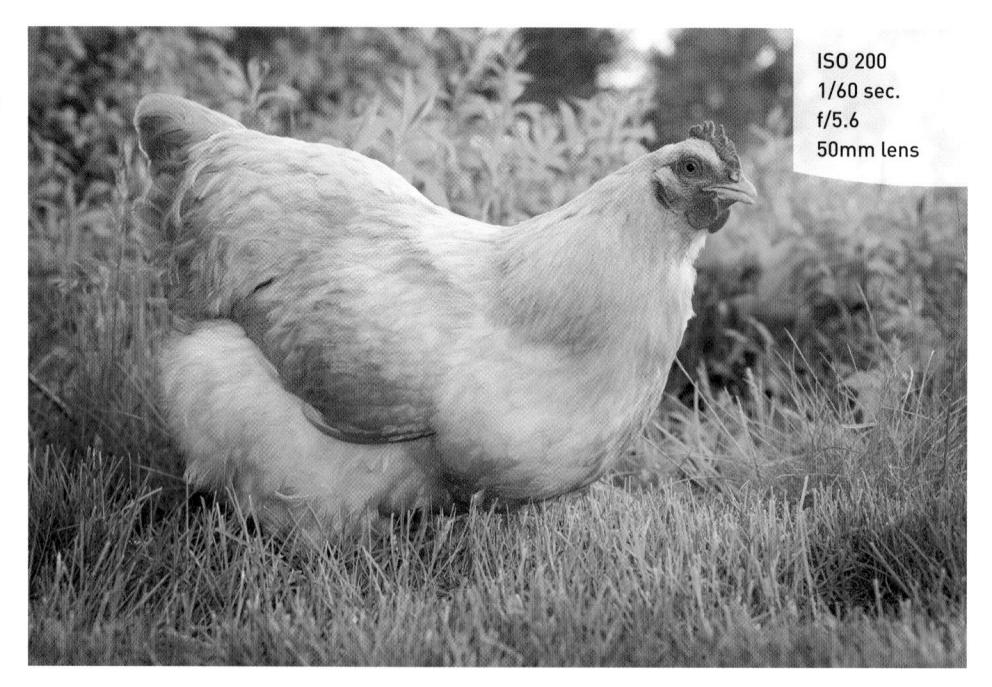

Let's face it: This is the lazy man's mode. But sometimes it's just nice to be lazy and click away without giving thought to anything but preserving a memory. There will be times, though, when you want to start using your camera's advanced features to improve your shots.

PORTRAIT MODE

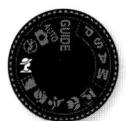

One problem with Auto mode is that it has no idea what type of subject you are photographing

and, therefore, uses the same settings for each situation. Shooting portraits is a perfect example. Typically, when you are taking a photograph of someone, you want the emphasis of the picture to be on the person, not necessarily the stuff going on in the background.

6 AUTO 512 0.0 E2 0.0 Gil Set

ISO-A SHON EEPT ♪

FIGURE 3.3 The Portrait mode's info screen.

This is what Portrait mode is all about (Figure 3.3). When you set your camera to this

mode, you are telling the camera to select a larger aperture so that the depth of field is much narrower and will give more blur to objects in the background. This blurry background places the attention on your subject (Figure 3.4). The other feature of this mode is the automatic selection of the D3200's built-in Portrait picture control (we'll go into more detail about picture controls in later chapters). This feature is optimized for skin tones and will also be a little softer to improve the look of skin.

USING THE BEST LENS FOR GREAT PORTRAITS

When using Portrait mode, use a lens length that is 50mm or longer. The longer lens will give you a natural view of the subject, as well as aid in keeping the depth of field narrow.

FIGURE 3.4
Portrait mode is
a great choice for
subjects like this.
Not only does it pick
a good aperture,
but it also sets the
picture control to a
setting that works
best for people.

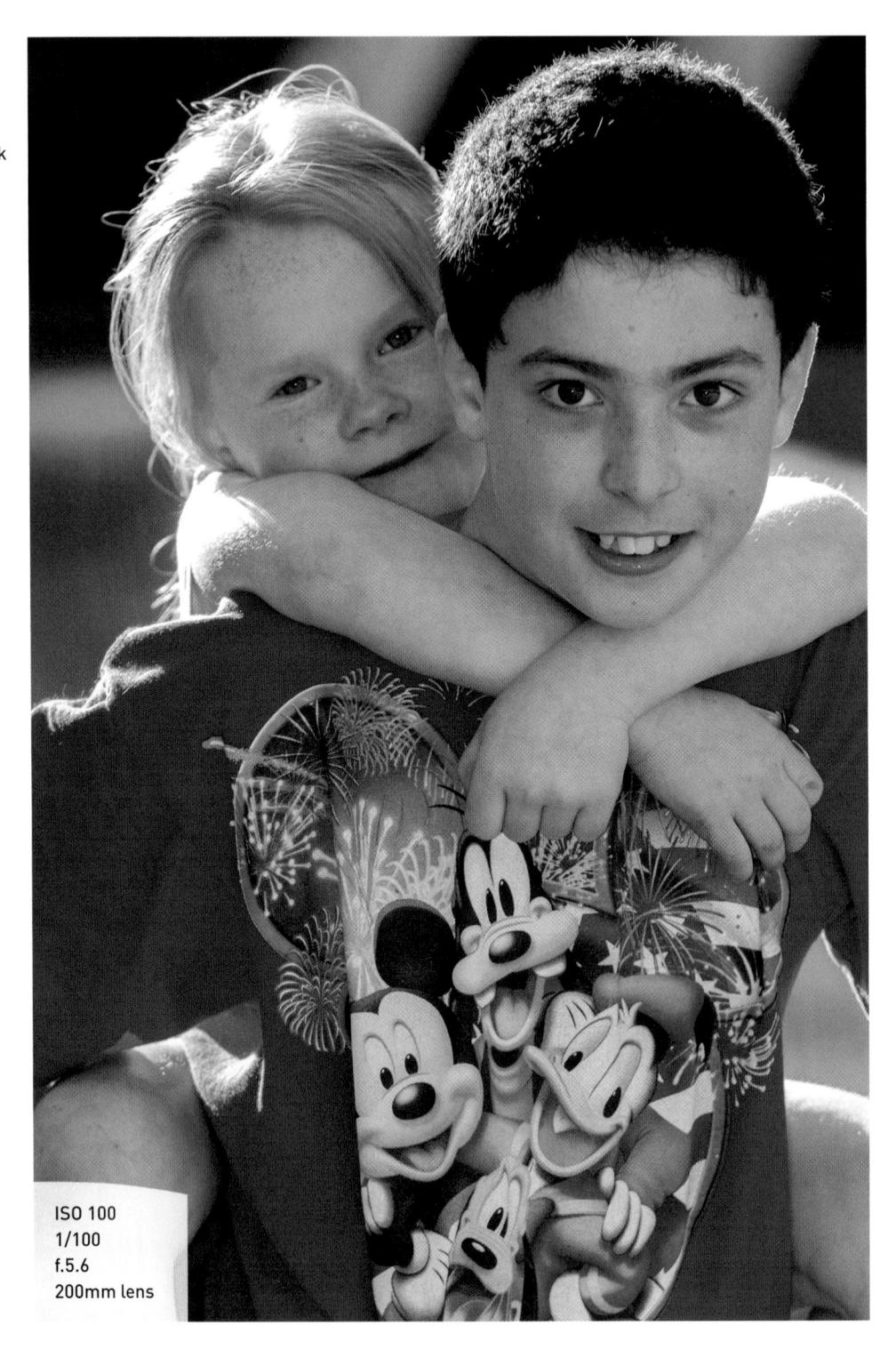

LANDSCAPE MODE

As you might have guessed, Landscape mode has been optimized for shooting landscape

images (Figure 3.5). Particular emphasis is placed on the picture control, with the camera trying to boost the greens and blues in the image (Figure 3.6). This makes sense, since the typical landscape would be outdoors, where grass, trees, and skies should look more colorful. This picture control also boosts the sharpness that is applied during processing. The camera also utilizes the

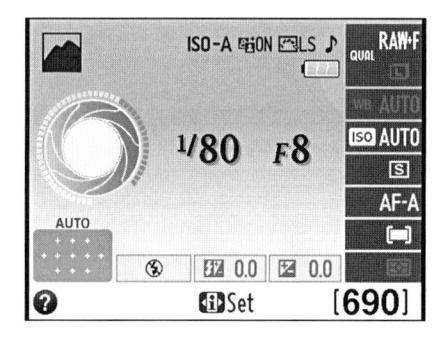

FIGURE 3.5 The Landscape mode's info screen.

lowest ISO settings possible in order to keep digital noise to a minimum. The downfall to this setting is that, once again, there is little control over the camera settings. The focus mode can be changed—but only from AF-A to Manual. Other changeable functions include image quality, ISO, and AF-area. Note that the flash cannot be used while in Landscape mode.

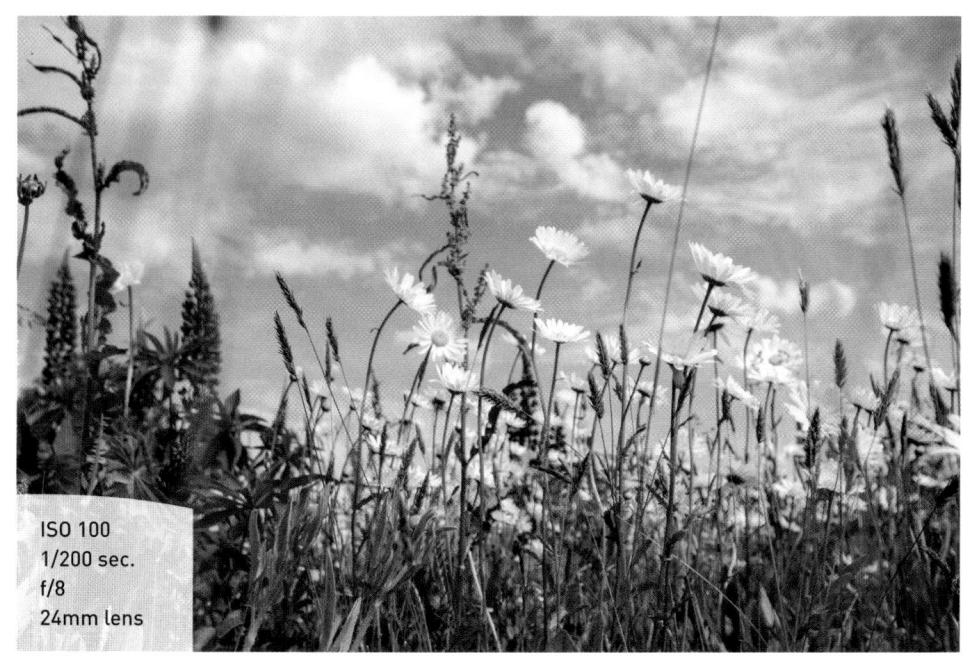

FIGURE 3.6
This scene was screaming for Landscape mode. The greens and blues were given more saturation, and a small aperture was used for greater depth of field.

CHILD MODE

Child mode is like a blend of the Sports and Portrait modes (Figures 3.7 and 3.8). Understanding

that children are seldom still, the camera will try to utilize a slightly faster shutter speed to freeze any movement. This picture control feature has also been optimized to render the bright, vivid colors that one normally associates with pictures of children.

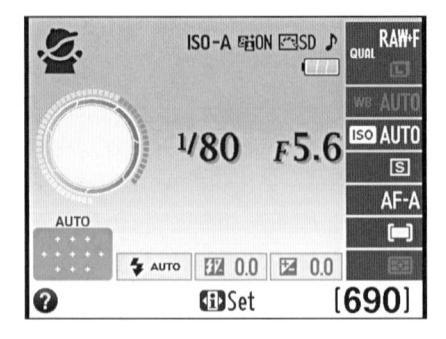

FIGURE 3.7 The Child mode's info screen.

FIGURE 3.8 Child mode tries to use a fast shutter speed, as well as make colors more bright and vivid.

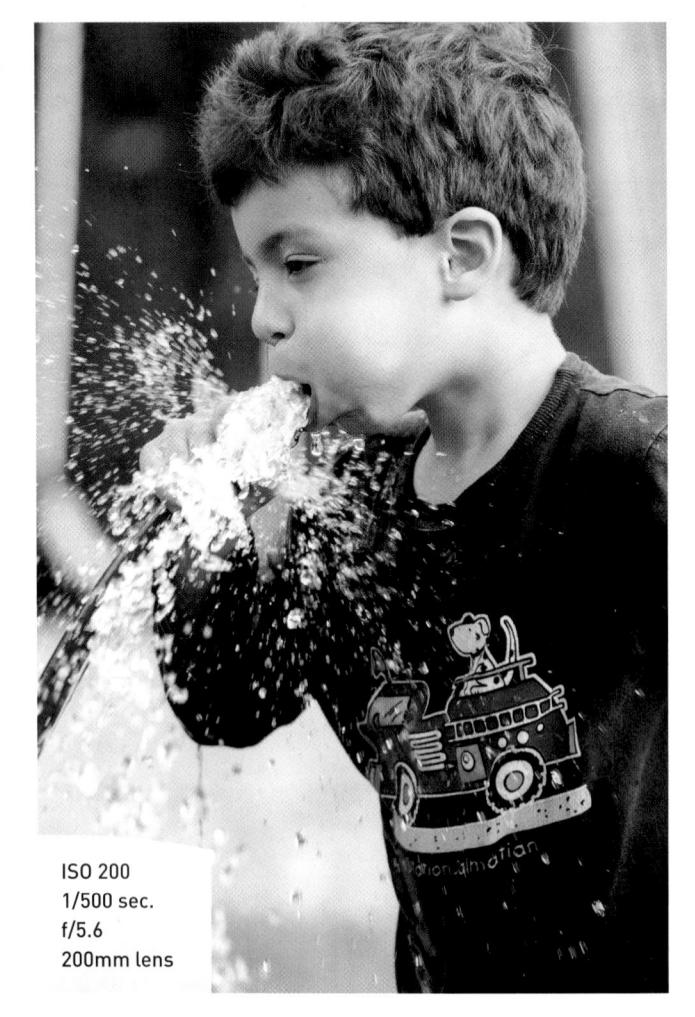
SPORTS MODE

While this is called Sports mode, you can use it for any moving subject that you are photograph-

ing (Figure 3.9). The mode is built on the principles of sports photography: continuous focusing, large apertures, and fast shutter speeds (Figure 3.10). To handle these requirements, the camera sets the focus mode to Dynamic, the aperture to a large opening, and the ISO to Auto. Overall, these are sound settings that will capture most moving subjects well. We will take an in-depth look

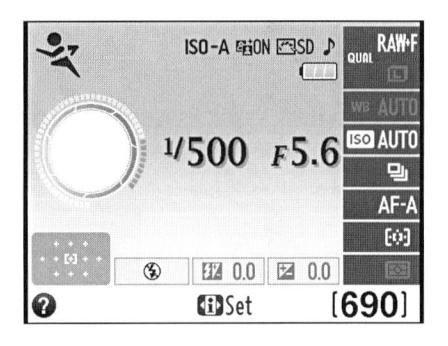

FIGURE 3.9 The Sports mode's info screen.

at all of these features, like Continuous shooting mode, in Chapter 5.

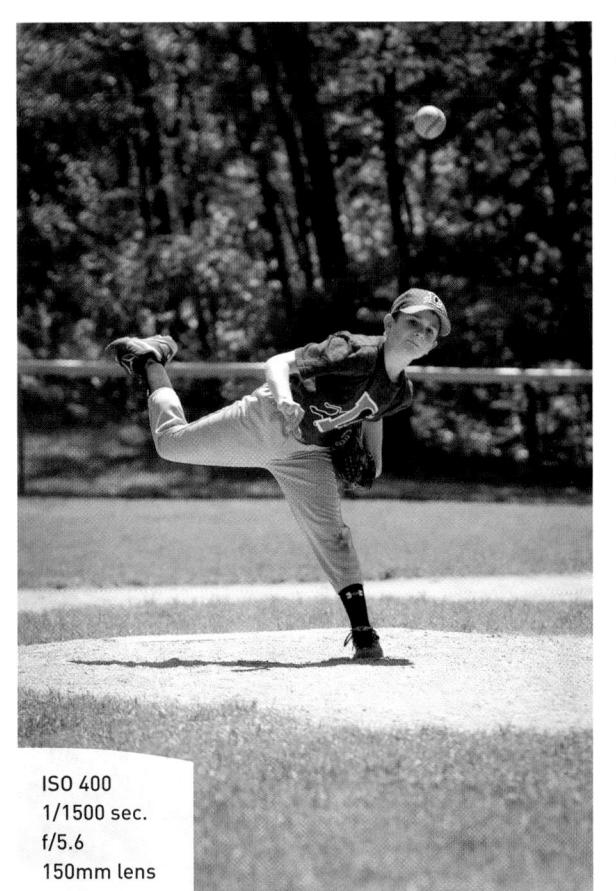

FIGURE 3.10

This is the type of shot that was made for Sports mode, where action-freezing shutter speeds and continuous focusing capture the moment. You can, however, run the risk of too much digital noise in your picture if the camera decides that you need a very high ISO (such as 1600). This is why you have the ability to change some options within Sports mode, such as the ISO and the release mode (Single and Continuous). Also, when using Sports mode, you can change the focus mode from AF-A to Manual. This is especially handy if you know when and where the action will take place and want to pre-focus the camera on a spot and wait for the right moment to take the photo.

CLOSE-UP MODE

Although most zoom lenses don't support true "macro" settings, that doesn't mean you can't shoot

some great close-up photos. The key here is to use your camera-to-subject distance to fill the frame while still being able to achieve sharp focus. This means that you move yourself as close as possible to your subject while still being able to get a good sharp focus. Oftentimes, your lens will be marked with the minimum focusing distance. On my 18–55mm zoom, it is about six inches with the

FIGURE 3.11
The Close-up mode's info screen.

lens set to 55mm. To help get the best focus in the picture, Close-up mode will use the smallest aperture it can while keeping the shutter speed fast enough to get a sharp shot (Figures 3.11 and 3.12). It does this by raising the ISO or turning on the built-in flash—or a combination of the two. Fortunately, these are two of the settings that you can change in this mode. The flash will be set to Auto by default, but you can also change it to Auto-redeye or Off, depending on your need. The ISO can be changed from the Auto setting to one of your own choosing. This probably only needs to be done in low-light settings, when the Auto ISO starts to move up to maintain exposure values. Other settings that can be changed are the image quality, release mode, focus mode (AF-A or Manual), and the AF-area.

FIGURE 3.12 Close-up mode provided the proper exposure for these lovely flowers growing alongside the path.

NIGHT PORTRAIT MODE

You're out on the town at night and want to take a nice picture of someone, but you want to

show some of the interesting scenery in the background as well. You could use Auto mode, which would probably turn on the flash and take the photo. The problem is that, while it would give you a decent exposure for your subject, the background would be completely dark. The solution is to use Night Portrait mode (Figure 3.13). When you set the dial to this mode, you are telling the camera

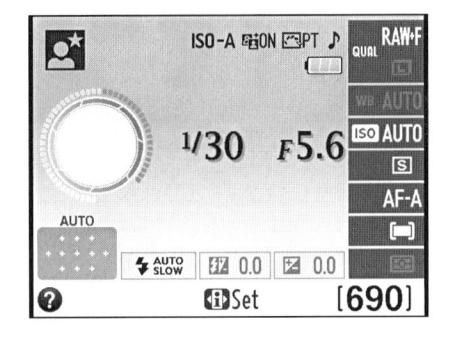

FIGURE 3.13 The Night Portrait mode's info screen.

that you want to use a slower-than-normal shutter speed so that the background is getting more time (and, thus, more light) to achieve a proper exposure.

The typical shutter speed for using flash is about 1/60 of a second or faster (but not faster than 1/200 of a second). By leaving the shutter open for a longer duration, the camera allows more of the background to be exposed so that you get a much more balanced scene (Figure 3.14). This is also a great mode for taking portraits during sunset. Once again, the camera uses an automatic ISO setting by default, so you will want to keep an eye on it to make sure that setting isn't so high that the noise levels ruin your photo.

FIGURE 3.14
Night Portrait
mode uses a slower
shutter speed,
higher ISO, and
larger aperture to
balance the background lights with
the flash exposure.

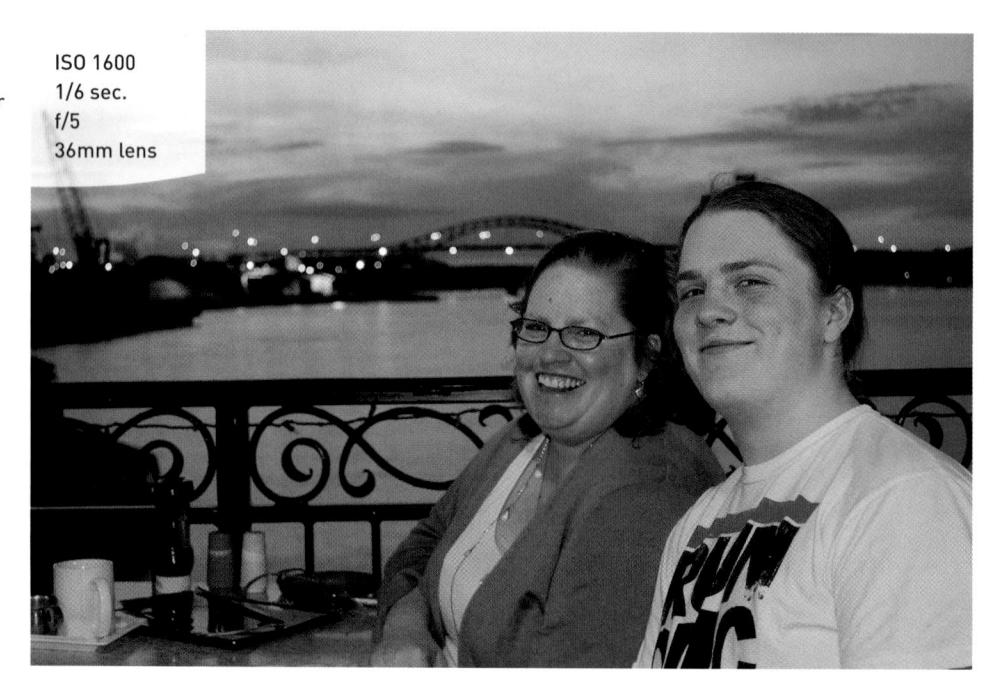

FLASH OFF MODE

Sometimes you will be in a situation where the light levels are low but you don't want to use the

flash. It could be that you are shooting in a place that restricts flash photography, such as a museum, or it could be a situation where you want to take advantage of the available light, as when shooting candles on a birthday cake. This is where Flash Off mode comes into play (Figure 3.15).

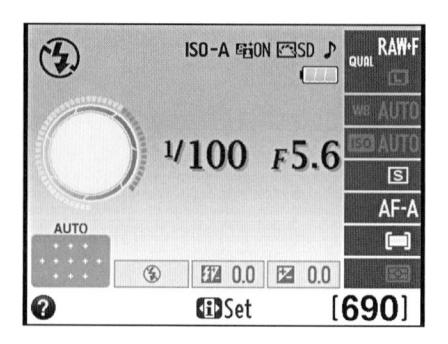

FIGURE 3.15
The Flash Off mode's info screen.

By keeping the flash from firing, you will be able to use just the available ambient light while the camera modifies the ISO setting to assist you in getting good exposures (Figure 3.16). If the camera feels that the shutter speed is going to be slow enough to introduce camera shake, it will give a warning on the rear information screen that reads "Subject is too dark." It will also list the shutter speed as "Lo" so that you know to check the camera settings.

Fortunately, most of the new Vibration Reduction (VR) lenses being sold today allow you to handhold the camera at much slower shutter speeds and still get great results. The two downfalls to this mode are the Auto ISO setting, which will quickly take your ISO setting up as high as 1600, and the possibility of getting blur from subject movement.

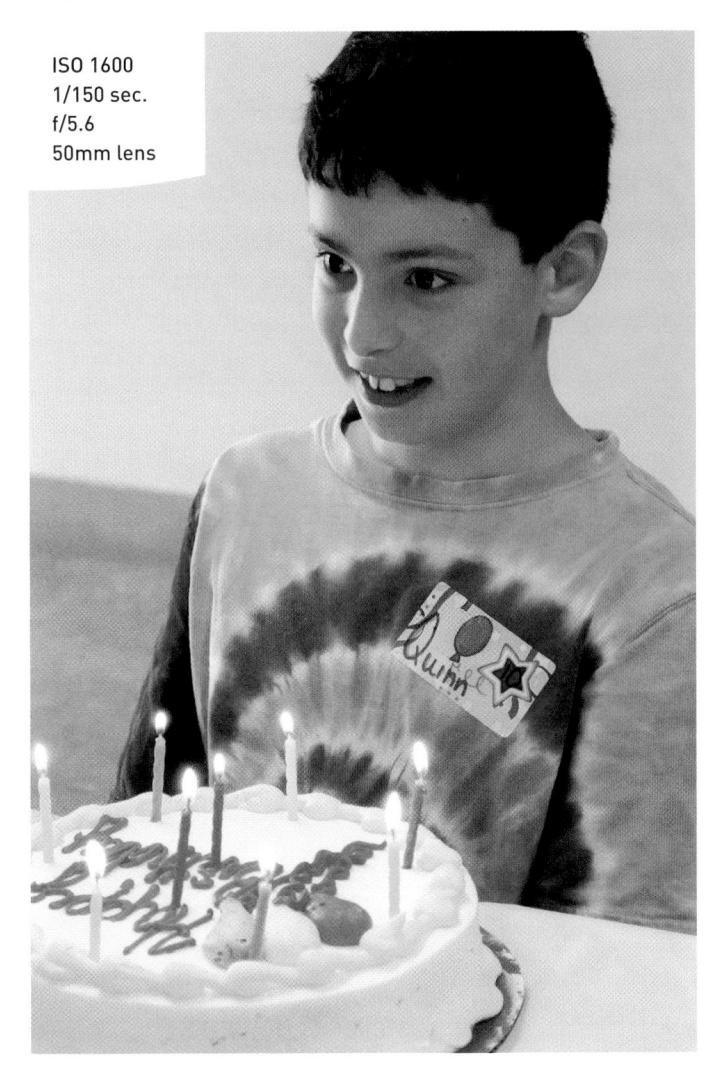

FIGURE 3.16
I didn't want the flash to overpower the light from the candles and what little light was coming in from the window on the side.

GUIDE MODE

Guide mode (Figure 3.17) is a step-by-step guide that walks you through several operations in your

camera, including shooting, reviewing your images, and setting up your camera. Since I cover most of these functions throughout this book, I am not going to cover them here. If you would like to find out more about how to use the guide, you should check out pages 19–22 in the user's manual.

FIGURE 3.17
The Guide mode.

WHY YOU MAY NEVER WANT TO USE THE AUTO MODES AGAIN

With so many easy-to-use camera modes, why would anyone ever want to use anything else? Well, the first thing that comes to my mind is control. It is the number one reason for using a digital SLR camera. The ability to control every aspect of your photography will open up creative avenues that just aren't available in the automatic scene modes. Let's face it: There is a reason that the Mode dial is split into two different categories. Let's look at what we are giving up when we work in the scene modes:

- White balance. There is no choice available for white balance. You are simply stuck with the Auto setting. This isn't always a bad thing, but your camera doesn't always get it right. And in the scene modes, there is just no way to change it.
- **Picture control.** All of the automatic modes have specifically tuned picture controls. Some of them use the control presets, such as Landscape or Vivid, but there is no way to change the characteristics of the controls while in the auto modes.
- Metering. All of the auto scene modes use the Matrix metering mode to establish
 the proper exposure. This is generally not a bad thing, but if there are scenarios
 that would benefit from a Center or Spot metering solution (which we'll cover in
 later chapters), you're just out of luck.

- Auto focus. While each of the modes may use a specific autofocus area mode, such as Spot or Dynamic, the actual focus mode for all of the scene modes is limited to either AF-A or Manual. AF-A is kind of a combination mode that lets you select a single focus point and then readjust if the subject moves. The problem is that you can't just use AF-S (single) or AF-C (continuous) as the default setting.
- Exposure compensation. You will notice that in each and every automatic scene mode, the ability to adjust the exposure through the use of the exposure compensation feature has been completely turned off. This makes it very difficult to make the slight adjustments to exposure that are often needed.
- Active D-Lighting. This is another feature that is unavailable for changing in the auto modes. There are default settings for this feature that change from scene to scene, but there is no way for you to override the effect.
- Flash compensation. Just like the exposure compensation, there is no way to make any adjustments to the power output of the flash. This means that you are stuck with whatever the camera feels is correct, even if it is too weak or too strong for your particular subject.

Another thing you will find when using any of the automatic modes is that there are fewer choices in the camera menus for you to adjust. Each scene mode presents its own set of restrictions for the available menu items. These aren't the only restrictions to using the automatic scene modes, but they should be enough to make you want to explore the other side of the Mode dial, which I like to call the professional modes.

FOCUS MODES ON THE NIKON D3200

Three focus modes are available on the D3200. Depending on the type of photography you are doing, you can easily select the mode that will be most beneficial. The standard mode is called AF-S, which allows you to focus on one spot and hold the focus until you take the picture or release the shutter button. The AF-C mode will constantly refocus the camera on your subject the entire time you are depressing the shutter release button. This is great for sports and action photography. The AF-A mode is a combination of both of the previous modes, using AF-S mode unless it senses that the subject is moving, when it will switch to AF-C mode.

Chapter 3 Assignments

These assignments will have you shooting in the various automatic scene modes so that you can experience the advantages and disadvantages of using them in your daily photography.

Shooting in Auto mode

It's time to give up complete control and just concentrate on what you see in the viewfinder. Set your camera to Auto and practice shooting in a variety of conditions, both indoors and outside. Take notice of the camera settings when you are reviewing your pictures. Try using the single-point AF-area mode to pick a spot to focus on, and then recompose before taking the picture.

Checking out Portrait mode

Grab your favorite photogenic person and start shooting in Portrait mode. Try switching between Auto and Portrait mode while photographing the same person in the same setting. You should see a difference in the sharpness of the background as well as the skin tones. If you are using a zoom lens, set it to about 55mm if available.

Capturing the scenery with Landscape and Close-up modes

Take your camera outside for some landscape and macro work. Find a nice scene and, with your widest available lens, take some pictures using Landscape mode; then switch back to Auto so that you can compare the settings used for each image as well as the changes to colors and sharpness. Now, while you are still outside, find something in the foreground—a leaf or a flower—and switch the camera to Close-up mode. See how close you can get, and take note of the f-stop that the mode uses. Then switch to Auto and shoot the same subject.

Stopping the action with Sports mode

This assignment will require that you find a subject that is in motion. That could be the traffic in front of your home or your child at play. The only real requirement is that the subject be moving. This will be your opportunity to test out Sports mode. There isn't a lot to worry about here. Just point and shoot. Try shooting a few frames one at a time, and then go ahead and hold down the shutter button and shoot a burst of about five or six frames. It will help if your subject is in good available light to start with so that the camera won't be forced to use high ISOs.

Capturing the mood with Night Portrait mode

This time, wait for it to get dark outside and have a friend sit in a location that has an incandescent lamp in the background (not too bright, though). Switch the camera to Night Portrait and, using a wide enough angle to see the subject and some of the room in the background, take a photo. The goal is to get a well-lit picture of your subject and balance that with the light from the lamp in the background. For a comparison, switch the camera back to Auto and shoot the same subject. Take notice of the difference in the brightness of the background. Now, take another picture with the camera set to Flash Off, but this time, have your subject sit near the lamp so that it lights up their face. Ask them to sit as still as possible while you hold the camera as still as possible.

Share your results with the book's Flickr group!

Join the group here: flickr.com/groups/nikond3200_fromsnapshotstogreatshots

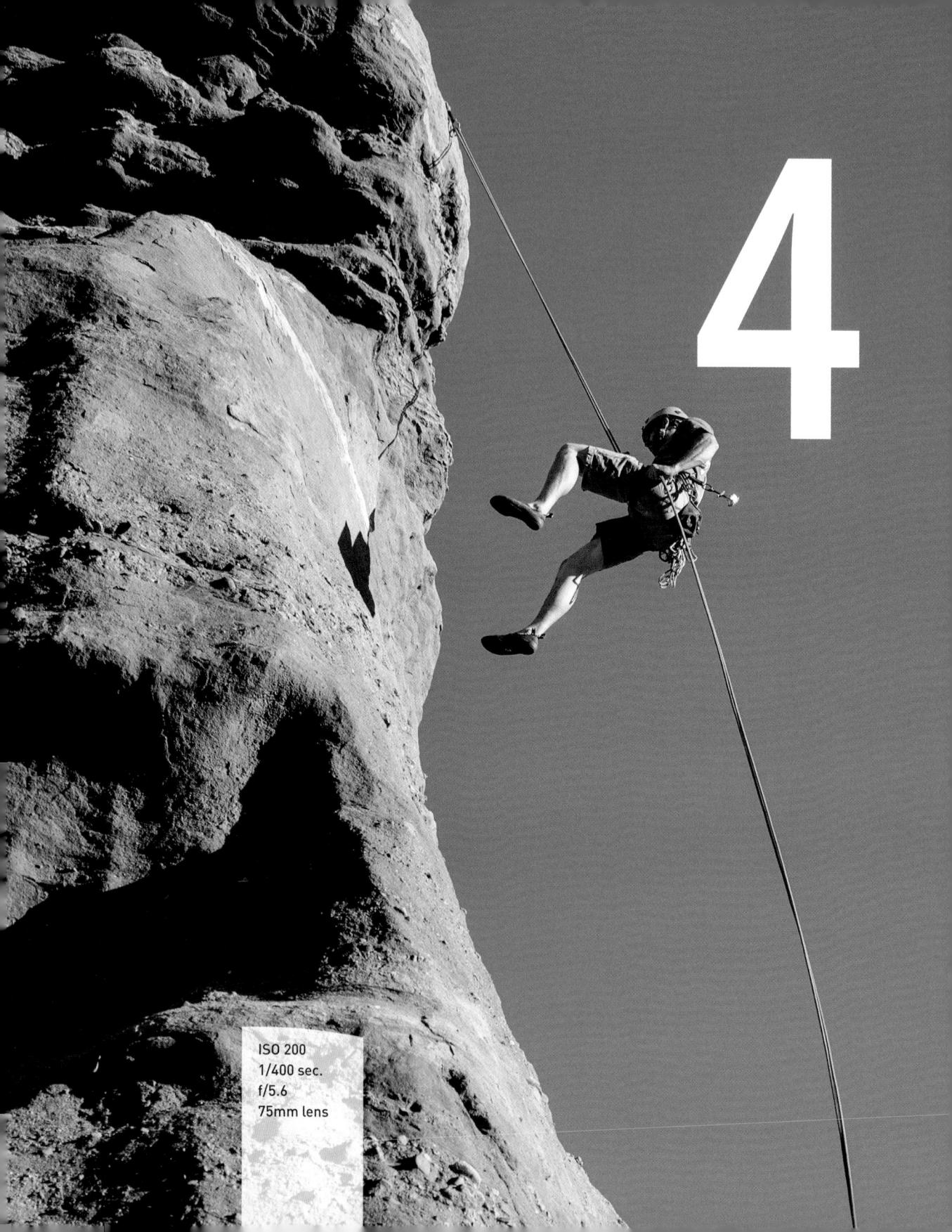

The Professional Modes

TAKING YOUR PHOTOGRAPHY TO THE NEXT LEVEL

If you talk to professional photographers, you will find that the majority of them are using a few selective modes that offer the greatest amount of control over their photography. To anyone who has been involved with photography for any period of time, these modes are known as the backbones of photography. They allow you to influence two of the most important factors in taking great photographs: aperture and shutter speed. To access these modes, you simply turn the Mode dial to one of the letter-designated modes and begin shooting. But wouldn't it be nice to know exactly what those modes control and how to make them do our bidding? Well, if you really want to take that next step in controlling your photography, it is essential that you understand not only how to control these modes but why you are controlling them. So let's move that Mode dial to the first of our professional modes: Program mode.

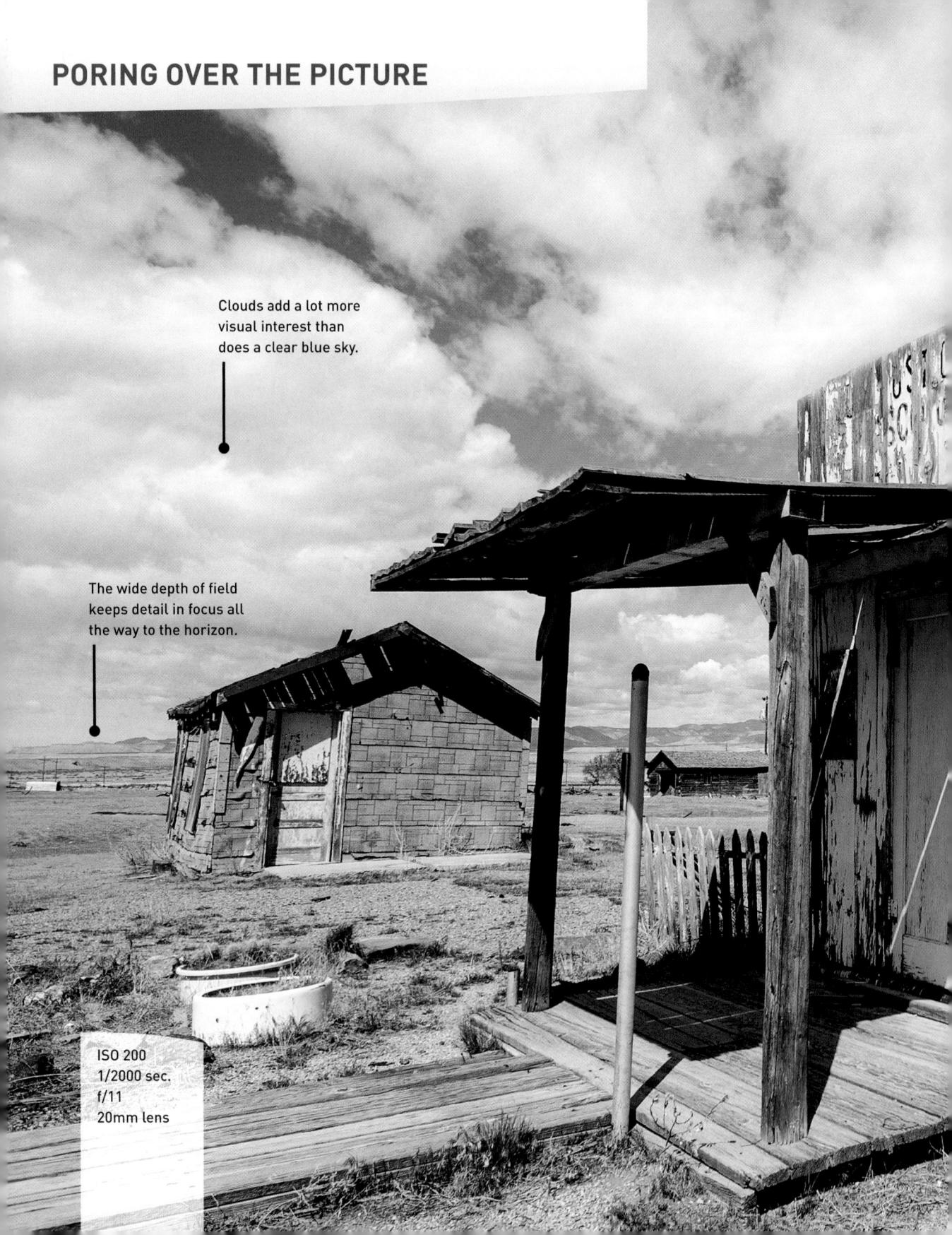

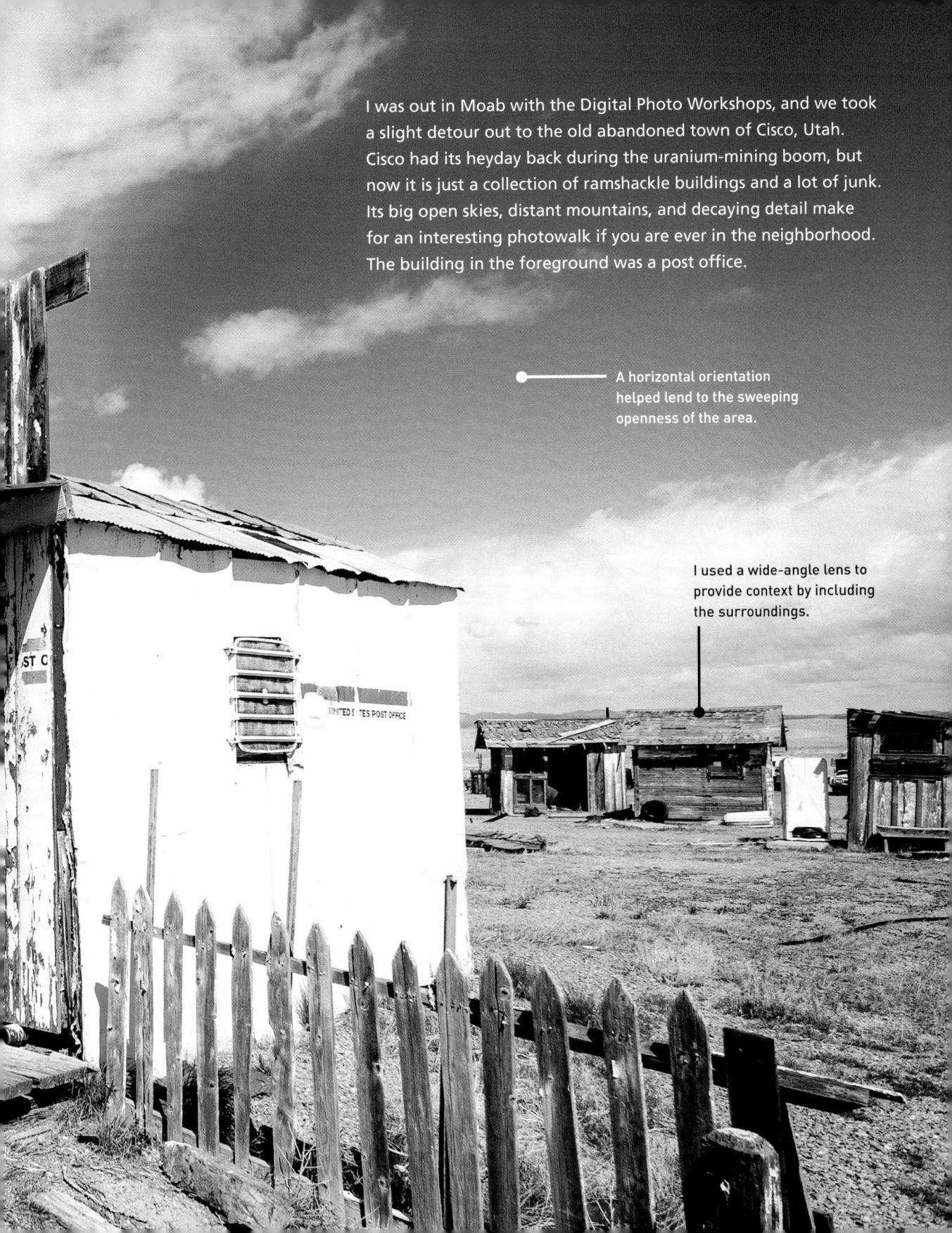

P: PROGRAM MODE

There is a reason that Program mode is only one click away from the automatic modes: With respect to apertures and shutter speeds, the camera is doing most of the thinking for you. So, if that is the case, why

even bother with Program mode? First, let me say that it is very rare that I will use Program mode, because it just doesn't give as much control over the image-making process as the other professional modes. There are occasions, however, when it comes in handy, like when I am shooting in widely changing lighting conditions and don't have the time to think through all of my options, or when I'm not very concerned with having ultimate control of the scene.

Think of a picnic outdoors in a partial shade/ sun environment. I want great-looking pictures, but I'm not looking for anything to hang in a museum. If that's the scenario, why choose Program over one of the scene modes? Because it gives me choices and control that none of the scene modes can deliver.

Manual Callout

To see a comparison of all of the different modes, check out the table on page 187 of your owner's manual.

WHEN TO USE PROGRAM (P) MODE INSTEAD OF THE AUTOMATIC SCENE MODES

- When shooting in a casual environment where quick adjustments are needed
- When you want more control over the ISO
- If you want to make corrections to the white balance
- When you want to change shutter speeds or the aperture to achieve a specific result

Let's go back to our picnic scenario. As I said, the light is moving from deep shadow to bright sunlight, which means that the camera is trying to balance our three photo factors (ISO, aperture, and shutter speed) to make a good exposure. From Chapter 1, we know that Auto ISO is just not a consideration, so we have already turned that feature off (you did turn it off, didn't you?). Well, in Program mode, you can choose which ISO you would like the camera to base its exposure on. The lower the ISO number, the better the quality of our photographs, but the less light sensitive the camera becomes. It's a balancing act, with the main goal always being to keep the ISO as low as possible—too low an ISO, and we will get camera shake in our images from a long shutter speed; and too high an ISO means we will have an unacceptable amount of digital noise. For our purposes, let's go ahead and select ISO 400 so that we provide

enough sensitivity for those shadows while allowing the camera to use shutter speeds that are fast enough to stop motion.

STARTING POINTS FOR ISO SELECTION

There is a lot of discussion concerning ISO in this and other chapters, but it might be helpful if you know where your starting points should be for your ISO settings. The first thing you should always try to do is use the lowest possible ISO setting. That being said, here are good starting points for your ISO settings:

- 100: Bright sunny day
- · 200: Hazy or outdoor shade on a sunny day
- · 400: Indoor lighting at night or cloudy conditions outside
- · 800: Late night, low-light conditions or sporting arenas at night

These are just suggestions, and your ISO selection will depend on a number of factors that will be discussed later in the book. You might have to push your ISO even higher as needed, but at least now you know where to start.

With the ISO selected, we can now make use of the other controls built into Program mode. By rotating the Command dial, we now have the ability to shift the program settings (Nikon calls this "flexible program"). Remember, your camera is using the internal meter to pick what it believes are suitable exposure values, but sometimes it doesn't know what it's looking at and how you want those values applied (Figures 4.1 and 4.2).

With the program shift, you can influence what the shot will look like. Do you need faster shutter speeds in order to stop the action? Just turn the Command dial to the right. Do you want a smaller aperture so that you get a greater depth of field? Then turn the dial to the left until you get the desired aperture. The camera shifts the shutter speed and aperture accordingly in order to get a proper exposure, and you will get the benefit of your choice as a result.

You will also notice that if you rotate the Command dial, a small star will appear above the letter P in the viewfinder and the rear display. This star is an indication that you modified the exposure from the one the camera chose. To go back to the default Program exposure, simply turn the dial until the star goes away or switch to a different mode and then back to Program mode again.

Let's set up the camera for Program mode and see how we can make all of this come together.

FIGURE 4.1 This is my first shot, using Program mode.

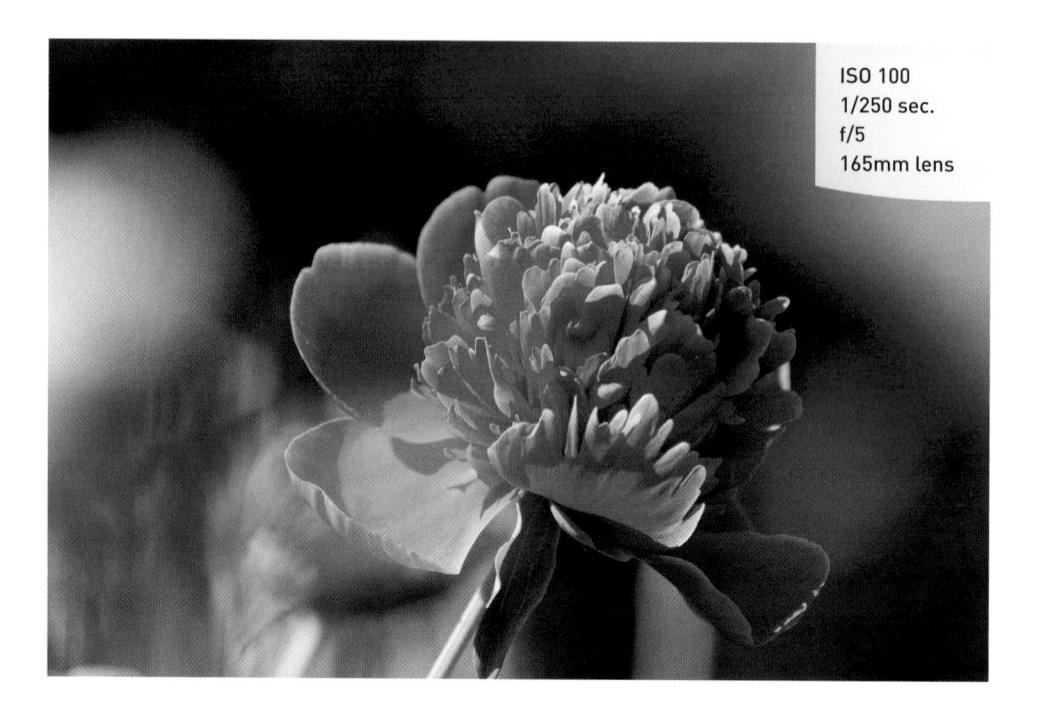

FIGURE 4.2
I decreased the size of the aperture by rotating the Command dial to the left to get a greater depth of field, and the shutter speed slowed down to maintain the same exposure value.

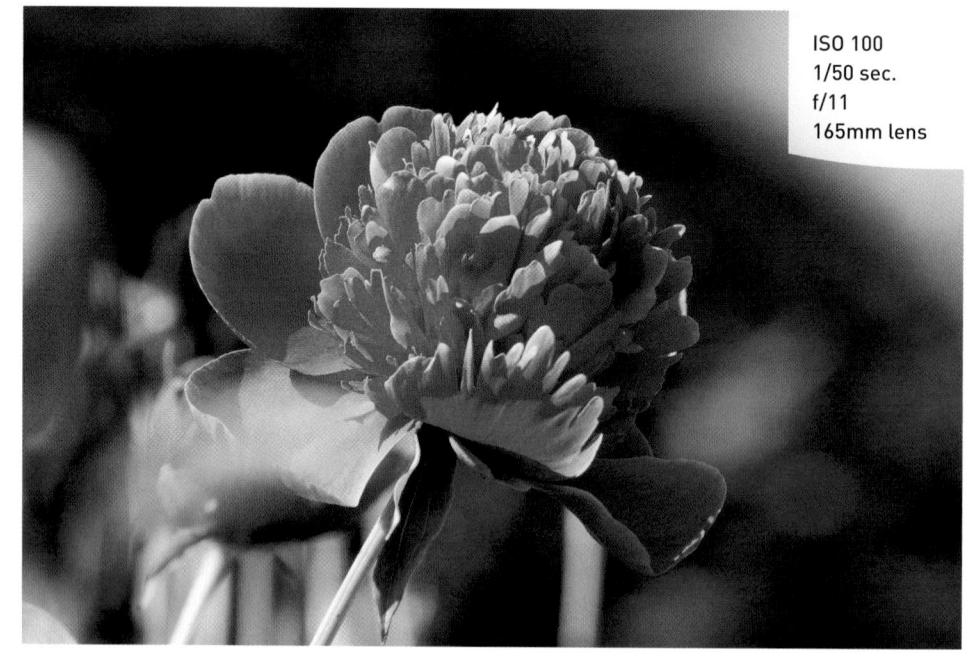

SETTING UP AND SHOOTING IN PROGRAM MODE

- Turn your camera on and then turn the Mode dial to align the P with the indicator line.
- 2. Select your ISO by pressing the i button on the lower-left portion of the back of the camera (if the camera's info screen is not visible, press the Info button or i button).
- 3. Press up or down on the Multi-selector to highlight the ISO option, then select OK.
- 4. Press down on the Multi-selector to select the desired ISO setting, and then press OK to lock in the change.
- **5.** Point the camera at your subject and then activate the camera meter by depressing the shutter button halfway.
- **6.** View the exposure information in the bottom of the viewfinder or by looking at the display panel on the back of the camera.
- 7. While the meter is activated, use your thumb to roll the Command dial left and right to see the changed exposure values.
- 8. Select the exposure that is right for you and start clicking. (Don't worry if you aren't sure what the right exposure is. We will start working on making the right choices for those great shots beginning with the next chapter.)

S: SHUTTER PRIORITY MODE

S mode is what we photographers commonly refer to as Shutter Priority mode. Just as the name implies, it is the mode that prioritizes or places major emphasis on the shutter speed above all other camera settings.

Just as with Program mode, Shutter Priority mode gives us more freedom to control certain aspects of our photography. In this case, we are talking about shutter speed. The selected shutter speed determines just how long you expose your camera's sensor to light. The longer it remains open, the more time your sensor has to gather light. The shutter speed also, to a large degree, determines how sharp your photographs are. This is different from the image being sharply in focus. One of the major influences on the sharpness of an image is just how sharp it is based on camera shake and the subject's movement. Because a slower shutter speed means that light from your subject is hitting the sensor for a longer period of time, any movement by you or your subject will show up in your photos as blur.

SHUTTER SPEEDS

A *slow* shutter speed refers to leaving the shutter open for a long period of time—like 1/30 of a second or longer. A *fast* shutter speed means that the shutter is open for a very short period of time—like 1/250 of a second or shorter.

WHEN TO USE SHUTTER PRIORITY (S) MODE

- When working with fast-moving subjects where you want to freeze the action (Figure 4.3); much more on this in Chapter 5
- When you want to emphasize movement in your subject with motion blur (Figure 4.4)
- When you want to use a long exposure to gather light over a long period of time (Figure 4.5); more on this in Chapter 8
- When you want to create that silky-looking water in a waterfall (Figure 4.6)

FIGURE 4.3 Even the fastest of subjects can be frozen with the right shutter speed.

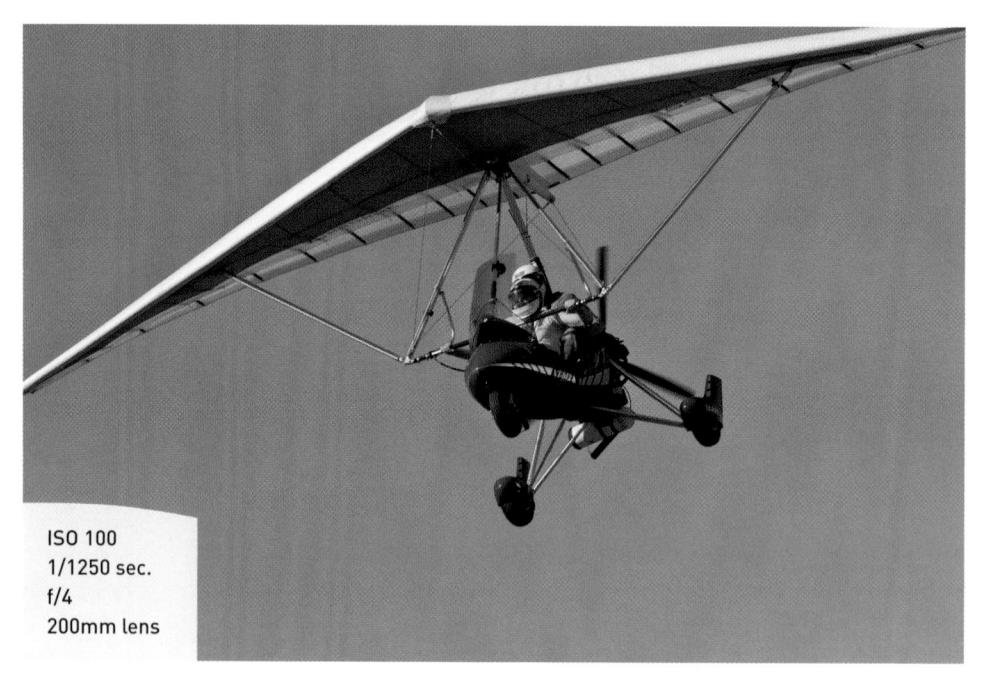

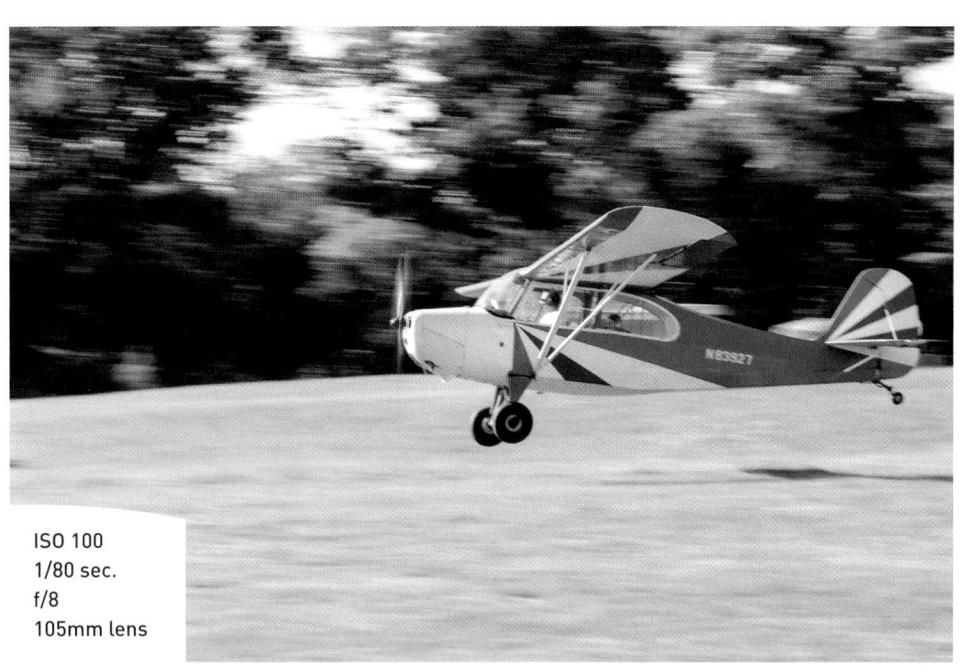

FIGURE 4.4 Slowing down the shutter speed and following the motion conveys a sense of movement in the shot.

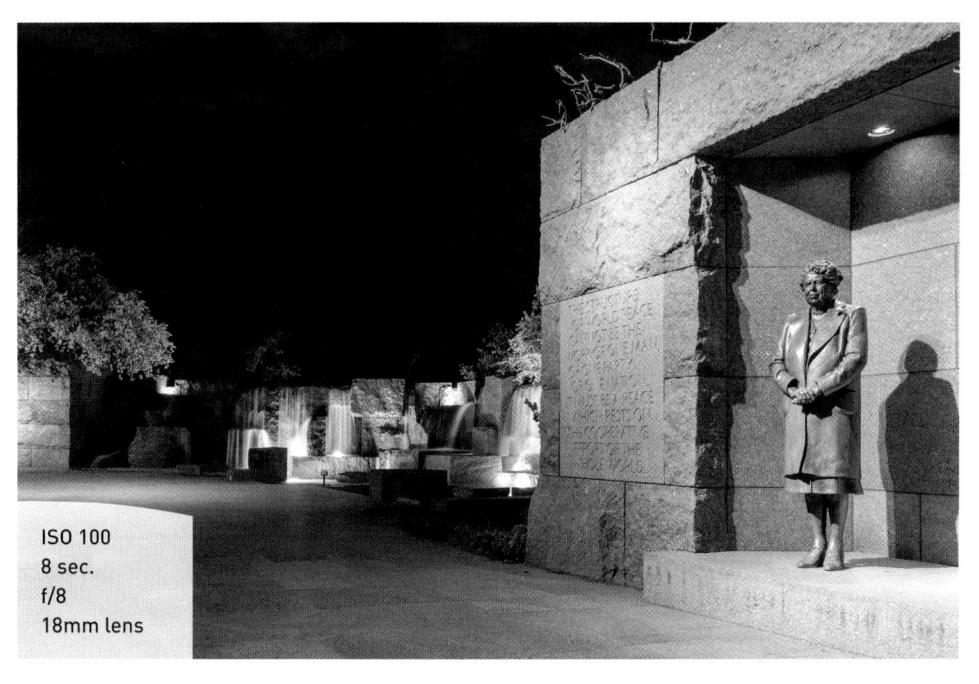

FIGURE 4.5 In this low-lit night scene, a long exposure was needed to capture the statue and its surroundings.

FIGURE 4.6 Increasing the length of the exposure time gives moving water a misty look.

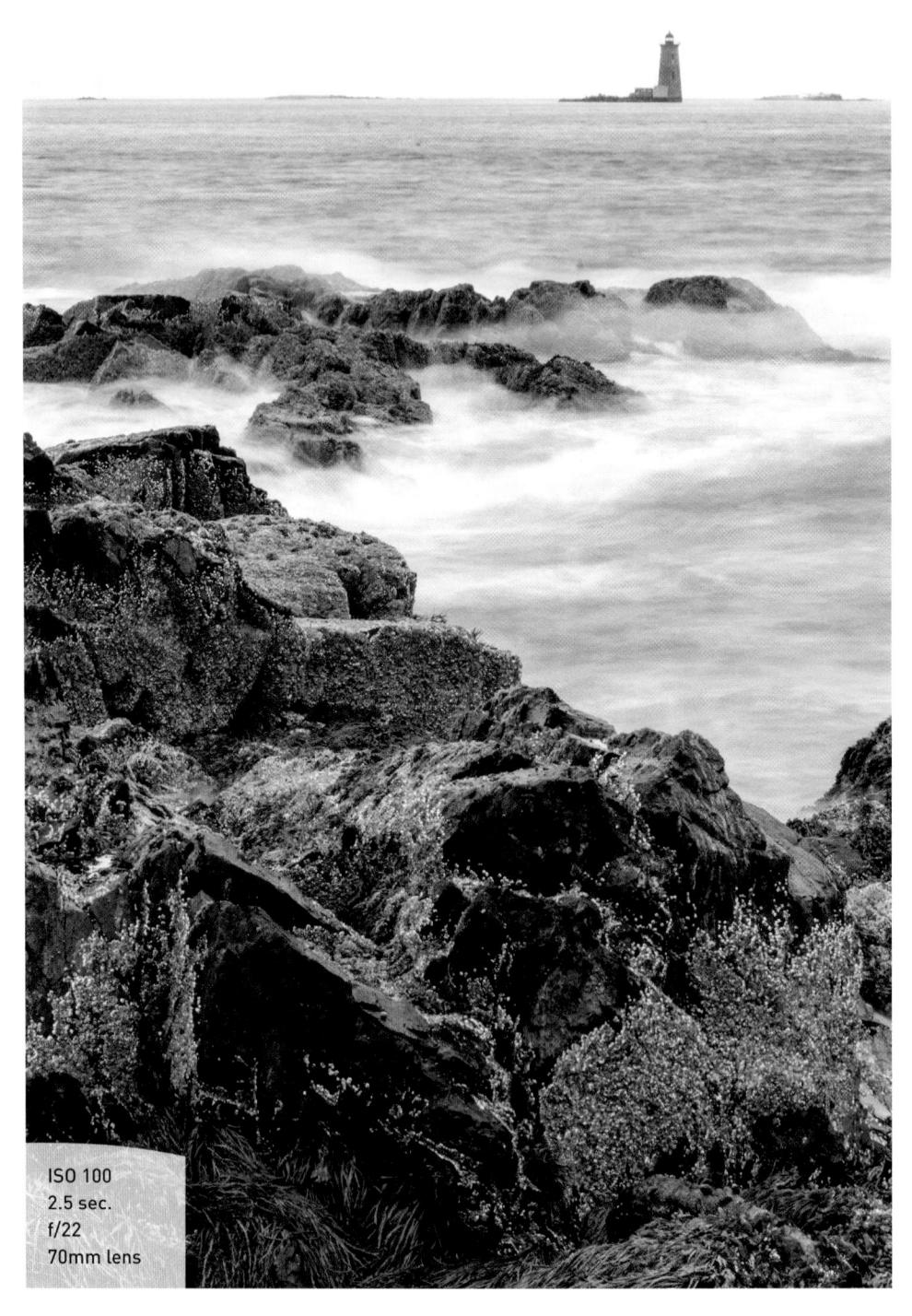

As you can see, the subject of your photo usually determines whether or not you will use Shutter Priority mode. It is important that you be able to visualize the result of using a particular shutter speed. The great thing about shooting with digital cameras is that you get instant feedback by viewing your shot on the LCD screen. But what if your subject won't give you a do-over? Such is often the case when shooting sporting events. It's not like you can go ask the quarterback to throw that touchdown pass again because your last shot was blurry from a slow shutter speed. This is why it's important to know what those speeds represent in terms of their capabilities to stop the action and deliver a blur-free shot.

First, let's examine just how much control you have over the shutter speeds. The D3200 has a shutter speed range from 1/4000 of a second to as long as 30 seconds. With that much latitude, you should have enough control to capture almost any subject. The other thing to think about is that Shutter Priority mode is considered a "semiautomatic" mode. This means that you are taking control over one aspect of the total exposure while the camera handles the other. In this instance, you are controlling the shutter speed and the camera is controlling the aperture. This is important, because there will be times that you want to use a particular shutter speed but your lens won't be able to accommodate your request.

For example, you might encounter this problem when shooting in low-light situations: If you are shooting a fast-moving subject that will blur at a shutter speed slower than 1/125 of a second but your lens's largest aperture is f/3.5, you might find that your aperture display blinks in the viewfinder and the rear LCD panel will display "Subject is too dark." This is your warning that there won't be enough light available for the shot—due to the limitations of the lens—so your picture will be underexposed.

Another case where you might run into a similar situation is when you are shooting moving water. To get that look of silky, flowing water, it's usually necessary to use a shutter speed of at least 1/15 of a second. If your waterfall is in full sunlight, you may get a message that reads "Subject is too bright" because the lens you are using only stops down to f/22 at its smallest opening. In this instance, your camera is warning you that you will be overexposing your image. There are workarounds for these problems, which we will discuss later (see Chapter 7), but it is important to know that there can be limitations when using Shutter Priority mode.

SETTING UP AND SHOOTING IN SHUTTER PRIORITY MODE

- Turn your camera on, and then turn the Mode dial to align the S with the indicator line.
- Select your ISO by pressing the i button on the lower-left portion of the back of the camera (if the camera's info screen is not visible, press the Info button or i button).
- 3. Press up or down on the Multi-selector to highlight the ISO option, and then press OK.
- **4.** Press down on the Multi-selector to select the desired ISO setting, then press OK to lock in the change.
- **5.** Point the camera at your subject, and then activate the camera meter by depressing the shutter button halfway.
- View the exposure information in the bottom area of the viewfinder or by looking at the rear LCD panel.
- 7. While the meter is activated, use your thumb to roll the Command dial left and right to see the changed exposure values. Roll the dial to the right for faster shutter speeds and to the left for slower speeds.

A: APERTURE PRIORITY MODE

You wouldn't know it from its name, but Aperture Priority mode is one of the most useful and popular of all the professional modes. This mode is one of my personal favorites, and I believe that it will quickly become one of yours as well. Aperture Priority mode is deemed a semiautomatic mode because it allows you to once again control one factor of exposure while the camera adjusts for the other.

Why, you may ask, is this one of my favorite modes? It's because the aperture of your lens dictates depth of field. Depth of field, along with composition, is a major factor in how you direct attention to what is important in your image. It is the controlling factor of how much area in your image is in focus. If you want to isolate a subject from the background, such as when shooting a portrait, you can use a large aperture to keep the focus on your subject and make both the foreground and background blurry. If you want to keep the entire scene sharply focused, such as with a landscape scene, then using a small aperture will render the greatest depth of field possible.

WHEN TO USE APERTURE PRIORITY (A) MODE

- When shooting portraits or wildlife (Figure 4.7)
- When shooting most landscape photography (Figure 4.8)
- When shooting macro, or close-up, photography (Figure 4.9)
- When shooting architectural photography, which often benefits from a large depth of field (Figure 4.10)

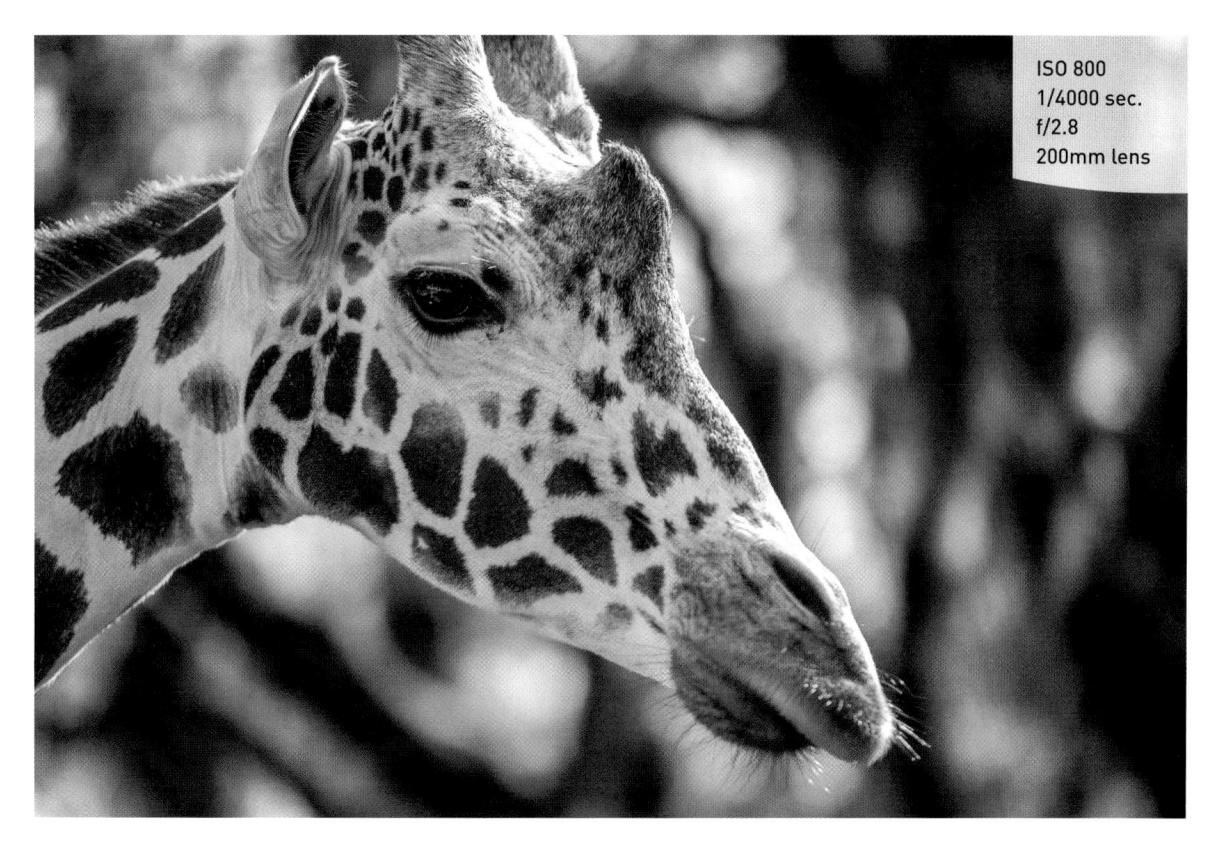

FIGURE 4.7
A large aperture created a very blurry background so all the emphasis was left on the subject.

FIGURE 4.8
The smaller aperture setting brings sharpness to near and far objects.

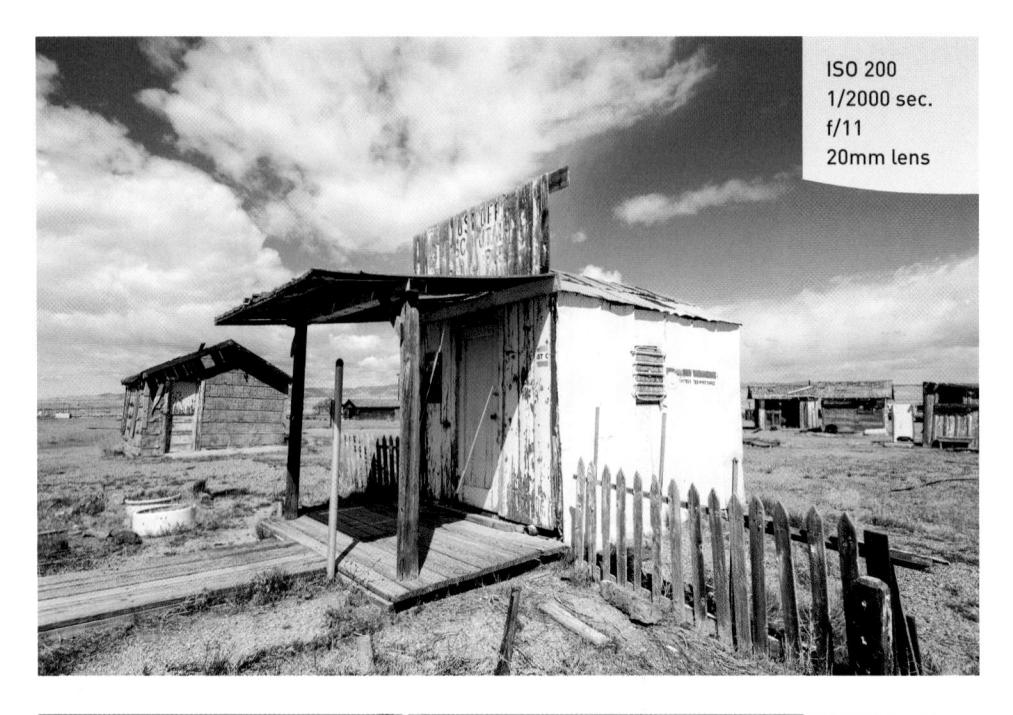

FIGURE 4.9
A small aperture
was used to capture
all the detail of this
newly emerged
black swallowtail
butterfly.

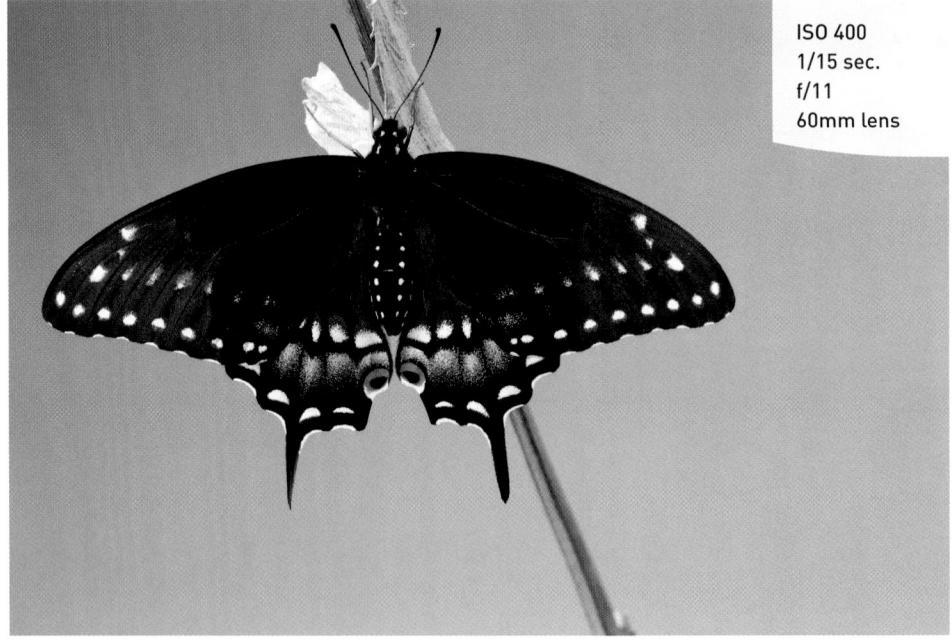

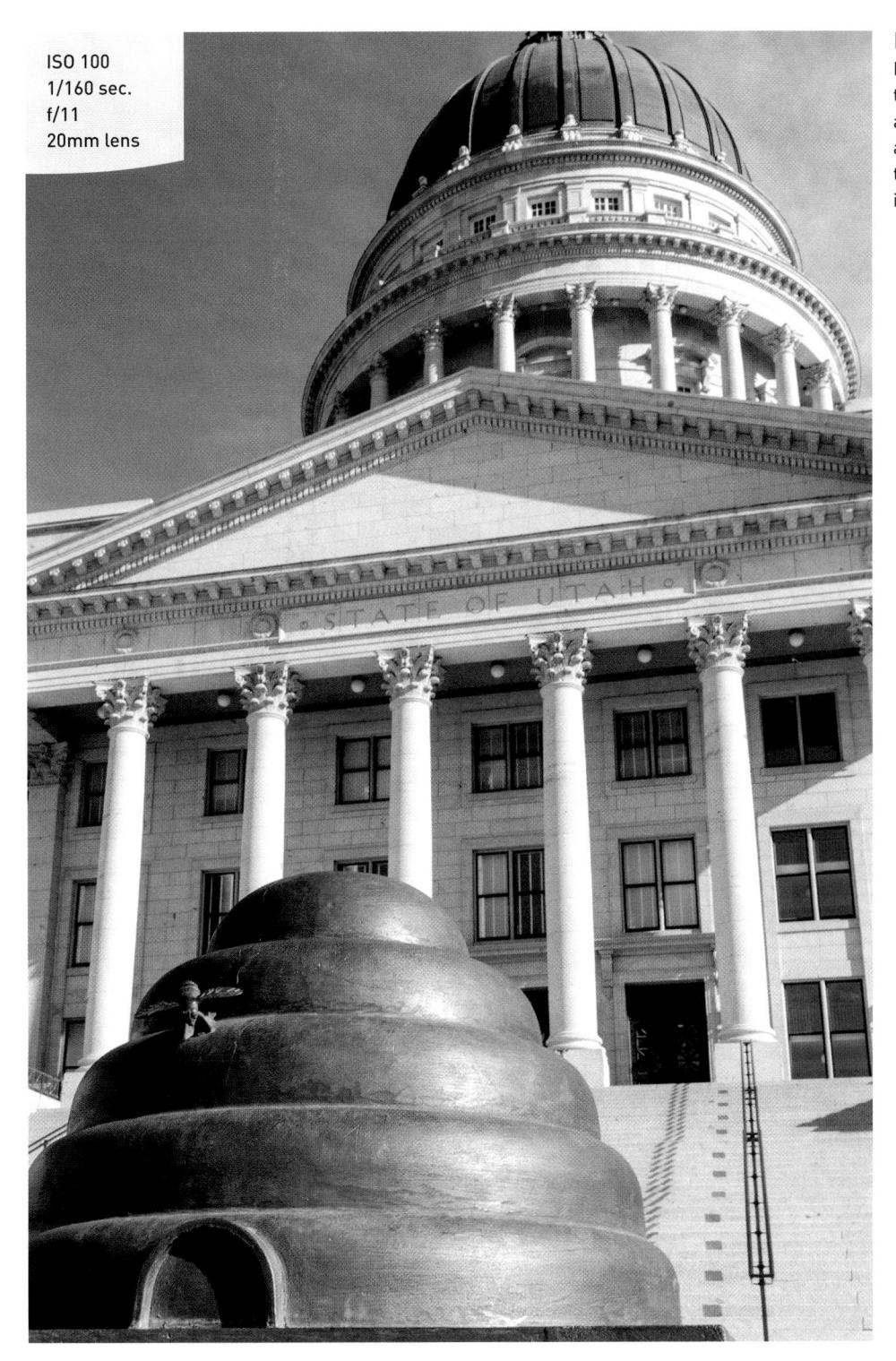

FIGURE 4.10 I typically like to use smaller apertures for architectural shots to keep everything in focus.

F-STOPS AND APERTURE

As discussed earlier, when referring to the numeric value of your lens aperture, you will find it described as an *f-stop*. The f-stop is one of those old photography terms that, technically speaking, relates to the focal length of the lens (e.g., 200mm) divided by the effective aperture diameter. These measurements are defined as "stops" and work incrementally with your shutter speed to determine proper exposure. Older camera lenses used one-stop increments to assist in exposure adjustments, such as 1.4, 2, 2.8, 4, 5.6, 8, 11, 16, and 22. Each stop represents about half the amount of light entering the lens iris as the larger stop before it. Today, most lenses don't have f-stop markings since all adjustments to this setting are performed via the camera's electronics. The stops are also now typically divided into 1/3-stop increments to allow much finer adjustments to exposures, as well as to match the incremental values of your camera's ISO settings, which are also adjusted in 1/3-stop increments.

So we have established that Aperture Priority (A) mode is highly useful in controlling the depth of field in your image. But it's also pivotal in determining the limits of available light that you can shoot in. Different lenses have different maximum apertures. The larger the maximum aperture, the less light you need in order to achieve an acceptably exposed image. You will recall that, when in Shutter Priority mode, there is a limit at which you can handhold your camera without introducing movement or hand shake, which causes blurriness in the final picture. If your lens has a larger aperture, you can let in more light all at once, which means that you can use faster shutter speeds. This is why lenses with large maximum apertures, such as f/1.4, are called "fast" lenses.

On the other hand, bright scenes require the use of a small aperture (such as f/16 or f/22), especially if you want to use a slower shutter speed (**Figure 4.11**). That small opening reduces the amount of incoming light, and this reduction of light requires that the shutter stay open longer.

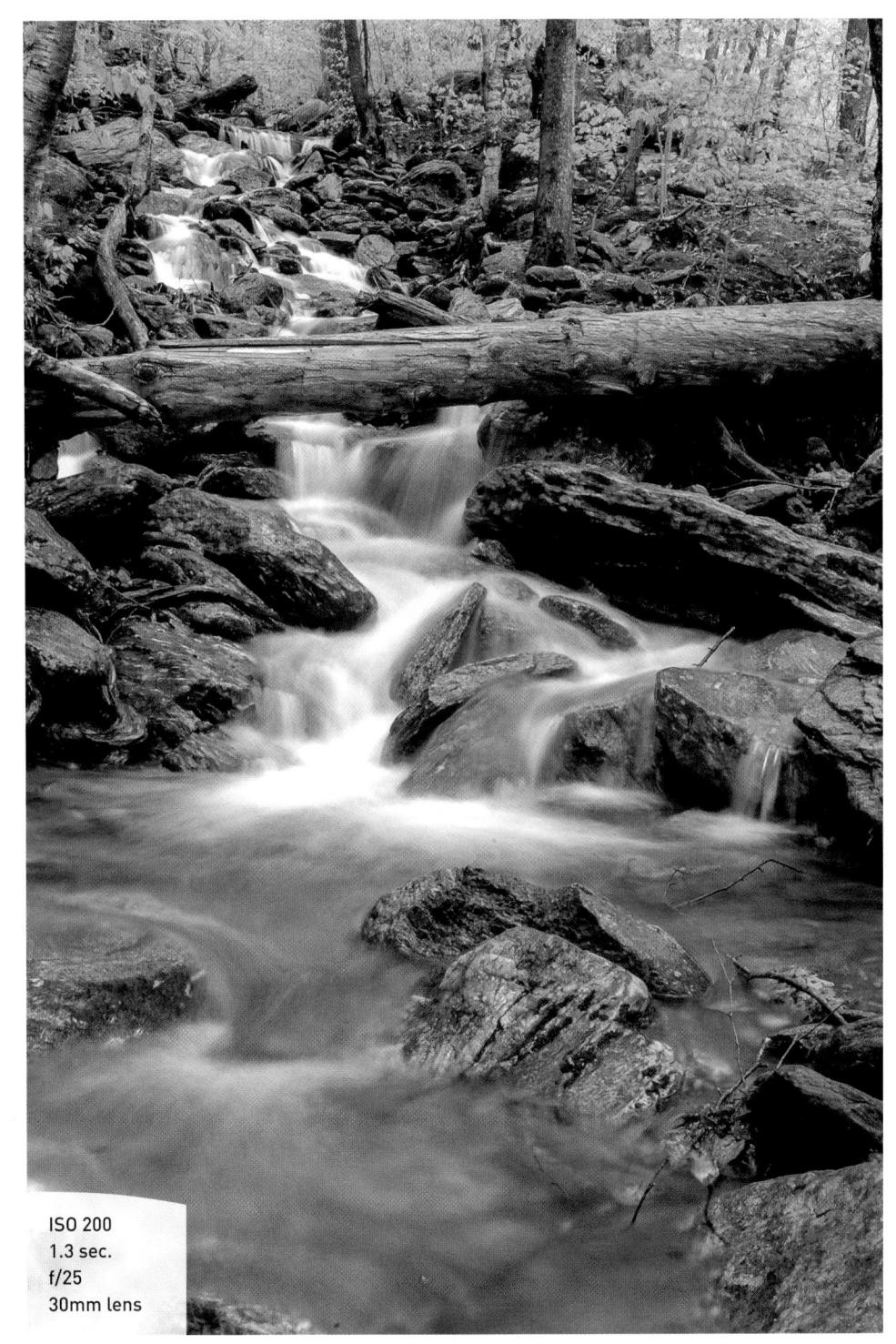

FIGURE 4.11
A wide-angle lens
combined with a
small aperture
added to the depth
of field. It also
created the need
for a long shutter
speed, which
helped add fluidity
to the falling water.

SETTING UP AND SHOOTING IN APERTURE PRIORITY MODE

- Turn your camera on, and then turn the Mode dial to align the A with the indicator line.
- 2. Select your ISO by pressing the i button on the lower-left portion of the back of the camera (if the camera's info screen is not visible, press the Info button or i button).
- 3. Press up or down on the Multi-selector to highlight the ISO option, then select OK.
- **4.** Press down on the Multi-selector to select the desired ISO setting, then press OK to lock in the change.
- 5. Point the camera at your subject, and then activate the camera meter by depressing the shutter button halfway.
- **6.** View the exposure information in the bottom area of the viewfinder or by looking at the rear display panel.
- 7. While the meter is activated, use your thumb to roll the Command dial left and right to see the changed exposure values. Roll the dial to the right for a smaller aperture (higher f-stop number) and to the left for a larger aperture (smaller f-stop number).

ZOOM LENSES AND MAXIMUM APERTURES

Some zoom lenses (like the 18-55mm kit lens) have a variable maximum aperture. This means that the largest opening will change depending on the zoom setting. In the example of the 18-55mm zoom, the lens has a maximum aperture of f/3.5 at 18mm and only f/5.6 when the lens is zoomed out to 55mm.

M: MANUAL MODE

Once upon a time, long before digital cameras and program modes, there was Manual mode. In those days it wasn't called "manual mode," because there were no other modes—it was just photography. In fact, many photographers cut their teeth on completely manual cameras. Let's face it—if you want to learn the effects of aperture and shutter speed on your photography, there is no better way to learn than by setting those adjustments yourself. However, today, with the advancement of camera technology, many new photographers never give this mode a second thought. That's truly a shame, as not only is it an excellent

way to learn your photography basics, but it's also an essential tool to have in your photographic bag of tricks.

When you have your camera set to Manual (M) mode, the camera meter will give you a reading of the scene you are photographing. It's your job, though, to set both the f-stop (aperture) and the shutter speed to achieve a correct exposure. If you need a faster shutter speed, you will have to make the reciprocal change to your f-stop. Using any other mode, such as Shutter Priority or Aperture Priority, would mean that you just have to worry about one of these changes, but Manual mode means you have to do it all yourself. This can be a little challenging at first, but after a while you will have a complete understanding of how each change affects your exposure, which will, in turn, improve the way that you use the other modes.

WHEN TO USE MANUAL (M) MODE

- When learning how each exposure element interacts with the others (Figure 4.12)
- When your environment is fooling your light meter and you need to maintain a certain exposure setting (Figure 4.13)
- When shooting silhouetted subjects, which requires overriding the camera's meter readings (Figure 4.14)

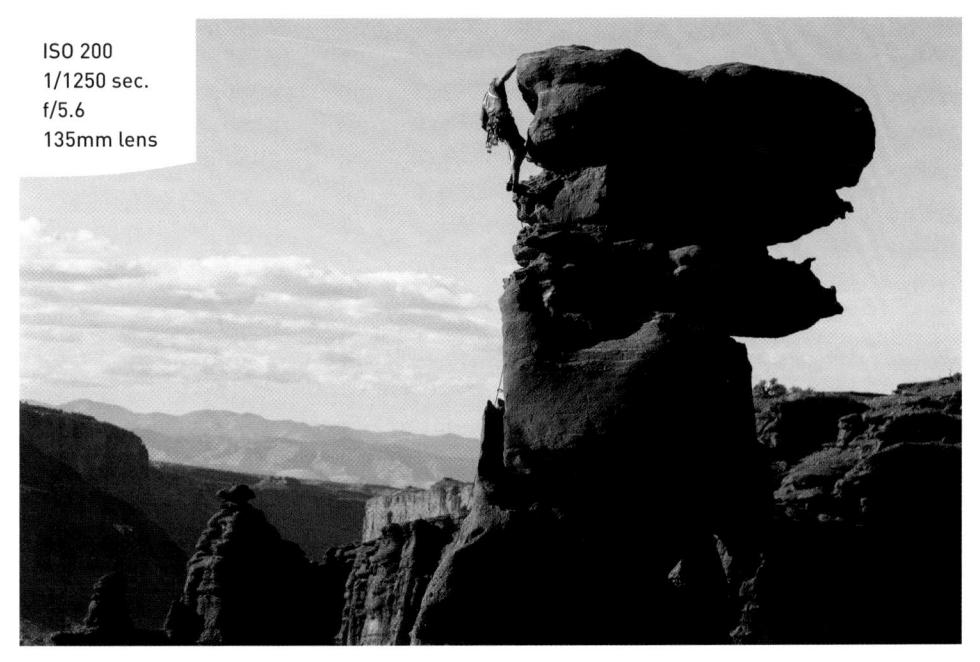

FIGURE 4.12
Since my main subject was in the light, I set the camera to Manual so I could underexpose and keep the sky darker and more blue without worrying about the areas that fell into shadow.

FIGURE 4.13
Beaches and
snow are always
a challenge for
light meters. Add
to that the desire to
have exact control
of depth of field
and shutter speed,
and you have a
perfect scenario
for Manual mode.

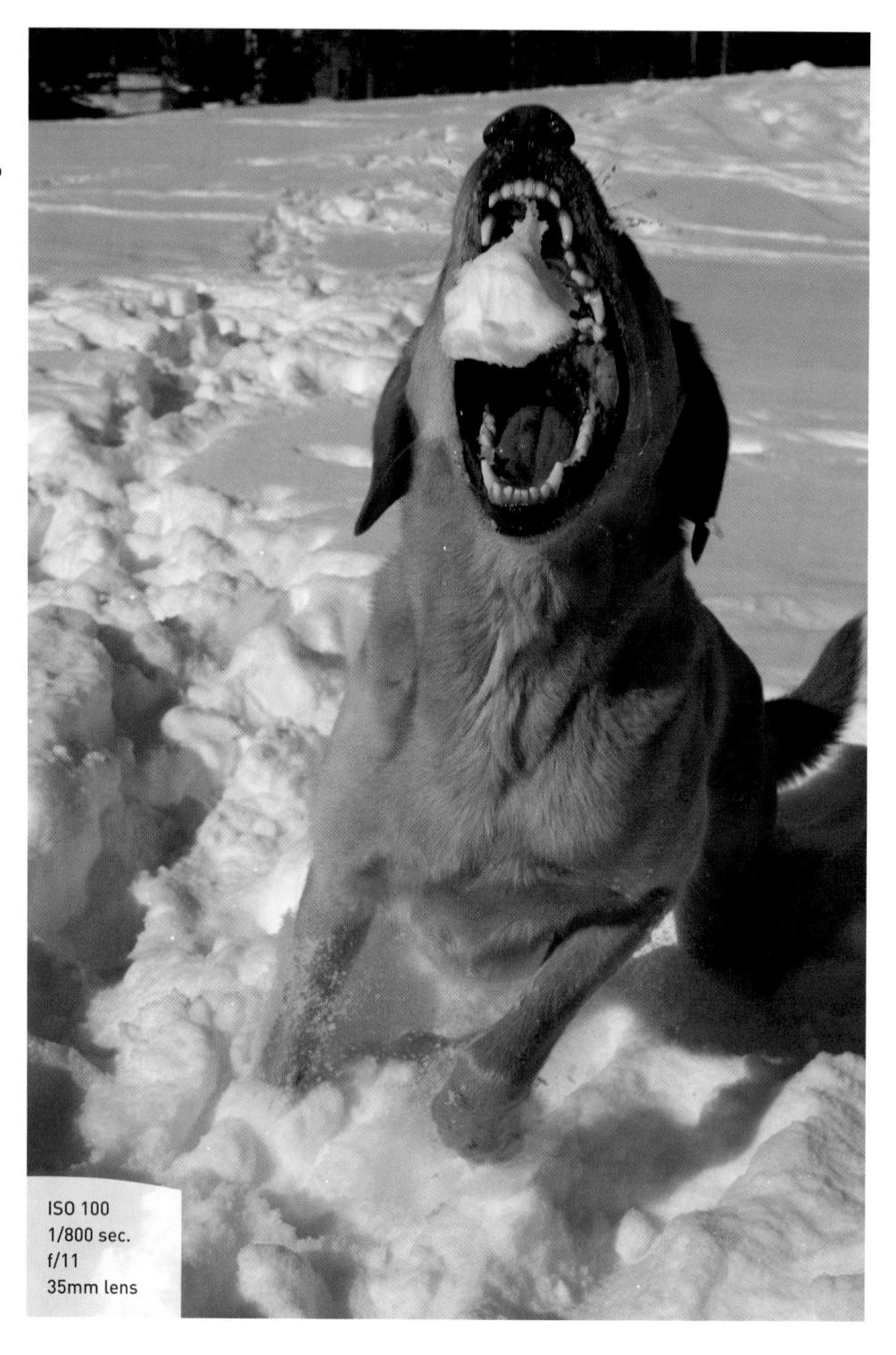

1/80 sec. f/8
165mm lens

FIGURE 4.14
While waiting for
the sun to rise,
I turned to a fellow
photographer and
used Manual mode
to push the foreground elements
into complete
silhouette.

SETTING UP AND SHOOTING IN MANUAL MODE

- 1. Turn your camera on, and then turn the Mode dial to align the M with the indicator line.
- 2. Select your ISO by pressing the i button on the lower-left portion of the back of the camera (if the camera's info screen is not visible, press the Info button or i button).
- **3.** Press up or down on the Multi-selector to highlight the ISO option, then select OK.
- Press down on the Multi-selector to select the desired ISO setting, then press OK to lock in the change.
- **5.** Point the camera at your subject, and then activate the camera meter by depressing the shutter button halfway.
- **6.** View the exposure information in the bottom area of the viewfinder or by looking at the display panel on the rear of the camera.
- 7. While the meter is activated, use your thumb to roll the Command dial left and right to change your shutter speed value until the exposure mark is lined up with the zero mark. The exposure information is displayed by a scale with marks that run from –2 to +2 stops. A "proper" exposure will line up with the arrow mark in the middle. As the indicator moves to the right, it is a sign that you will be underexposing (there is not enough light on the sensor to provide adequate

- exposure). Move the indicator to the left and you will be providing more exposure than the camera meter calls for; this is overexposure.
- 8. To set your exposure using the aperture, depress the shutter release button until the meter is activated. Then, while holding down the Exposure Compensation/ Aperture button (located behind and to the right of the shutter release button), rotate the Command dial to change the aperture. Rotate right for a smaller aperture (large f-stop number) and left for a larger aperture (small f-stop number).

Remember that when you are using Manual mode, it is up to you to decide what is the most important thing to worry about. Do you need a fast shutter? Do you want narrow depth of field? You decide and then you take control. It's really one of the best ways to learn how each change affects your image.

HOW I SHOOT: A CLOSER LOOK AT THE CAMERA SETTINGS I USE

The great thing about working with a DSLR camera is that I can always feel confident that some things will remain unchanged from camera to camera. For me, these are the Aperture Priority (A) and Shutter Priority (S) shooting modes. Regardless of the subject I am shooting—from landscape to portrait to macro—I am almost always going to be concerned with my depth of field. Whether it's isolating my subject with a large aperture or trying to maximize the overall sharpness of a sweeping landscape, I always keep an eye on my aperture setting. If I do need to control the action (Figure 4.15), I use Shutter Priority. If I am trying to create a silky waterfall effect, I can depend on Shutter Priority mode to provide the long shutter speed that gets the desired result. Or perhaps I am shooting a baseball game—I definitely need fast shutter speeds that will freeze the fast-moving action.

While the other camera modes have their place, I think you will find that, like me and most other working pros, you will use the Aperture Priority and Shutter Priority modes for 90 percent of your shooting.

The other concern that I have when I am setting up my camera is just how low I can keep my ISO. This is always a priority for me because a low ISO will deliver the cleanest image. I raise the ISO only as a last resort, because each increase in sensitivity is an opportunity for more digital noise to enter my image. To that end, I always have the Noise Reduction feature turned on (see Chapter 7).

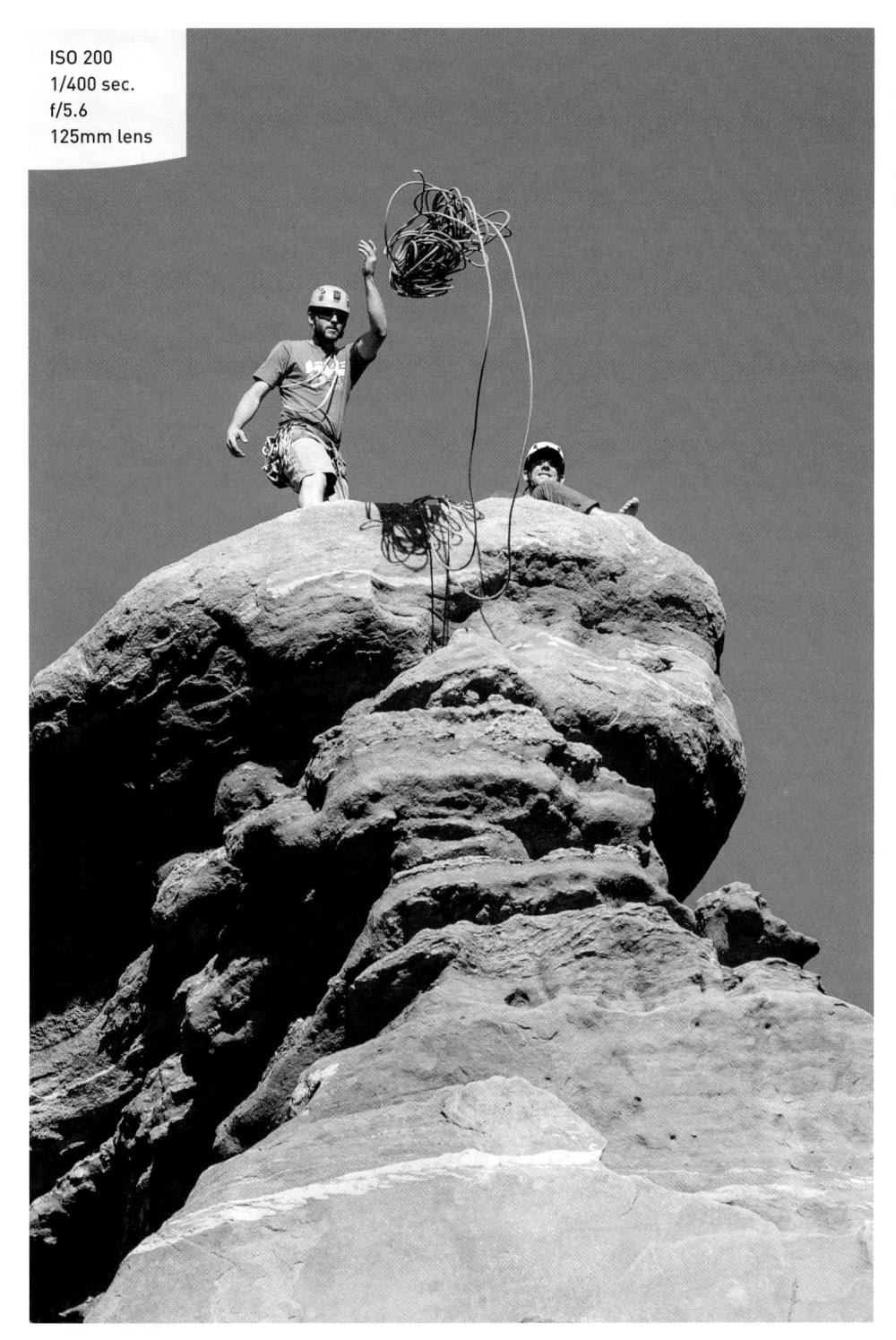

FIGURE 4.15 I wanted to make sure the rope was frozen in midair, so I chose a shutter speed that would stop the action.

To make quick changes while I shoot, I often use the Exposure Compensation feature (covered in Chapter 7) so that I can make small over- and underexposure changes. This is different than changing the aperture or shutter; it is more like fooling the camera meter into thinking the scene is brighter or darker than it actually is. To get to this function quickly, I simply press the Exposure Compensation/Aperture button, then dial in the desired amount of compensation. Truth be told, I usually have this set to -1/3 so that there is just a tiny bit of underexposure in my image. This usually leads to better color saturation. (Note: When shooting in Manual mode, the Exposure Compensation feature must be set by using the i button.)

One of the reasons I change my exposure is to make corrections when I see the "blinkies" in my rear LCD. Blinkies are the warning signal that part of my image has been overexposed to the point that I no longer have any detail in the highlights. When the Highlight Alert feature is turned on, the display will flash wherever the potential exists for overexposure. The black and white flashing will appear only in areas of your picture that are in danger of overexposure and that might suffer from a loss of detail.

SETTING UP THE HIGHLIGHT ALERT FEATURE

- 1. Press the Menu button, then use the Multi-selector to access the Playback Menu.
- 2. Once in the Playback Menu, move the Multi-selector to the Playback display options and press OK (A).
- 3. Select Additional photo info, and press the Multi-selector to the right (B).

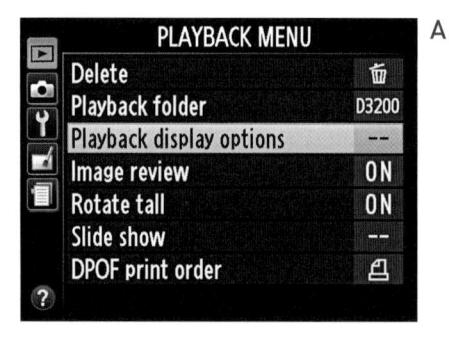

- **4.** Move the Multi-selector down to select the Highlights option, then press OK to place a checkmark next to the word Highlights (**C**).
- 5. Now move back up to select Done, and press OK again to lock in your change (D).

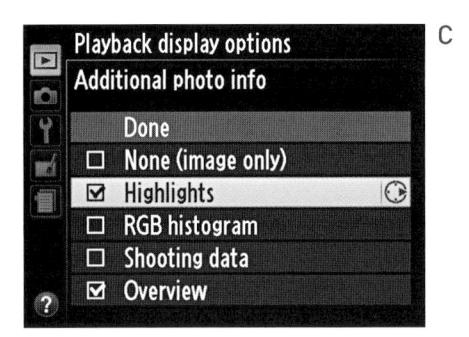

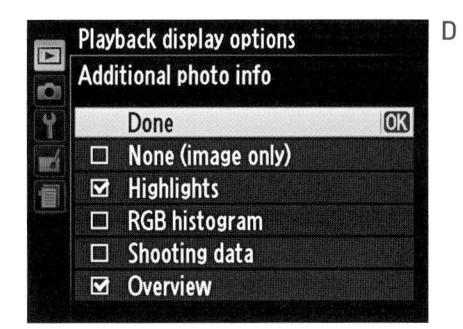

Once the highlight warning is turned on, I use it to check my images on the rear LCD after taking a shot. If I see an area that is blinking (Figure 4.16), I will usually set the Exposure Compensation feature to an underexposed setting like -1/3 or -2/3 stops

and take another photo, checking the result on the screen. I repeat this process until the warning is gone.

Sometimes, such as when shooting into the sun, the warning will blink no matter how much you adjust the exposure, because there is just no detail in the highlights. Use your best judgment to determine if the warning is alerting you to an area where you want to retain highlight detail.

To see the highlight, or "blinkie," warning, you will need to change your display mode. To do this, press the Image Review button on the

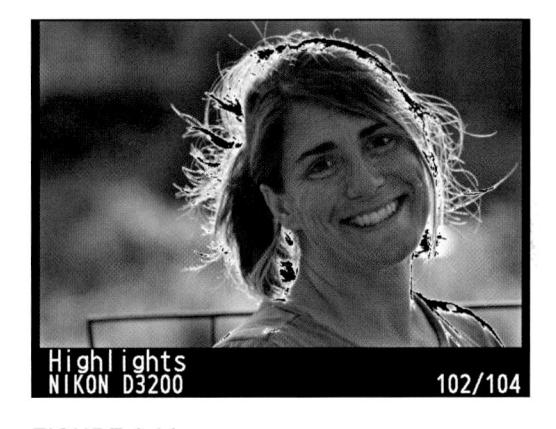

FIGURE 4.16
The blinking black and white areas (shown in this image as black) are a warning that part of the image is overexposed at the current camera settings.

back of the camera and then press up or down on the Multi-selector until you see the word "Highlights" at the bottom of the display screen. This will now be your default display mode unless you change it or turn off the highlight warning.

As you work your way through the coming chapters, you will see other tips and tricks I use in my daily photography, but the most important tip I can give is that you should understand the features of your camera so that you can leverage the technology in a knowledgeable way. This will result in better photographs.

Chapter 4 Assignments

This will be more of a mental challenge than anything else, but you should put a lot of work into these lesson assignments because the information covered in this chapter will define how you work with your camera from this point on. Granted, there may be times that you just want to grab some quick pictures and will resort to the automatic scene modes, but to get serious with your photography, you will want to learn the professional modes inside and out.

Starting off with Program mode

Set your camera on Program mode and start shooting. Become familiar with the adjustments you can make to your exposure by turning the Command dial. Shoot in bright sun, deep shade, indoors—anywhere that you have different types and intensities of light. While you are shooting, make sure that you keep an eye on your ISO and raise or lower it according to your environment.

Learning to control time with Shutter Priority mode

Find some moving subjects and then set your camera to S mode. Have someone ride a bike back and forth, or even just photograph cars as they go by. Start with a slow shutter speed of around 1/30 of a second, and then start shooting with faster and faster shutter speeds. Keep shooting until you can freeze the action. Now find something that isn't moving, like a flower, and work your way down from a fast shutter speed, like 1/500 of a second. Don't brace the camera on a steady surface. Just try to shoot as slowly as possible, down to about 1/4 of a second. The point is to see how well you can handhold your camera before you start introducing hand shake into the image, making it appear soft and somewhat unfocused.
Controlling depth of field with Aperture Priority mode

The name of the game with Aperture Priority mode is depth of field. Set up three items in a line moving away from you. I would use chess pieces or something similar. Now focus on the middle item, and set your camera to the largest aperture that your lens allows (remember, large aperture means a small number, like f/3.5). Now, while still focusing on the middle subject, start shooting with ever-smaller apertures until you are at the smallest f-stop for your lens. If you have a zoom lens, try doing this exercise with the lens at the widest and then the most telephoto settings. Now move up to subjects that are farther away, like telephone poles, and shoot them in the same way. The idea is to get a feel for how each aperture setting affects your depth of field.

Giving and taking with Manual mode

Manual mode is not going to require a lot of work, but you should pay close attention to your results. Go outside on a sunny day and, using the camera in Manual mode, set your ISO to 100, your shutter speed to 1/125 of a second, and your aperture to f/16. Now press your shutter release button to get a meter reading. You should be pretty close to that zero mark. If not, make small adjustments to one of your settings until it hits that mark. Now is where the fun begins. Start moving your shutter speed slower, to 1/60, and then set your aperture to f/22. Now go the other way. Set your aperture on f/8 and your shutter speed to 1/500. Now review your images. If all went well, all the exposures should look the same. This is because you balanced the light with reciprocal changes to the aperture and shutter speed. Now go back to our original setting of 1/125 at f/16 and try moving just the shutter speed without changing the aperture. Just make 1/3-stop changes (1/125 to 1/100 to 1/80 to 1/60), and then review your images to see what 1/3 stop of overexposure looks like. Then do the same thing going in the opposite way. It's hard to know if you want to over- or underexpose a scene until you have actually done it and seen the results.

With each of the assignments, make sure that you keep track of your modes and exposures so that you can compare them with the image. If you are using software to review your images, you should also be able to check the camera settings that are embedded within the image's metadata.

Share your results with the book's Flickr group!

Join the group here: flickr.com/groups/nikond3200_fromsnapshotstogreatshots

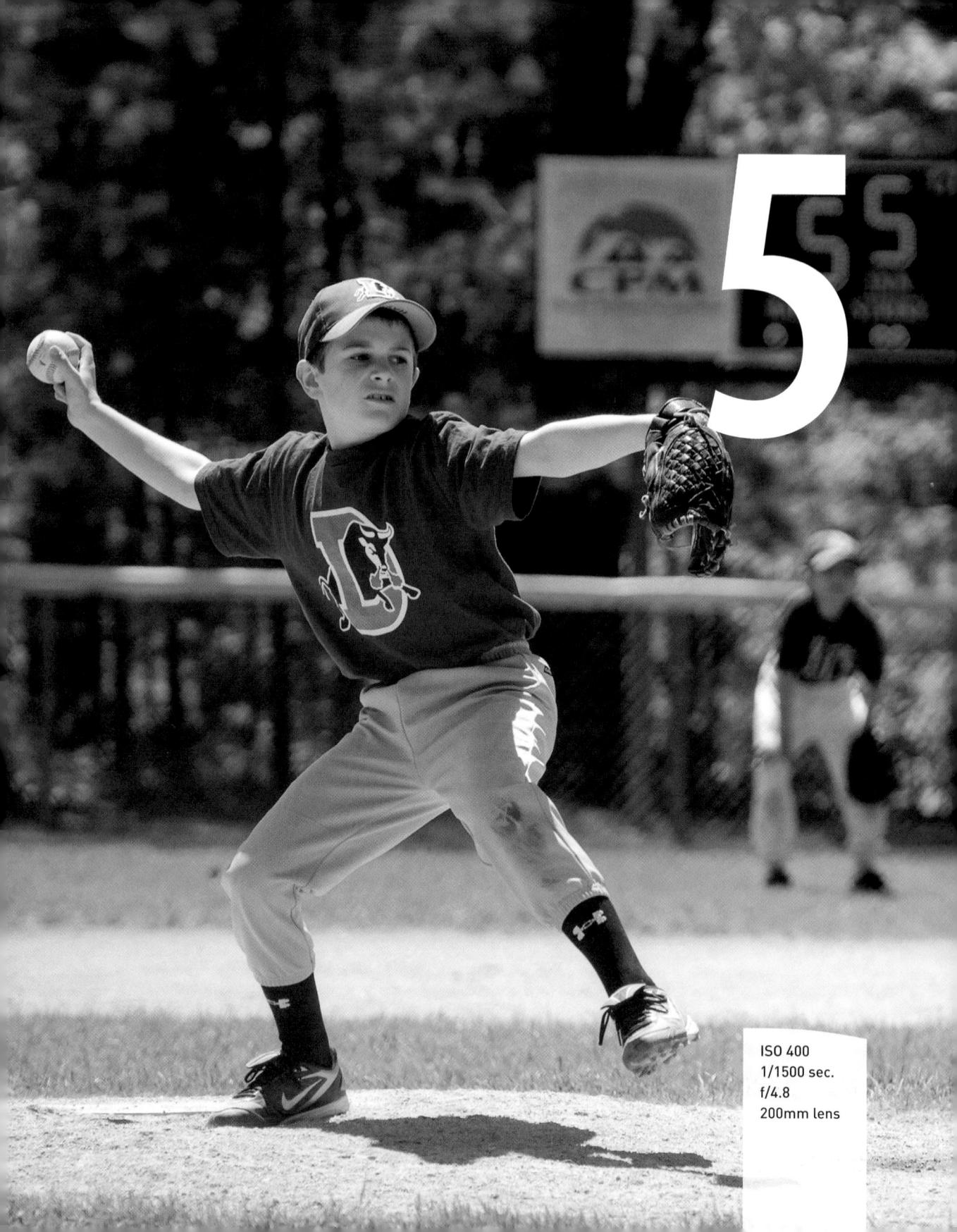

Moving Target

THE TRICKS TO SHOOTING SUBJECTS IN MOTION

Now that you have learned about the professional modes, it's time to put your newfound knowledge to good use. Whether you are shooting the action at a professional sporting event, an osprey swooping for a fish, or a child on a merry-go-round, this chapter will teach you techniques that will help you bring out the best in your photography when your subject is in motion.

The number one thing to know when trying to capture a moving target is that speed is king! I'm not talking about how fast your subject is moving, but rather how fast your shutter is opening and closing. Shutter speed is the key to freezing the moment in time—but also to conveying movement. It's all in how you turn the dial. There are also some other considerations for taking your shot to the next level: composition, lens selection, and a few more items that we will explore in this chapter. So strap on your seatbelt and hit the gas, because here we go!

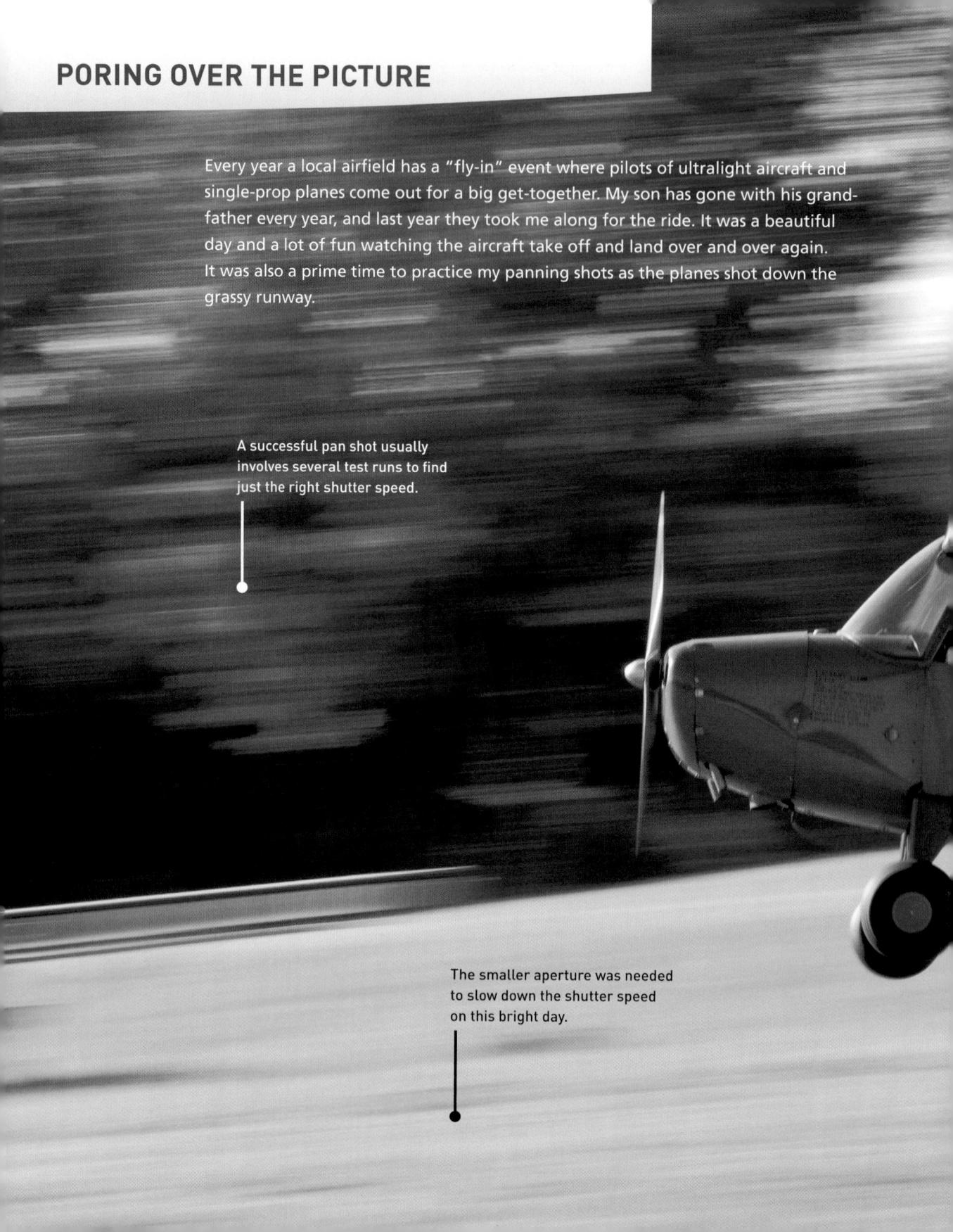

A solid stance or a monopod is required to reduce up and down motion as you pivot with the subject. Several shots were taken using the Continuous shooting mode while following the aircraft with the lens. ISO 100 1/40 sec. f/10 70mm lens

STOP RIGHT THERE!

Shutter speed is the main tool in the photographer's arsenal for capturing great action shots. The ability to freeze a moment in time often makes the difference between a good shot and a great one. To take advantage of this concept, you should have a good grasp of the relationship between shutter speed and movement. When you press the shutter release button, your camera goes into action by opening the shutter curtain and then closing it after a predetermined length of time. The longer you leave your shutter open, the more your subject will move across the frame, so common sense dictates that the first thing to consider is just how fast your subject is moving.

Typically, you will be working in fractions of a second. Just how long those fractions are depends on several factors. Subject movement, while simple in concept, is actually based on three factors. The first is the direction of travel. Is the subject moving across your field of view (left to right) or traveling toward or away from you? The second consideration is the actual speed at which the subject is moving. There is a big difference between a moving sports car and a child on a bicycle. Finally, the distance from you to the subject has a direct bearing on how fast the action seems to be taking place. Let's take a brief look at each of these factors to see how they might affect your shooting.

DIRECTION OF TRAVEL

Typically, the first thing that people think about when taking an action shot is how fast the subject is moving, but in reality the first consideration should be the direction of travel. Where you are positioned in relation to the subject's direction of travel is critically important in selecting the proper shutter speed. When you open your shutter, the lens gathers light from your subject and records it on the camera sensor. If the subject is moving across your viewfinder, you need a faster shutter speed to keep that lateral movement from being recorded as a streak across your image. Subjects that are moving toward or away from your shooting location do not move across your viewfinder so appear to be more stationary. This allows you to use a slightly slower shutter speed. A subject that is moving in a diagonal direction—both across the frame and toward or away from you—requires a shutter speed in between the two (Figure 5.1).

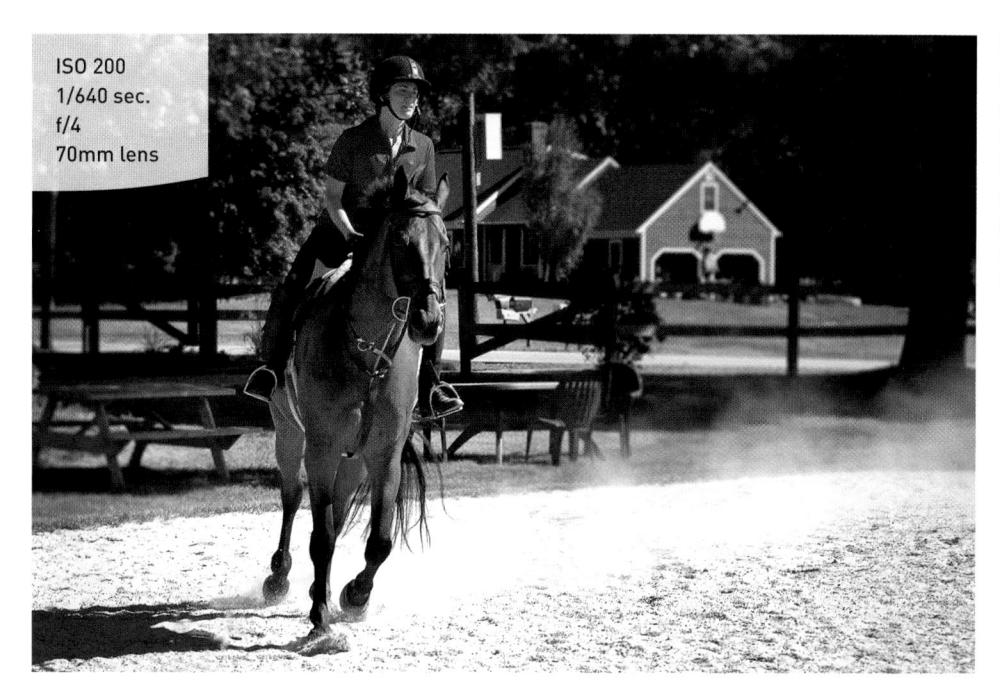

FIGURE 5.1
Action coming
toward the camera
at an angle can
be captured with
slower shutter
speeds than action
moving perpendicular to your position.

SUBJECT SPEED

Once the angle of motion has been determined, you can then assess the speed at which the subject is traveling. The faster your subject moves, the faster your shutter speed needs to be in order to "freeze" that subject (Figure 5.2). A person walking across your frame might only require a shutter speed of 1/60 of a second, while a cyclist traveling in the same direction would call for 1/500 of a second. That same cyclist traveling at the same rate of speed toward you—rather than across the frame—might only require a shutter speed of 1/125 of a second. You can start to see how the relationship of speed and direction comes into play in your decision-making process.

FIGURE 5.2 A fast-moving subject that is crossing your path will require a faster shutter speed.

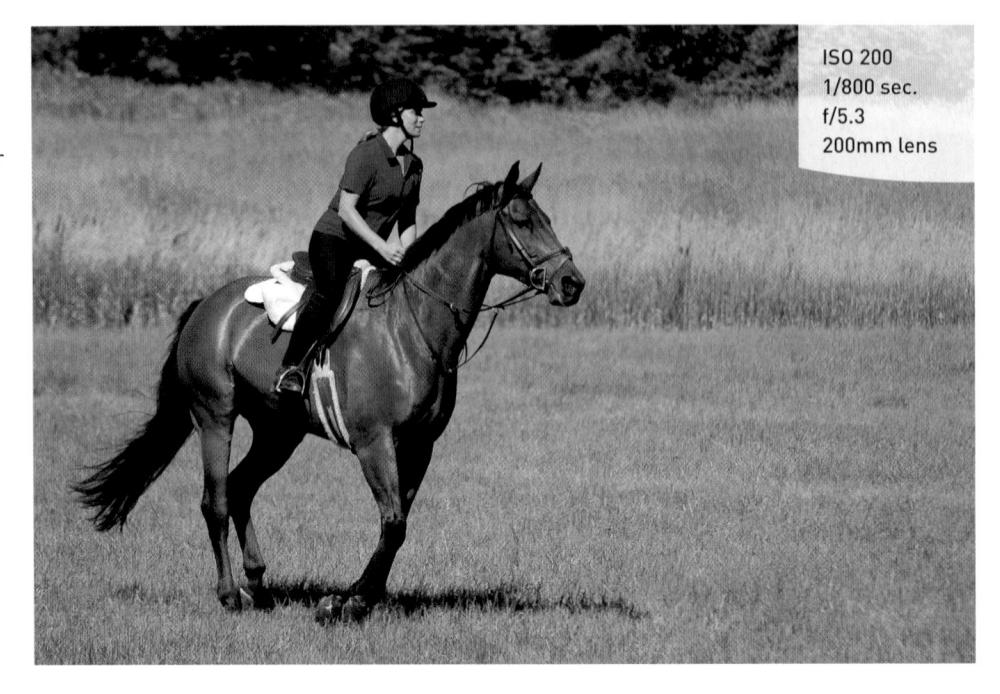

SUBJECT-TO-CAMERA DISTANCE

So now we know both the direction and the speed of your subject. The final factor to address is the distance between you and the action. Picture yourself looking at a highway full of cars from up in a tall building a quarter of a mile from the road. As you stare down at the traffic moving along at 55 miles per hour, the cars and trucks seem to be slowly moving along the roadway. Now picture yourself standing in the median of that same road as the same traffic flies by at the same rate of speed.

Although the traffic is moving at the same speed, the shorter distance between you and the traffic makes the cars look like they are moving much faster. This is because your field of view is much narrower; therefore, the subjects are not going to present themselves within the frame for the same length of time. The concept of distance applies to the length of your lens as well (Figure 5.3). If you are using a wide-angle lens, you can probably get away with a slower shutter speed than if you were using a telephoto, which puts you in the heart of the action. It all has to do with your field of view. That telephoto gets you "closer" to the action—and the closer you are, the faster your subject will be moving across your viewfinder.

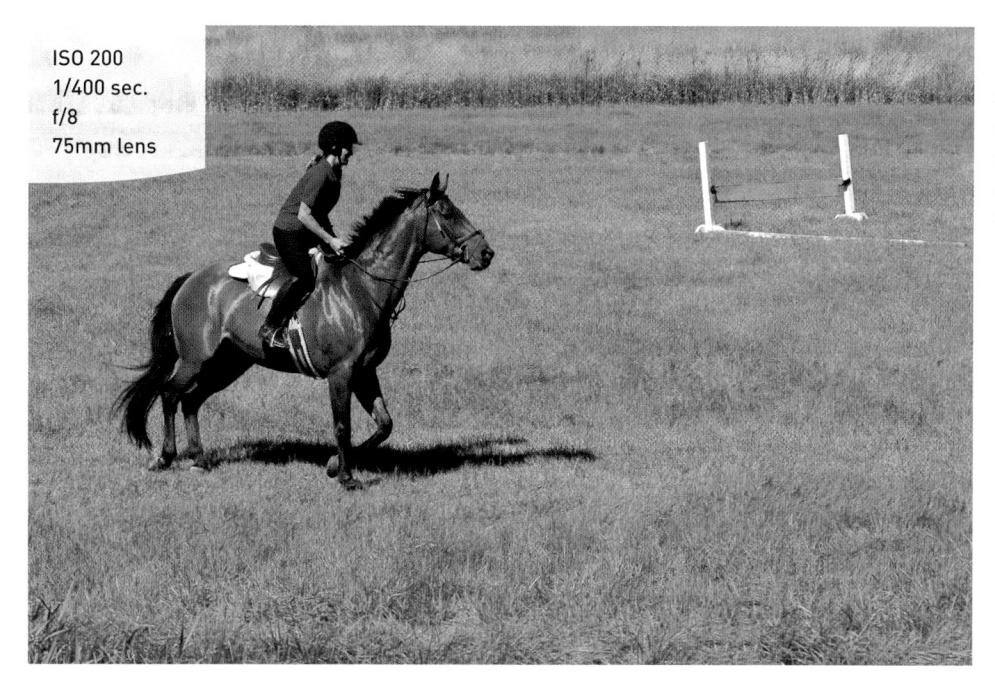

FIGURE 5.3
Because of the action's distance from the camera, a slower shutter speed could be used to capture it.

USING SHUTTER PRIORITY (S) MODE TO STOP MOTION

In Chapter 4, you were introduced to the professional shooting modes. You'll remember that the mode that gives you ultimate control over shutter speed is Shutter Priority, or S, mode, where you are responsible for selecting the shutter speed while handing over the aperture selection to the camera. The ability to concentrate on just one exposure factor helps you quickly make changes on the fly while staying glued to your viewfinder and your subject.

There are a couple of things to consider when using Shutter Priority mode, both of which have to do with the amount of light that is available when shooting. While you have control over which shutter speed you select in Shutter Priority mode, the range of shutter speeds that is available to you depends largely on how well your subject is lit.

When shooting fast-paced action, you will typically be working with very fast shutter speeds. This means that your lens will probably be set to its largest aperture. If the light is not sufficient for the shutter speed selected, you will need to do one of two things: select a lens that offers a larger working aperture, or raise the ISO of

the camera. Working off the assumption that you have only one lens available, let's concentrate on balancing your exposure using the ISO.

Let's say that you are shooting a soccer game at night, and you want to get some great action shots. You set your camera to Shutter Priority mode and, after testing out some shutter speeds, determine that you need to shoot at 1/500 of a second to freeze the action on the field. When you place the viewfinder to your eye and press the shutter button halfway, you notice that the f-stop is now flashing and the message "Subject is too dark" is displayed on the LCD screen. This is your camera's way of telling you that the lens has now reached its maximum aperture and you are going to be underexposed if you shoot your pictures at the currently selected shutter speed. You could slow your shutter speed down until the indicator goes away, but then you might get images with too much motion blur.

ZOOM IN TO BE SURE

When reviewing your shots on the LCD, don't be fooled by the display. The smaller your image is, the sharper it will look. To ensure that you are getting sharp, blur-free images, make sure that you zoom in on your LCD display.

To zoom in on your images, press the Playback button located at the top left on the rear of the camera and then press the Zoom In button to zoom (**Figure 5.4**). Continue pressing the Zoom In button to increase the zoom ratio.

To zoom back out, simply press the Zoom Out button (the magnifying glass with the minus sign on it) or press the Playback button again.

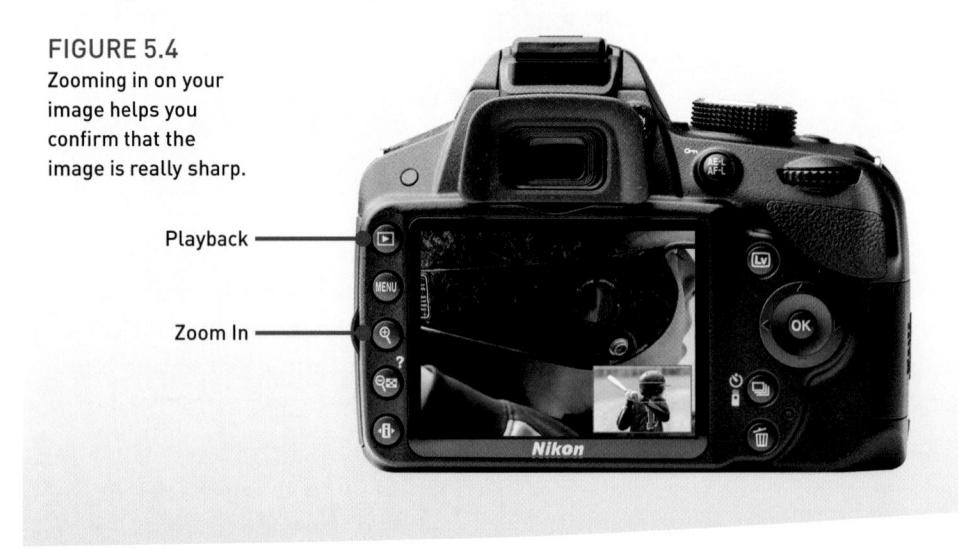

The alternative is to raise your ISO to a level that is high enough for a proper exposure. The key here is to always use the lowest ISO that you can get away with. That might mean ISO 200 in bright sunny conditions or ISO 6400 for an indoor or night situation (**Figure 5.5**). Just remember that the higher the ISO, the greater the amount of noise in your image. This is the reason that you see professional sports photographers using those mammoth lenses perched atop a monopod: They could use a smaller lens, but to get those very large apertures they need a huge piece of glass on the front of the lens. The larger the glass on the front of the lens, the more light it gathers and the larger the aperture for shooting. For the working pro, the large aperture translates into lower ISO (and thus lower noise), fast shutter speeds, and razor-sharp action.

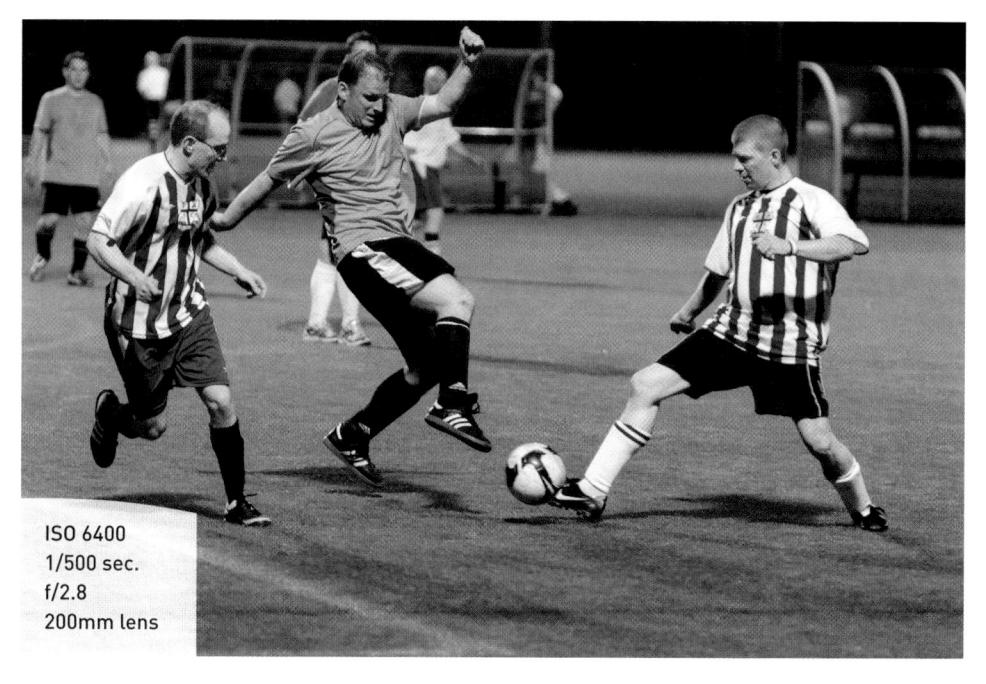

FIGURE 5.5 Sometimes the only way to stop action under the lights is to crank up your ISO.

ADJUSTING YOUR ISO ON THE FLY

- 1. Look at the exposure values (the shutter speed and aperture settings) in the lower portion of your viewfinder.
- 2. If the aperture is flashing, press the i button on the lower-left portion of the back of the camera (if the camera's info screen is not visible, press the Info button or i button).

- **3.** Press up or down on the Multi-selector button to highlight the ISO sensitivity option and then press OK (A).
- **4.** Press down on the Multi-selector to select a higher ISO setting, and press OK to lock in the change **(B)**.
- 5. If you now see that the aperture setting in the display is no longer flashing, shoot away. If you still see "Subject is too dark" on the LCD, repeat steps 2–4 until it is set correctly.

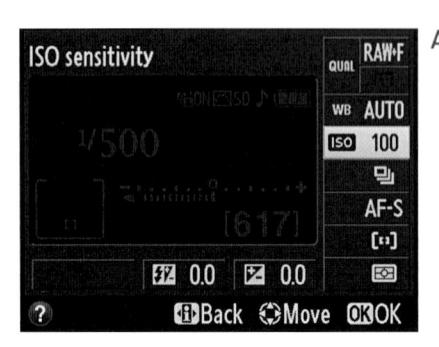

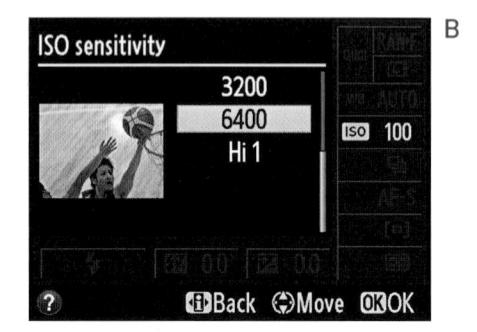

USING APERTURE PRIORITY (A) MODE TO ISOLATE YOUR SUBJECT

One of the benefits of working in Shutter Priority mode with fast shutter speeds is that, more often than not, you will be shooting with the largest aperture available on your lens. Shooting with a large aperture allows you to use faster shutter speeds, but it also narrows your depth of field.

To isolate your subject in order to focus your viewer's attention on it, a larger aperture is required. The larger aperture reduces the foreground and background sharpness: The larger the aperture, the more blurred they will be.

The reason that I bring this up here is that when you are shooting most sporting events, the idea is to isolate your main subject by having it in focus while the rest of the image has some amount of blur. This sharp focus draws your viewer right to the subject. Studies have shown that the eye is drawn to sharp areas before moving on to the blurry areas. Also, depending on what your subject matter is, there can be a tendency to get distracted by a busy background if everything in the photo is equally sharp. Without a narrow depth of field, it might be difficult for the viewer to establish exactly what the main subject is in your picture.

Let's look at how to use depth of field to bring focus to your subject. In the previous section, I told you that you should use Shutter Priority mode for getting those really fast shutter speeds to stop action. Generally speaking, Shutter Priority mode will be the mode you most often use for shooting sports and other action, but there will be times when you want to ensure that you are getting the narrowest depth of field possible in your image. The way to do this is by using Aperture Priority mode.

So how do you know when you should use Aperture Priority mode as opposed to Shutter Priority mode? It's not a simple answer, but your LCD screen can help you make this determination. The best scenario for using Aperture Priority mode is a brightly lit scene where maximum apertures will still give you plenty of shutter speed to stop the action.

Let's say that you are shooting a soccer game in the midday sun. If you have determined that you need something between 1/500 and 1/1250 of a second for stopping the action, you could just set your camera to a high shutter speed in Shutter Priority mode and start shooting. But you also want to be using an aperture of, say, f/4.5 to get that narrow depth of field. Here's the problem: If you set your camera to Shutter Priority mode and select 1/1000 of a second as a nice compromise, you might get that desired f/stop—but you might not. As the meter is trained on your moving subject, the light levels could rise or fall, which might actually change that desired f-stop to something higher like f/5.6 or even f/8. Now the depth of field is extended, and you will no longer get that nice isolation and separation that you wanted.

To rectify this, switch the camera to Aperture Priority mode and select f/4.5 as your aperture. Now, as you begin shooting, the camera holds that aperture and makes exposure adjustments with the shutter speed. As I said before, this works well when you have lots of light—enough light so that you can have a high-enough shutter speed without introducing motion blur.

USING AUTO ISO THE RIGHT WAY

You might recall earlier in the book where I said that Auto ISO is a bad thing and that it should be turned off. Well, there is an exception to that rule, thanks to the smart engineers at Nikon. They built a system into your camera that lets you define how you want the ISO to work by setting up parameters to keep things in check while making automatic adjustments for you. So here's the way it works.

While shooting your child's soccer game, let's say you determine that the minimum shutter speed you can work with and still freeze motion is 1/500 of a second. And let's say you want to use a large aperture to help blur the background. The problem

is that it's a partly cloudy day and the sun keeps moving in and out of the clouds, making it difficult to shoot with your desired settings without having to change the ISO, as discussed earlier. Instead of having to make changes to the ISO, you can turn on your ISO sensitivity settings, which allow you to shoot at your desired settings without having to manually adjust the ISO. It also lets you pick a ceiling for your ISO so that it doesn't get set so high that noise becomes an issue.

SETTING UP AUTO ISO SENSITIVITY

- 1. First, determine what minimum shutter speed you would like to use. You might want to take a couple of practice shots to figure this out.
- 2. Press the Menu button and then use the Multi-selector to get to the Shooting Menu.
- 3. Highlight the item called ISO sensitivity settings, and press the OK button (A).
- 4. The top item will be the ISO setting that you want to work with. You should set this to the lowest ISO possible for your situation. If you are working outdoors in daylight, you might set this to 100. Just highlight the top item and press OK. Select the desired ISO and press OK to go back to the previous screen. If you have already set an ISO using the info screen, that setting is the one that will be listed.
- 5. To turn on the Auto ISO feature, you need to move the cursor down to the next item, called Auto ISO sensitivity control, and turn it on by pressing the OK button. Highlight the word On and press OK once again (B).
- 6. Now that the feature is turned on, you will see a couple of items that are now available to change. The first is Maximum sensitivity. This setting lets you put a cap on just how high the ISO can go before maxing out. Try something like 800 or 1600 to start with (C).

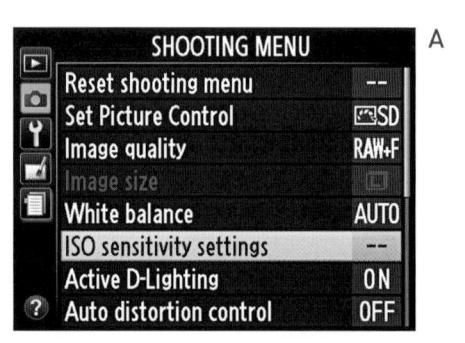

7. The second item is the Minimum shutter speed. This tells the camera the lower limits of shutter speed that you want to use before raising the camera ISO. If you determined that 1/500 of a second was the slowest you could shoot and still get good, sharp images, then set that as your minimum (D).

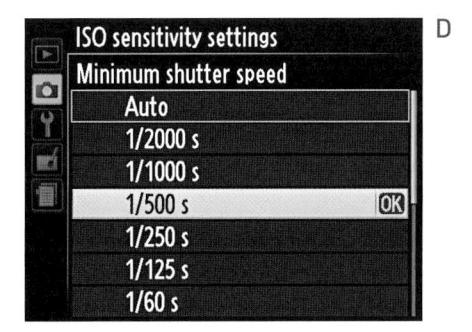

Once you have set these three items, you are now ready to start shooting. Just set the camera to A for Aperture Priority, dial in your desired aperture setting for the lens, and start shooting. The camera will now monitor your settings and make sure that the slowest your shutter speed gets is that 1/500 of a second that you selected. If the scene gets too dark for that, it will raise your ISO enough for you to keep shooting at that speed. The great thing is that it only raises it enough to get the shot, so it won't use whole stops when adjusting the ISO. Just don't forget to turn the Auto ISO Sensitivity feature off when you are done using it.

KEEP THEM IN FOCUS WITH CONTINUOUS-SERVO FOCUS AND AF FOCUS POINT SELECTION

With the exposure issue handled for the moment, let's move on to an area that is equally important: focusing. If you have browsed your manual, you know that there are several focus modes to choose from in the D3200. To get the greatest benefit from each of them, it is important to understand how they work and the situations where each mode will give you the best opportunity to grab a great shot. Because we are discussing subject movement, our first choice is going to be Continuous-servo AF mode (AF-C). AF-C mode uses all of the focus points in the camera to find a moving subject and then lock in the focus when the shutter button is completely depressed.

SELECTING AND SHOOTING IN CONTINUOUS-SERVO AF FOCUS MODE

- 1. Press the i button on the lower-left portion of the back of the camera (if the camera's info screen is not visible, press the Info button or i button).
- 2. Press up or down on the Multi-selector to highlight the Focus mode (A) and then press the OK button.

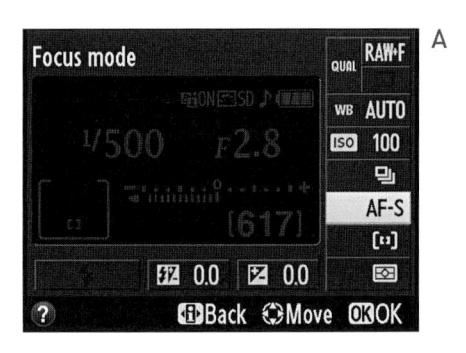

- Locate your subject in the viewfinder, then press and hold the shutter button halfway to activate the focus mechanism.
- 5. The camera will maintain the subject's focus as long as it remains within one of the focus points in the viewfinder or until you release the shutter button or take a picture.

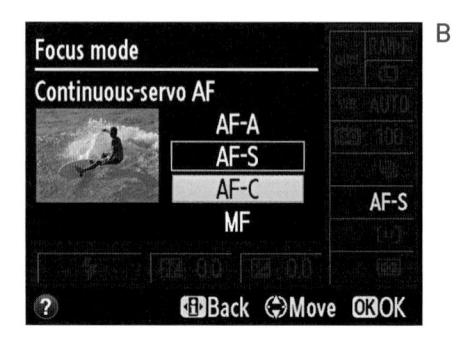

You should take note that holding down the shutter button for long periods of time will cause your battery to drain much faster because the camera will be constantly focusing on the subject.

When using the AF-C mode, you can set the AF-area mode to the Dynamic area, which uses a focus point of your choosing as the primary focus, but uses information from the surrounding points if your subject happens to move away from the point.

SETTING THE AF-AREA MODE TO DYNAMIC

- 1. To set the AF-area mode, press the i button on the lower-left portion of the back of the camera.
- 2. Press up or down on the Multi-selector to highlight the AF-area mode and then press the OK button (A).
- 3. Use the Multi-selector to choose the Dynamic AF mode and press OK (B).

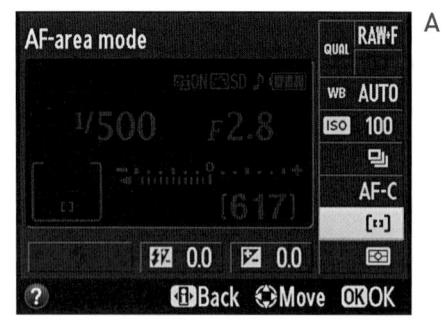

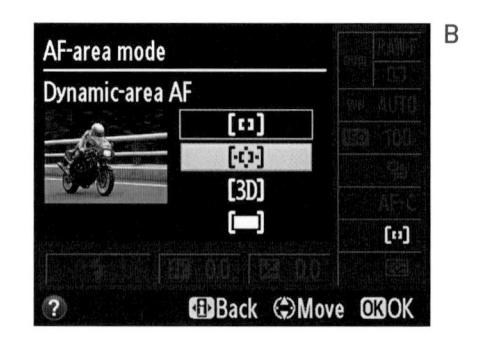

To select a focus point you want to use, simply move the Multi-selector up, down, left, or right until the desired point is highlighted in your viewfinder. Pressing the

OK button in the center of the Multi-selector will reset your focus point to the center position.

Note that the AF-area mode is used to select the method with which the camera will focus the lens. This is different from the Automatic Focus (AF) points, which are a cluster of small points that are visible in the viewfinder and are used to determine where you want the lens to focus (Figure 5.6).

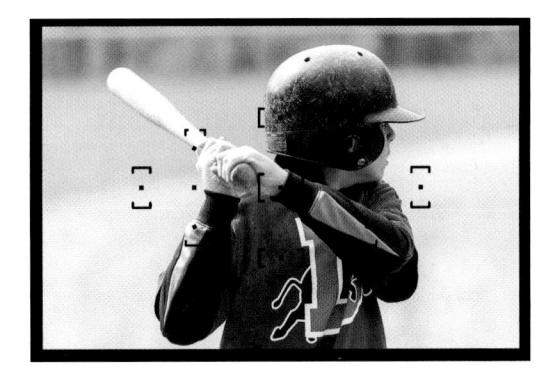

FIGURE 5.6
The Automatic Focus (AF) points are the 11 small boxes arranged in your viewfinder.

STOP AND GO WITH 3D-TRACKING AF

If you are going to be changing between a moving target and one that is still, you should consider using the 3D-tracking AF mode. This mode mixes both the AF-S and Dynamic modes for shooting a subject that goes from stationary to moving without having to adjust your focus mode.

When you have a stationary subject, simply place your selected focus point on your subject and the camera will focus on it. If your subject begins to move out of focus, the camera will track the movement, keeping a sharp focus.

For example, suppose you are shooting a football game. The quarterback has brought the team to the line and is standing behind the center, waiting for the ball to be hiked. If you are using the 3D-tracking AF mode, you can place your focus point on the quarterback and start taking pictures of him as he stands at the line. As soon as the ball is hiked and the action starts, the camera will switch to tracking mode and follow his movement within the frame. This can be a little tricky at first, but once you master it, it will make your action shooting effortless.

To select 3D-tracking, simply follow the same steps listed previously for selecting the Dynamic AF-area mode, but instead select the 3D-tracking mode. It is important to know that the 3D-tracking AF mode uses color and contrast to locate and then follow the subject, so this mode might be less effective when everything is similar in tone or color.

MANUAL FOCUS FOR ANTICIPATED ACTION

Although I utilize the automatic focus modes for the majority of my shooting, there are times when I like to fall back on manual focus. This is usually when I know when and where the action will occur and want to capture the subject as it crosses a certain plane of focus. This is useful in sports like motocross or auto racing, where the subjects are on a defined track and I know exactly where I want to capture the action. I could try tracking the subject, but sometimes the view can be obscured by a curve. By pre-focusing the camera, all I have to do is wait for the subject to approach my point of focus and then start firing the camera.

Take a look at **Figure 5.7**. If you want to get up close and personal shooting baseball, then I highly suggest attending a minor league baseball game. My friend Dave Cleaveland had a press pass to shoot the Portland Sea Dogs, and he was kind enough to invite me along. We spent most of the game just inside the home team dugout and had a blast. Unfortunately, the game was called due to fog (yeah, Portland, Maine, is a port town after all), but not before we got some awesome action shots. We were pretty close to first base, so with the falling light level and increasing fog I used the single-point focus method to focus on the exact spot that I wanted and then switched the lens to manual focus and waited for the play. As soon as the runner started moving I started firing in Continuous mode to try to nail the peak of action (he was safe). Many thanks to Dave and the Sea Dogs for a great night!

FIGURE 5.7
Pre-focus the
camera on a point
where you know the
subject will be, and
start shooting right
before they get
there.

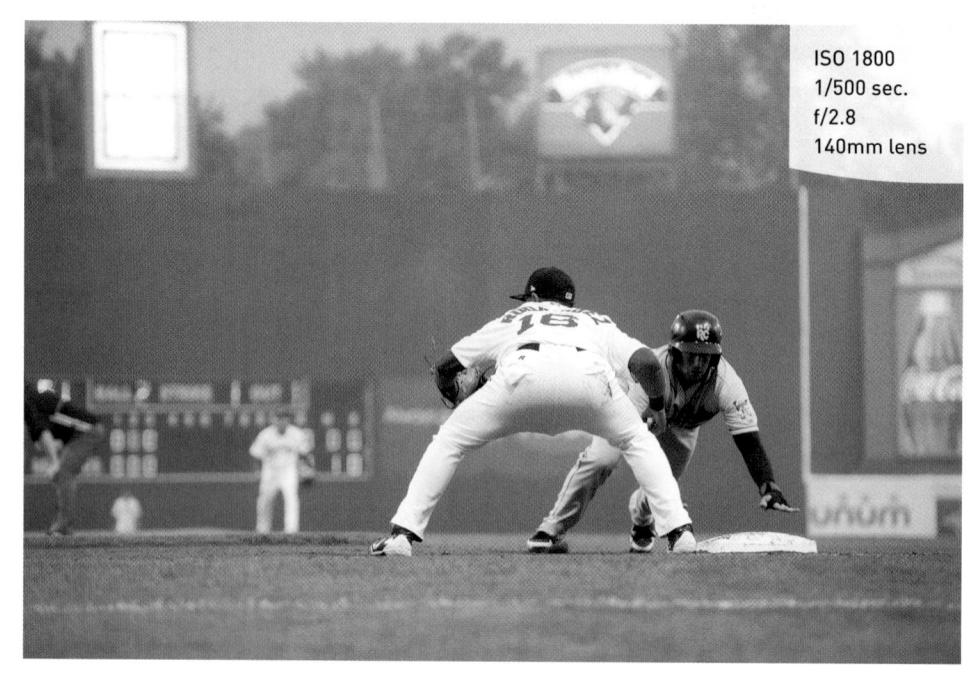

DRIVE MODES

The drive mode determines how fast your camera will take pictures. Single-frame mode is for taking one photograph at a time. With every full press of the shutter release button, the camera will take a single image. Continuous mode allows for a more rapid capture rate. Think of it like a machine gun. When you are using Continuous mode, the camera will continue to take pictures as long as the shutter release button is held down.

KEEPING UP WITH THE CONTINUOUS SHOOTING MODE

Getting great focus is one thing, but capturing the best moment on the sensor can be difficult if you are shooting just one frame at a time. In the world of sports, and in life in general, things move pretty fast. If you blink, you might miss it. The same can be said for shooting in Single-frame mode. Fortunately, your D3200 comes equipped with a Continuous—or "burst"—shooting mode that lets you capture a series of images at up to three frames a second (Figure 5.8).

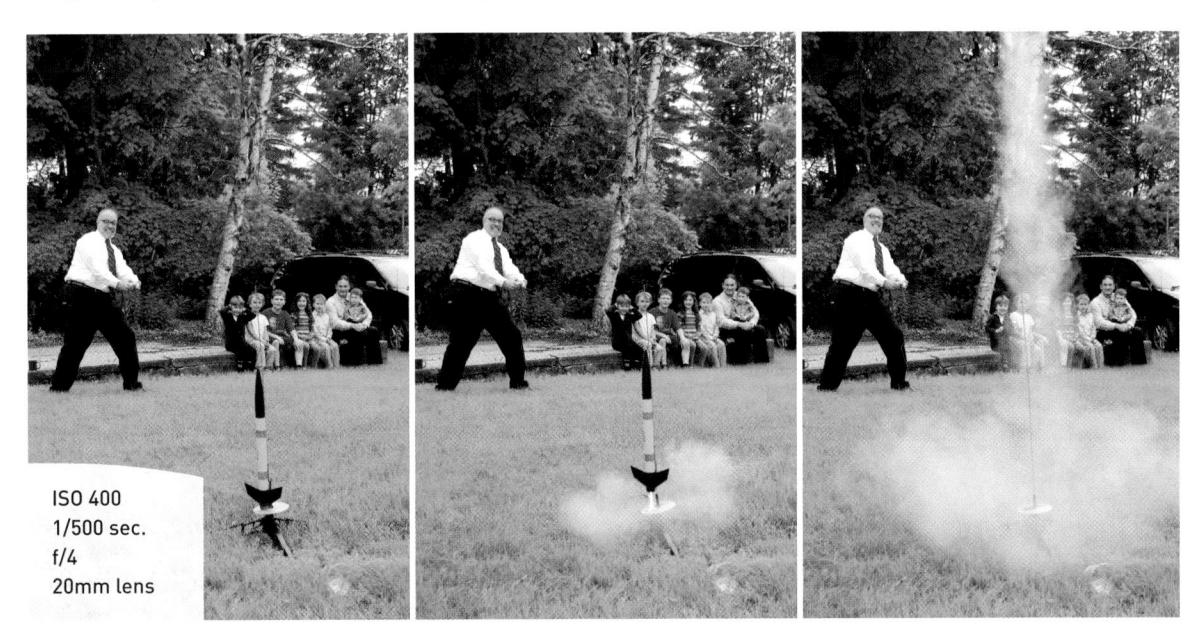

FIGURE 5.8
Using the Continuous shooting mode means that you are sure to capture the peak of the action.

Using the Continuous shooting mode causes the camera to keep taking images for as long as you hold down the shutter release button. In Single mode, you have to release the button and then press it again to take another picture.

SETTING UP AND SHOOTING IN THE CONTINUOUS SHOOTING MODE

The Release Mode button is located on the back of the camera, just to the right of the LCD screen. To select Continuous mode, push the Release Mode button to jump right to the Release Mode menu screen, highlight Continuous, and press OK.

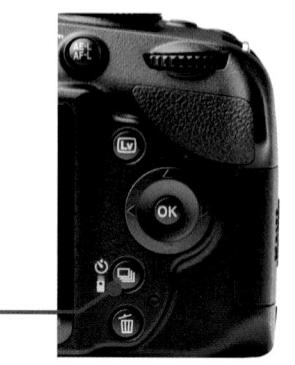

Release Mode Button -

Your camera has an internal memory, called a "buffer," where images are stored while they are being processed prior to being moved to your memory card. If the buffer fills up (this is more likely when you are shooting in the RAW format), the camera will stop shooting until space is made for new images. The camera readout in the viewfinder tells you how many frames you have available in burst mode. Just look in the viewfinder at the bottom right to see the maximum number of images for burst shooting. As you shoot, the number will go down and then back up as the images are written to the memory card.

A SENSE OF MOTION

Shooting action isn't always about freezing the action. There are times when you want to convey a sense of motion so that the viewer can get a feel for the movement and flow of an event. Two techniques you can use to achieve this effect are panning and motion blur.

PANNING

Panning has been used for decades to capture the speed of a moving object as it moves across the frame. It doesn't work well for subjects that are moving toward or away from you. Panning is achieved by following your subject across your frame, moving your camera along with the subject, and using a slower-than-normal shutter speed so that the background (and sometimes even a bit of the subject) has a sideways blur but the main portion of your subject is sharp and blur-free. The key to a

great panning shot is selecting the right shutter speed: Too fast and you won't get the desired blurring of the background; too slow and the subject will have too much blur and will not be recognizable. Practice the technique until you can achieve a smooth motion with your camera that follows along with your subject. The other thing to remember when panning is to follow through even after the shutter has closed. This will keep the motion smooth and give you better images.

In **Figure 5.9**, I used the panning technique to follow this plane as it began to lift off the ground. I set the camera to the Continuous shooting mode, and I used Shutter Priority mode to select a shutter speed of 1/40 of a second while the focus mode was on Dynamic. Even though my aperture was f/10, I knew that the panning motion would blur my background.

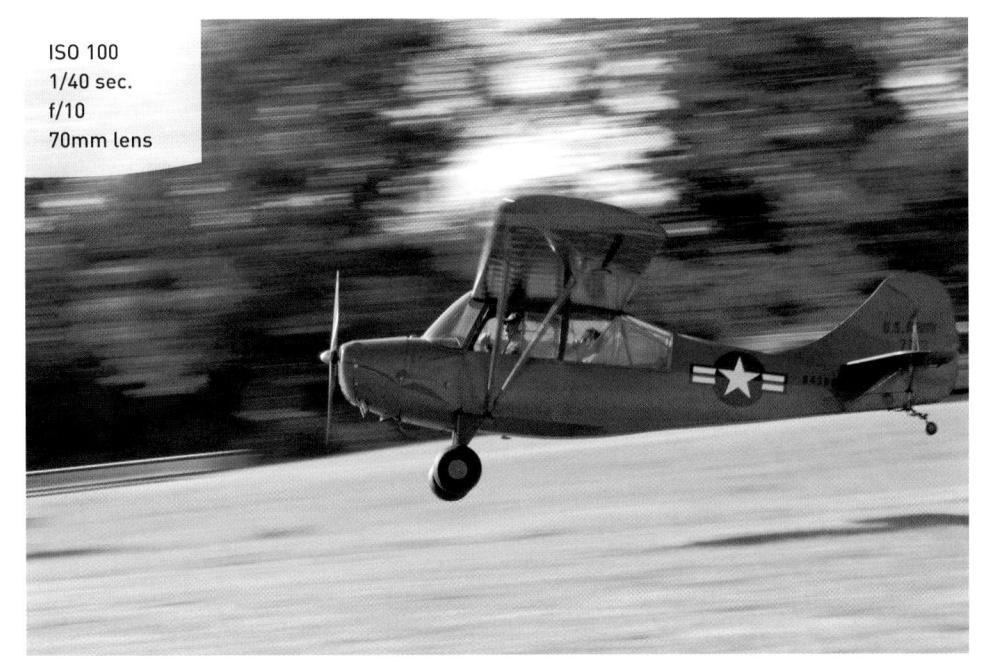

FIGURE 5.9
Following the subject as it moves across the field of view allows for a slower shutter speed and adds a sense of motion.

MOTION BLUR

Another way to let the viewer in on the feel of the action is to simply include some blur in the image. This isn't accidental blur from choosing the wrong shutter speed; this blur is more exaggerated, and it tells a story. In **Figure 5.10**, I was watching my son go around the racetrack. I took many shots with a nice fast shutter speed and froze him in his tracks, but I also decided to slow down the shutter speed and let the motion tell part of the story too.

FIGURE 5.10
The movement
of the go-karts
coupled with the
slow shutter speed
conveys a sense of
action in the shot.

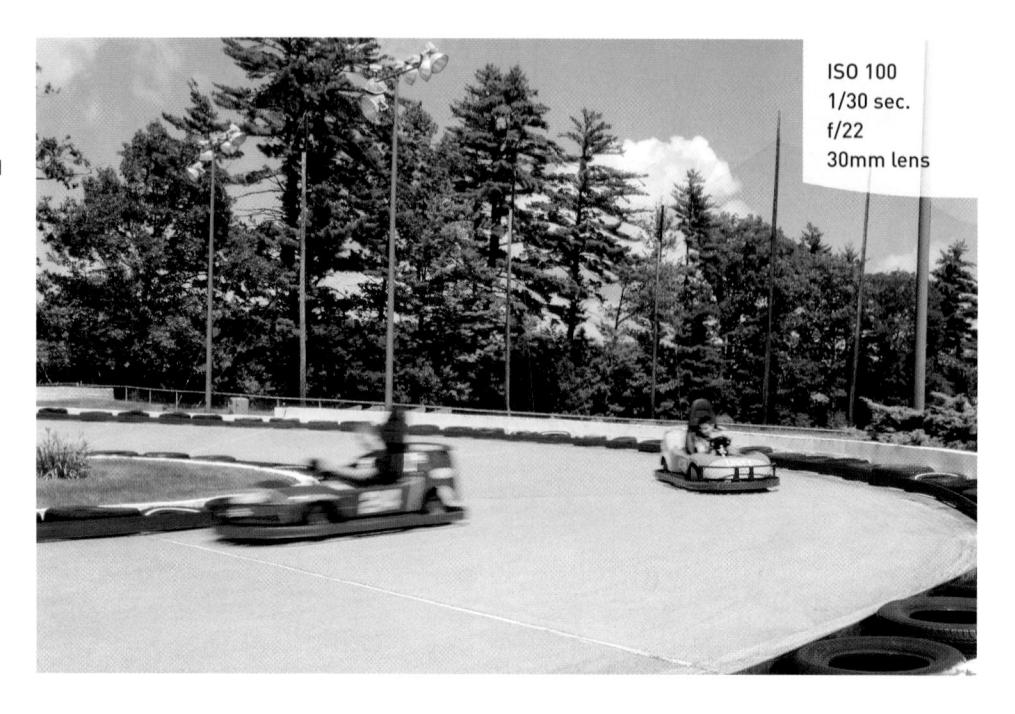

Just as in panning, there is no preordained shutter speed to use for this effect. It is simply a matter of trial and error until you have a look that conveys the action. I try to get some area of the subject that is frozen. The key to this technique is the correct shutter speed combined with keeping the camera still during the exposure. You are trying to capture the motion of the subject, not the photographer or the camera, so use a good shooting stance or even a tripod.

TIPS FOR SHOOTING ACTION

GIVE THEM SOMEWHERE TO GO

Whether you are shooting something as simple as your child's soccer match or as complex as the aerial acrobatics of a motorcycle jumper, where you place the subject in the frame is equally as important as how well you expose the image. A poorly composed shot can completely ruin a great moment by not holding the viewer's attention.

The one mistake I see many times in action photography is that the photographer doesn't use the frame properly. If you are dealing with a subject that is moving horizontally across your field of view, give the subject somewhere to go by placing them to the side of the frame, with their motion leading toward the middle of the frame (Figure 5.11). This offsetting of the subject will introduce a sense of direction and anticipation for the viewer. Unless you are going to completely fill the image with the action, try to avoid placing your subject in the middle of the frame.

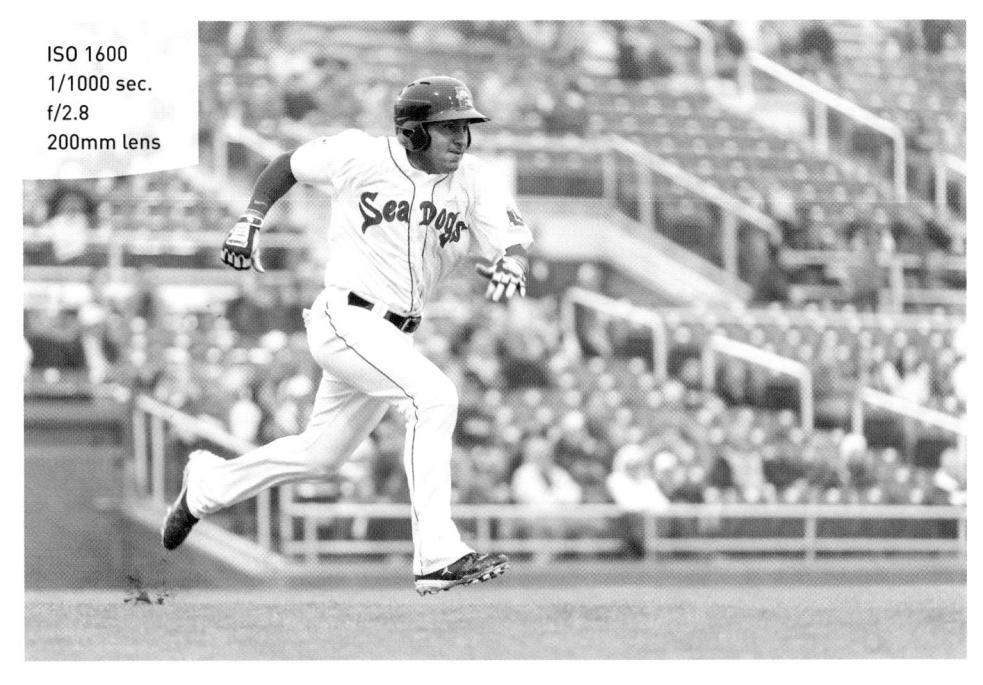

FIGURE 5.11
Try to leave space in front of your subject to lead the action in a direction.

GET IN FRONT OF THE ACTION

Here's another one. When shooting action, show the action coming toward you (Figure 5.12). Don't shoot the action going away from you. People want to see faces. Faces convey the action, the drive, the sense of urgency, and the emotion of the moment. So if you are shooting action involving people, always position yourself so that the action is either coming at you or is at least perpendicular to your position.

FIGURE 5.12 Try to position yourself so that the action is coming at you face-first.

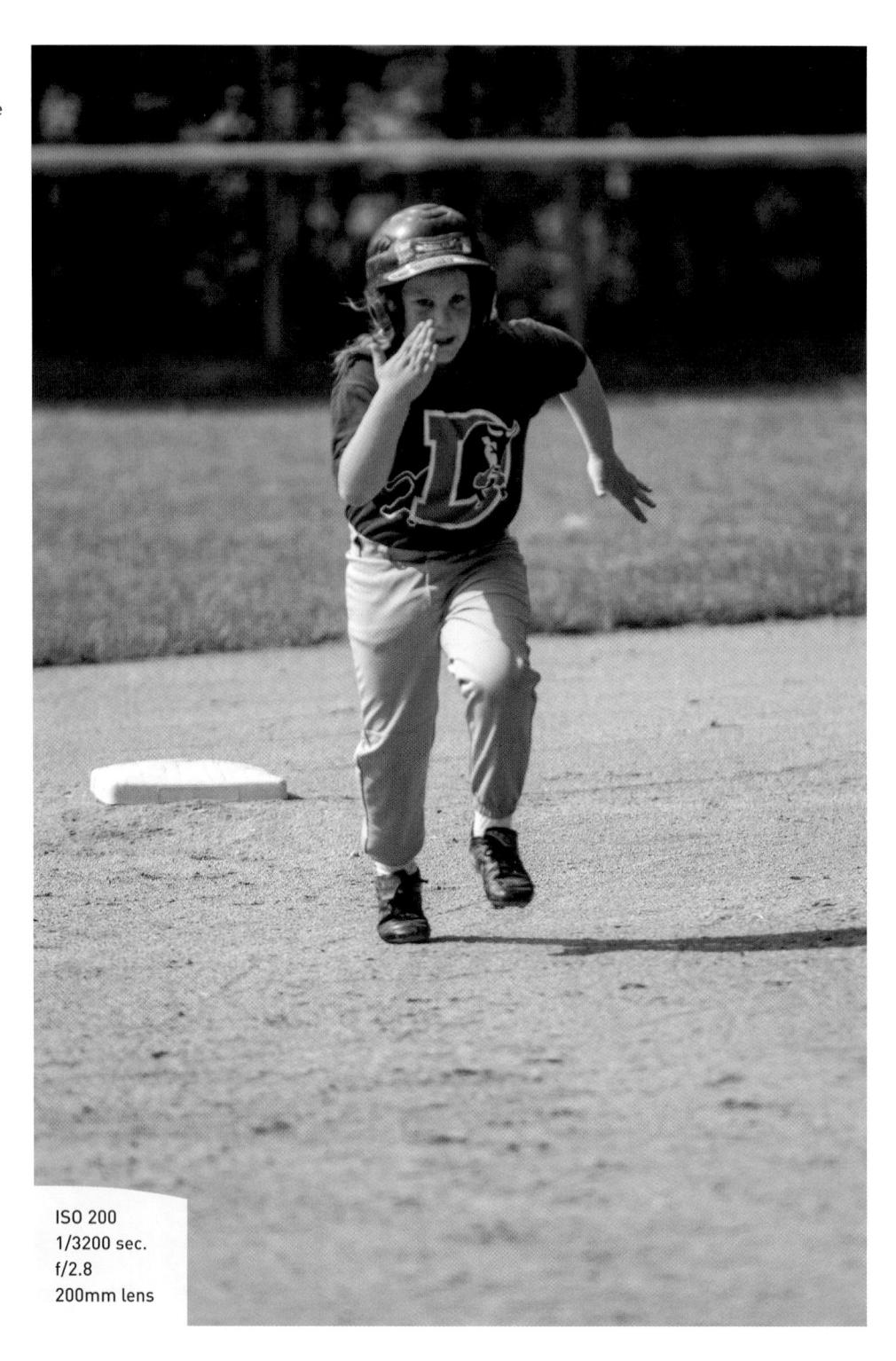

SHOOT IN MANUAL MODE TO LOCK IN YOUR EXPOSURE

Aperture Priority and Shutter Priority modes are great, but sometimes it pays to just do things yourself. If you find yourself shooting in an environment where the action is moving across backgrounds that will play havoc with your meter readings, you might just do better by setting up your shot in Manual mode.

While waiting for my friend Avery to accept his diploma, I found that my meter readings were changing a lot because of the boys' dark-colored gowns next to the white gowns worn by the girls. The light in the gymnasium was pretty awful, but it was consistent, so after doing some trial and error in Manual mode I settled on a combination of settings that would freeze the action as he walked toward the camera and would give the sensor enough light to properly expose his face (Figure 5.13). I did have to crank the ISO pretty high, but in a situation like this it was better to have a noisy capture of the right moment than to miss it completely.

FIGURE 5.13 Sometimes it pays to shoot in Manual mode.

Chapter 5 Assignments

The mechanics of motion

For this first assignment, you need to find some action. Explore the relationship between the speed of an object and its direction of travel. Use the same shutter speed to record your subject moving toward you and across your view. Try using the same shutter speed for both to compare the difference made by the direction of travel.

Getting a feel for focusing modes

We discussed two different ways to autofocus for action: Dynamic and 3D-tracking. Starting with Dynamic mode, find a moving subject and get familiar with the way the mode works. Now repeat the process using the 3D-tracking AF mode. The point of the exercise is to become familiar enough with the two modes to decide which to use for the situation you are photographing.

Anticipating the spot using manual focus

For this assignment, you will need to find a subject that you know will cross a specific line that you can pre-focus on. A street with moderate traffic works well for this. Focus on a spot on the street that the cars will travel across (don't forget to set your lens for manual focus). To do this right, you need to set the drive mode on the camera to Continuous. Now, when a car approaches the spot, start shooting. Try shooting in three- or four-frame bursts.

Following the action

Panning is a great way to show motion. To begin, find a subject that will move across your path at a steady speed, and practice following it in your viewfinder from side to side. Now, with the camera in Shutter Priority mode, set your shutter speed to 1/30 of a second and the focus mode to Dynamic. Now pan along with the subject and shoot as it moves across your view. Experiment with different shutter speeds and focal lengths. Panning is one of those skills that takes some time to get a feel for, so try it with different types of subjects moving at different speeds.

Share your results with the book's Flickr group!

Join the group here: flickr.com/groups/nikond3200_fromsnapshotstogreatshots

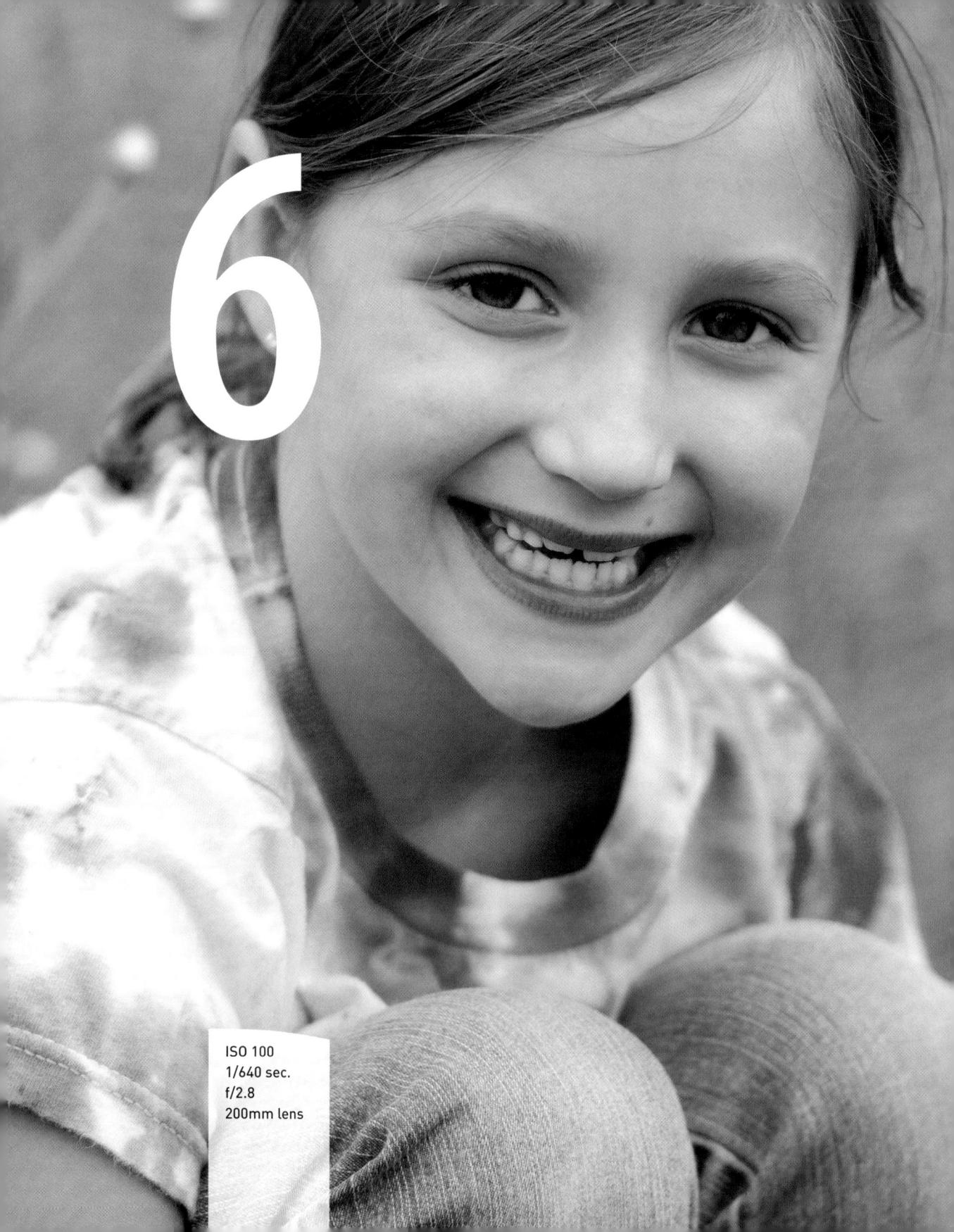

Say Cheese!

SETTINGS AND FEATURES TO MAKE GREAT PORTRAITS

Taking pictures of people is one of the great joys of photography. You will experience a great sense of accomplishment when you capture the spirit and personality of someone in a photograph. At the same time, you have a great responsibility because the person in front of the camera is depending on you to make them look good. You can't always change how someone looks, but you can control the way you photograph that individual. In this chapter, we will explore some camera features and techniques that can help you create great portraits.

PORING OVER THE PICTURE

Last year, one of my friends asked if I would take a photo of her awesome kids for their Christmas card. She really planned ahead by asking me in October. Oddly enough, we had a freak snowstorm on Halloween, so we bundled the kids up first thing that morning (despite being without power) and had a quick photo op with a genuine snowy backdrop. The background of your photo can sometimes be just as important as the subject, so always pay attention to what is going on behind the person you are photographing.

I intentionally left a lot of open space to show the background and leave room for any text they wanted to add to the card.

A large aperture helped blur the background.

ISO 200 1/500 sec. f/2.8 200mm lens

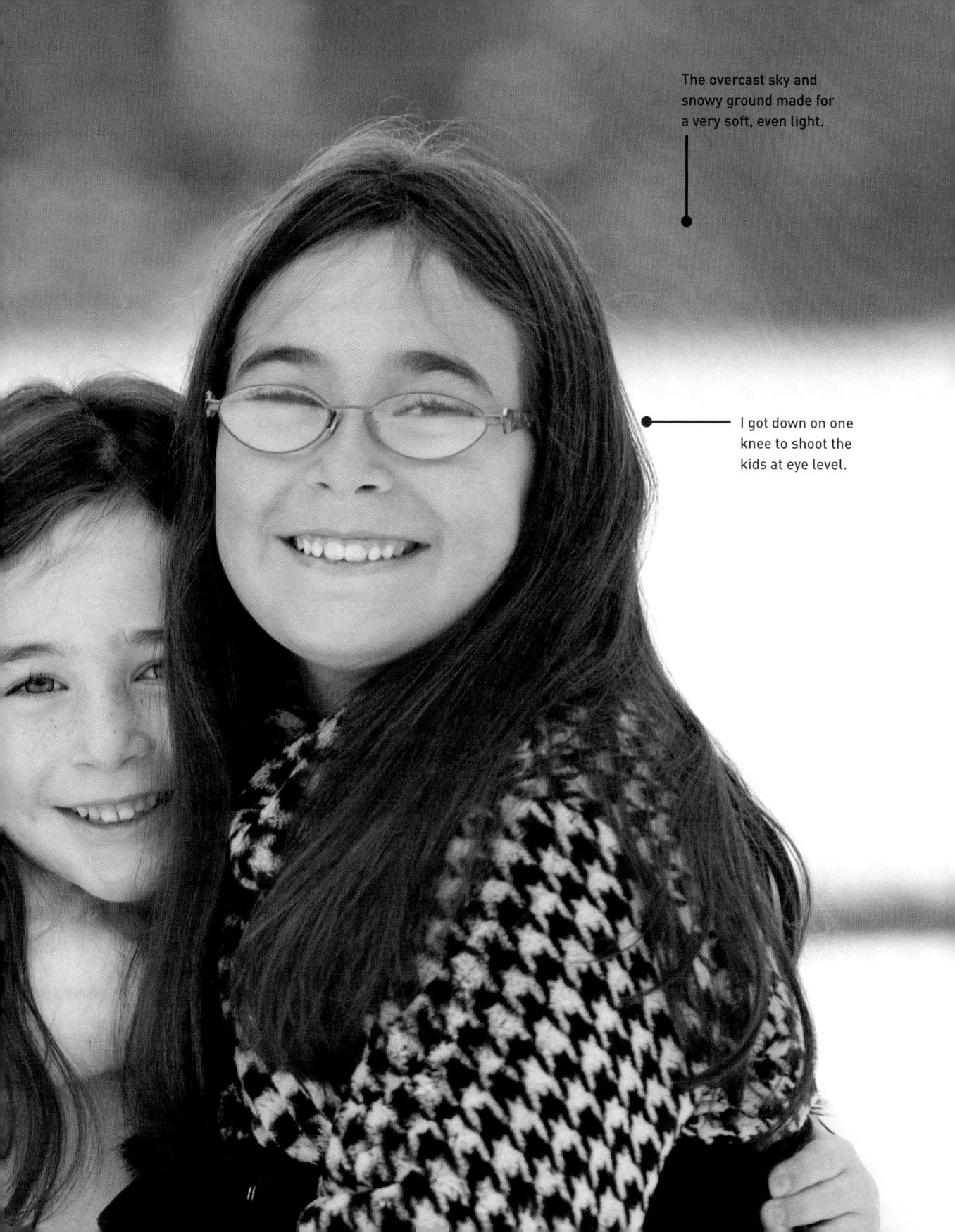

AUTOMATIC PORTRAIT MODE

In Chapter 3, we reviewed all of the automatic scene modes. One of them, Portrait, is dedicated to shooting portraits. While this is not my preferred camera setting, it is a great jumping-off point for those who are just starting out. The key to using this mode is to understand what is going on with the camera so that when you venture further into portrait photography, you can expand on the settings and get the most from your camera and, more importantly, your subject.

Whether you are photographing an individual or a group, the emphasis should always be on the subject. Portrait mode utilizes a larger aperture setting to keep the depth of field very narrow, which means that the background will appear slightly blurred or out of focus. To take full advantage of this effect, use a medium- to telephoto-length lens. Also, keep a pretty close distance to your subject. If you shoot from too far away, the narrow depth of field will not be as effective.

USING APERTURE PRIORITY MODE

If you took a poll of portrait photographers to see which shooting mode was most often used for portraits, the answer would certainly be Aperture Priority (A) mode. Selecting the right aperture is important for placing the most critically sharp area of the photo on your subject, while simultaneously blurring all of the distracting background clutter (Figure 6.1). Not only will a large aperture give the narrowest depth of field, it will also allow you to shoot in lower light levels at lower ISO settings.

This isn't to say that you have to use the largest aperture on your lens. A good place to begin is f/5.6. This will give you enough depth of field to keep the entire face in focus, while providing enough blur to eliminate distractions in the background. This isn't a hard-and-fast setting; it's just a good, all-around number to start with. Your aperture might change depending on the focal length of the lens you are using and on the amount of blur that you want for your foreground and background elements.

FIGURE 6.1 Using a large aperture, especially with a longer lens, blurs distracting background details.

GO WIDE FOR ENVIRONMENTAL PORTRAITS

There will be times when your subject's environment is of great significance to the story you want to tell. This might mean using a smaller aperture to get more detail in the background or foreground. Once again, by using Aperture Priority mode, you can set your aperture to a higher f-stop, such as f/8 or f/11, and include the important details of the scene that surrounds your subject.

Using a wider-than-normal lens can also assist in getting more depth of field as well as showing the surrounding area. A wide-angle lens requires less stopping down of the aperture (making the aperture smaller) to achieve an acceptable depth of field. This is because wide-angle lenses cover a greater area, so the depth of field appears to cover a greater percentage of the scene.

A wider lens might also be necessary to relay more information about the scenery (Figure 6.2). Select a lens length that is wide enough to tell the story but not so wide that you distort the subject. There's little in the world of portraiture quite as unflattering as giving someone a big, distorted nose (unless you are going for that sort of look). When shooting a portrait with a wide-angle lens, keep the subject away from the edge of the frame. This will reduce the distortion, especially in very wide focal lengths. As the lens length increases, distortion will be reduced. I generally don't like to go wider than about 24mm for portraits.

FIGURE 6.2

A wide-angle lens allows you to capture more of the environment in the scene without having to increase the distance between you and the subject.

METERING MODES FOR PORTRAITS

For most portrait situations, the Matrix metering mode is ideal. (For more on how metering works, see the "Metering Basics" sidebar.) This mode measures light values from all portions of the viewfinder and then establishes a proper exposure for the scene. The only problem that you might encounter when using this metering mode is when you have very light or very dark backgrounds in your portrait shots.

METERING BASICS

There are multiple metering modes in your camera, but the way they work is very similar. A light meter measures the amount of light being reflected off your subject and then renders a suggested exposure value based on the brightness of the subject and the ISO setting of the sensor. To establish this value, the meter averages all of the brightness values to come up with a middle tone, sometimes referred to as 18 percent gray. The exposure value is then rendered based on this middle gray value. This means that a white wall would be underexposed and a black wall would be overexposed in an effort to make each one appear gray. To assist with special lighting situations, the D3200 has three metering modes: Matrix (Figure 6.3), which uses the entire frame; Spot (Figure 6.4), which takes specific readings from small areas (often used with a gray card); and Center-weighted (Figure 6.5), which looks at the entire frame but places most of the exposure emphasis on the center of the frame.

FIGURE 6.3
The Matrix metering mode uses the entire frame.

FIGURE 6.4
The Spot metering
mode uses a very small
area of the frame.

FIGURE 6.5
The Center-weighted metering mode looks at the entire frame but emphasizes the center of it.

In these instances, the meter might be fooled into using the wrong exposure information because it will be trying to lighten or darken the entire scene based on the prominence of dark or light areas (**Figure 6.6**). You can deal with this in one of two ways. You can use the Exposure Compensation feature, which we cover in Chapter 7, to dial in adjustments for over- and underexposure. Or you can change the metering mode to Center-weighted metering. The Center-weighted metering mode concentrates on the center area of the viewfinder (about 9 percent) to get its exposure

information. This is the best way to achieve proper exposure for most portraits; metering off skin tones, averaged with hair and clothing, will often give a more accurate exposure (**Figure 6.7**). This metering mode is also great to use when the subject is strongly backlit.

FIGURE 6.6
The bright background fooled the
meter into choosing
a slightly underexposed setting for
the photo.

FIGURE 6.7
When I switched to the Center-weighted metering mode, my camera was able to ignore much of the background and add a little more time to the exposure.

SETTING YOUR METERING MODE TO CENTER-WEIGHTED METERING

- 1. Press the i button to activate the cursor in the information screen.
- 2. Use the Multi-selector to move the cursor to the Metering icon, and press the OK button (A).
- 3. Select the Center-weighted icon, and press the OK button to lock in the change (B).

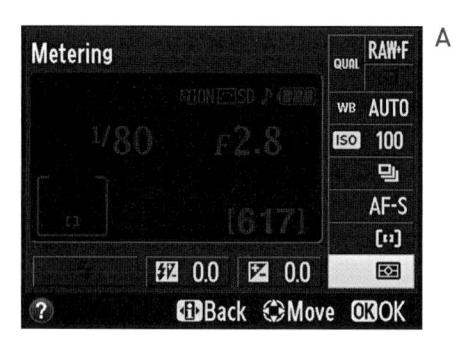

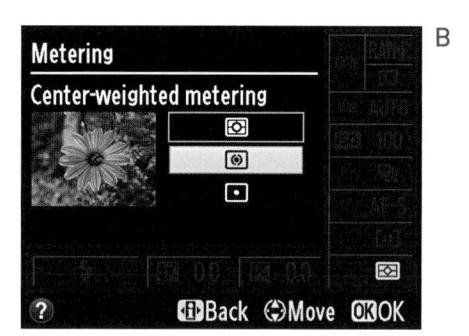

USING THE AE-L (AUTO EXPOSURE LOCK) FEATURE

There will often be times when your subject is not in the center of the frame but you still want to use the Center-weighted metering mode. So how can you get an accurate reading if the subject isn't in the center? Try using the AE-L (Auto Exposure Lock) feature to hold the exposure setting while you recompose.

AE Lock lets you use the exposure setting from any portion of the scene that you think is appropriate, and then lock that setting in regardless of how the scene looks when you recompose. An example of this would be when you're shooting a photograph of someone and a large amount of blue sky appears in the picture. Normally, the meter might be fooled by all that bright sky and try to reduce

Manual Callout

There is a way to lock in your AE-L reading so that you can continue shooting without having to hold in the AE-L button. This involves changing the button function in the Buttons section of the Setup Menu, but I prefer to leave this feature turned off because I would, more often than not, forget that it is on and end up using the wrong metering for a new subject. If you want to learn more about this feature, check out pages 61 and 143 of the PDF manual.

the exposure. Using AE Lock, you can establish the correct metering by zooming in on the subject (or even pointing the camera toward the ground), taking the meter reading and locking it in with AE-L feature, and then recomposing and taking your photo with the locked-in exposure.

SHOOTING WITH THE AE LOCK FEATURE

- 1. Find the AE Lock button on the back of the camera and place your thumb on it.
- 2. While looking through the viewfinder, place the focus point on your subject, press the shutter release button halfway to get a meter reading, and focus the camera.
- 3. Press and hold the AE Lock button to lock in the meter reading. You should see the AE-L indicator in the viewfinder.
- 4. While holding in the AE-L button, recompose your shot and take the photo.
- 5. To take more than one photo without having to take another meter reading, just hold down the AE Lock button until you are done using the meter setting.

FOCUSING: THE EYES HAVE IT

It has been said that the eyes are the windows to the soul, and nothing could be truer when you are taking a photograph of someone (**Figure 6.8**). You could have the perfect composition and exposure, but if the eyes aren't sharp the entire image suffers. While there are many different focusing modes to choose from on your D3200, for portrait work you can't beat AF-S (Single-Servo AF) mode using a single focusing point. AF-S focusing will establish a single focus for the lens and then hold it until you take the photograph; the other focusing modes continue focusing until the photograph is taken. The single-point selection lets you place the focusing point right on your subject's eye and set that spot as the critical focus spot. Using AF-S mode lets you get that focus and recompose all in one motion.

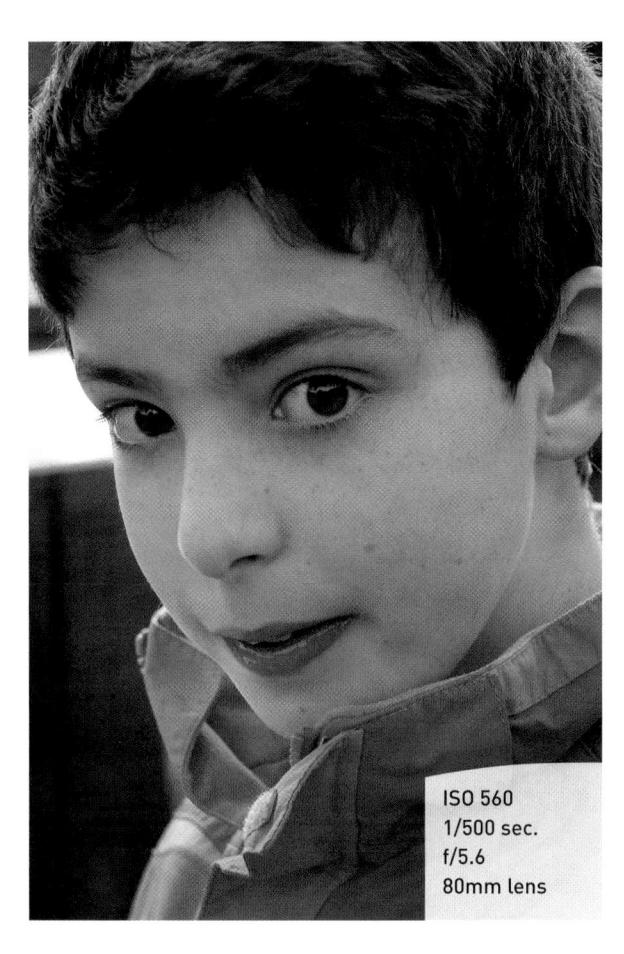

FIGURE 6.8 When photographing people, you should almost always place the emphasis on the eyes.

SETTING UP FOR AF-S FOCUS MODE

- 1. Press the i button to activate the cursor in the information screen.
- 2. Use the Multi-selector to move the cursor to the Focus mode icon, and press the OK button (A).
- 3. Select the AF-S setting and then press the OK button (B).

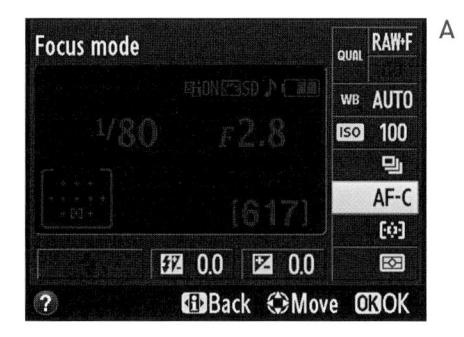

SETTING YOUR FOCUS TO A SINGLE POINT

- 1. Press the i button to activate the cursor in the information screen.
- 2. Use the Multi-selector to move the cursor to the AF-area mode icon, and press the OK button (A).
- 3. Select the Single-point AF icon and press the OK button (B).
- 4. When you are back in shooting mode, use the Multi-selector to move the focus point to one of the eleven available positions. This is visible while looking through the viewfinder but also on the information screen.

Now, to shoot using this focus point, place that point on your subject's eye and press the shutter button halfway until you hear the chirp. While still holding the shutter button down halfway, recompose if necessary and take your shot.

I typically use the center point for focus selection. I find it easier to place that point directly on the location where my critical focus should be established and then recompose the shot. Even though the single point can be selected from any of the focus points, it typically takes me longer to figure out where those points should be in relation to my subject. By using the center point, I can quickly establish focus and get on with my shooting.

CLASSIC BLACK AND WHITE PORTRAITS

There is something timeless about a black and white portrait. It eliminates the distraction of color and puts all the emphasis on the subject. To get great black and whites without having to resort to any image-processing software, set your picture control to Monochrome (Figure 6.9). You should know that the picture controls are automatically applied when shooting with the JPEG file format. If you are shooting in RAW, the picture that shows up on your rear LCD display will look black and white, but it will appear as a color image when you open it in non-Nikon RAW processing software (like Adobe Photoshop Lightroom or Apple Aperture). This is because the nature of RAW data is that the camera hasn't processed it. If using Nikon's ViewNX 2 or Capture NX 2 software, you'll see the assigned picture control when you first open the photo, and you can use the software to apply it or any other picture control to your RAW photo.

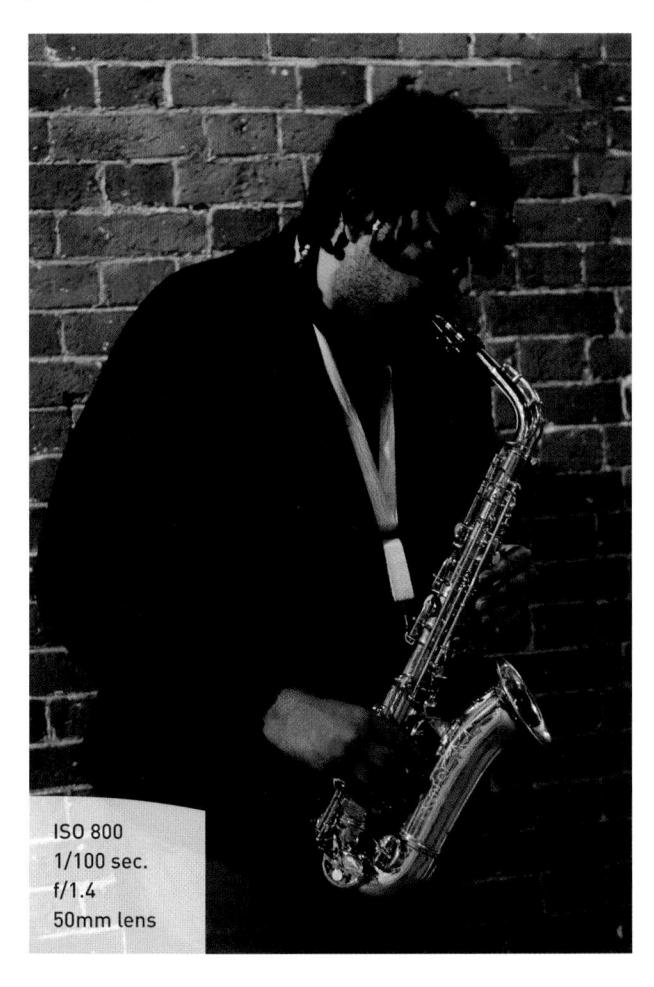

FIGURE 6.9
Getting black and white
portraits can be as simple
as setting the picture
control to Monochrome.

The real key to using the Monochrome picture control is to customize it for your portrait subject. The control can be changed to alter the sharpness and contrast. For women, children, puppies, and anyone else who should look somewhat soft, set the Sharpness setting to 0 or 1. For old cowboys, longshoremen, and anyone else who you want to look really detailed, try a setting of 6 or 7. I typically like to leave Contrast at a setting of around -1 or -2. This gives me a nice range of tones throughout the image.

The other adjustment that you should try is to change the picture control's Filter effect from None to one of the four available settings (Yellow, Orange, Red, and Green). Using the filters will have the effect of either lightening or darkening the skin tones. The Red and Yellow filters usually lighten skin, while the Green filter can make skin appear a bit darker. Experiment to see which one works best for your subject.

SETTING YOUR PICTURE CONTROL TO MONOCHROME

- 1. Press the Menu button, use the Multi-selector to move the cursor to the Set Picture Control icon in the Shooting Menu, and press the OK button (A).
- 2. Select the Monochrome setting, then press the OK button (B).

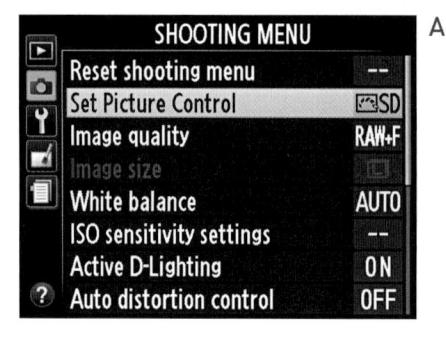

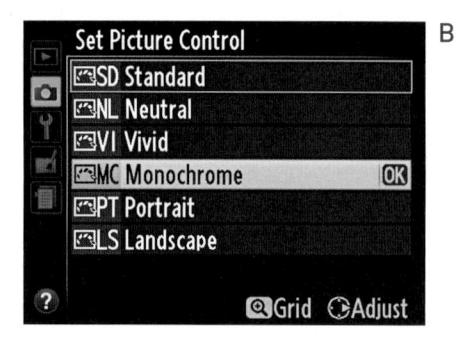

CUSTOMIZING YOUR MONOCHROME PICTURE CONTROL

 Follow the previous steps to get to the Set Picture Control menu and highlight Monochrome, but instead of pressing the OK button, press the Multi-Selector to the right to enter the customization menu (C).

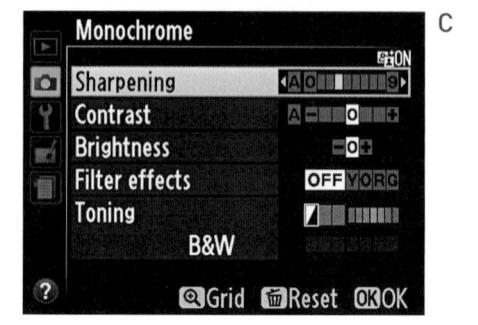

2. Press the OK button to save your changes. When you return to the Picture Control menu, you will now see a small star next to the MC. This is your clue that you have altered the default settings for that particular control.

THE PORTRAIT PICTURE CONTROL FOR BETTER SKIN TONES

As long as we are talking about picture controls for portraits, there is another control on your D3200 that has been tuned specifically for this type of shooting. Cleverly enough, it's called Portrait. To set this control on your camera, simply follow the same directions as earlier, except this time select the Portrait control (PT) instead of Monochrome. There are also individual options for the Portrait control that, like the Monochrome control, include sharpness and contrast. You can also change the saturation (how intense the colors will be) and hue, which lets you change the skin tones from more reddish to more yellowish. I prefer brighter colors, so I like to boost the Saturation setting to +2 and leave everything else at the defaults. You won't be able to use the same adjustments for everyone, especially when it comes to color tone, so do some experimenting to see what works best.

DETECT FACES WITH LIVE VIEW

Face detection in digital cameras has been around for a few years, but it's still a new concept in the world of the DSLR. Your D3200 has four different autofocus

modes for Live View: Wide area, Normal area, Subject Tracking, and my personal favorite, Face Priority. These modes are different from the standard modes like AF-S, AF-C, and AF-A. Face Priority mode is probably the slowest of the Live View focusing modes, so I use it mostly when I am working with a tripod or when my subjects are going to remain fairly still. When you turn on Live View with Face Priority focusing, the camera does an amazing thing: It zeroes in on any face appearing on the LCD and places a box around it (Figure 6.10). I'm not sure how it works—it just does.

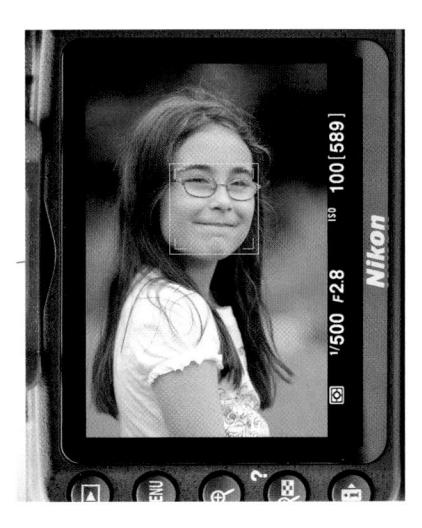

FIGURE 6.10 The Live View Face Priority mode can lock in on your subject's face for easy focusing.

If there is more than one face in the frame, a box will appear over each of them, but it will only use one to focus. The box that has the small corners outlined inside is the one the camera is currently using for focus (this is usually on the face that is closest to the camera).

SETTING UP AND SHOOTING WITH LIVE VIEW AND FACE PRIORITY FOCUSING

- 1. Put the camera in Live View mode by using the Live View button on the back of the camera.
- 2. Press the i button, move the cursor to the AF-area mode icon, and then press the OK button (A).
- 3. Use the Multi-selector to select Face-priority AF, then press the OK button (B).
- **4.** Press the **i** button to go back to Live View mode.
- Point your camera at a person, and watch as the frame appears over the face in the LCD.
- **6.** Depress and hold the shutter release button halfway to focus on the face, and wait until you hear the confirmation chirp.
- 7. Press the shutter button fully to take the photograph.

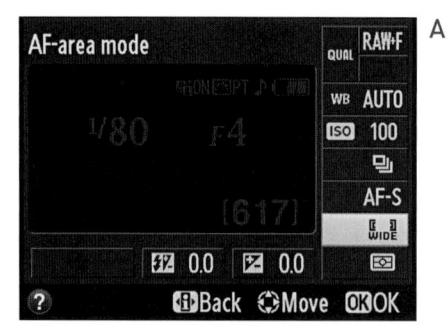

If you are having difficulty getting a face in focus, you can simply place the standard focus box over the person's face and then press the shutter button to focus. Sometimes Face Priority mode has difficulty on faces of people wearing glasses. If you are taking a photograph of more than one person and you're using Face Priority mode, you will see boxes appear over each face. To switch the focus priority from one face to another, simply press left or right on the Multi-selector. Live View can be used with any of the shooting modes, but if you want to use Guide mode, you need to select it in the Start Shooting section.

Manual Callout

There is a complete chapter in the

printed user's manual that is dedi-

cated to using Live View mode. It

starts on page 80.

USE FILL FLASH FOR REDUCING SHADOWS

A common problem when taking pictures of people outside, especially during the midday hours, is that the overhead sun can create dark shadows under the eyes and chin. You could have your subject turn his or her face to the sun, but that is usually considered cruel and unusual punishment. So how can you have your subject's back to the sun and still get a decent exposure of the face? Try turning on your flash to fill in the shadows (Figure 6.11). This also works well when you are photographing someone with a ball cap on. The bill of the hat tends to create heavy shadows over the eyes, and the fill flash will lighten up those areas while providing a really nice catchlight in the eyes.

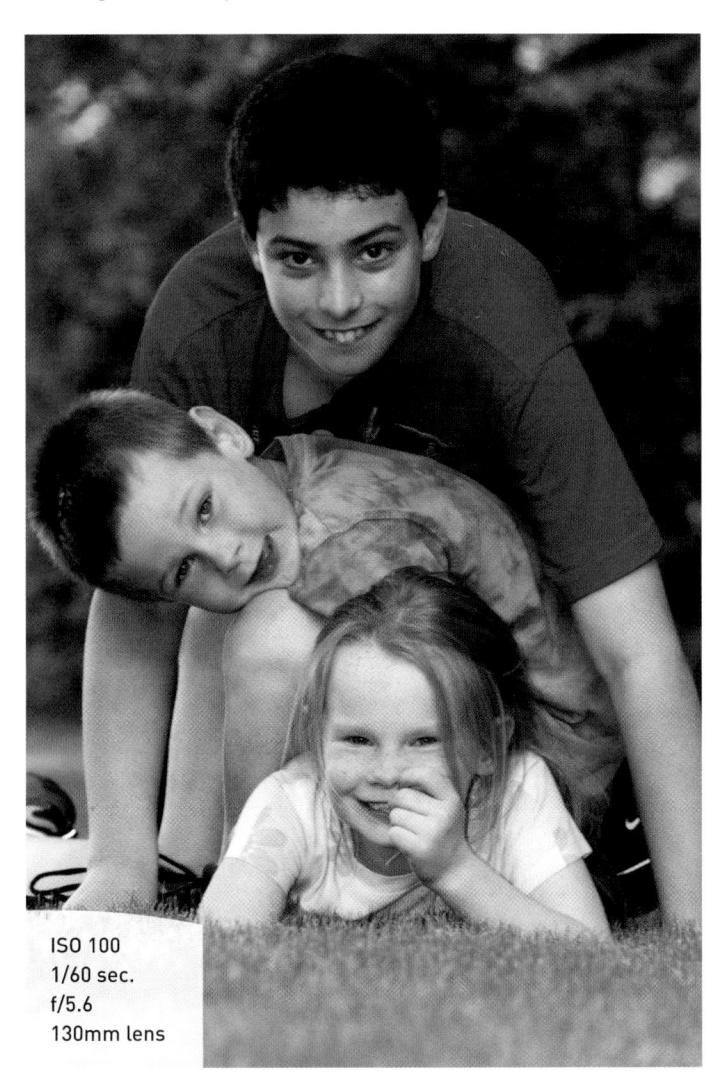

FIGURE 6.11 I used a little fill flash to lighten the faces of this pile of subjects and add a catchlight to their eyes.

CATCHLIGHT

A *catchlight* is that little sparkle that adds life to the eyes. When you are photographing a person with a light source in front of them, their eyes will usually reflect that light, be it your flash, the sun, or something else brightly reflecting in the eye. The light is reflected off the surface of the eyes as bright highlights and serves to bring attention to the eyes.

The key to using the flash as a fill is to not use it on full power. If you do, the camera will try to balance the flash with the daylight, and you will get a very flat and featureless face.

SETTING UP AND SHOOTING WITH FILL FLASH

- 1. Press the pop-up flash button to raise your pop-up flash into the ready position.
- 2. Press the i button to activate the cursor in the information screen.
- 3. Use the Multi-selector to navigate to the Flash Compensation icon located along the bottom of the screen, and press the OK button (A).
- **4.** Select a flash setting of –0.3 and press OK (**B**).
- **5.** Take a photograph and check your playback LCD to see if it looks good. If it doesn't, try reducing power in 1/3-stop increments.

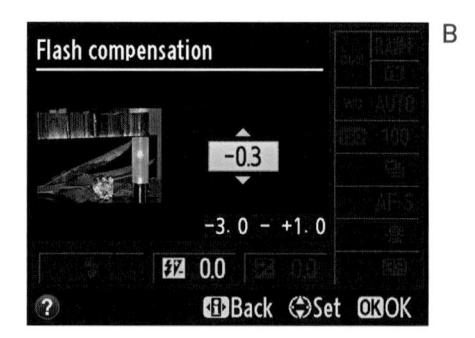

One problem that can quickly surface when using the on-camera flash is red-eye. Not to worry, though—we will talk about that in Chapter 8.

PORTRAITS ON THE MOVE

Not all portraits are shot with the subject sitting in a chair, posed and ready for the picture. Sometimes you might want to get an action shot that says something about the person, similar to an environmental portrait. Children, especially, just like to move. Why fight it? Set up an action portrait instead.

For the photo in **Figure 6.12**, I set my camera to Shutter Priority mode. I knew that there would be a good deal of movement involved, and I wanted to make sure that I had a fairly high shutter speed to freeze the action, so I set it to 1/250 of a second. I set the focus mode to AF-C and the drive mode to Continuous, and I just let it rip. There were quite a few throwaway shots, but I was able to capture one that conveyed the energy and action.

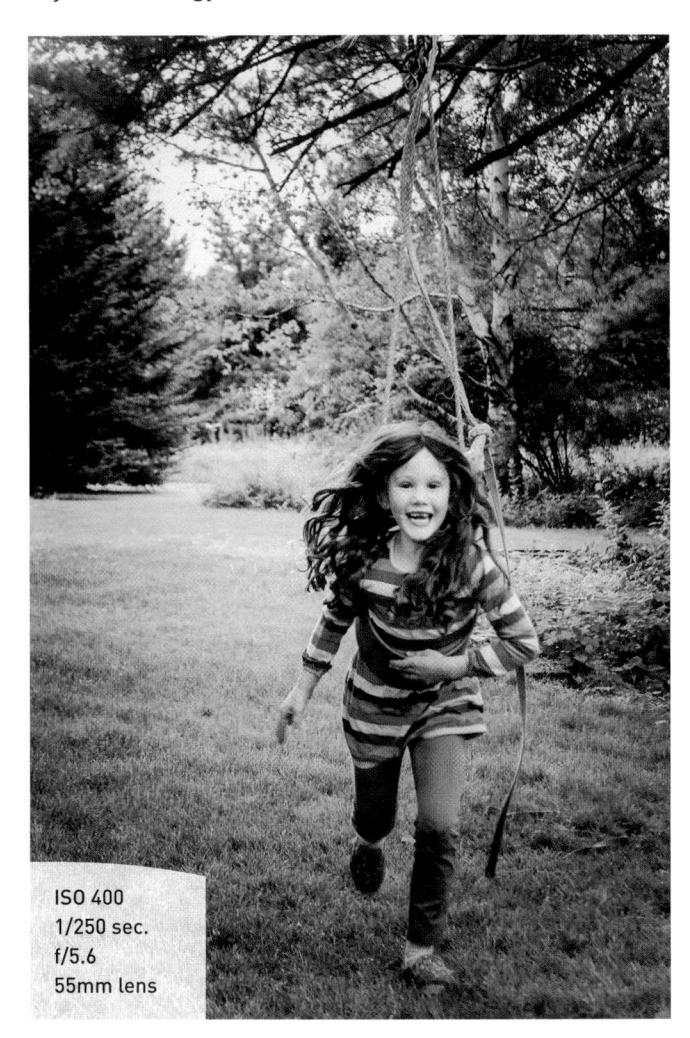

FIGURE 6.12 A higher ISO allowed me to use a faster shutter speed to stop the action.

TIPS FOR SHOOTING BETTER PORTRAITS

Before we get to the assignments for this chapter, I thought it might be a good idea to leave you with a few extra pointers on shooting portraits that don't necessarily have anything specific to do with your camera. There are entire books that cover things like portrait lighting, posing, and so on. But here are a few pointers that will make your people pics look a lot better.

AVOID THE CENTER OF THE FRAME

This falls under the category of composition. Place your subject to the side of the frame (Figure 6.13)—it just looks more interesting than plunking them smack dab in the middle (Figure 6.14).

FIGURE 6.13 Try cropping in a bit, and place the subject's face off center to improve the shot.

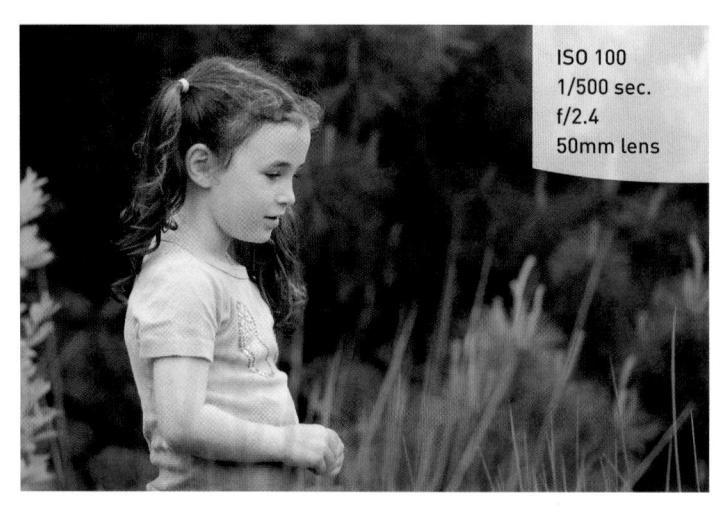

FIGURE 6.14 Having the subject in the middle of the frame with empty space on the sides can make for a less-than-interesting portrait.

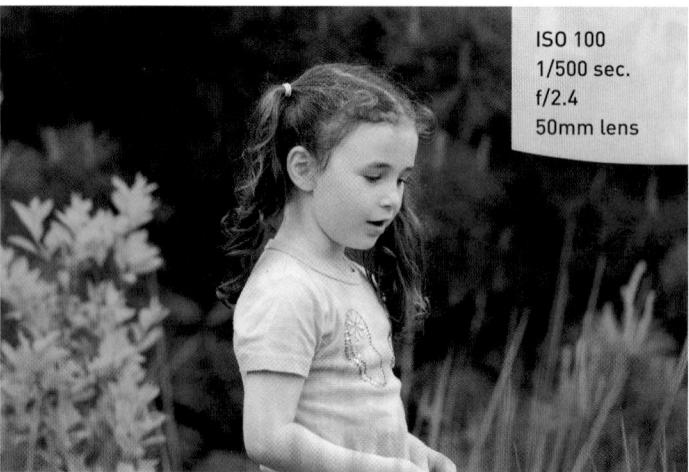

CHOOSE THE RIGHT LENS

Choosing the correct lens can make a huge impact on your portraits. A wide-angle lens can distort the features of your subject, which can lead to an unflattering portrait (**Figure 6.15**). Select a longer focal length if you will be close to your subject (**Figure 6.16**).

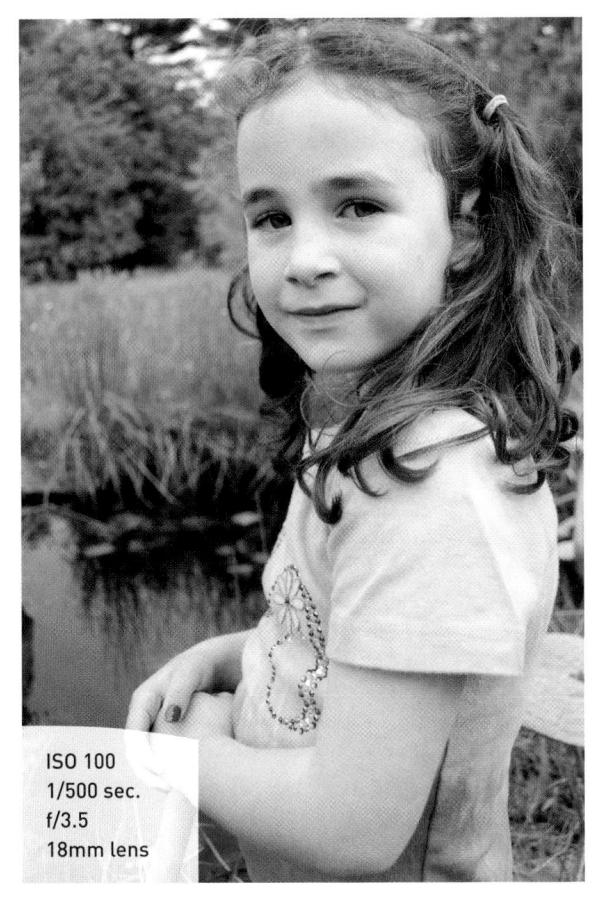

FIGURE 6.15 At this close distance, the 18mm lens is distorting the subject's face.

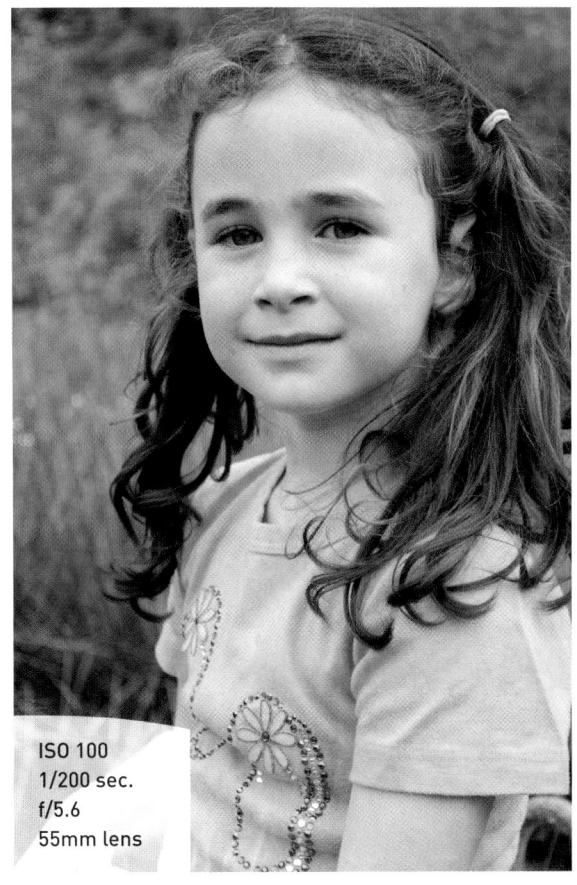

FIGURE 6.16
By zooming out to 55mm, I am able to remove the distortion for a much better photo.

DON'T CUT THEM OFF AT THE KNEES

There is an old rule about photographing people: Never crop the picture at a joint. This means no cropping at the ankles, knees, or waist. If you need to crop at the legs, the proper place to crop is mid-shin or mid-thigh (Figure 6.17).

FIGURE 6.17 A good crop for people is at midthigh or mid-shin.

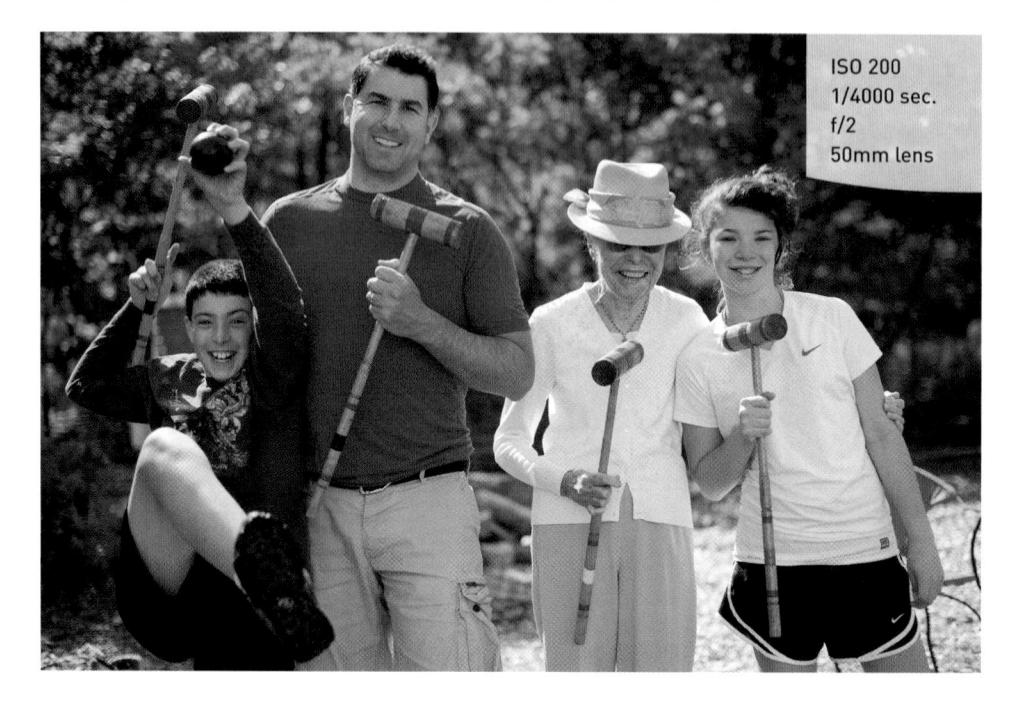

USE THE FRAME

Have you ever noticed that most people are taller than they are wide? Turn your camera vertically for a more pleasing composition (**Figure 6.18**).

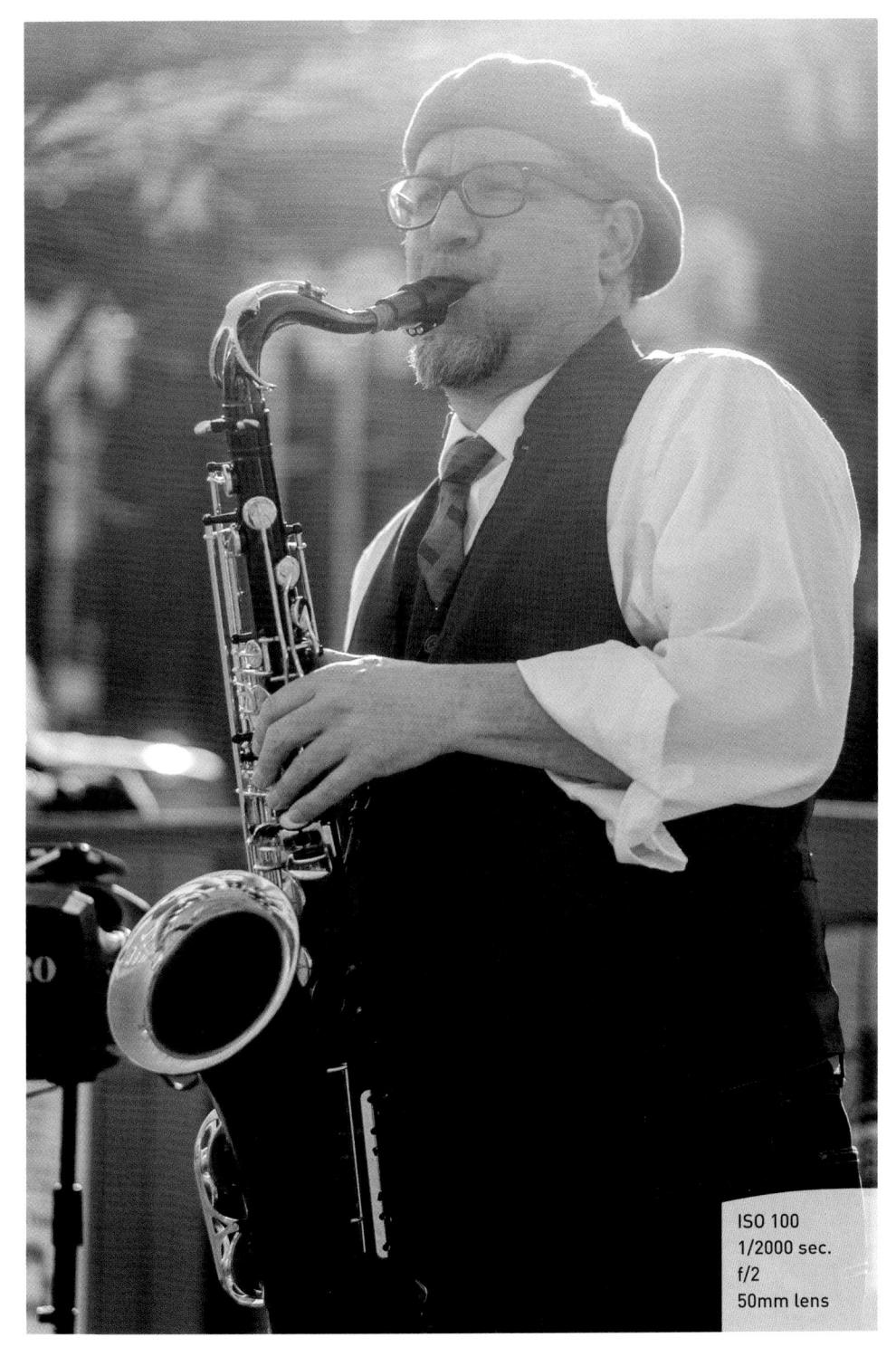

FIGURE 6.18
Get in the habit
of turning your
camera to a vertical position when
shooting portraits.
This is also referred
to as portrait
orientation.

SUNBLOCK FOR PORTRAITS

The midday sun can be harsh and can do unflattering things to people's faces (Figure 6.19). If you can, find a shady spot out of the direct sunlight. You will get softer shadows, smoother skin tones, and better detail (Figure 6.20). This holds true for overcast skies as well. Just be sure to adjust your white balance accordingly.

FIGURE 6.19 The dappled sunlight can result in overexposure in the highlights.

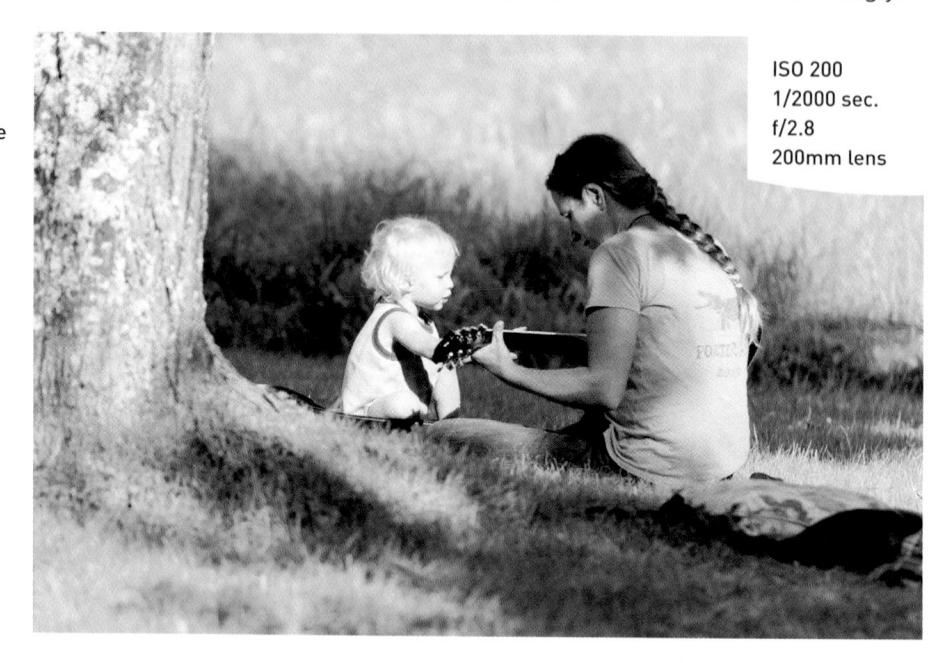

FIGURE 6.20
By changing my
position and waiting
for a cloud to pass
in front of the sun,
I was able to get a
much more even
and pleasing result.

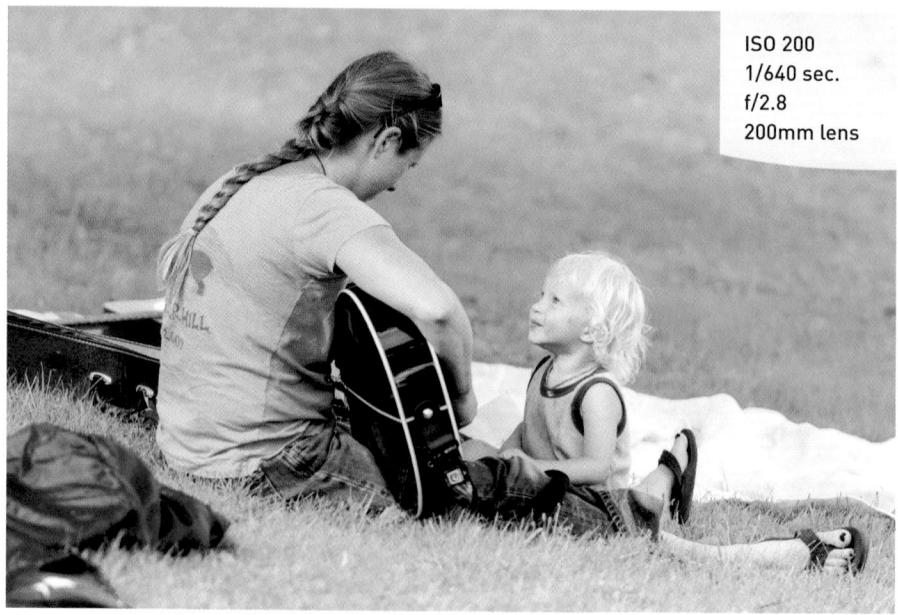

GIVE THEM A HEALTHY GLOW

Nearly everyone looks better with a warm, healthy glow. Some of the best light of the day happens just a little before sundown, so shoot at that time if you can (**Figure 6.21**).

ELIMINATE SPACE BETWEEN YOUR SUBJECTS

One of the problems you can encounter when taking portraits of more than one person is that of personal space. What feels like a close distance to the subjects can look impersonal to the viewer. Have your subjects move close together, eliminating any open space between them (**Figure 6.22**).

FIGURE 6.21
You just can't beat the glow of the late afternoon sun for adding warmth to your portraits.

FIGURE 6.22
Getting kids to squish together will usually result in great smiles and laughter.

FRAME THE SCENE

Using elements in the scene to create a frame around your subject is a great way to draw the viewer in. You don't have to use a window frame to do this. Just look for elements in the foreground that could be used to force the viewer's eye toward your subject (Figure 6.23).

FIGURE 6.23 I'll often look for elements of the surrounding background to use as compositional elements in my portraits.

GET DOWN ON THEIR LEVEL

If you want better pictures of children, don't shoot from an adult's eye level. Getting the camera down to the child's level will make your images look more personal (Figure 6.24).

FIGURE 6.24
Sometimes taking photographs of children means taking a knee to get the camera down on their level, but the result is a much better image.

MORE THAN JUST A PRETTY FACE

Most people think of a portrait as a photo of someone's face. Don't ignore other aspects of your subject that reflect their personality—hands, especially, can go a long way toward describing someone and capturing the moment, such as when your child collects the first egg from your chickens (Figure 6.25).

FIGURE 6.25There's more to a person than just their face. Hands can tell a lot about what is happening in the scene.

Chapter 6 Assignments

Depth of field in portraits

Let's start with something simple. Grab your favorite person and start experimenting with using different aperture settings. Shoot wide open (the widest your lens goes, such as f/3.5 or f/5.6) and then really stopped down (like f/22). Look at the difference in the depth of field and how it plays an important role in placing the attention on your subject. (Make sure you don't have your subject standing against the background. Give some distance so that there is a good blurring effect of the background at the wide f-stop setting.)

Discovering the qualities of natural light

Pick a nice sunny day and try shooting some portraits in the midday sun. If your subject is willing, have them turn so the sun is in their face. If they are still speaking to you after blinding them, have them turn their back to the sun. Try this with and without the fill flash so you can see the difference. Finally, move them into a completely shaded spot and take a few more.

Picking the right metering method

Find a very dark or light background and place your subject in front of it. Now take a couple of shots, giving a lot of space around your subject for the background to show. Now switch metering modes and use the AE Lock feature to get a more accurate reading of your subject. Notice the differences in exposure between the metering methods.

Picture controls for portraits

Have some fun playing with the different picture controls. Try the Portrait control as compared to the Standard. Then try out Monochrome and play with the different color filter options to see how they affect skin tones.

Share your results with the book's Flickr group!

Join the group here: flickr.com/groups/nikond3200_fromsnapshotstogreatshots

Landscape Photography

TIPS, TOOLS, AND TECHNIQUES TO GET THE MOST OUT OF YOUR LANDSCAPE PHOTOGRAPHY

There's something about shooting landscapes that has always brought a sense of joy to my photography. It might have something to do with being outdoors and working at the mercy of Mother Nature. Maybe it's the way it challenges me to visualize the landscape and try to capture it with my camera. It truly is a celebration of light, composition, and the world we live in.

In this chapter, we will explore some of the features of the D3200 that not only improve the look of your landscape photography, but also make it easier to take great shots. We will also explore some typical scenarios and discuss methods to bring out the best in your landscape photography.

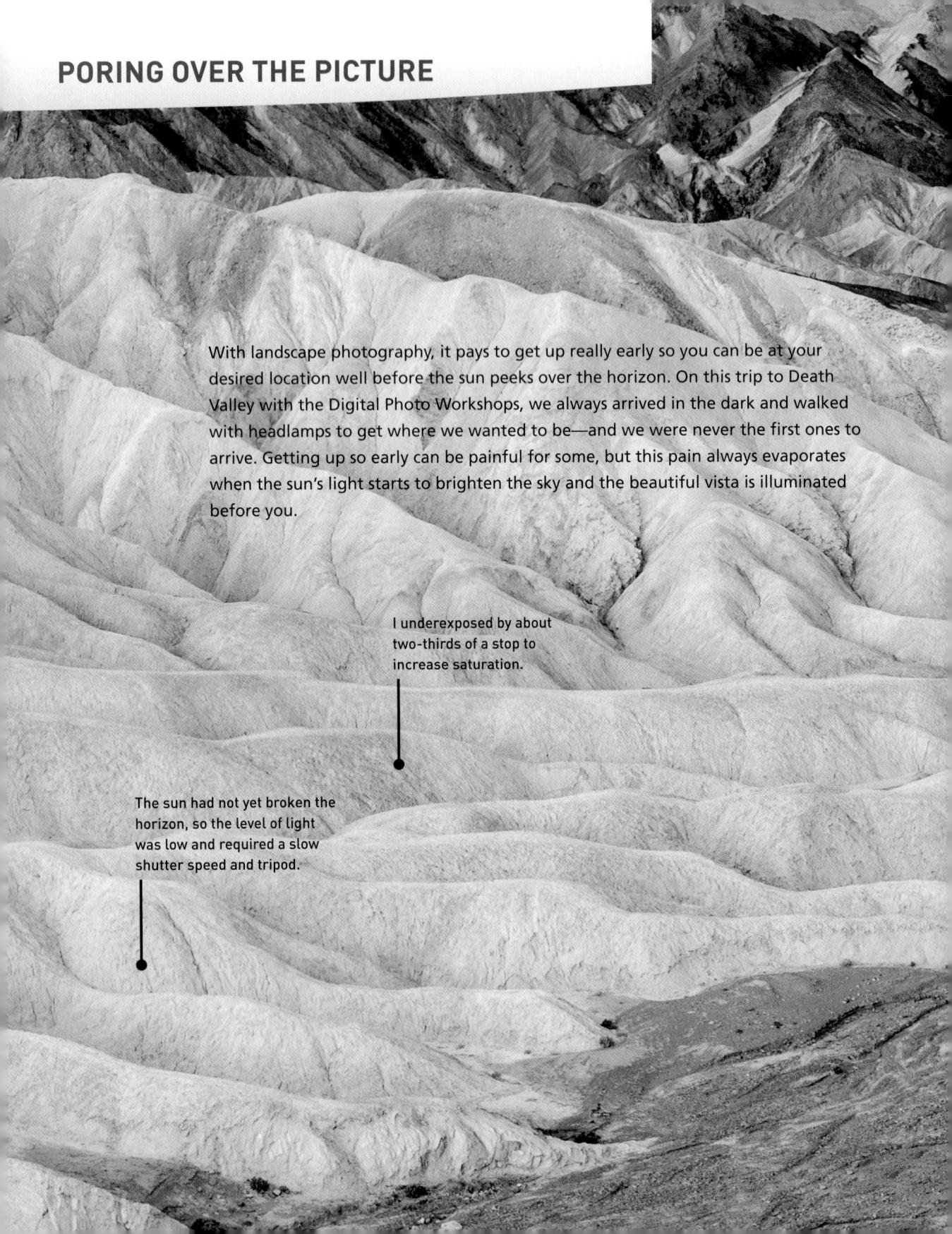

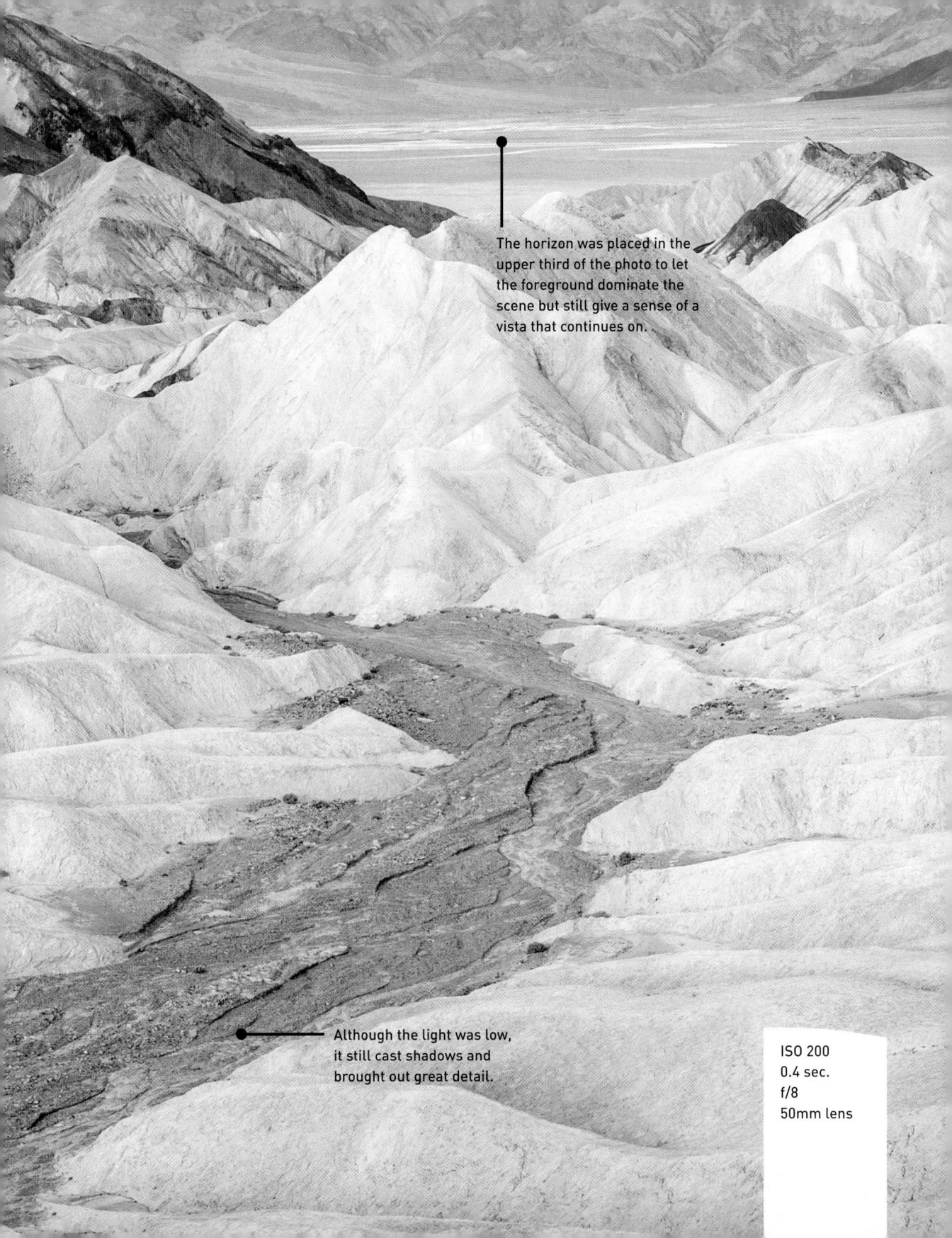

SHARP AND IN FOCUS: USING TRIPODS

Throughout the previous chapters we have concentrated on using the camera to create great images. We will continue that trend through this chapter, but there is one additional piece of equipment that is crucial in the world of landscape shooting: the tripod. There are a couple of reasons why tripods are so critical to your landscape work, the first being the time of day that you will be working. For reasons that will be explained later, the best light for most landscape work happens at sunrise and just before sunset. While this is the best time to shoot, it's also kind of dark. That means you'll be working with slow shutter speeds. Slow shutter speeds mean camera shake. Camera shake equals bad photos.

The second reason is also related to the amount of light that you're gathering with your camera. When taking landscape photos, you will usually want to be working with very small apertures, as they give you lots of depth of field. This also means that, once again, you will be working with slower-than-normal shutter speeds.

Slow shutter = camera shake = bad photos.

Do you see the pattern here? The one tool in your arsenal to truly defeat the camera shake issue and ensure tack-sharp photos is a good tripod (Figure 7.1).

FIGURE 7.1 A sturdy tripod is the key to sharp landscape photos. (Photo: istockphoto/ sculpies)

So what should you look for in a tripod? Well, first make sure it is sturdy enough to support your camera and any lens that you might want to use. Next, check the height of the tripod. Bending over all day to look through the viewfinder of a camera on a short tripod can wreak havoc on your back. Finally, think about getting a tripod that utilizes a quick-release head. This usually employs a plate that screws into the bottom of the camera and then quickly snaps into place on the tripod. This will be especially handy if you are going to move between shooting by hand and using the tripod. You'll find more information about tripods in the bonus chapter, "Pimp My Ride."

TRIPOD STABILITY

Most tripods have a center column that allows the user to extend the height of the camera above the point where the tripod legs join together. This might seem like a great idea, but the reality is that the farther you raise that column, the less stable your tripod becomes. Think of a tall building that sways near the top. To get the most solid base for your camera, always try to use it with the center column at its lowest point so that your camera is right at the apex of the tripod legs.

VR LENSES AND TRIPODS DON'T MIX

If you are using Vibration Reduction (VR) lenses on your camera, you need to remember to turn this feature off when you use a tripod (**Figure 7.2**). This is because the Vibration Reduction can, while trying to minimize camera movement, actually create movement when the camera is already stable. To turn off the VR feature, just slide the VR selector switch on the side of the lens to the Off position.

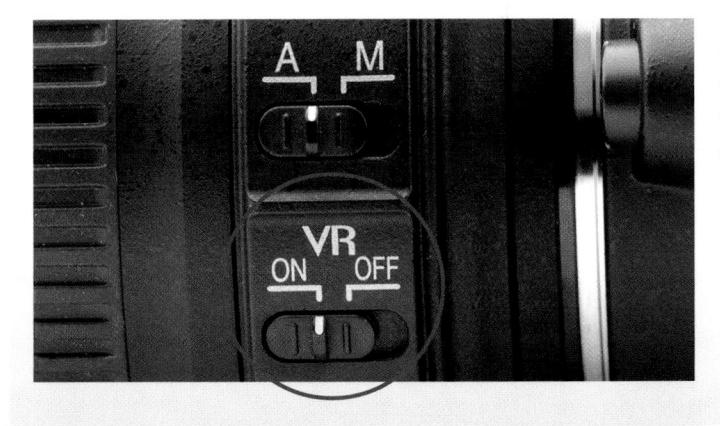

FIGURE 7.2 Turn off the Vibration Reduction feature when using a tripod.

SELECTING THE PROPER ISO

For most landscape scenes, the ISO is the one factor that should only be increased as a last resort. While it is easy to select a higher ISO to get a smaller aperture, the noise that it can introduce into your images can be quite harmful. The noise is not only visible as large, grainy artifacts; it can also be multi-colored, which further degrades the image quality and color balance.

Take a look at Figures 7.3 and 7.4, which show a photograph taken with an ISO of 1600. The purpose was to shorten the shutter speed and still use a small aperture setting of f/11. The problem is that the noise level is so high that, in addition to being distracting, it is obscuring fine details in the trees and hills.

FIGURE 7.3 A high ISO setting created a lot of digital noise in the trees and hills.

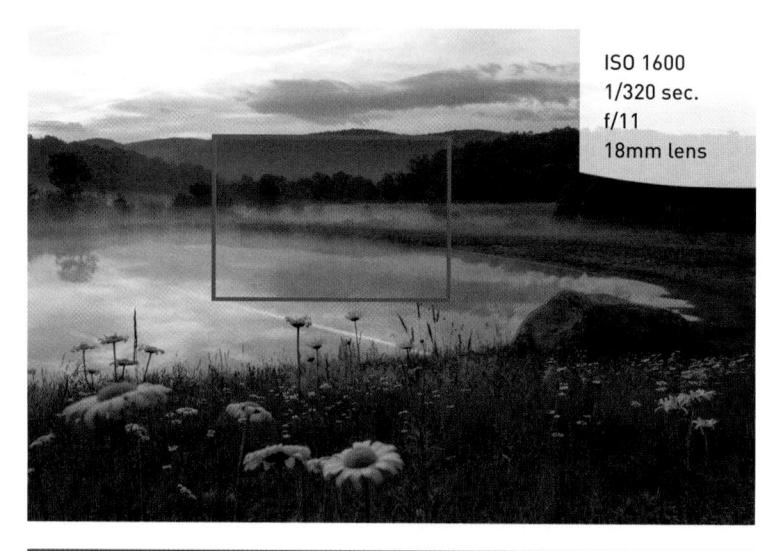

FIGURE 7.4 When the image is enlarged, the noise is even more apparent.

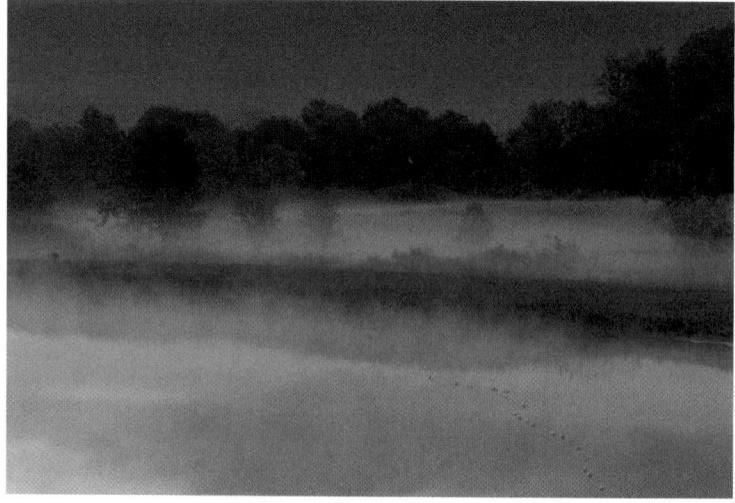

Now check out another image that was taken minutes later, but with a much lower ISO setting (Figures 7.5 and 7.6). As you can see, the noise levels are much lower, which means that my blacks look black, and the fine details are beautifully captured.

When you're shooting landscapes, set your ISO to the lowest possible setting at all times. Between the use of Vibration Reduction lenses (if you are shooting handheld) and a good tripod, there should be few circumstances where you would need to shoot landscapes with anything above an ISO of 400.

As you start shooting with shutter speeds that exceed one second, the level of image noise can increase. Your camera has a feature called Noise Reduction that you can turn on to combat noise from long exposures and high ISOs.

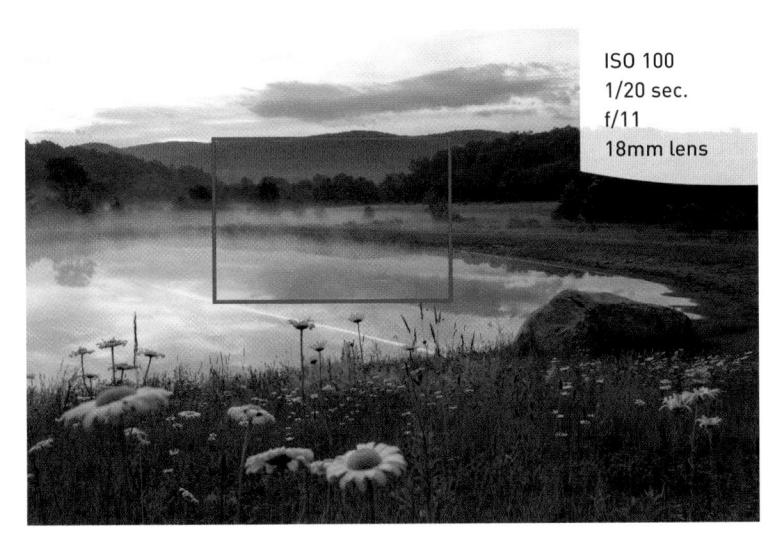

FIGURE 7.5 By lowering the ISO to 100, I was able to avoid the noise and capture a clean image.

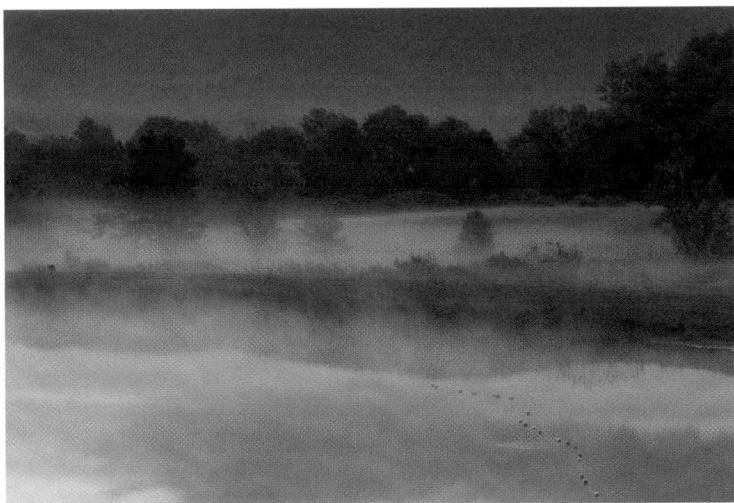

FIGURE 7.6 Zooming in shows that the noise levels for this image are almost nonexistent.

SETTING UP NOISE REDUCTION

- Press the Menu button, then use the Multi-selector to get to the Shooting Menu.
- 2. Using the Multi-selector, locate the Noise reduction menu item and then press OK (A). Change this option to On (B) and press the OK button.

That's all there is to it. Now when you shoot, your camera will be aware of the settings and work toward minimizing unwanted noise in your images.

SELECTING A WHITE BALANCE

This probably seems like a no-brainer. If it's sunny, select Daylight; if it's overcast, choose the Shade or Cloudy setting. Those choices wouldn't be wrong for those circumstances, but why limit yourself? Sometimes you can actually change the mood of the photo by selecting a white balance that doesn't quite fit the light for the scene that you are shooting.

Figure 7.7 is an example of a correct white balance. It was morning and the sky was just starting to warm up as the sun got higher in the sky. The white balance for this image was set to Daylight.

But what if I want to make the scene look like it was shot even earlier in the morning? Simple, I just change the white balance to Fluorescent, which is a much cooler setting (Figure 7.8).

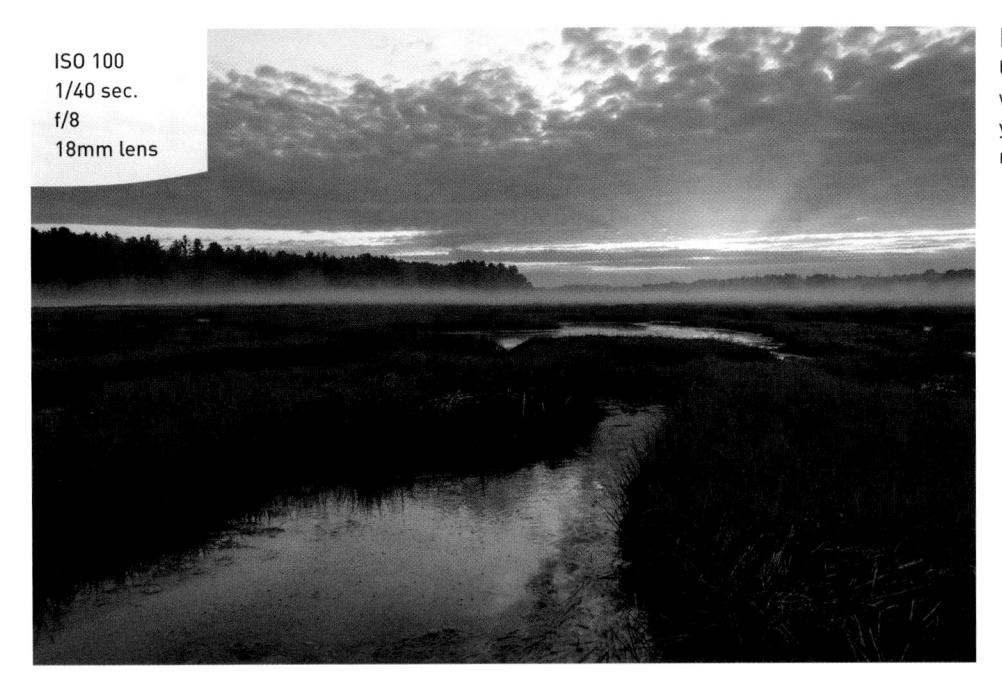

FIGURE 7.7 Using the "proper" white balance yields predictable results.

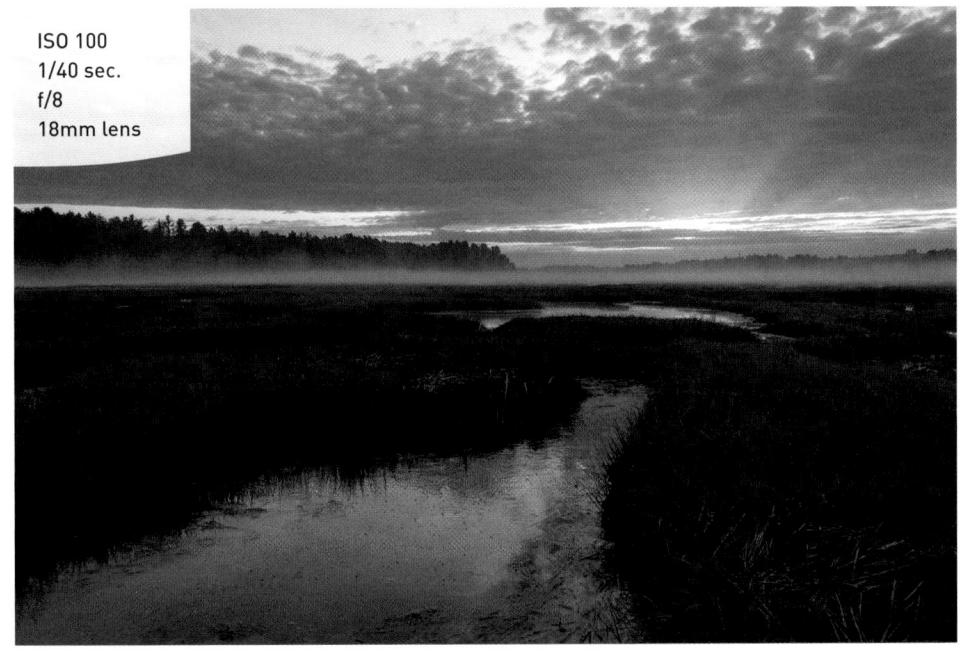

FIGURE 7.8
Changing the
white balance to
Fluorescent gives
the impression that
the picture was
taken at a different
time of day than it
really was.

So how do you know what a good white balance selection is? You could just take a guess, but the easiest way is to take a shot, review it on the LCD, and keep the one you like. Of course, you would need to take one for each white balance setting, which means that you would have to change the white balance using the menu or info edit screen (i button). There is, of course, an easier way to preview the white balance without ever taking a shot. Just turn on your Live View and change the white balance setting while previewing the effect on the LCD screen. You'll need to set up a shortcut to bring up the white balance selection by using the Function (Fn) button.

CUSTOMIZING THE FUNCTION BUTTON FOR WHITE BALANCE

- Press the Menu button and use the Multi-selector to access the Setup Menu.
- 2. Now highlight the item called Buttons and press OK (A).
- 3. Select Assign Fn button and press OK (B).

讈

4. Now select White balance and press OK (**C**).

Now you can quickly change the white balance setting by holding in the Function button and spinning the Command dial with your thumb.

USING THE LANDSCAPE PICTURE CONTROL

When shooting landscapes, I always look for great color and contrast. This is one of the reasons that so many landscape shots are taken in the early morning or during sunset. The light is much more vibrant and colorful at these times of day and adds a sense of drama to an image. There are also much longer and deeper shadows due to the angle of the light. These shadows are what give depth to your image.

Manual Callout

Check out pages 76–79 in the PDF camera manual for more information on setting picture controls.

You can help boost the vibrancy and contrast, especially in the less-than-golden hours of the day, by using the Landscape picture control (**Figure 7.9**). Just as in the Landscape mode found in the automatic scene modes, you can set up your landscape shooting so that you capture images with increased sharpness and a slight boost in blues and greens. This control will add some pop to your landscapes without the need for additional processing in any software.

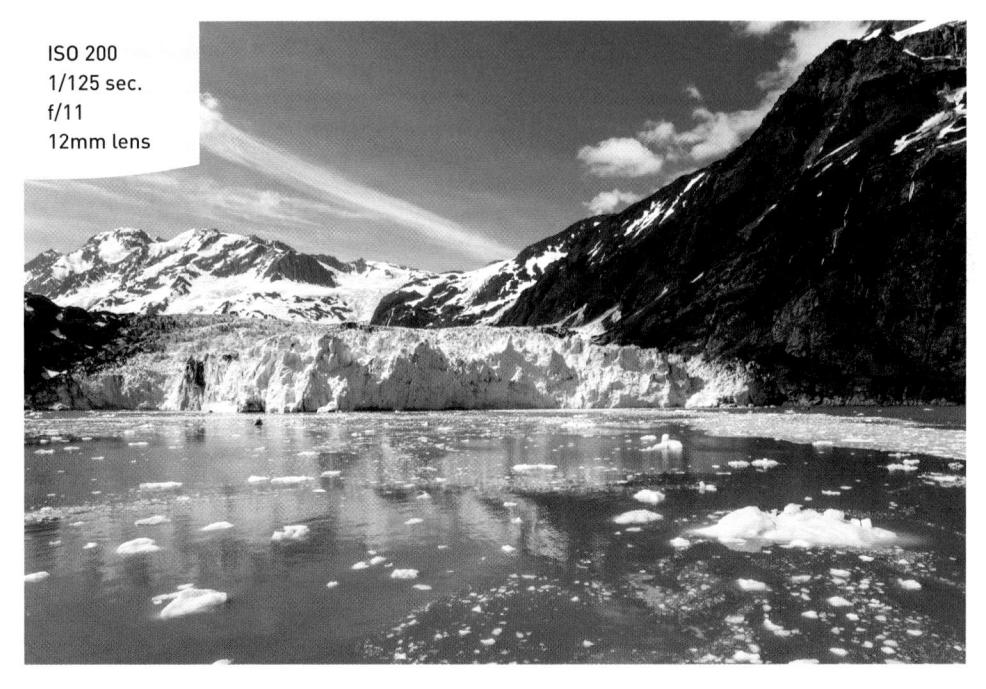

FIGURE 7.9
Using the
Landscape picture
control can add
sharpness and
more vivid color
to skies and
vegetation.

SETTING UP THE LANDSCAPE PICTURE CONTROL

- Press the Menu button, use the Multi-selector to highlight the Set Picture Control item found in the Shooting Menu (this is normally set to SD [Standard]), and then press OK (A).
- 2. Now use the Multi-selector to scroll down to the Landscape option, and press OK to lock in your change (B).

The camera will now apply the Landscape picture control to all of your photos. This style will be locked in to the camera even after turning it off and back on again, so make sure to change it back to Standard when you are done with your landscape shoot.

TAMING BRIGHT SKIES WITH EXPOSURE COMPENSATION

Balancing exposure in scenes that have a wide contrast in tonal ranges can be extremely challenging. The one thing you should try to avoid is overexposing your skies to the point of blowing out your highlights (unless, of course, that is the look you are going for). It's one thing to have white clouds, but it's a completely different and bad thing to have no detail at all in those clouds. This usually happens when the camera is trying to gain exposure in the darker areas of the image (Figure 7.10). The one way to tell if you have blown out your highlights is to turn on the Highlight Alert, or "blinkies," feature on your camera (see the "How I Shoot" section in Chapter 4). When you take a shot where the highlights are exposed beyond the point of having any detail, that area will blink in your LCD display. It is up to you to determine if that particular area is important enough to regain detail by altering your exposure. If the answer is yes, then the easiest way to go about it is to use some exposure compensation.

With this feature, you can force your camera to choose an exposure that ranges, in 1/3-stop increments, from five stops over to five stops under the metered exposure (Figure 7.11).

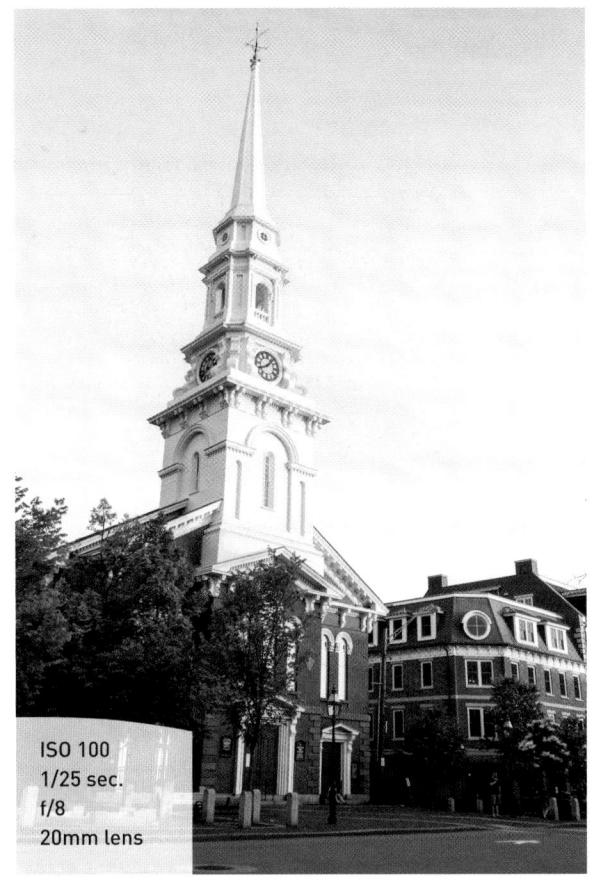

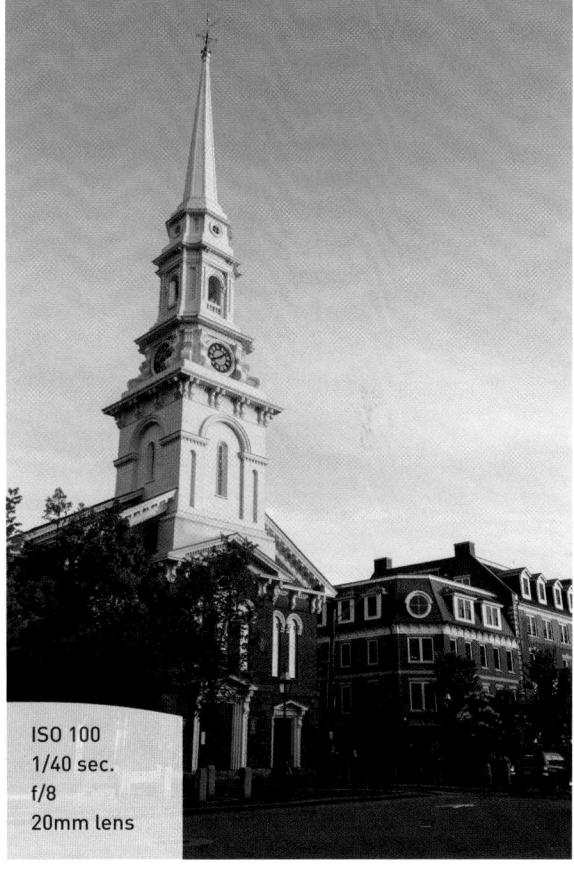

FIGURE 7.10

The trees in the foreground are properly exposed, but the steeple and sky look washed out and lack saturation.

FIGURE 7.11

A compensation of one stop of underexposure brought back the color and detail in the highlights.

HIGH-KEY AND LOW-KEY IMAGES

When you hear someone refer to a subject as being *high key*, it usually means that the entire image is composed of a very bright subject with very few shadow areas—think snow or beach. It makes sense, then, that a *low-key* subject has very few highlight areas and a predominance of shadow areas. Think of a cityscape at night as an example of a low-key photo.

USING EXPOSURE COMPENSATION TO REGAIN DETAIL IN HIGHLIGHTS

- 1. Activate the camera meter by lightly pressing the shutter release button.
- 2. Using your index finger, press and hold the Exposure Compensation button to change the over-/underexposure setting by rotating the Command dial.
- 3. Rotate the Command dial to the right one click and take another picture (each click of the Command dial is a 1/3-stop exposure change).
- 4. If the blinkies are gone, you are good to go. If not, keep subtracting from your exposure by 1/3 of a stop until you have a good exposure in the highlights.

I generally keep my camera set to -1/3 stop for most of my landscape work unless I am working with a location that is very dark or low key.

You can also change the Exposure Compensation setting by using the i button on the rear of the camera.

ADJUSTING EXPOSURE COMPENSATION USING THE I BUTTON

- 1. Press the i button to activate the cursor in the information display.
- **2.** Use the Multi-selector to move the cursor to the Exposure Compensation position, and press OK.
- 3. Now press in a downward direction on the Multi-selector to lower the compensation by 1/3 of a stop. Each press downward will continue to reduce the exposure in 1/3-stop increments for up to five stops (although I rarely need to go past one stop).

Note that any exposure compensation will remain in place even after turning the camera off and then on again. Don't forget to reset it once you have successfully captured your image. Also, exposure compensation works only in the Program, Shutter Priority, Aperture Priority, and Manual modes. Changing between these four modes will hold the compensation you set while switching from one to the other. When you change the Mode dial to one of the automatic scene modes, the compensation will set itself to zero.

If you want to use exposure compensation while using the Manual shooting mode, you need to use the i button method described above to make the change. This is because the Exposure Compensation button acts as the Aperture Change button when the mode is set to Manual.
SHOOTING BEAUTIFUL BLACK AND WHITE LANDSCAPES

There's nothing as timeless as a beautiful black and white landscape photo. For many, it is the purest form of photography. The genre conjures up thoughts of Ansel Adams out in Yosemite Valley, capturing stunning monoliths with his 8x10 view camera. Well, just because you are shooting with a digital camera doesn't mean you can't create your own stunning photos using the power of the Monochrome picture control. (See the "Classic Black and White Portraits" section of Chapter 6 for instructions on setting up this feature.) Not only can you shoot in black and white, you can also customize the camera to apply built-in filters to lighten or darken different elements within your scene, as well as add contrast and definition.

The four filter colors are red, yellow, green, and orange. The most typically used filters in black and white photography are red and yellow. This is because the color of these filters will darken opposite colors and lighten similar colors. So if you want to darken a blue sky, you would use a yellow filter because blue is the opposite of yellow. To darken green foliage, you would use a red filter. Check out the series of shots in **Figure 7.12** with different filters applied.

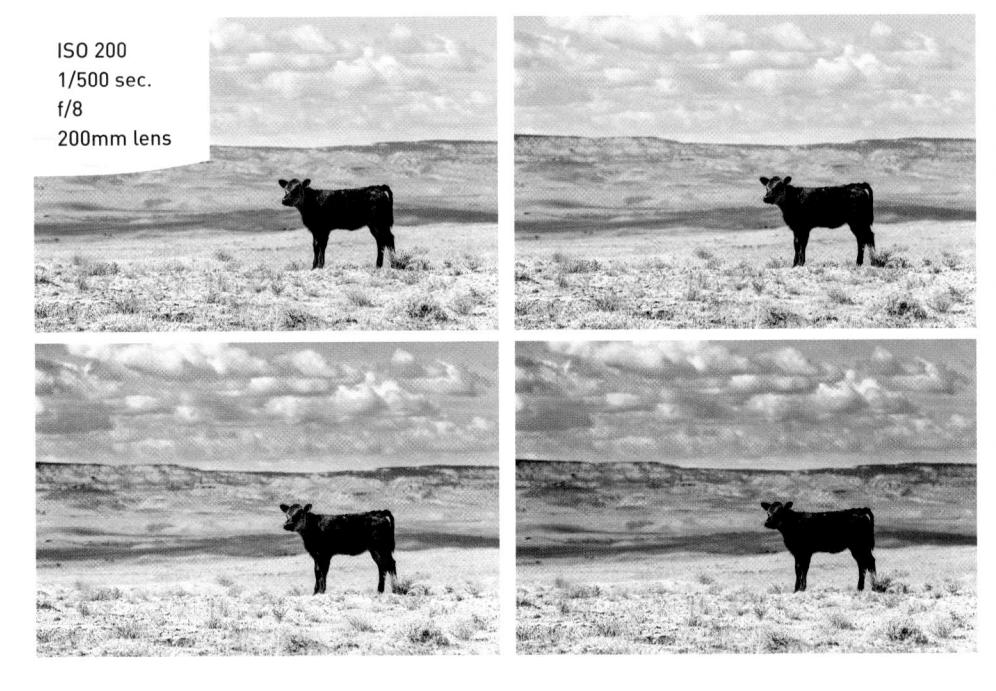

FIGURE 7.12
Adding color
filter settings to
the Monochrome
picture control
allows you to
lighten or darken
elements in your
scene. The top right
image has no filter
applied to it. The
bottom left has a
green filter, and the
bottom right has a
yellow filter.

You can see that there is no real difference in contrast between the color image and the black and white image with no filter. The green filter has the effect of darkening the skies slightly and giving a significantly lighter look to the vegetation. Using the yellow filter makes the vegetation darker but dramatically darkens the sky. There is no right or wrong to choosing a filter for your black and white shots. It's pretty much whatever you prefer. In this instance, I think I prefer the image with the green filter.

Other options in the Monochrome picture control enable you to adjust the sharpness and contrast and even add some color toning (like sepia) to the final image. This information is also in the "Classic Black and White Portraits" section of Chapter 6. I like to have Sharpness set to 5 and Contrast set to +1 for my landscape images. This gives an overall look to the black and white image that is reminiscent of the classic black and white films. Experiment with the various settings to find the combination that is most pleasing to you.

WARM AND COOL COLOR TEMPERATURES

These two terms are used to describe the overall color cast of an image. Reds and yellows are said to be *warm*, which is usually the look that you get from the late afternoon sun. Blue is usually the predominant color when talking about a *cool* cast.

THE GOLDEN LIGHT

If you ask any professional landscape photographer what their favorite time of day to shoot is, chances are they will tell you it's the hours surrounding daybreak and sunset (Figures 7.13 and 7.14). The reason for this is that the light is coming from a very low angle to the landscape, which creates shadows and gives depth and character. There is also a quality to the light that seems cleaner and is more colorful than the light you get when shooting at midday. One thing that can dramatically improve any morning or evening shot is the presence of clouds. The sun will fill the underside of the clouds with a palette of colors and add drama to your image.

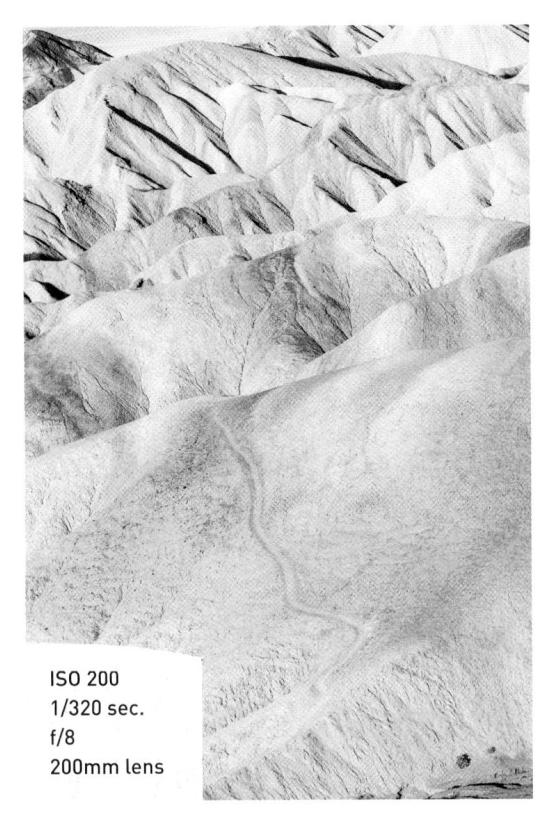

ISO 200 1/500 sec. f/5.6 80mm lens

FIGURE 7.13
The right subject can come alive with color during the few minutes after sunrise.

FIGURE 7.14
Late afternoon sun is usually warmer and adds drama and warmth to the landscape.

WHERE TO FOCUS

Large landscape scenes are great fun to photograph, but they can present a problem: Where exactly do you focus when you want everything to be sharp? Since our goal is to create a great landscape photo, we will need to concentrate on how to best create an image that is tack sharp, with a depth of field that renders great focus throughout the scene.

I have already stressed the importance of a good tripod when shooting landscapes. The tripod lets you concentrate on the aperture portion of the exposure without worrying about how long your shutter will be open. This is because the tripod provides the stability to handle any shutter speed you might need when shooting at small apertures. I find that for most of my landscape work I set my camera to Aperture Priority mode and the ISO to 100 (for a clean, noise-free image).

However, shooting with the smallest aperture on your lens doesn't necessarily mean that you will get the proper sharpness throughout your image. The real key is knowing where in the scene to focus your lens to maximize the depth of field for your chosen aperture. To do this, you must utilize something called the "hyper focal distance" of your lens.

Hyper focal distance, also referred to as HFD, is the point of focus that will give you the greatest acceptable sharpness from a point near your camera all the way out to infinity. If you combine good HFD practice in combination with a small aperture, you will get images that are sharp to infinity.

There are a couple of ways to do this, and the one that is probably the easiest is, as you might guess, the one that is most widely used by working pros. When you have your shot all set up and composed, focus on an object that is about one-third of the distance into your frame (Figure 7.15). It is usually pretty close to the proper distance and will render favorable results. When you have the focus set, take a photograph and then zoom in on the preview on your LCD to check the sharpness of your image.

One thing to remember is that as your lens gets wider in focal length, your HFD will be closer to the camera position. This is because the wider the lens, the greater depth of field you can achieve. This is yet another reason why a good wide-angle lens is indispensable to the landscape shooter.

FIGURE 7.15 To get maximum focus from near to far, the focus was set one-third of the way along the rocks. I then recomposed before taking the picture. Using this point of focus with an aperture of f/8 gave me a sharply focused image all the way back to the distant rocks. This is another excellent place to use the AF-S focus mode as well.

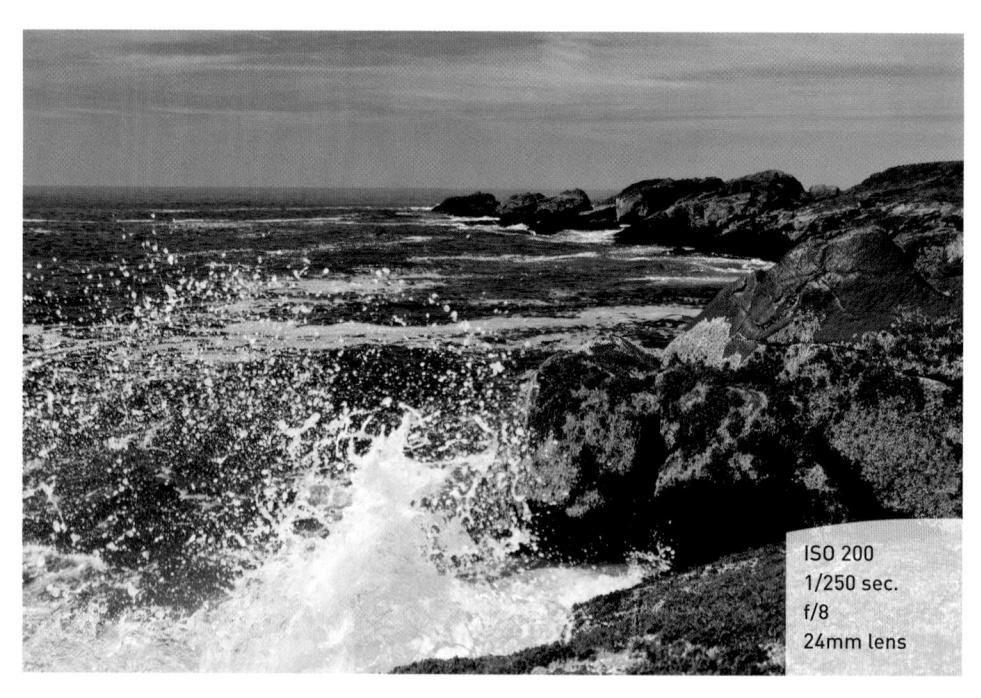

TACK SHARP

Here's one of those terms that photographers like to throw around. *Tack sharp* refers not only to the focus of an image but also to the overall sharpness of the image. This usually means that there is excellent depth of field in terms of sharp focus for all elements in the image. It also means that there is no sign of camera shake, which can give soft edges to subjects that should look nice and crisp. To get your images tack sharp, use a small depth of field, don't forget your tripod, use the self-timer to activate the shutter if no cable release is handy, and practice achieving good hyper focal distance (HFD) when picking your point of focus.

EASIER FOCUSING

There's no denying that the automatic focus features on the D3200 are great, but sometimes it just pays to turn them off and focus manually. This is especially true if you are shooting on a tripod: Once you have your shot composed in the viewfinder and you are ready to focus, chances are that the area you want to focus on is not going to be in the area of one of the focus points. Often this is the case when you have a foreground element that is fairly low in the frame. You could use a single focus point set low in your viewfinder and then pan the camera down until it rests on your subject. But then you would have to press the shutter button halfway to focus the camera and then try to recompose and lock down the tripod. It's no easy task.

But you can have the best of both worlds by having the camera focus for you, then switching to manual focus to comfortably recompose your shot (**Figure 7.16** on the following page).

GETTING FOCUSED WHILE USING A TRIPOD

- 1. Set up your shot and find the area that you want to focus on.
- 2. Pan your tripod head so that your active focus point is on that spot.
- 3. Press the shutter button halfway to focus the camera.
- **4.** Switch the camera to manual focus by sliding the switch on the lens barrel from A to M.
- **5.** Recompose the composition on the tripod and then take the shot.

The camera will fire without trying to refocus the lens. This works especially well for wide-angle lenses, which can be difficult to focus in manual mode.

FIGURE 7.16
Using the HFD
(hyper focal distance) one-third
rule, I focused on
the red lobster boat,
then switched the
lens to manual focus
before recomposing
for the final shot.

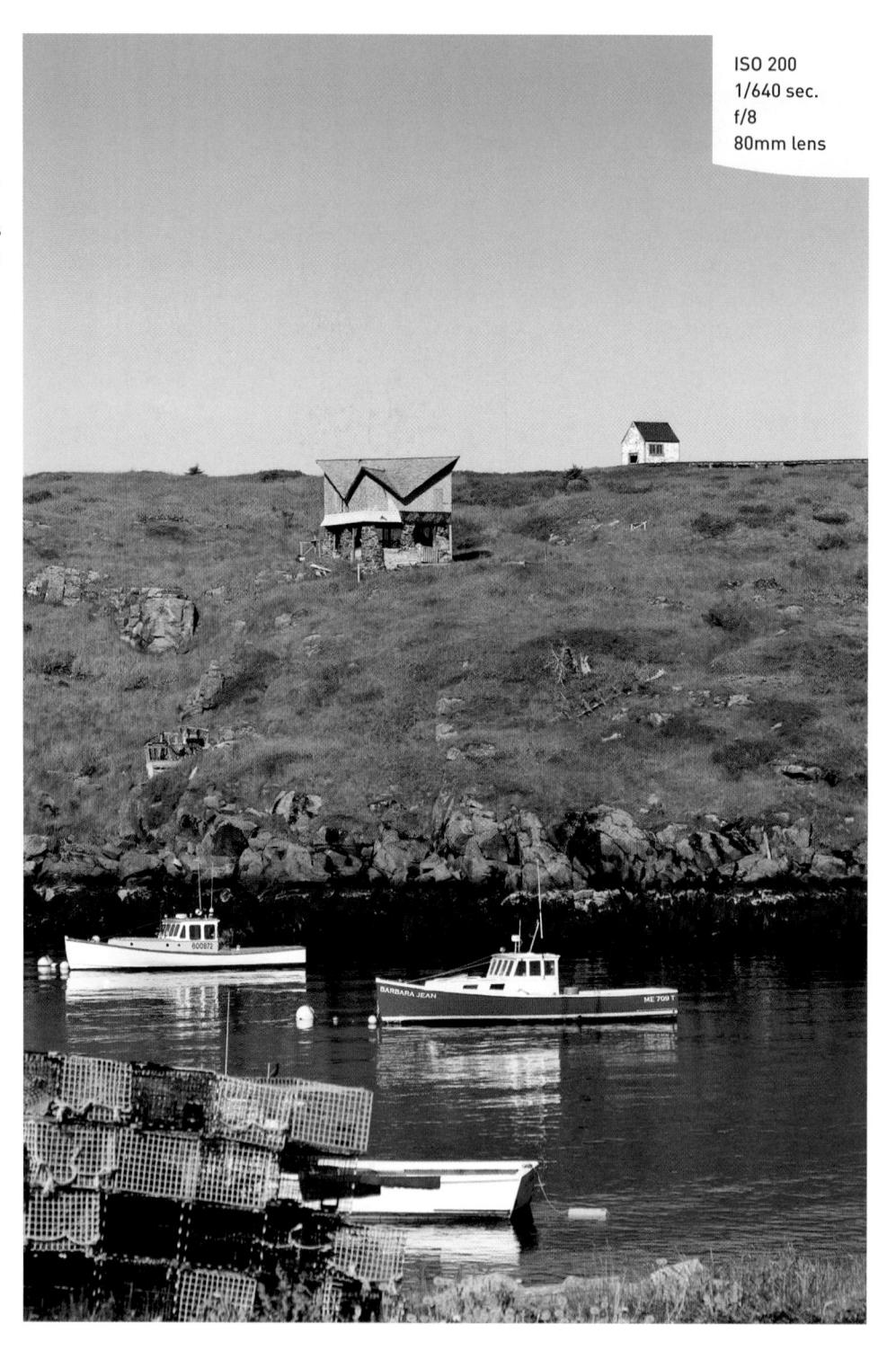

MAKING WATER FLUID

There's little that is quite as satisfying for the landscape shooter as capturing a silky waterfall shot. Creating the smooth-flowing effect is as simple as adjusting your shutter speed to allow the water to be in motion while the shutter is open. The key is to have your camera on a stable platform (such as a tripod) so that you can use a shutter speed that's long enough to work (**Figure 7.17**). To achieve a great effect, use a shutter speed that is at least 1/15 of a second or longer.

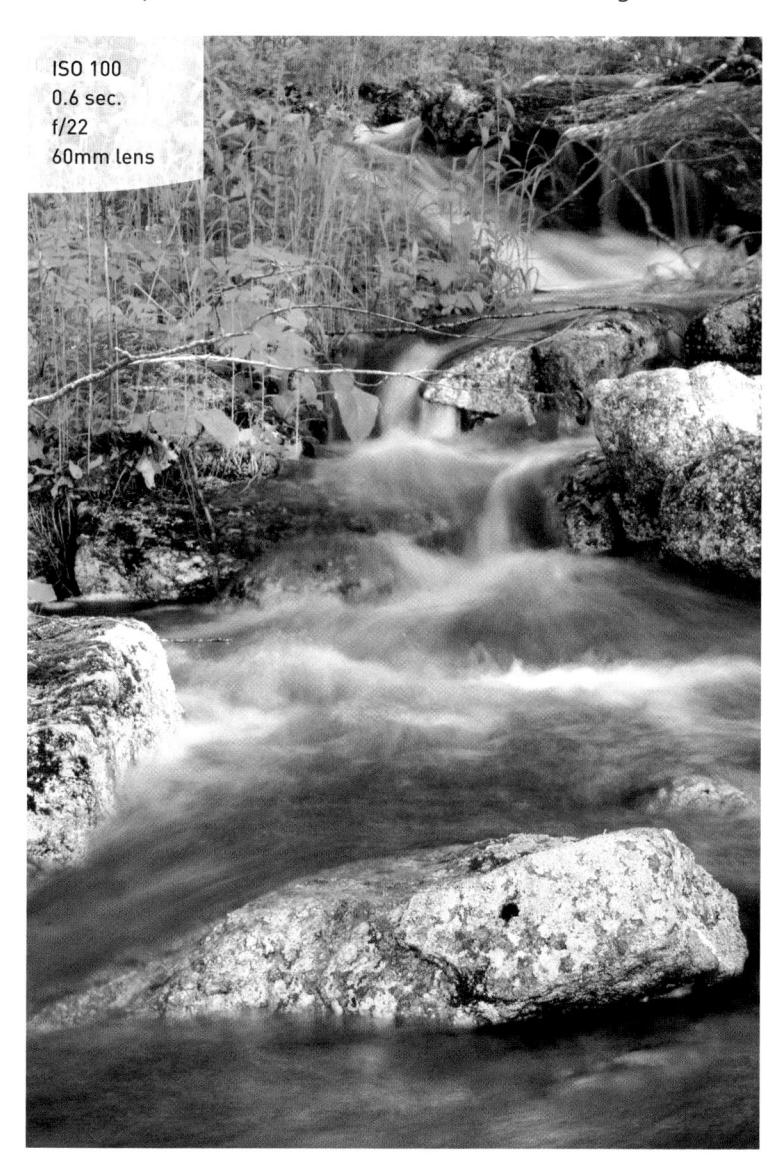

FIGURE 7.17
This stream was in the shade of the forest, but it was still pretty bright, so using f/22 allowed me to get the slower shutter speed I needed.

SETTING UP FOR A WATERFALL SHOT

- 1. Attach the camera to your tripod, then compose and focus your shot.
- 2. Make sure the ISO is set to 100.
- 3. Using Aperture Priority mode, set your aperture to the smallest opening (such as f/22 or f/36).
- 4. Press the shutter button halfway so the camera takes a meter reading.
- **5.** Check to see if the shutter speed is 1/15 of a second or slower.
- 6. Take a photo and then check the image on the LCD.

You can also use Shutter Priority mode for this effect by dialing in the desired shutter speed and having the camera set the aperture for you. I prefer to use Aperture Priority to ensure that I have the greatest depth of field possible.

If the water is blinking on the LCD, indicating a loss of detail in the highlights, then use the Exposure Compensation feature (as discussed earlier in this chapter) to bring details back into the waterfall. You will need to have the Highlight Alert feature turned on to check for overexposure (see "How I Shoot" in Chapter 4).

There is a possibility that you will not be able to have a shutter speed that is long enough to capture a smooth, silky effect, especially if you are shooting in bright daylight conditions. To overcome this obstacle, you need a filter for your lens—either a polarizing filter or a neutral density filter. The polarizing filter redirects wavelengths of light to create more vibrant colors, reduce reflections, and darken blue skies; it also lengthens exposure times by about two stops due to the darkness of the filter (this amount can vary depending on the brand of filter used). It is a handy filter for landscape work. The neutral density filter is typically just a dark piece of glass that serves to darken the scene by one, two, or three stops (Figure 7.18). This allows you to use slower shutter speeds during bright conditions. Think of it as sunglasses for your camera lens. You will find more discussion on filters in the bonus chapter, "Pimp My Ride."

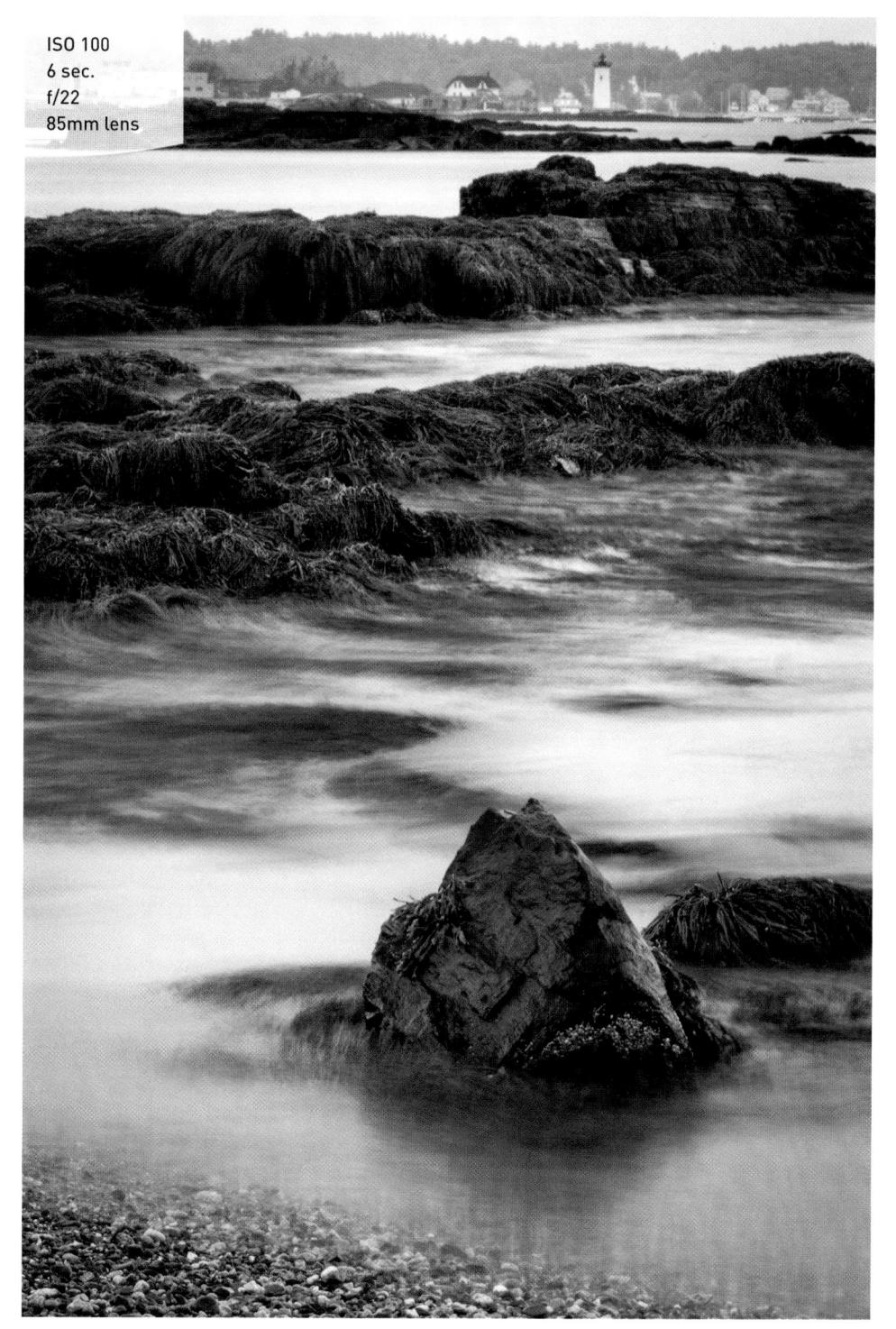

FIGURE 7.18 I used a neutral density filter to add two stops of exposure, thus allowing for a longer exposure time.

DIRECTING THE VIEWER: A WORD ABOUT COMPOSITION

As a photographer, it's your job to lead the viewer through your image. You accomplish this by utilizing the principles of composition, which is the arrangement of elements in the scene that draw the viewer's eyes through your image and holds their attention. As the director of this viewing, you need to understand how people see, and then use that information to focus their attention on the most important elements in your image.

There is a general order at which we look at elements in a photograph. The first is brightness. The eye wants to travel to the brightest object within a scene. So if you have a bright sky, it's probably the first place the eye will travel to. The second order of attention is sharpness. Sharp, detailed elements will get more attention than soft, blurry areas. Finally, the eye will move to vivid colors while leaving the dull, flat colors for last. It is important to know these essentials in order to grab—and keep—the viewer's attention and then direct them through the frame.

In **Figure 7.19**, the eye is drawn to the bright wooden cross at the bottom of the frame. From there, it is pulled toward the contrast of the dark crow perched on top. The eye moves upward to the bright moon, then down to the sharpness and color of the flowers and grass that are anchoring the lower portion of the image. The elements within the image all help to keep the eye moving but never leave the frame.

RULE OF THIRDS

There are, in fact, quite a few philosophies concerning composition. The easiest one to begin with is known as the "rule of thirds." Using this principle, you simply divide your viewfinder into thirds by imagining two horizontal and two vertical lines that divide the frame equally.

The key to using this method of composition is to have your main subject located at or near one of the intersecting points (Figure 7.20).

By placing your subject near these intersecting lines, you are giving the viewer space to move within the frame. The one thing you don't want to do is place your subject smack dab in the middle of the frame. This is sometimes referred to as "bull's eye" composition, and it requires the right subject matter for it to work. It's not always wrong, but it will usually be less appealing and may not hold the viewer's attention.

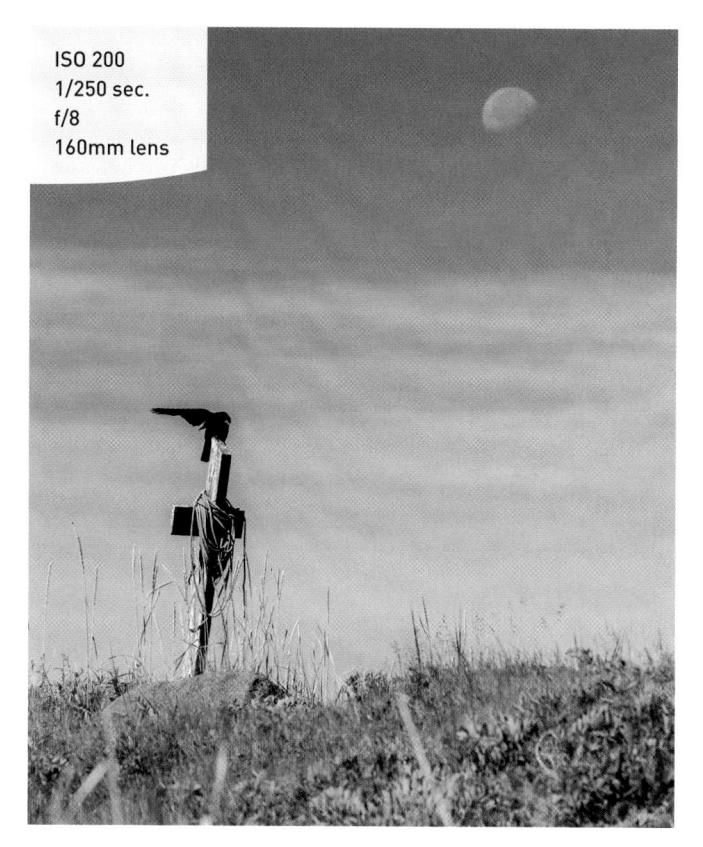

FIGURE 7.19
The composition of
the elements pulls
the viewer's eyes
around the image,
leading from one
element to the next
in a circular pattern.

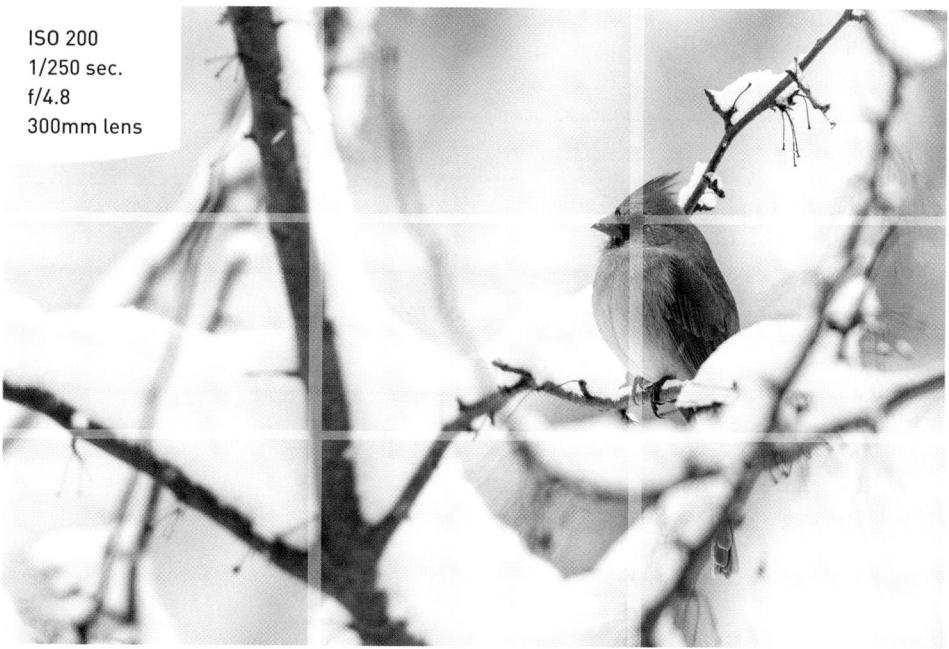

FIGURE 7.20
Placing the cardinal in the right portion of the image, with her eye at the junction of the lines, creates a much more interesting composition than having her dead center in the frame.

Speaking of the middle of the frame: The other general rule of thirds deals with horizon lines. Generally speaking, you should position the horizon one third of the way up or down in the frame. Splitting the frame in half by placing your horizon in the middle of the picture is akin to placing the subject in the middle of the frame; it doesn't lend a sense of importance to either the sky or the ground.

The D3200 has a visual tool for assisting you in composing your photo in the view-finder in the form of a grid overlay. The grid can be turned on when using the Live View mode so that a 3 x 3 grid appears in the viewfinder. This won't necessarily help in aligning your scene in thirds, but it will assist you keeping your horizons straight as well as giving you some visual alignment cues.

USING A GRID OVERLAY IN LIVE VIEW MODE

- 1. Activate Live View by pressing the Live View button on the back of the camera.
- 2. Press the info button on the top of the camera to change the display mode on the Live View screen. There are three different display modes, so keep pressing the button until you see the grid.

CREATING DEPTH

Because a photograph is a flat, two-dimensional space, you need to create a sense of depth by using the elements in the scene to create a three-dimensional feel. This is accomplished by including different and distinct spaces for the eye to travel: foreground, middle ground, and background. By using these three spaces, you draw the viewer in and render depth to your image.

The view through Mesa Arch, shown in **Figure 7.21**, illustrates this well. The arch strongly defines the foreground area. The nearest mesa defines the middle ground, and the mesas receding into the background draw the eye into the distance.

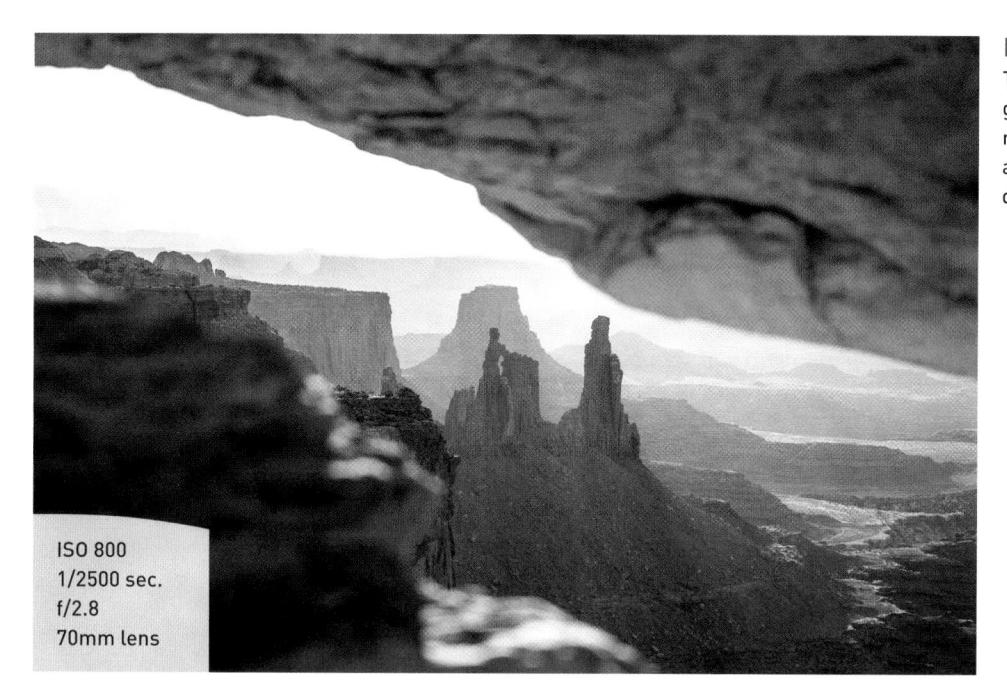

FIGURE 7.21
The strong foreground arch and
receding mesas
add to the feeling of
depth in the image.

ADVANCED TECHNIQUES TO EXPLORE

This section comes with a warning attached. All of the techniques and topics up to this point have been centered on your camera. The following two sections, covering panoramas and high dynamic range (HDR) images, require you to use image-processing software to complete the photograph. They are, however, important enough that you should know how to correctly shoot for success should you choose to explore these two popular techniques.

SHOOTING PANORAMAS

If you have ever visited the Grand Canyon, you know just how large and wide open it truly is—so much so that it would be difficult to capture its splendor in just one frame. The same can be said for a mountain range or a cityscape or any extremely wide vista. There are two methods that you can use to capture the feeling of this type of scene.

THE "FAKE" PANORAMA

The first method is to shoot with your lens set to its widest focal length, and then crop out the top and bottom portion of the frame in your imaging software.

Panoramic images are generally two or three times wider than a normal image.

CREATING A FAKE PANORAMA

- 1. To create the look of the panorama, find your widest lens focal length. In my case, it might be the 18mm setting on the 18–55mm AF-S kit lens.
- 2. Using the guidelines discussed earlier in the chapter, compose and focus your scene, and select the smallest aperture possible.
- **3.** Shoot your image using whichever technique and shooting mode you desire. That's all there is to it, from a photography standpoint.
- **4.** Then, open the image in your favorite image-processing software and crop the extraneous foreground and sky from the image, leaving you with a wide panorama of the scene.

Figure 7.22 shows an example using a photo taken in Alaska.

As you can see, the image was shot with a wide perspective, using an 18mm lens. While it is not a bad photo, it lacks visual impact. This isn't a problem, though, because it was shot for the express purpose of creating a "fake" panorama. Now look at the same image, cropped for panoramic view (Figure 7.23). As you can see, it makes a huge difference in the image and gives much higher visual impact by reducing the uninteresting foreground as well as the sky, and it draws your eyes across the length of the horizon.

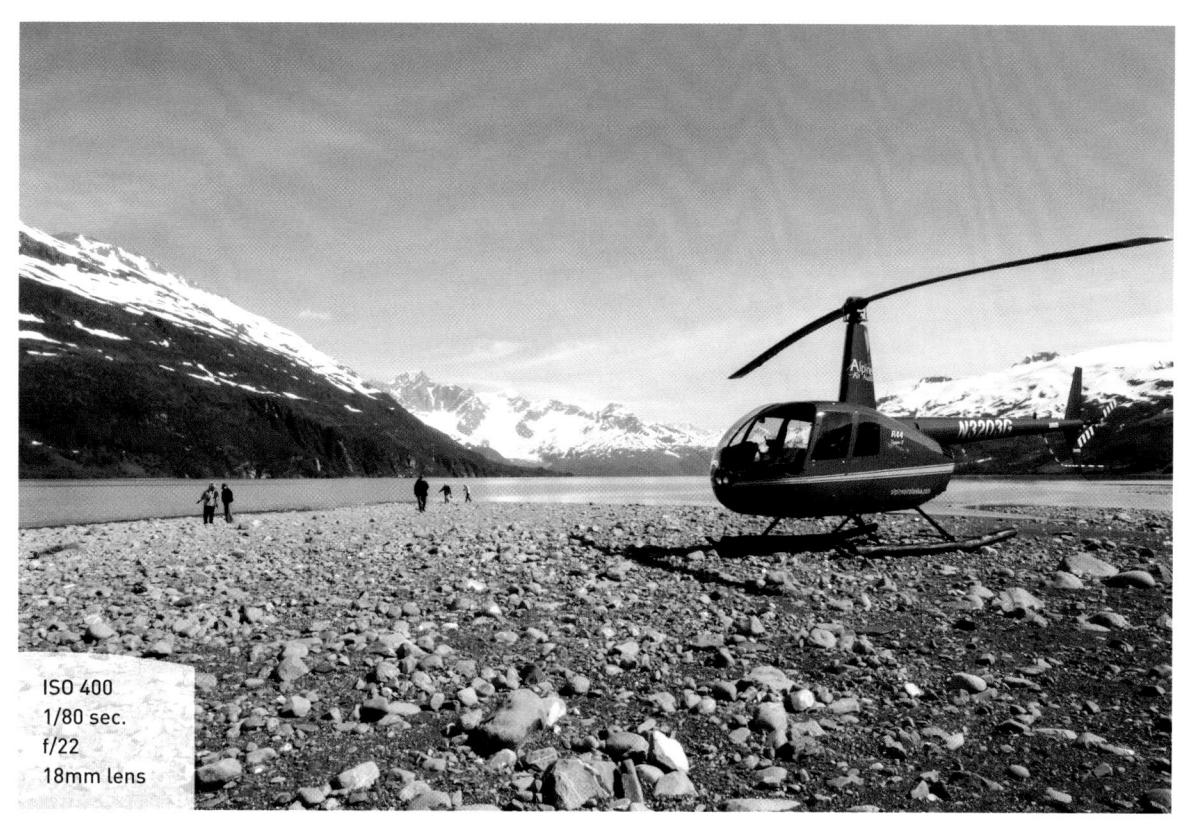

FIGURE 7.22 This is a nice image, but it lacks visual impact.

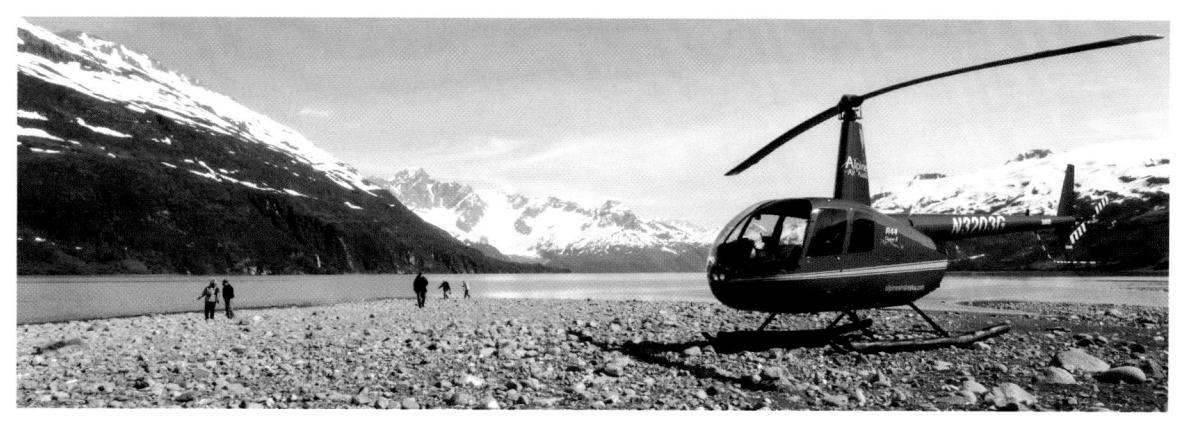

FIGURE 7.23 Cropping gives the feeling of a sweeping vista and makes the shot visually appealing.

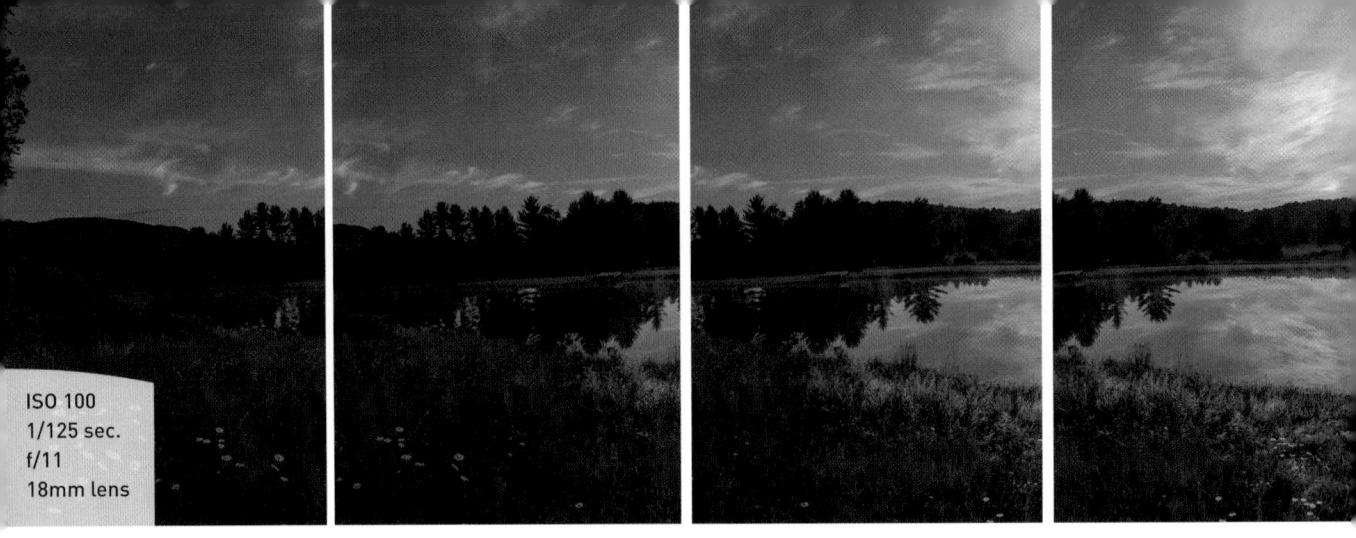

FIGURE 7.24

Here you see the makings of a panorama, with eight shots overlapping by about 30 percent from frame to frame.

THE MULTIPLE-IMAGE PANORAMA

The reason the previous method is sometimes referred to as a "fake" panorama is because it is made with a standard-size frame and then cropped down to a narrow perspective. To shoot a true panorama, you need to use either a special panorama camera that shoots a very wide frame, or the following method, which requires the combining of multiple frames.

The multiple-image pano has gained in popularity in the past few years; this is principally due to advances in image-processing software. Many software options are available now that will take multiple images, align them, and then "stitch" them into a single panoramic image. The real key to shooting a multiple-image pano is to overlap your shots by about 30 percent from one frame to the next (Figures 7.24 and 7.25). It is possible to handhold the camera while capturing your images, but the best method for capturing great panoramic images is to use a tripod.

Now that you have your series of overlapping images, you can import them into your image-processing software to stitch them together and create a single panoramic image.

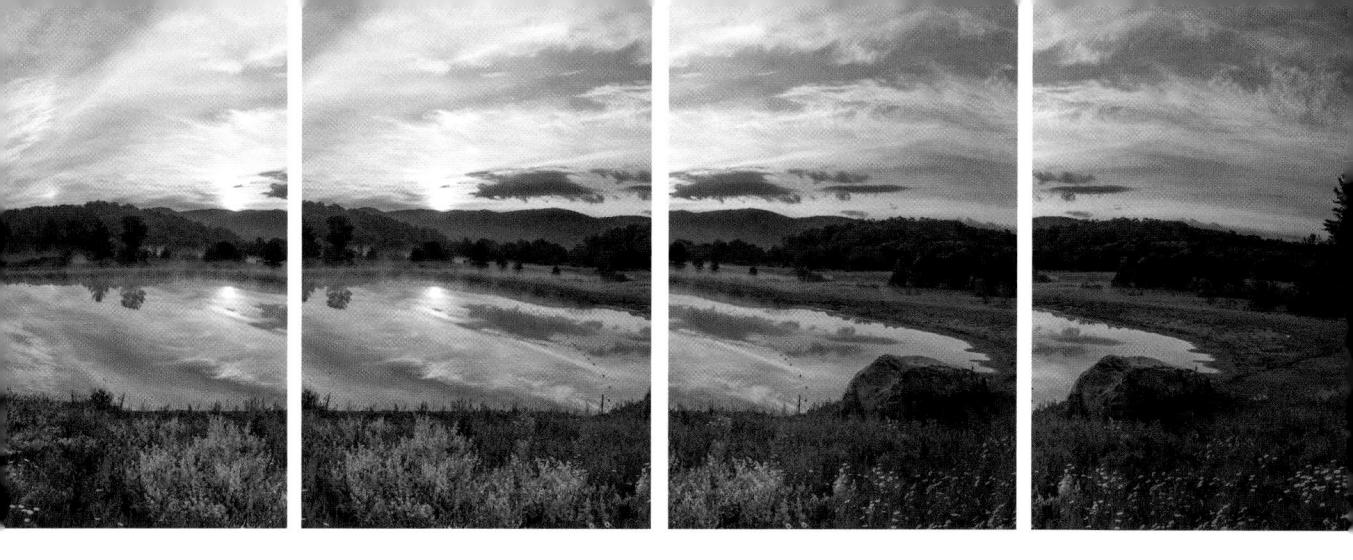

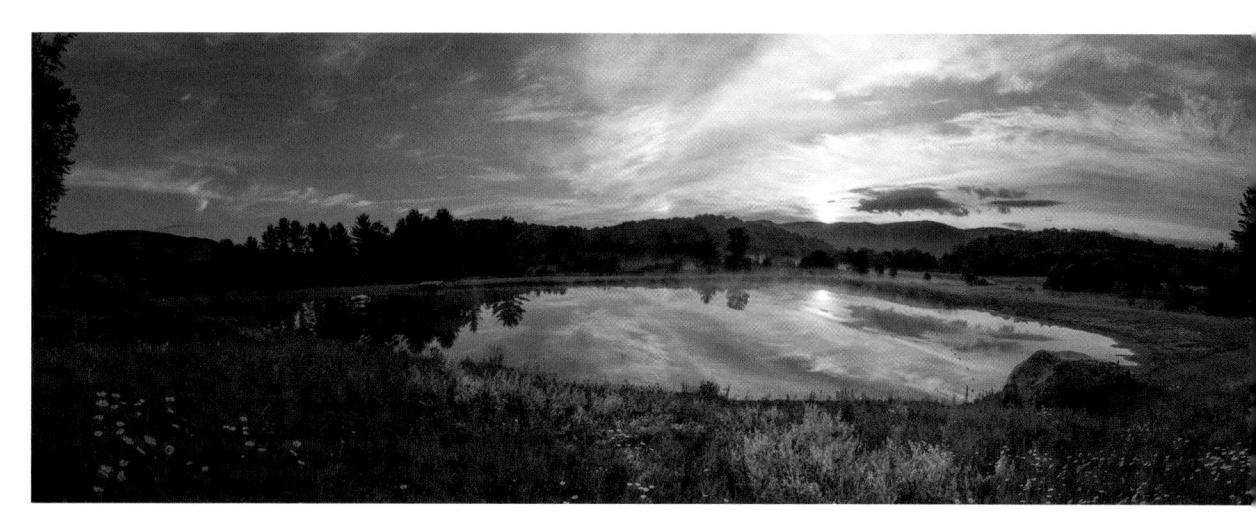

FIGURE 7.25
I used Adobe Photoshop to combine all of the exposures into one large panoramic image.

SHOOTING PROPERLY FOR A MULTIPLE-IMAGE PANORAMA

- 1. Mount your camera on your tripod and make sure it is level.
- Choose a focal length for your lens that is somewhere between 35mm and 50mm.
- 3. In Aperture Priority mode, use a very small aperture for the greatest depth of field. Take a meter reading of a bright part of the scene, and make note of it.
- **4.** Now change your camera to Manual mode (M), and dial in the aperture and shutter speed that you obtained in the previous step.
- 5. Set your lens to manual focus, and then focus your lens for the area of interest using the HFD method of finding a point one-third of the way into the scene. (If you use the autofocus, you risk getting different points of focus from image to image, which will make the image stitching more difficult for the software.)
- **6.** While carefully panning your camera, shoot your images to cover the entire area of the scene from one end to the other, leaving a 30 percent overlap from one frame to the next.
- **7.** For the final step, use your favorite imaging software to combine all of the photographs into a single panoramic image.

SORTING YOUR SHOTS FOR THE MULTI-IMAGE PANORAMA

If you shoot more than one series of shots for your panoramas, it can sometimes be difficult to know when one series of images ends and the other begins. Here is a quick tip for separating your images.

Set up your camera using the steps listed here. Now, before you take your first good exposure in the series, hold up one finger in front of the camera and take a shot. Now move your hand away and begin taking your overlapping images. When you have taken your last shot, hold two fingers in front of the camera and take another shot.

Now, when you go to review your images, use the series of shots that falls between the frames with one and two fingers in them. Then just repeat the process for your next panorama series.

SHOOTING HIGH DYNAMIC RANGE (HDR) IMAGES

One of the more recent trends in digital photography is the use of high dynamic range (HDR) to capture the full range of tonal values in your final image. When you photograph a scene that has a wide range of tones from shadows to highlights, you typically have to make a decision regarding which tonal values you are going to emphasize, and then adjust your exposure accordingly. This is because your camera has a limited dynamic range, at least as compared to the human eye. HDR photography allows you to capture multiple exposures for the highlights, shadows, and midtones, and then combine them into a single image using software (Figures 7.26 through 7.29). A number of software applications allow you to combine the images and then perform a process called "tonemapping," whereby the complete range of exposures is represented in a single image. I will not be covering the software applications, but I will explore the process of shooting a scene to help you render properly captured images for the HDR process. Note that using a tripod is absolutely necessary for this technique, since you need to have perfect alignment of each image when they are combined.

SETTING UP FOR SHOOTING AN HDR IMAGE

- 1. If possible, set your ISO to 100 to ensure clean, noise-free images.
- 2. Set your program mode to Aperture Priority. During the shooting process, you will be taking three shots of the same scene, creating an overexposed image, an underexposed image, and a normal exposure. Since the camera is going to be adjusting the exposure, you want it to make changes to the shutter speed, not the aperture, so that your depth of field is consistent.
- 3. Set your camera file format to RAW. This is extremely important because the RAW format contains a much larger range of exposure values than a JPEG file, and the HDR software needs this information.
- **4.** Focus the camera using the manual focus method discussed earlier in the chapter, compose your shot, and secure the tripod.
- **5.** Press the shutter button halfway to activate the meter and the set your exposure.
- **6.** Press the Exposure Compensation button and turn the Command dial six clicks to the right to get your first exposure of –2 stops. Take one photo.
- 7. Now press the Exposure Compensation button again and turn the Command dial six clicks to the left and take a picture. This will put the camera back to the normal exposure setting.
- **8.** Finally, repeat the last step and go six more clicks to the left and take a photo to get your two-stop overexposure.

 $\label{eq:figure_figure} FIGURE~7.26 \\ Under exposing~two~stops~will~render~more~detail~in~the~highlight~areas.$

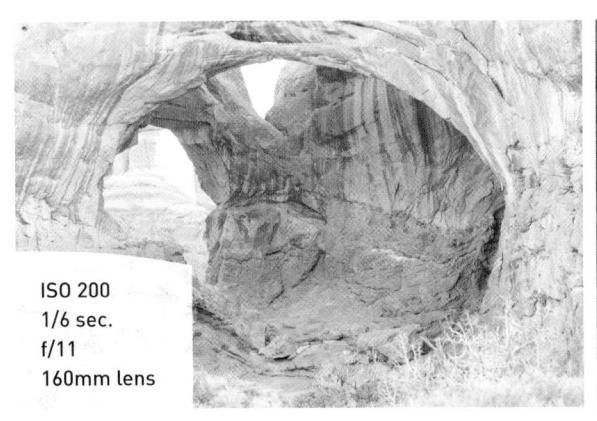

FIGURE 7.28
Overexposing by two stops ensures that the darker areas are exposed for detail in the shadows.

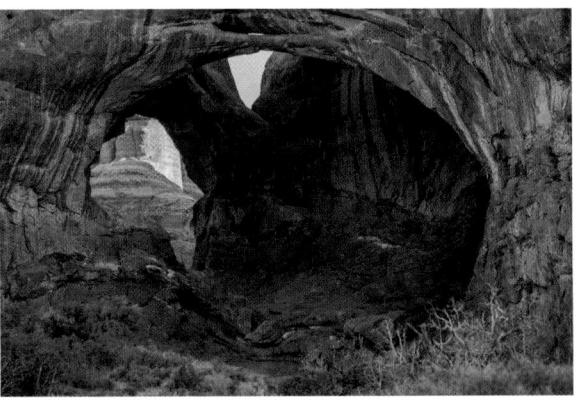

FIGURE 7.29
This is the final HDR image that was rendered from the three other exposures you see here.

A software program, such as Photoshop, Photomatix Pro, or HDR Efex Pro can process your exposure-bracketed images into a single HDR file. You can find more information on HDR photography and creating HDR images in the Tutorials section at www.photowalkpro.com.

Chapter 7 Assignments

We've covered a lot of ground in this chapter, so it's definitely time to put this knowledge to work in order to get familiar with these new camera settings and techniques.

Comparing depth of field: Wide-angle vs. telephoto

Practice using the hyper focal distance of your lens to maximize the depth of field. You can do this by picking a focal length to work with on your lens. If you have a zoom lens, try using the longest length. Compose your image and find an object to focus on. Set your aperture to f/22 and take a photo.

Now do the same thing with the zoom lens at its widest focal length. Use the same aperture and focus point. Review the images and compare the depth of field when using wide-angle lens as opposed to a telephoto lens. Try this again with a large aperture as well.

Applying hyper focal distance to your landscapes

Pick a scene that has objects that are near the camera position and something that is clearly defined in the background. Try using a wide to medium-wide focal length for this (18–35mm). Use a small aperture and focus on the object in the foreground; then recompose and take a shot. Without moving the camera position, use the object in the background as your point of focus and take another shot. Finally, find a point that is one-third of the way into the frame from near to far and use that as the focus point.

Compare all of the images to see which method delivered the greatest range of depth of field from near to infinity.

Placing your horizons

Finally, find a location with a defined horizon, and using the rule-of-thirds grid overlay, shoot the horizon along the top third of the frame, in the middle of the frame, and along the bottom third of the frame.

Share your results with the book's Flickr group!

Join the group here: flickr.com/groups/nikond3200_fromsnapshotstogreatshots

S

1SO 200 1/200 sec. f/11 18mm lens

Mood Lighting

SHOOTING WHEN THE LIGHTS GET LOW

There is no reason to put your camera away when the sun goes down. Your D3200 has some great features that let you work with available light as well as the built-in flash. In this chapter, we will explore ways to push your camera's technology to the limit in order to capture great photos in difficult lighting situations. We will also explore the use of flash and how best to utilize your built-in flash features to improve your photography. But let's first look at working with low-level available light.

PORING OVER THE PICTURE

If you ever have a chance to learn how to paint with light with Dave Black (www.daveblackphotography.com), I highly recommend jumping on the opportunity. All the light you see in this scene came from one very small LED flashlight that I used—during one of Dave's recent classes—to paint different areas of the photo over a 30-second exposure. Illuminating a scene in this way is a great way to learn about using directional light to add interest and dimension to your photographs. Plus, it's a whole lot of fun!

With a table-top scene like this, a 30-second exposure is a good starting point for learning the technique.

Painting with light requires a lot of trial and error as you review previous attempts and look at ways to keep improving your technique.

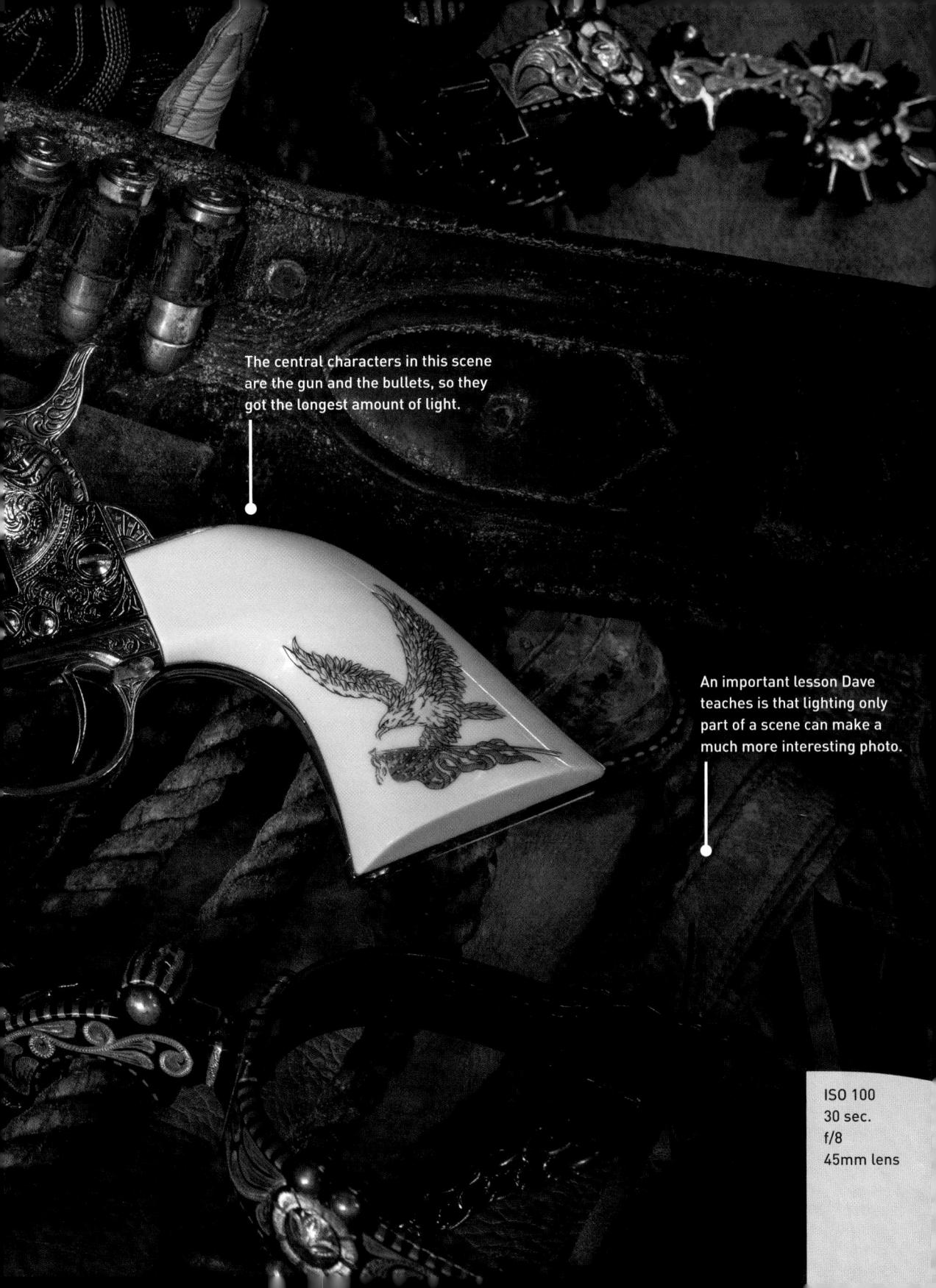

RAISING THE ISO: THE SIMPLE SOLUTION

Let's begin with the obvious way to keep shooting when the lights get low: raising the ISO (Figure 8.1). By now you know how to change the ISO by using the i button and the Multi-selector. In typical shooting situations, you should keep the ISO in the 100–800 range. This will keep your pictures nice and clean by keeping the digital noise to a minimum. But as the available light gets low, you might find yourself working in the higher ranges of the ISO scale, which could lead to more noise in your image.

You could use the flash, but that has a limited range (15–20 feet) that might not work for you. Also, you could be in a situation where flash is prohibited or at least frowned upon, like at a wedding or in a museum.

FIGURE 8.1 The size of the cat's pupils give an indication of how low the light was.

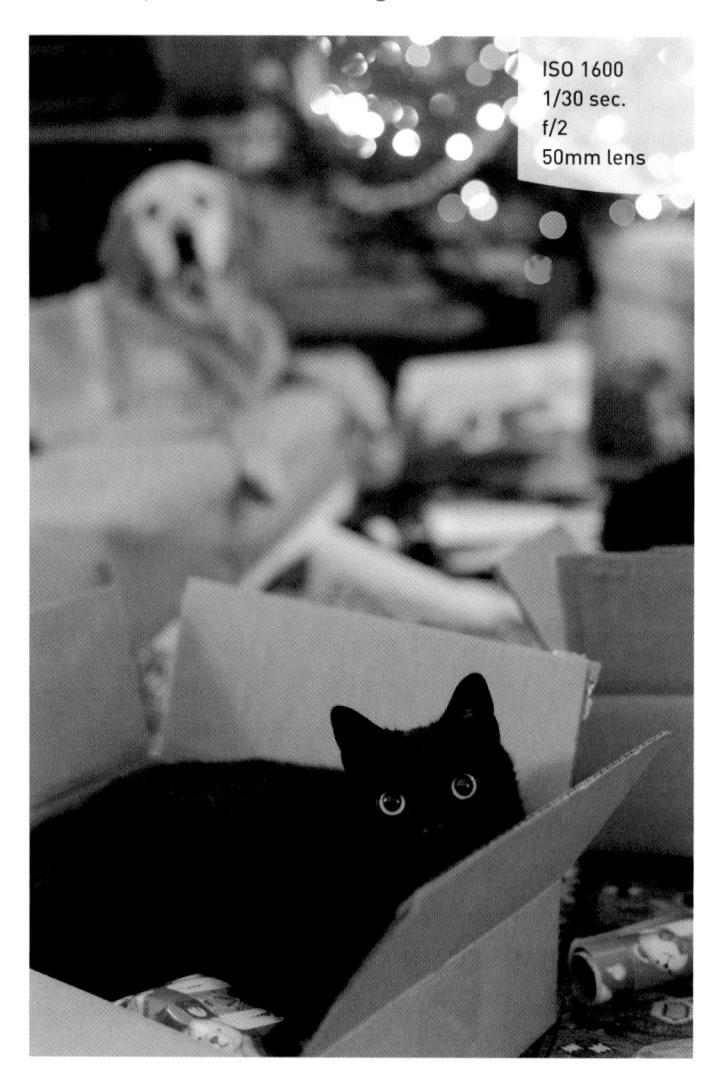

And what about a tripod in combination with a long shutter speed? That is also an option, and we'll cover it a little further into the chapter. The problem with using a tripod and a slow shutter speed in low-light photography, though, is that it performs best when subjects aren't moving. Besides, try to set up a tripod in a museum and see how quickly you grab the attention of the security guards.

So if the only choice to get the shot is to raise the ISO to 800 or higher, make sure that you turn on the Noise Reduction feature. This menu function is set to Off by default, but as you start using higher ISO values you should consider turning it on. (Chapter 7 explains how to set the Noise Reduction features.)

To see the effect of Noise Reduction, you need to zoom in and take a closer look (Figures 8.2 and 8.3).

Turning on the Noise Reduction feature slightly increases the processing time for your images, so if you are shooting in the Continuous drive mode you might see a little reduction in the speed of your frames per second.

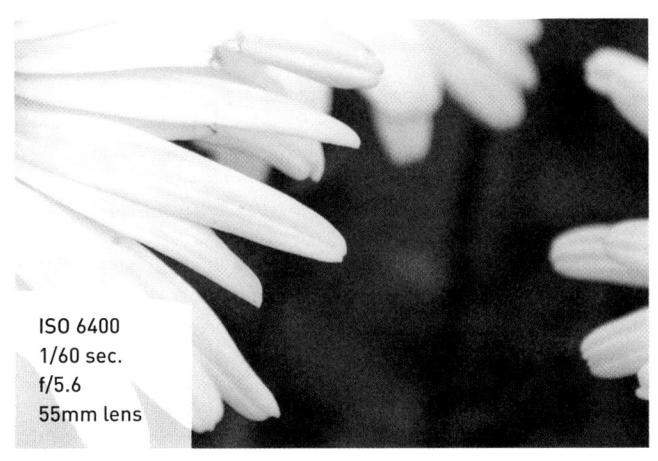

FIGURE 8.2 Here is an enlargement of a flower shot without any Noise Reduction.

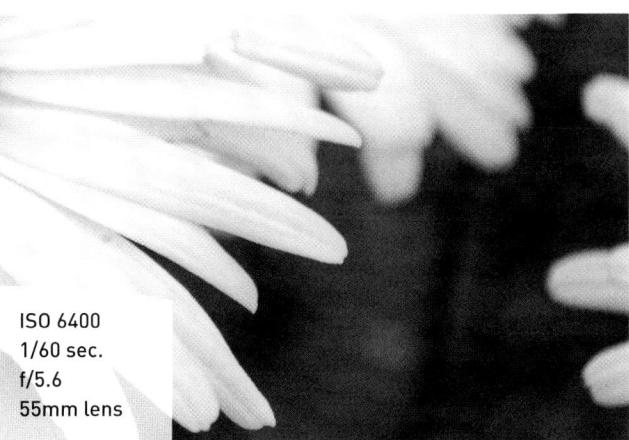

FIGURE 8.3
Here is the same flower photographed with Noise Reduction turned to On.
While it doesn't get rid of all the noise, it certainly reduces the effect and improves the look of your image.

NOISE REDUCTION SAVES SPACE

When shooting at very high ISO settings, running Noise Reduction can save you space on your memory card. If you are saving your photos as JPEGs, the camera will compress the information in the image to take up less space. When you have excessive noise, you can literally add megabytes to the file size. This is because the camera has to deal with more information: It views the noise in the image as photo information and, therefore, tries not to lose that information during the compression process. That means more noise equals bigger files. So not only will turning on the Noise Reduction feature improve the look of your image, it will also save you some space so you can take a few more shots.

USING VERY HIGH ISOS

Is ISO 6400 just not enough for you? Well, in that case, you will need to set your camera to the expanded ISO setting. This setting opens up another stop of ISO, raising the limit to 12800. The new setting will not appear in your ISO scale as a number, but as Hi 1 for 12800.

USING THE HIGHER ISO SETTINGS

- 1. With the information screen active, press the i button to activate the cursor and then use the Multi-selector to place it on the ISO sensitivity setting (A).
- 2. Press the OK button, use the Multi-selector to scroll down through the ISO settings until you reach the Hi 1 setting, then press the OK button (B).
- 3. Press the shutter release button to return to active shooting mode.

A word of warning about the expanded ISO setting: Although it is great to have this high ISO setting available during low-light shooting, it should always be your last resort. Even with the Noise Reduction turned on, the amount of visible noise will be very high. But although it should be avoided, you might find yourself at a nighttime sporting event under the lights, which would require a very high ISO to improve your shutter speed enough to capture the action (Figure 8.4).

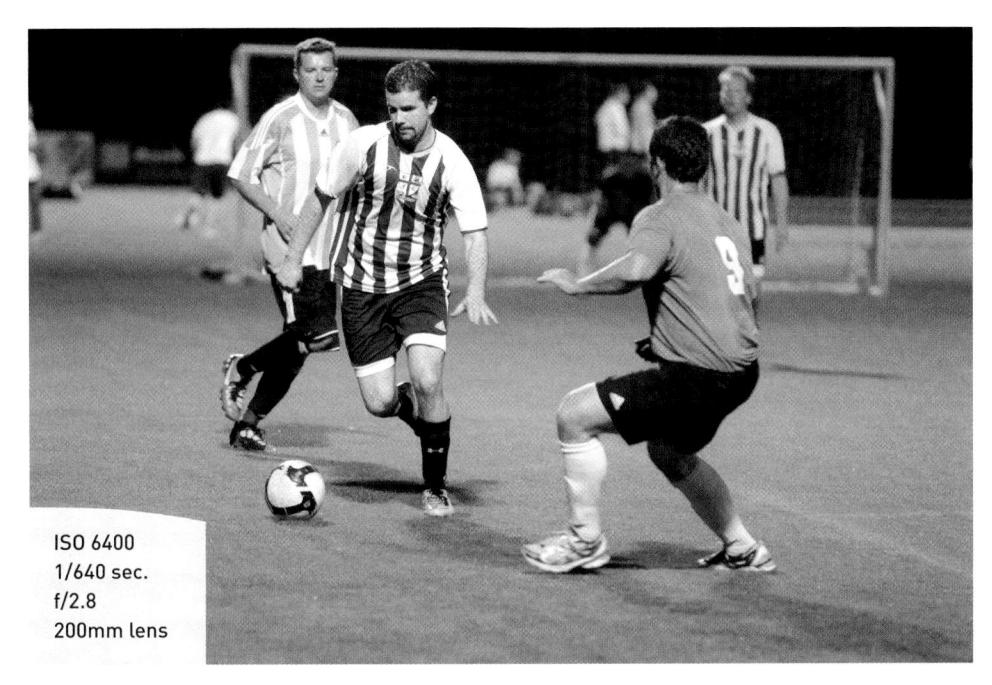

FIGURE 8.4
The only way to get a fast-enough shutter speed during this night soccer game was to raise the ISO to 6400.

STABILIZING THE SITUATION

If you purchased your camera with the Vibration Reduction (VR) lens, you already own a great tool to squeeze two stops of exposure out of your camera when shooting without a tripod. Typically, the average person can handhold their camera down to about 1/60 of a second before blurriness results due to hand shake. As the length of the lens is increased (or zoomed), the ability to handhold at slow shutter speeds (1/60 and slower) and still get sharp images is further reduced (Figure 8.5).

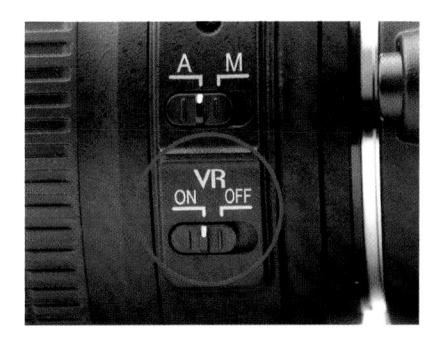

FIGURE 8.5 Turning on the VR switch helps you shoot in low-light conditions.

The Nikon VR lenses contain small gyro sensors and servo-actuated optical elements, which correct for camera shake and stabilize the image. The VR function is so good that it is possible to improve your handheld photography by two or three stops, meaning that if you are pretty solid at a shutter speed of 1/60, the VR feature lets you shoot at 1/15, and possibly even 1/8, of a second (Figures 8.6 and 8.7). When shooting in low-light situations, make sure you set the VR switch on the side of your lens to the On position.

FIGURE 8.6
This image was shot handheld with the VR turned off.

FIGURE 8.7 Here is the same subject shot with the same camera settings, but this time I turned the VR on.

SELF-TIME YOUR WAY TO SHARPER IMAGES

Whether you are shooting with a tripod or even resting your camera on a wall, you can increase the sharpness of your pictures by taking your hands out of the equation. Whenever you use your finger to depress the shutter release button, you are increasing the chance that there will be a little bit of shake in your image. To eliminate this possibility, try setting up your camera to use the self-timer. There are four self-timer modes: 2, 5, 10, and 20 seconds. I generally use the 2-second mode to cut down on time between exposures. If you want to change the timer delay, you will need to go to the Setup Menu under the Self-Timer Delay setting.

FOCUSING IN LOW LIGHT

The D3200 has a great focusing system, but occasionally the light levels might be too low for the camera to achieve an accurate focus. There are a few things that you can do to overcome this obstacle.

First, you should know that the camera utilizes contrast in the viewfinder to establish a point of focus. This is why your camera will not be able to focus when you point it at a white wall or a cloudless sky. It simply can't find any contrast in the scene to work with. Knowing this, you might be able to use a single focus point in AF-S mode to find an area of contrast that is at the same distance as your subject. You can then hold that focus by holding down the shutter button halfway and recomposing your image.

Then there are those times when there just isn't anything there for you to focus on. A perfect example of this would be a fireworks display or a starry sky. If you point your lens to the night sky in any automatic focus (AF) mode, it will just keep searching for—and not finding—a focus point. On these occasions, you can simply turn off the autofocus feature and manually focus the lens (Figure 8.8). Look for the A/M switch on the side of the lens and slide it to the M position.

Don't forget to put it back in A mode at the end of your shoot.

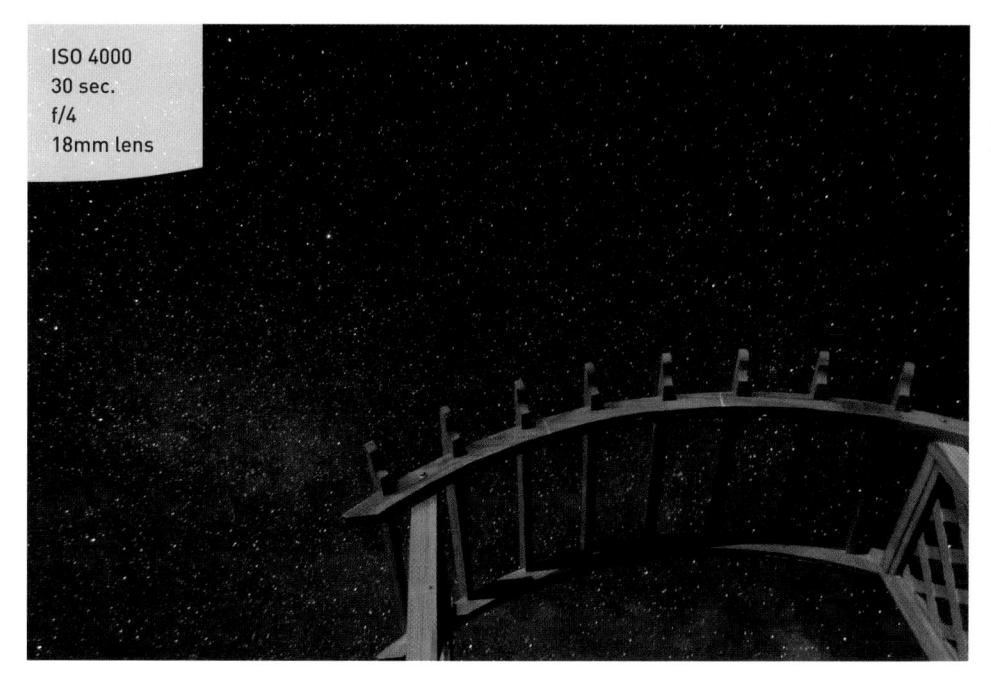

FIGURE 8.8 Focusing on the night sky is best done in Manual focus mode.

AF ASSIST

Another way to ensure good focus is to use the D3200's AF Assist. AF Assist uses a small, bright beam of light from the front of the camera to shine some light on the scene, which assists the autofocus system in locating more detail. This feature is automatically activated when using the flash (except in Landscape, Sports, and Flash Off modes, for the following reasons: In Landscape mode, the subject is usually too far away; in Sports mode, the subject is probably moving; and in Flash Off mode, you've disabled the flash entirely). Also, AF Assist will be disabled when shooting in the AF-C or Manual focus mode, as well as when the feature is turned off in the camera menu. If you are using the Single or Dynamic AF modes, you must be using the center focus point or the light will not activate. The AF Assist should be enabled by default, but you can check the menu just to make sure.

TURNING ON THE AF ASSIST FEATURE

- 1. Press the Menu button and access the Shooting Menu.
- Navigate to the item called Built-in AF-assist illuminator, and press the OK button (A).
- 3. Set the option to On and press the OK button to complete the setup (B).

DISABLING THE FLASH

If you are shooting in one of the automatic scene modes, the flash might be set to activate automatically. If you don't wish to operate the flash, you will have to turn it off in the information screen.

DISABLING THE FLASH

- 1. Press the i button to activate the cursor in the information screen, and use the Multi-selector to select the Flash mode item (located in the lower-left portion of the screen) (A).
- 2. Press OK and then use the Multi-selector to find the option that turns off the flash (look for the lightning bolt with the circle and slash) (B).
- 3. Press OK, and then make sure the pop-up flash is in the down position before shooting.

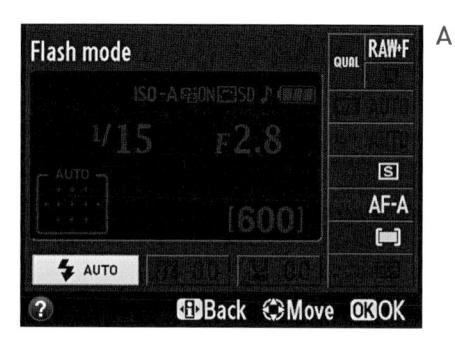

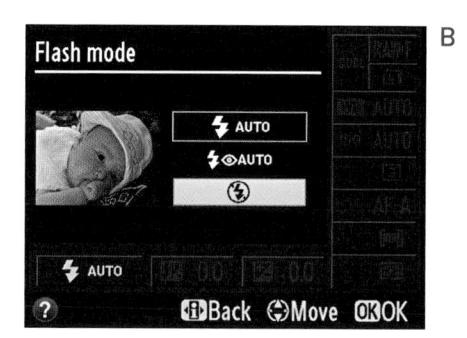

To disable the flash in the professional modes, simply keep the flash head in the lowered position. It will not be active unless you raise it.

SHOOTING LONG EXPOSURES

We have covered some of the techniques for shooting in low light, so let's go through the process of capturing a night or low-light scene for maximum image quality (**Figure 8.9**). The first thing to consider is that in order to shoot in low light with a low ISO, you will need to use shutter speeds that are longer than you could possibly handhold (longer than 1/15 of a second). This will require the use of a tripod or stable surface for you to place your camera on. For maximum quality, the ISO should be low—somewhere at or below 400. The noise reduction should be turned on to minimize the effects of exposing for longer durations. (To set this up, see Chapter 7.)

Once you have the noise reduction turned on, set your camera to Aperture Priority (A) mode. That way, you can concentrate on the aperture that you believe is most appropriate and let the camera determine the best shutter speed. If it is too dark for the autofocus to function properly, try manually focusing. Finally, consider using a remote switch (see the bonus chapter, "Pimp My Ride") to activate the shutter. If you don't have one, check out the sidebar "Self-time Your Way to Sharper Images,"

earlier in this chapter. Once you shoot the image, you may notice some lag time before it is displayed on the rear LCD. This is due to the noise reduction process, which can take anywhere from a fraction of a second up to 30 seconds, depending on the length of the exposure. Typically, the noise reduction process will take the same amount of time as the exposure itself.

FIGURE 8.9
A long exposure
and a tripod were
necessary to
catch the lights of
the cars streaking through town
at night. The
small aperture is
responsible for the
starburst effect on
the streetlights.

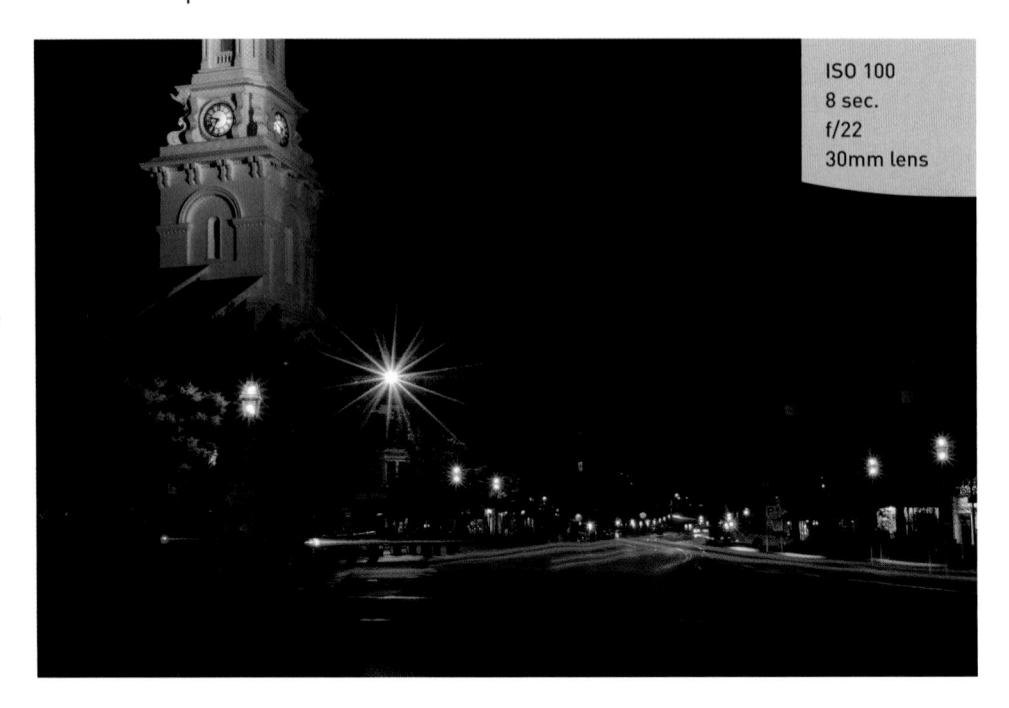

FLASH SYNC

The basic idea behind the term *flash synchronization* (*flash sync* for short) is that when you take a photograph using the flash, the camera needs to ensure that the shutter is fully open at the time that the flash goes off. This is not an issue if you are using a long shutter speed such as 1/15 of a second but does become more critical for fast shutter speeds. To ensure that the flash and shutter are synchronized so that the flash is going off while the shutter is open, the D3200 implements a top sync speed of 1/200 of a second. This means that when you are using the flash, you will not be able to have your shutter speed be any faster than 1/200. If you did use a faster shutter speed, the shutter would actually start closing before the flash fired, which would cause a black area to appear in the frame where the light from the flash was blocked by the shutter.

USING THE BUILT-IN FLASH

There will be times when you have to turn to your camera's built-in flash to get the shot. The pop-up flash on the D3200 is not extremely powerful, but with the camera's advanced metering system it does a pretty good job of lighting up the night...or just filling in the shadows.

If you are working with one of the automatic scene modes, the flash should automatically activate when needed. If, however, you are working in one of the professional modes, you will have to turn the flash on for yourself. To do this, just press the popup flash button located on the front of the camera (**Figure 8.10**). Once the flash is up, it is ready to go (**Figure 8.11**). It's that simple.

FIGURE 8.10
A quick press of the pop-up flash button will release the built-in flash up to its ready position

FIGURE 8.11 The pop-up flash in its ready position.

FLASH RANGE

Because the pop-up flash is fairly small, it does not have enough power to illuminate a large space (Figure 8.12). The effective distance varies depending on the aperture and ISO setting. At ISO 200 and f/4, the range is about 13 feet. This range can be extended to as far as 27 feet by using a wider aperture or higher ISO setting. For the best image quality, your ISO setting should not go above 800. Anything higher will begin to introduce excessive noise into your photos. Check out page 50 of your PDF manual for a chart that shows the effective flash range for differing ISO and aperture settings.

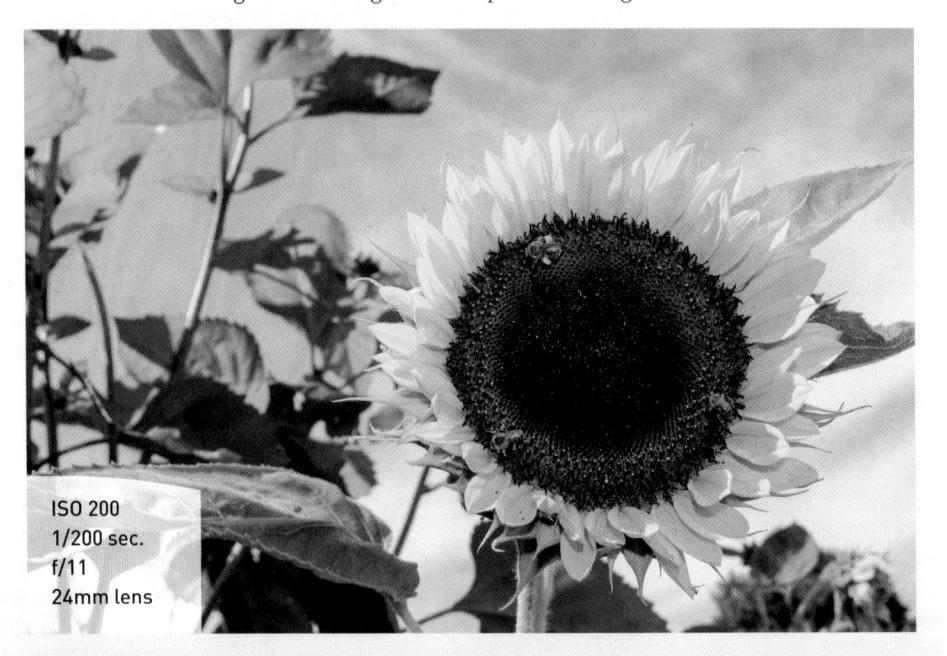

FIGURE 8.12

The pop-up flash was used as a fill flash to illuminate the front of the sunflower. This is very handy when you are shooting with the sun coming in from behind your subject.
SHUTTER SPEEDS

The standard flash synchronization speed for your camera is between 1/60 and 1/200 of a second. When you are working with the built-in flash in the automatic and scene modes, the camera will typically use a shutter speed of 1/60 of a second. The exception to this is when you use the Night Portrait mode, which will fire the flash with a slower shutter speed so that some of the ambient light in the scene has time to record in the image.

The real key to using the flash to get great pictures is to control the shutter speed. The goal is to balance the light from the flash with the existing light so that everything in the picture has an even illumination. Let's take a look at the shutter speeds for the professional modes.

Program (P): The shutter speed stays at 1/60 of a second. The only adjustment you can make in this mode is overexposure or underexposure using the exposure compensation setting or flash compensation settings.

Shutter Priority (S): You can adjust the shutter speed to as fast as 1/200 of a second all the way down to 30 seconds. The lens aperture will adjust accordingly, but at long exposures the lens will typically be set to its smallest aperture.

Aperture Priority (A): This mode will allow you to adjust the aperture but will adjust the shutter speed between 1/200 and 1/60 of a second in the standard flash mode.

METERING MODES

The built-in flash uses a technology called TTL (Through The Lens) metering to determine the appropriate amount of flash power to output for a good exposure. When you depress the shutter button, the camera quickly adjusts focus while gathering information from the entire scene to measure the amount of ambient light. As you press the shutter button down completely, the flash uses that exposure information and fires a predetermined amount of light at your subject during the exposure.

The default setting for the flash meter mode is TTL. The meter can also be set to Manual mode. In Manual flash mode, you can determine how much power you want coming out of the flash, ranging from full power all the way down to 1/32 power. Each setting from full power on down will cut the power by half. This is the equivalent of reducing flash exposure by one stop with each power reduction.

SETTING THE FLASH TO THE MANUAL POWER SETTING

- 1. Press the Menu button and then navigate to the Shooting Menu.
- Using the Multi-selector, highlight the item labeled Flash cntrl for built-in flash, and press the OK button (A).
- 3. Change the setting to Manual (B), press the OK button to adjust the desired power—Full, ½, ¼, and so on—and then press the OK button (C).

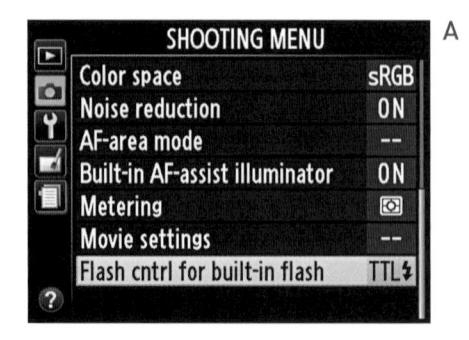

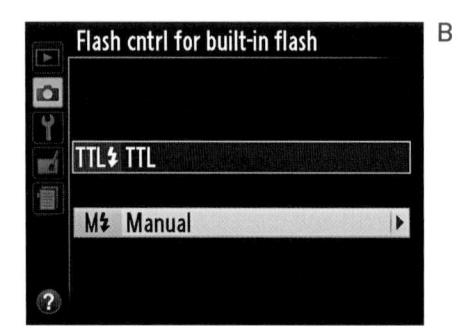

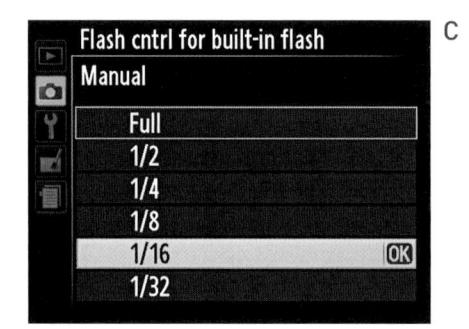

Don't forget to set it back to TTL when you are done, because the camera will hold this setting until you change it.

COMPENSATING FOR THE FLASH EXPOSURE

The TTL system will usually do an excellent job of balancing the flash and ambient light for your exposure, but it does have the limitation of not knowing what effect you want in your image. You may want more or less flash in a particular shot. You can achieve this by using the Flash Exposure Compensation feature.

Just as with exposure compensation, flash compensation allows you to dial in a change in the flash output in increments of 1/3 of a stop. You will probably use this most often to tone down the effects of your flash, especially when you are using the flash as a subtle fill light (**Figures 8.13** and **8.14**). The range of compensation goes from +1 stop down to -3 stops.

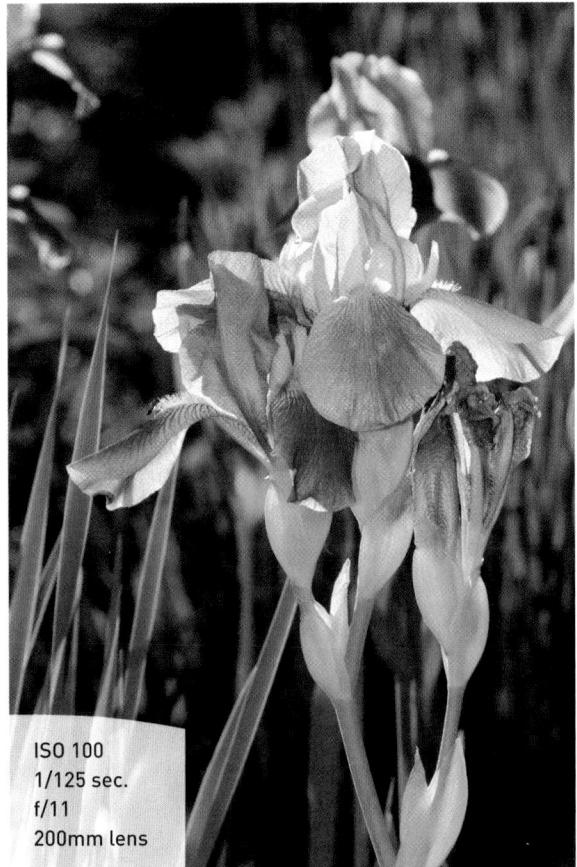

FIGURE 8.13
This shot was taken with the pop-up flash set to normal power. As you can see, it was trying too hard to illuminate my subject.

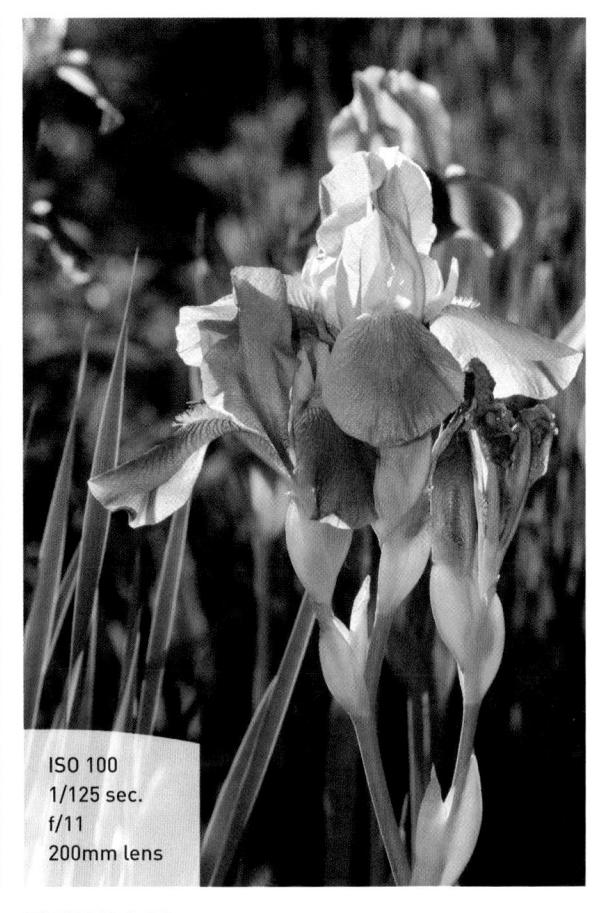

FIGURE 8.14
This image was made with the same camera settings.
The difference is that the flash compensation was set to -1.3 stops.

USING THE FLASH EXPOSURE COMPENSATION FEATURE TO CHANGE THE FLASH OUTPUT

- 1. With the flash in the upright and ready position, press and hold the flash compensation and exposure compensation buttons at the same time.
- 2. While holding down these two buttons, rotate the Command dial to set the amount of compensation you desire. Turning to the right reduces the flash power 1/3 of a stop with each click of the dial. Turning left increases the flash power.
- **3.** Press the shutter button halfway to return to shooting mode, and then take the picture.

4. Review your image to see if more or less flash compensation is required, and repeat these steps as necessary.

You can also change the flash compensation by using the information screen on the back of the camera.

ADJUSTING THE FLASH COMPENSATION USING THE INFORMATION SCREEN

- 1. Press the i button to activate the cursor in the information screen, and use the Multi-selector to set it to the Flash compensation item (located along the bottom portion of the screen) (A).
- 2. Press the OK button, use the Multi-selector to select the amount of compensation, and then press the OK button again (B).

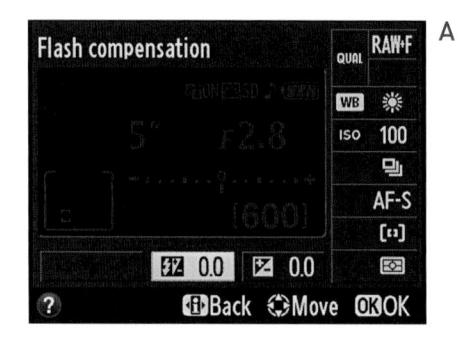

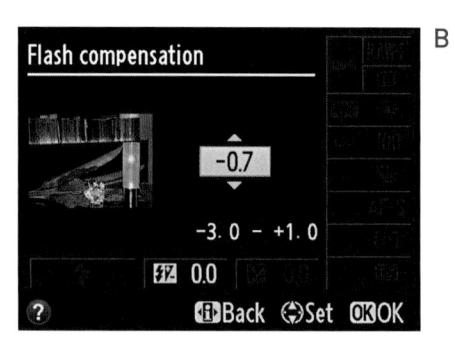

The Flash Exposure Compensation feature does not reset itself when the camera is turned off, so whatever compensation you have set will remain in effect until you change it. Your only clue to knowing that the flash output is changed will be the presence of the Flash Exposure Compensation symbol in the viewfinder. It will disappear when there is zero compensation set.

REDUCING RED-EYE

We've all seen the result of using on-camera flashes when shooting people: the dreaded red-eye! This demonic effect is the result of the light from the flash entering the pupil and then reflecting back as an eerie red glow. The closer the flash is to the lens, the greater the chance that you will get red-eye. This is especially true when it is dark and the subject's pupils are fully dilated. There are two ways to combat this problem. The first is to get the flash away from the lens. That's not really an option, though, if you are using the pop-up flash. Therefore, you will need to turn to the Red-Eye Reduction feature.

This is a simple feature that shines a light from the camera at the subject, causing their pupils to shrink, thus eliminating or reducing the effects of red-eye (Figure 8.15).

The feature is set to Off by default and needs to be turned on by using the information screen or by using a combination of the flash button and the Command dial.

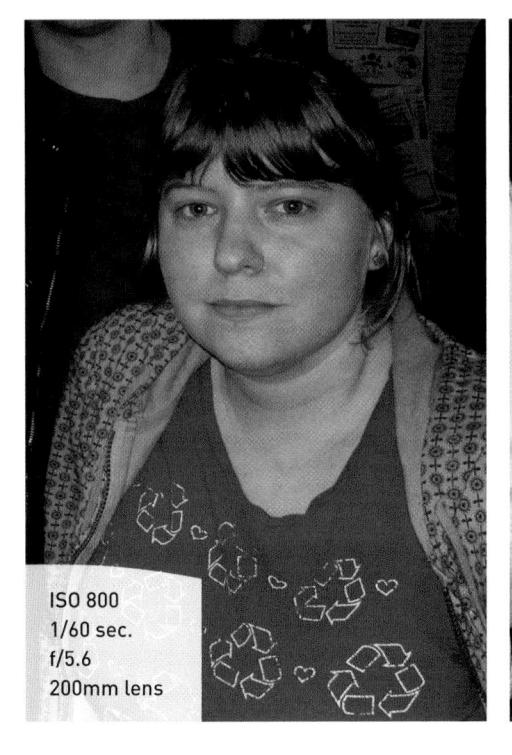

FIGURE 8.15
The picture on the left did not utilize red-eye reduction, thus the glowing red eyes. Notice that the pupils on the image on the right, without redeye, are smaller as a result of using the red-eye reduction lamp.

TURN ON THE LIGHTS!

When you're shooting indoors, another way to reduce red-eye—or just shorten the length of time that the reduction lamp needs to be shining into your subject's eyes—is to turn on a lot of lights. The brighter the ambient light levels, the smaller the subject's pupils will be. This will reduce the time necessary for the red-eye reduction lamp to shine. It will also allow you to take more candid pictures because your subjects won't be required to stare at the red-eye lamp while waiting for their pupils to reduce.

TURNING ON THE RED-EYE REDUCTION FEATURE

- 1. Press the i button to activate the cursor in the information screen and use the Multi-selector to set it to the Flash mode item (located along the lower-left portion of the screen) (A).
- 2. Press the OK button and then use the Multi-selector to select Red-Eye Reduction mode, represented by an eye icon (B).
- 3. With the Red-Eye Reduction feature activated, compose your photo and then press the shutter release button to take the picture.

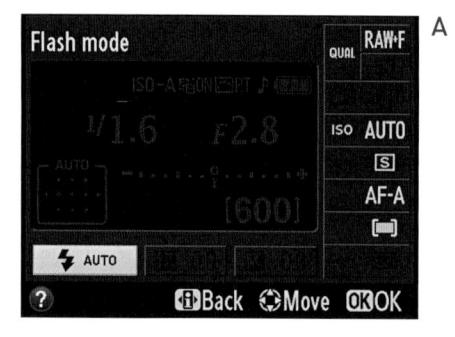

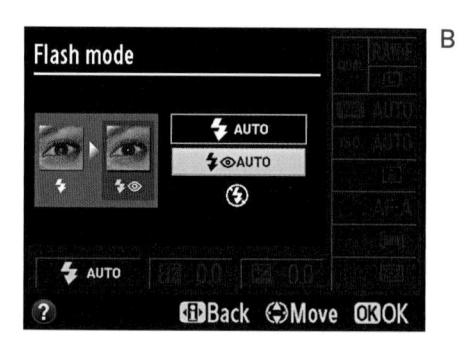

When red-eye reduction is activated, the camera will not fire the instant that you press the shutter release button. Instead, the red-eye reduction lamp will illuminate for a second or two and then fire the flash for the exposure. This is important to remember, as people have a tendency to move around, so you will need to instruct them to hold still for a moment while the lamp works its magic.

Truth be told, I rarely shoot with red-eye reduction turned on because of the time it takes before being able to take a picture. If I am after candid shots and have to use the flash, I will take my chances on red-eye and try to fix the problem in my image processing software or even in the camera's retouching menu.

REAR CURTAIN SYNC

There are two flash synchronization modes in the D3200: front curtain and rear curtain. You may be asking, "What in the world does synchronization do, and what's with these 'curtains'?" Good question.

When your camera fires, there are two curtains that open and close to make up the shutter. The first, or front, curtain moves out of the way, exposing the camera sensor to the light. At the end of the exposure, the second, or rear, curtain moves in front of the sensor, ending that picture cycle. In flash photography, timing is extremely important because the flash fires in milliseconds and the shutter is usually opening in tenths or hundredths of a second. To make sure these two functions happen in order, the camera usually fires the flash just as the first curtain moves out of the way (see the "Flash Sync" sidebar, earlier in this chapter).

In Rear Curtain Sync mode, the flash will not fire until just before the second shutter curtain ends the exposure. So, why have this mode at all? Well, there might be times when you want to have a longer exposure to balance out the light from the background to go with the subject needing the flash. Imagine taking a photograph of a friend standing in Times Square at night with all the traffic moving about and the bright lights of the streets overhead. If the flash fires at the beginning of the exposure, and then the objects around the subject move, those objects will often blur or even obscure the subject a bit. If the camera is set to Rear Curtain Sync, though, all of the movement is recorded using the existing light first, and then the subject is "frozen" by the flash at the end by the exposure.

There is no right or wrong to it. It's just a decision on what type of effect it is that you would like to create. Many times, Rear Curtain Sync is used for artistic purposes or to record movement in the scene without it overlapping the flash-exposed subject (**Figure 8.16**). To make sure that the main subject is always getting the final pop of the flash, I leave my camera set to Rear Curtain Sync most of the time.

You can have a lot of fun with Rear Curtain Sync. Figure 8.17 shows an example of a long exposure to record the light trail from a cool iPad app called Holographium (you type a word into the app and move the iPad across the frame during a long exposure to extrude the word across your photo), with a burst of flash at the end that gives

FIGURE 8.16
The effect of using
Rear Curtain Sync
is most evident
during long flash
exposures, such as
in this photo of a
barbarian charging
into battle on
a carousel.

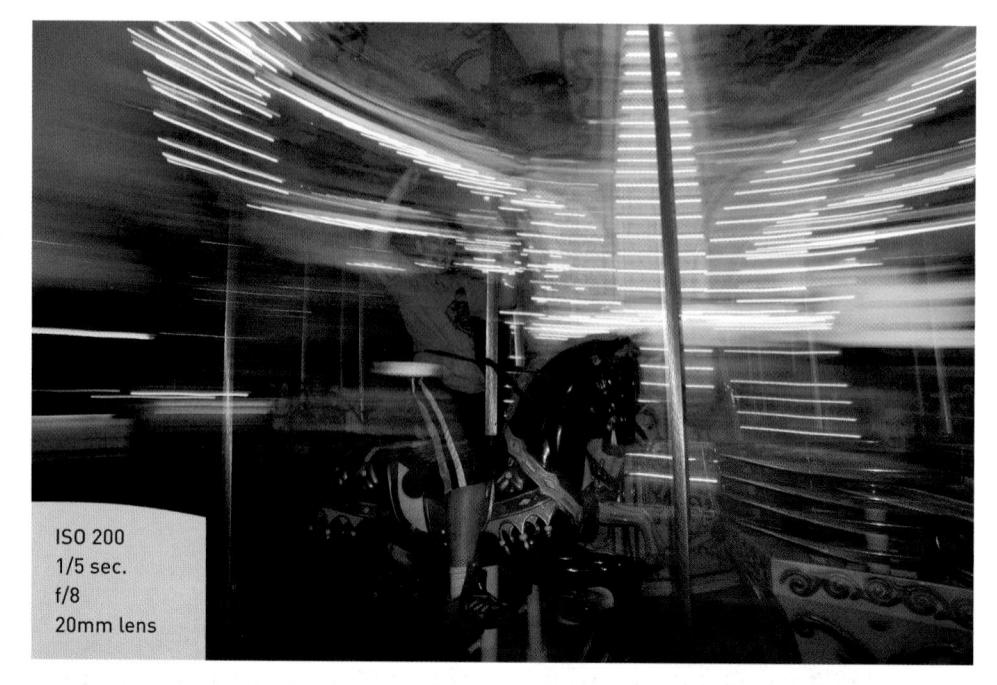

FIGURE 8.17
This effect is
possible because
the flash fired at
the end of the exposure using Rear
Curtain Sync.

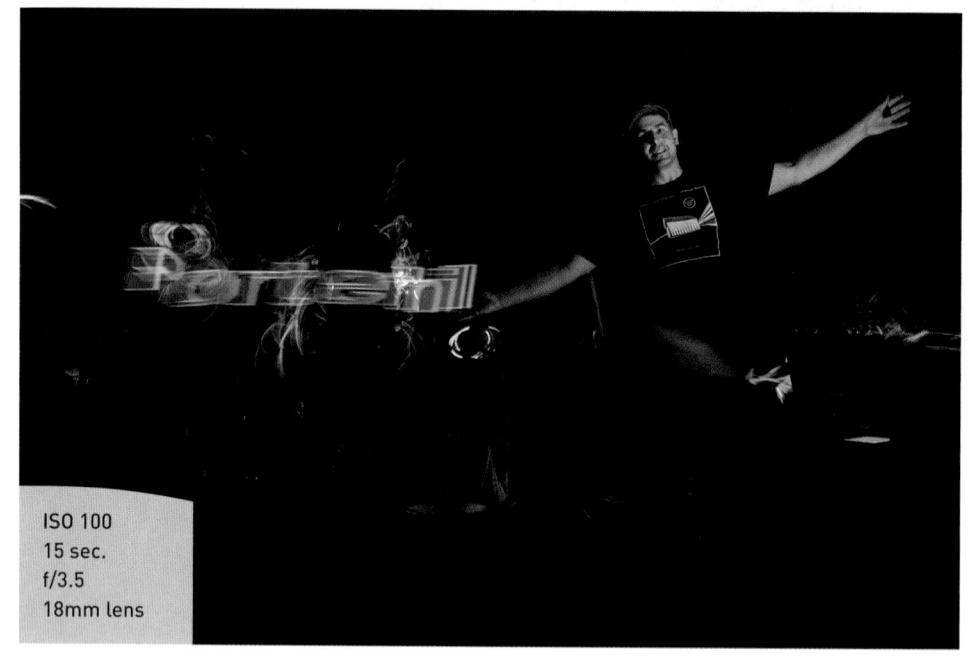

a ghostly appearance to yours truly. As you can see, my friends and I were playing around with various light-emitting devices in the background.

Note that if you do intend to use a long exposure with first curtain synchronization, you need to have your subject remain fairly still so that any movement that occurs after the flash will be minimized in the image.

SETTING YOUR FLASH SYNC MODE TO REAR CURTAIN SYNC

- 1. Press the i button to activate the cursor in the information screen, and use the Multi-selector to set it to the Flash mode item (located along the lower-left portion of the screen) (A).
- 2. Press the OK button and then use the Multi-selector to select the Rear mode (B).
- 3. With Rear Curtain Sync activated, compose your photo, adjust your shutter or aperture depending on the shooting mode you are using, and then press the shutter release button to take the picture.

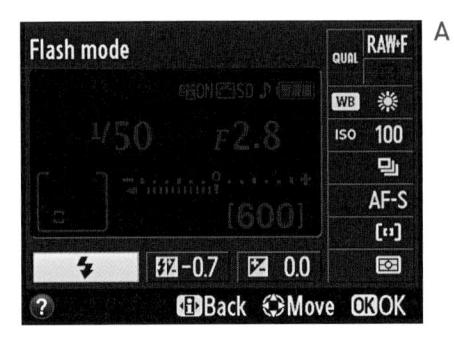

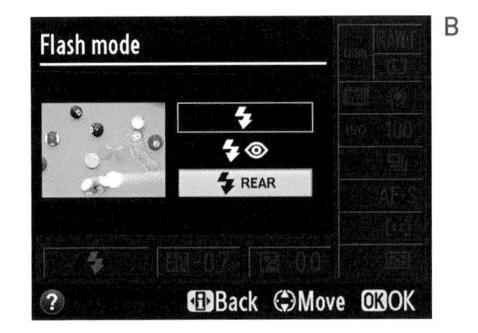

FLASH AND GLASS

If you find yourself in a situation where you want to use your flash to shoot through a window or display case, try placing your lens right against the glass so that the reflection of the flash won't be visible in your image (Figures 8.18 and 8.19). This is extremely useful in museums and aquariums.

FIGURE 8.18
The bright spot on the left of the frame is a result of the flash reflecting off the display glass.

FIGURE 8.19
To eliminate the reflection, place the lens against the glass or as close to it as possible. This might also require zooming the lens out a little.

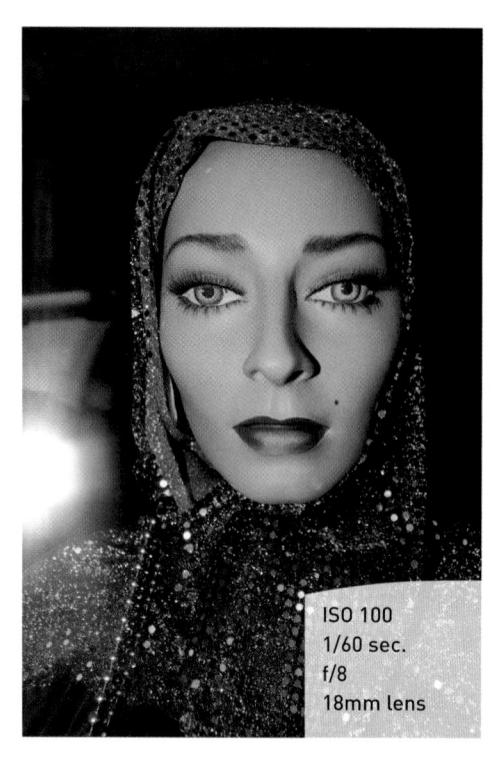

A FEW WORDS ABOUT EXTERNAL FLASH

We have discussed several ways to get control over the built-in pop-up flash on the D3200. The reality is that, as flashes go, it will only render fairly average results. For people photography, it is probably one of the most unflattering light sources that you could ever use. This isn't because the flash isn't good—it's actually very sophisticated for its size. The problem is that light should come from any

Manual Callout

For more information on the use of external Speedlight flashes on your D3200, check out pages 172–175 of your manual.

direction besides the camera to best flatter a human subject. When the light emanates from directly above the lens, it gives the effect of becoming a photocopier. Imagine putting your face down on a scanner: The result would be a flatly lit, featureless photo.

To really make your flash photography come alive with possibilities, you should consider buying an external flash such as the Nikon SB-700 Speedlight. The SB-700 has a swiveling flash head and more power, and it communicates with the camera and the TTL system to deliver balanced flash exposures. For more information about the Nikon Speedlight system, be sure to check out the bonus chapter, "Pimp My Ride."

Chapter 8 Assignments

Now that we have looked at the possibilities of shooting after dark, it's time to put it all to the test. These assignments cover the full range of shooting possibilities, both with flash and without. Let's get started.

How steady are your hands?

It's important to know just what your limits are in terms of handholding your camera and still getting sharp pictures. This will change depending on the focal length of the lens you are working with. Wider-angle lenses are more forgiving than telephoto lenses, so check this out for your longest and shortest lenses. Using the 18–55mm zoom as an example, set your lens to 55mm and then, with the camera set to ISO 200 and the mode set to Shutter Priority, turn off the VR and start taking pictures with lower and lower shutter speeds. Review each image on the LCD at a zoomed-in magnification to take note of when you start seeing visible camera shake in your images. It will probably be around 1/60 of a second for a 55mm lens.

Now do the same for the wide-angle setting on the lens. My limit is about 1/30 of a second. These shutter speeds are with the Vibration Reduction feature turned off. If you have a VR lens, try it with and without the VR feature enabled to see just how slow you can set your shutter while getting sharp results.

Pushing your ISO to the extreme

Find a place to shoot where the ambient light level is low. This could be at night or indoors in a darkened room. Using the mode of your choice, start increasing the ISO from 100 until you get to 12800 Hi 1. Make sure you evaluate the level of noise in your image, especially in the shadow areas. Only you can decide how much noise is acceptable in your pictures. I can tell you from personal experience that I never like to stray above the ISO 1600 mark.

Getting rid of the noise

Turn on the Noise Reduction and repeat the previous assignment. Find your acceptable limits with the noise reduction turned on. Also pay attention to how much detail is lost in your shadows with this function enabled.

Long exposures in the dark

If you don't have a tripod, find a stable place to set your camera outside and try some long exposures. Set your camera to Aperture Priority mode and then use the self-timer to activate the camera (this will keep you from shaking the camera while pressing the shutter button).

Shoot in an area that has some level of ambient light, be it a streetlight, traffic lights, or even a full moon. The idea is to get some late-night, low-light exposures.

Testing the limits of the pop-up flash

Wait for the lights to get low, and then press that pop-up flash button to start using the built-in flash. Try using the different shooting modes to see how they affect your exposures. Use the Flash Exposure Compensation feature to take a series of pictures while adjusting from -3 stops all the way to +1 stops so that you become familiar with how much latitude you will get from this feature.

Getting the red out

Find a friend with some patience and a tolerance for bright lights. Have them sit in a darkened room or outside at night and then take their picture with the flash. Now turn on the Red-Eye Reduction feature to see if you get better results. Don't forget to have them sit still while the red-eye lamp does its thing.

Getting creative with Rear Curtain Sync

Now it's time for a little creative fun. Set your camera up for Rear Curtain Sync and start shooting. Moving targets are best. Experiment with Shutter Priority and Aperture Priority modes to lower the shutter speeds and exaggerate the effect. Try using a low ISO so the camera is forced to use longer shutter speeds. Be creative and have some fun!

Share your results with the book's Flickr group!

Join the group here: flickr.com/groups/nikond3200_fromsnapshotstogreatshots

Creative Compositions

IMPROVE YOUR PICTURES WITH SOUND COMPOSITIONAL ELEMENTS

Creating a great photograph takes more than just the right settings on your camera. To take your photography to the next level, you need to gain an understanding of how the elements within the frame come together to create a compositionally pleasing image. Composition is the culmination of light, shape, and, to borrow a word from the iconic photographer Jay Maisel, gesture. Composition is a way for you to pull your viewing audience into your image and guide them through the scene. Let's examine some common compositional elements you can use to add interest to your photos.

PORING OVER THE PICTURE

After shooting these two climbers in Moab, I walked around the base of the rock they had been climbing and was struck by the way the rock framed them both and by how one climber framed the other as they stood chatting in the afternoon sun. I also really liked the way the climber in red was surrounded by red rock while the climber in blue was surrounded by blue sky. Even though they are not climbing in this scene, the helmets and gear hanging off their belts helps to tell the story of what is happening.

The frame created by the rock and the climber in blue brings your eye to the smile on the climber in red's face.

The dominant foreground rock, — mid-ground climbers, and back-ground cliffs add a sense of depth to the photo.

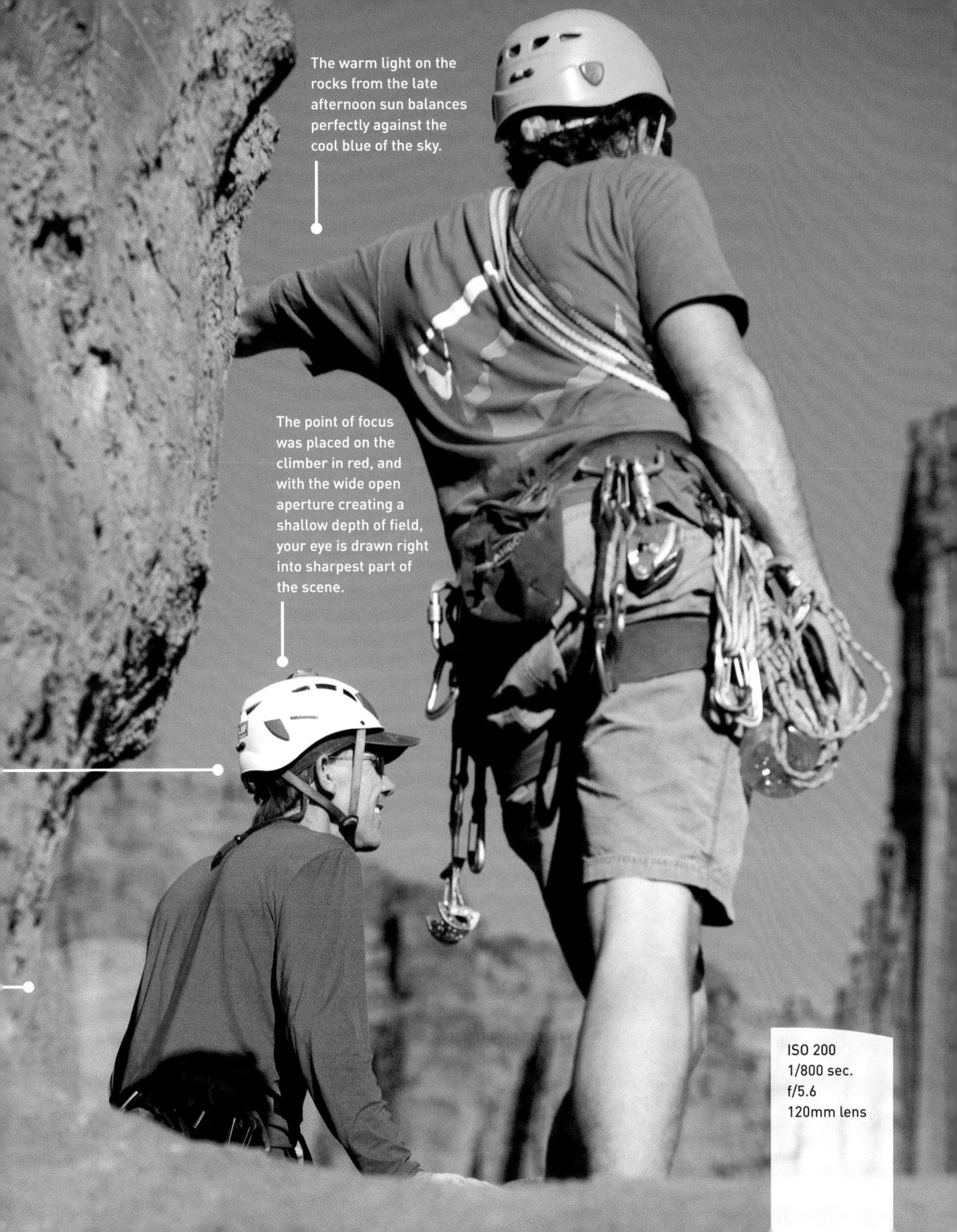

DEPTH OF FIELD

Long focal lengths and large apertures allow you to isolate your subject from the chaos that surrounds it. I utilize Aperture Priority mode for the majority of my shooting. I also like to use a longer focal length lens to shrink the depth of field to a very narrow area (Figure 9.1).

The blurred background forces the viewer's eye toward the sharper, in-focus areas, which gives greater emphasis to the subject.

Occasionally, a greater depth of field is required to maintain a sharp focus across a greater distance. This might be due to the sheer depth of your subject, where you have objects that are near the camera but sharpness is desired at a greater distance as well (Figure 9.2).

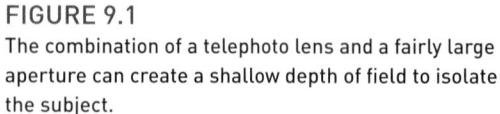

FIGURE 9.2 I switched to a small aperture to demonstrate maximum depth of field.

Or perhaps you are photographing a reflection in a puddle or lake. With a narrow depth of field, you would only be able to get either the reflected object or the puddle in focus. By making the aperture smaller, you will be able to maintain acceptable sharpness in both areas (Figure 9.3).

FIGURE 9.3 Getting a distant subject in focus in a reflection, along with the reflective surface, requires a small aperture.

PHOTOGRAPHING REFLECTIONS

A mirror is a two-dimensional surface, so why do I have to focus at a different distance for the image in the mirror? This was one of those questions that drove me crazy when I began to learn about photography. The answer is pretty simple, and it has to do with light. When you focus your lens, you are focusing the light being reflected off a surface onto your camera sensor. So if you wanted to focus on the mirror itself, it would be at one distance, but if you wanted to focus on the subject being reflected, you would have to take into account the distance that the object is from the mirror and then to you. Remember that the light from the subject has to travel all the way to the mirror and then to your lens. This is why a smaller aperture can be required when shooting reflected subjects. Sit in your car and take a few shots of objects in the side view mirrors to see what I mean.

ANGLES

Having strong angular lines in your image can add to the composition, especially when they are juxtaposed to each other (**Figure 9.4**). This can create a tension that is different from the standard horizontal and vertical lines that we are so accustomed to seeing in photos.

POINT OF VIEW

Sometimes the easiest way to influence your photographs is to simply change your perspective (Figure 9.5). Instead of always shooting from a standing position, try moving your camera to a place where you normally would not see your subject. Try getting down on your knees or even lying on the ground. This low angle can completely change how you view your subject and can create a new interest in common subjects.

There are also times when you can accentuate the angles in your images by tilting the camera, thus adding an unfamiliar angle to the subject, which draws the viewer's attention.

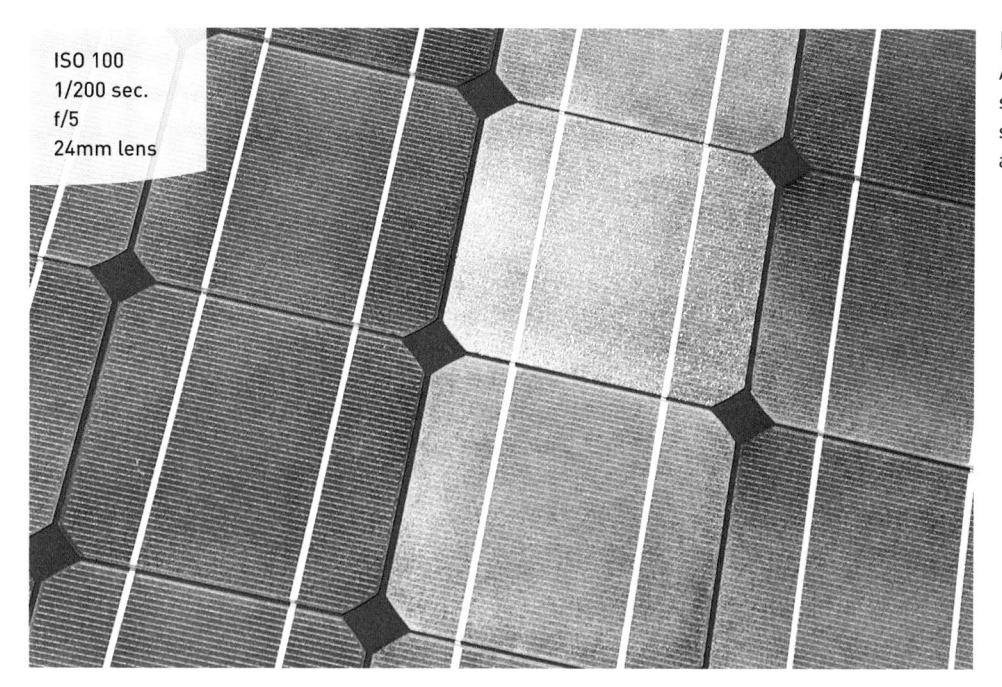

FIGURE 9.4 A close-up of a slightly turned solar panel is all angles.

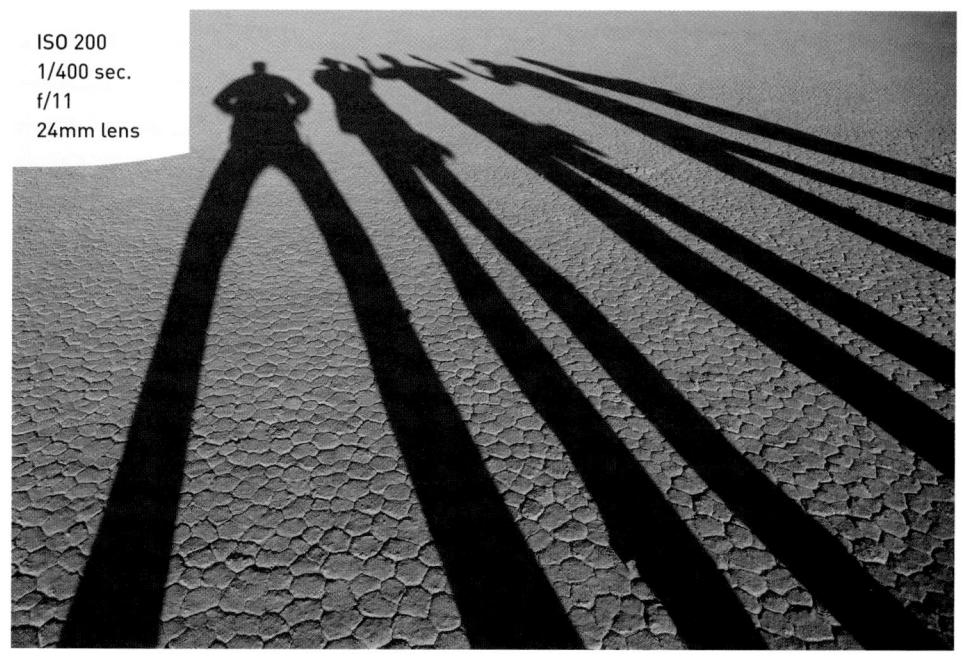

FIGURE 9.5 A fun way to do a group portrait that shows both where we were and that we were having a good time.

PATTERNS

Rhythm and balance can be added to your images by finding the patterns in everyday life and concentrating on the elements that rely on geometric influences. Try to find the balance and patterns that often go unnoticed (**Figure 9.6**).

FIGURE 9.6
The playa is like
a hard, dried clay
full of patterns and
shapes that spread
as far as the eye
can see.

COLOR

Color works well as a tool for composition when you have very saturated colors to work with. Some of the best colors are those within the primary palette. Reds, greens, and blues, along with their complementary colors (cyan, magenta, and yellow), can all be used to create visual tension (**Figure 9.7**). This tension between bright colors will add visual excitement, drama, and complexity to your images when combined with other compositional elements.

You can also use a color as a theme for your photography. Scenes that combine color, pattern, shape, and point of view are all around you when you start looking for them (Figure 9.8).

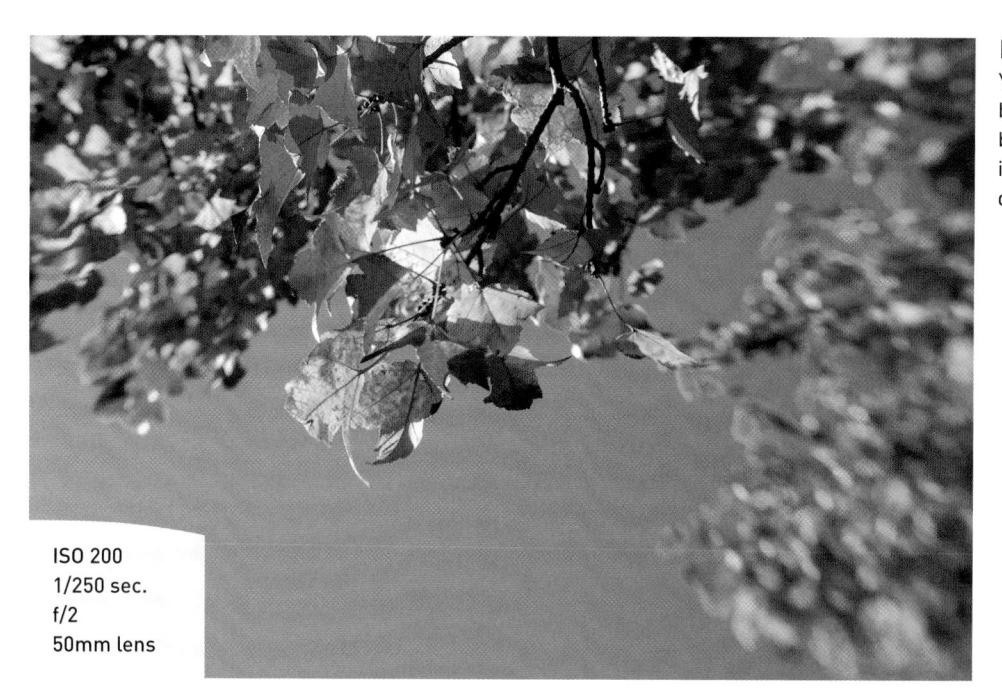

FIGURE 9.7 You just can't beat the awesome bursts of color in the northeast during the fall.

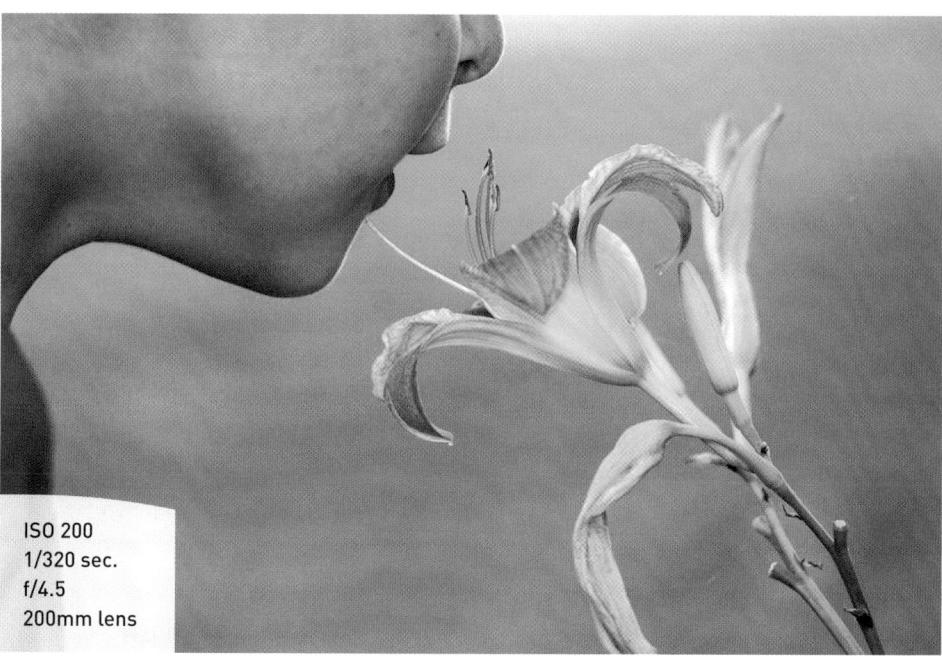

FIGURE 9.8
Combining a telephoto lens and wide aperture turned boring grass into a solid background of green to contrast with the colors of the flower and shirt.

CONTRAST

We just saw that you can use color as a strong compositional tool. One of the most effective uses of color is to combine two contrasting colors that make the eye move back and forth across the image (**Figure 9.9**). There is no exact combination that will work best, but consider using dark and light colors, like red and yellow or blue and yellow, to provide the strongest contrasts.

FIGURE 9.9
The contrasting colors complement each other and add balance to the scene.

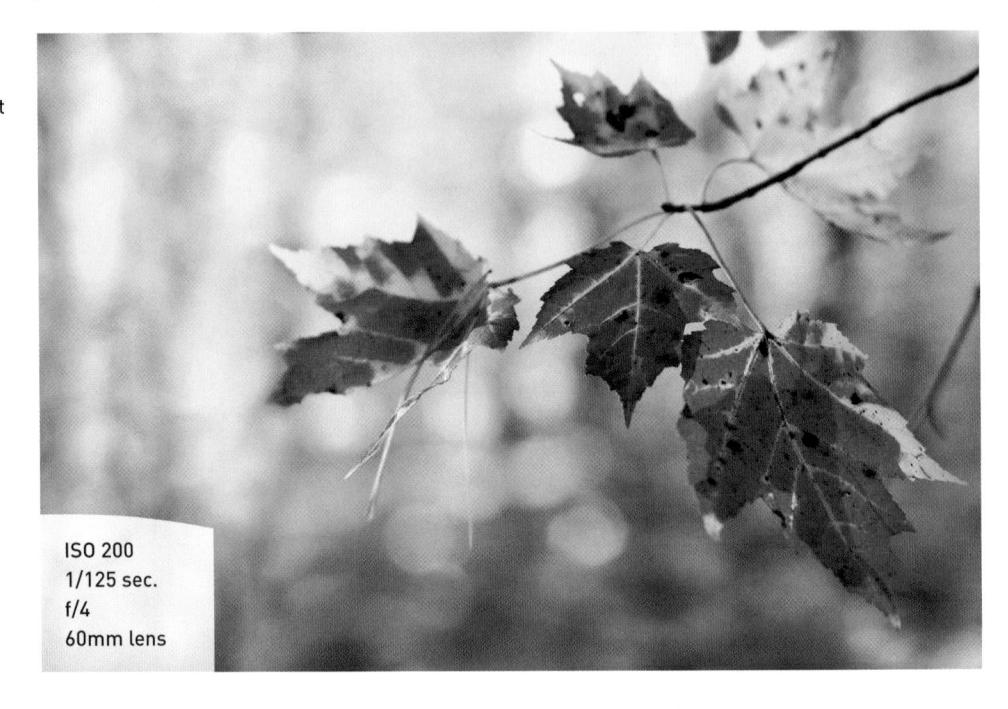

You can also introduce contrast through different geometric shapes that battle (in a good way) for the attention of the viewer. You can combine circles and triangles, ovals and rectangles, curvy and straight, hard and soft, dark and light, and so many more (Figure 9.10). You aren't limited to just one contrasting element either. Combining more than one element of contrast will add even more interest. Look for these contrasting combinations whenever you are out shooting, and then use them to shake up your compositions.

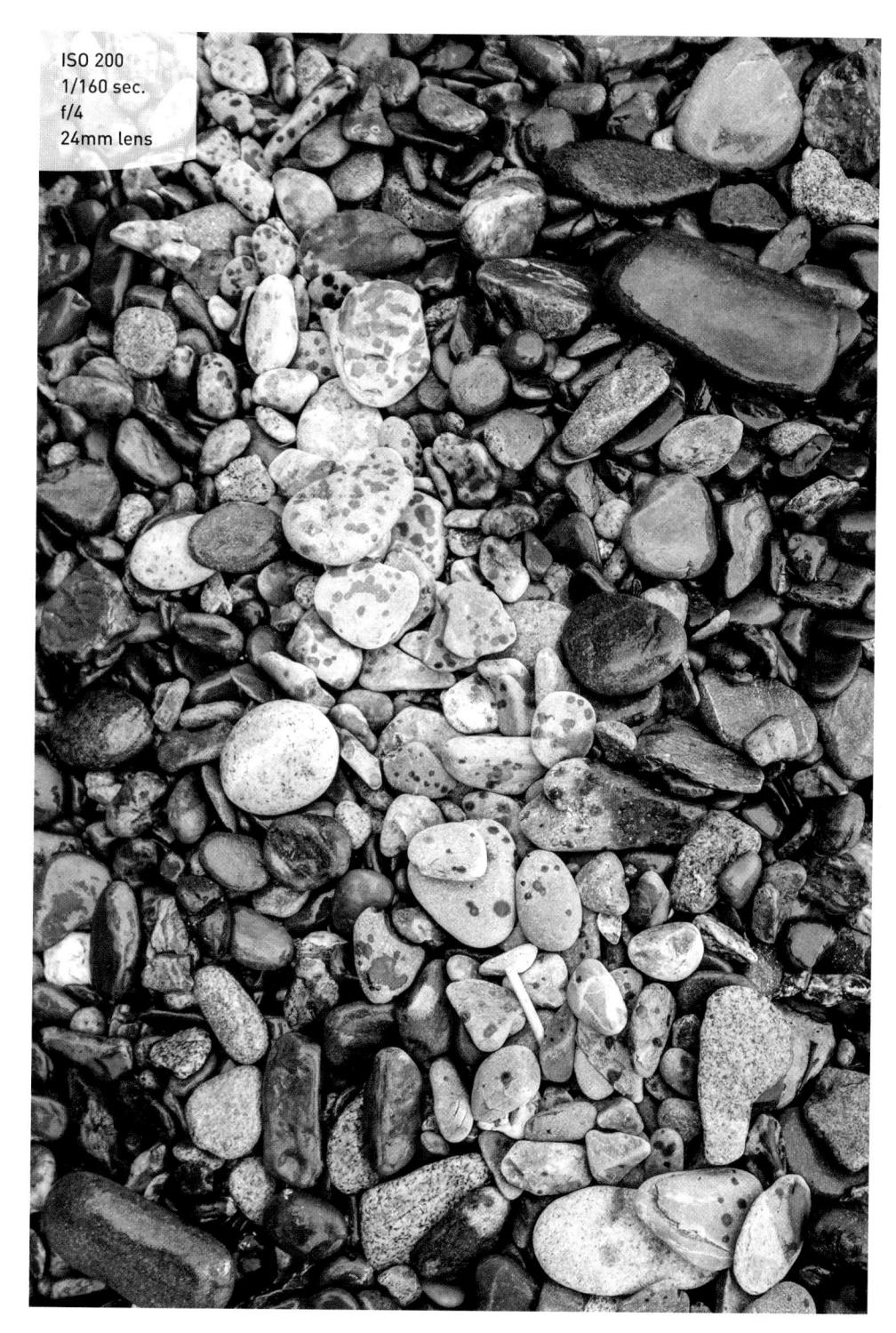

FIGURE 9.10
On a drizzling day
I came across a
patch of stones
partially protected
by a fallen branch.
It created a contrast
of light and dark as
well as wet and dry.

LEADING LINES

One way to pull a viewer into your image is to incorporate leading lines. These are elements that come from the edge of the frame and then lead into the image toward the main subject. This can be the result of vanishing perspective lines (Figure 9.11), an element such as a river, or some other feature used to move the eye through the image.

FIGURE 9.11 The stone wall leads the eye from the first tree to the second.

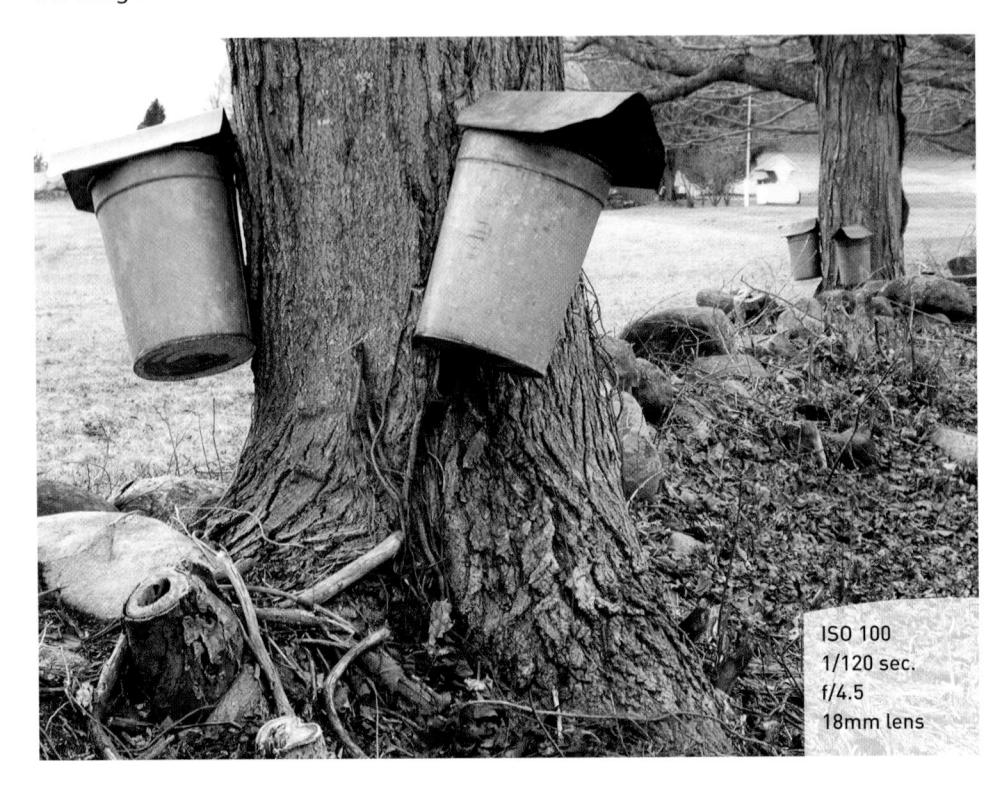

SPLITTING THE FRAME

Splitting the frame right down the middle is not necessarily your best option. While it may seem more balanced, it can actually be pretty boring. Generally speaking, you should utilize the rule of thirds when deciding how to divide your frame (Figure 9.12).

With horizons, a low horizon will give a sense of stability to the image. Typically, this is done when the sky is more appealing than the landscape below (Figure 9.13). When the emphasis is to be placed on the landscape, the horizon line should be moved upward in the frame, leaving the bottom two-thirds to the subject below.

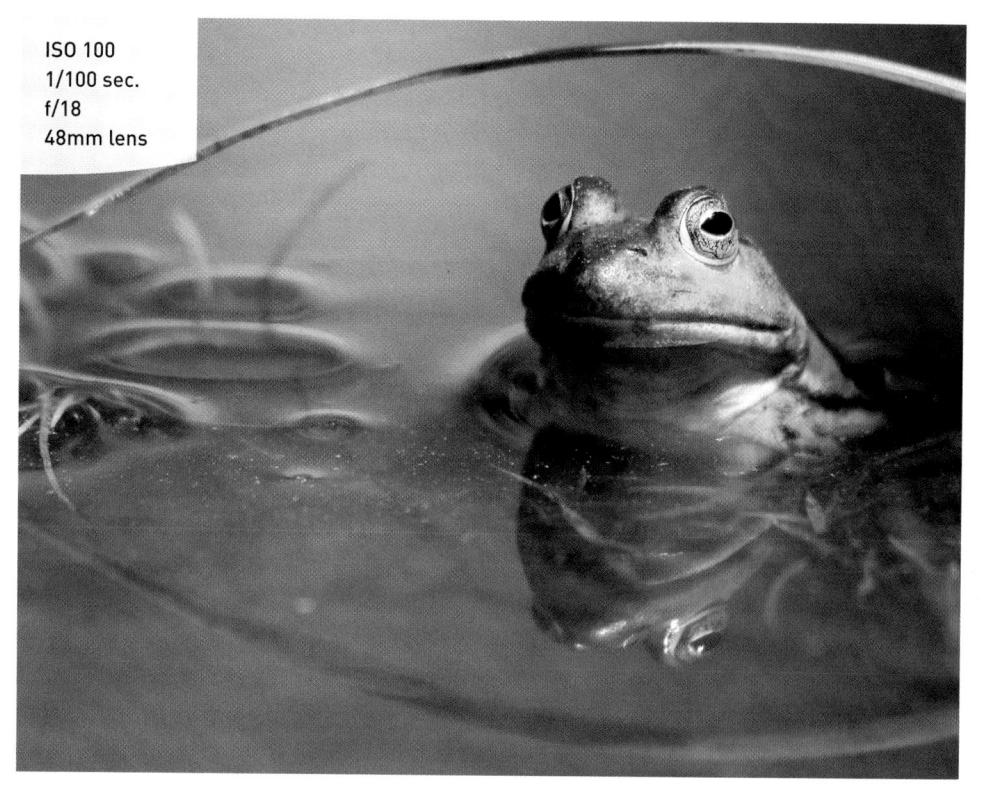

FIGURE 9.12
The frog is in the upper-right third of the frame, its mirror image resides in the lower-right third, and both are framed nicely by the arc of the grass.

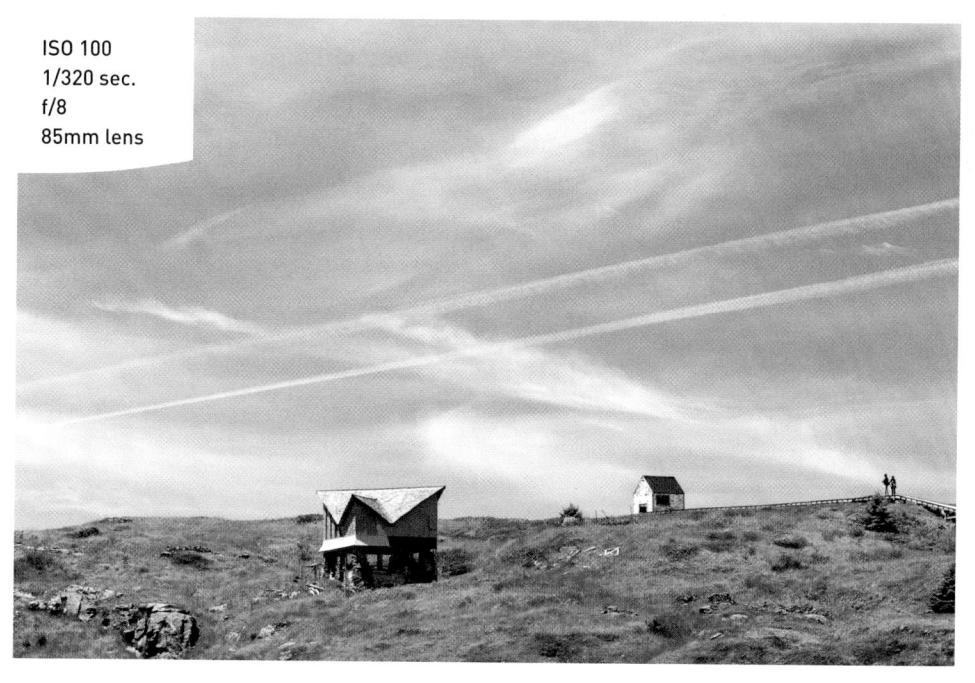

FIGURE 9.13 I love the parallel lines of the jet trails and the way they contrast with the feathery soft clouds in the background.

FRAMES WITHIN FRAMES

The outer edge of your photograph acts as a frame to hold all of the visual elements of the photograph. One way to add emphasis to your subject is through the use of internal frames (**Figure 9.14**). Depending on how the frame is used, it can create the illusion of a third dimension to your image, giving it a feeling of depth.

FIGURE 9.14
The inside of the
Utah State Capitol
building is amazing
and a frequent
venue for wedding
photographs—if you
follow the frames
of the receding
arches, you'll see
one in progress.

Chapter 9 Assignments

Apply the shooting techniques and tools that you have learned in the previous chapters to these assignments, and you'll improve your ability to incorporate good composition into your photos. Make sure you experiment with all the different elements of composition and see how you can combine them to add interest to your images.

Learning to see lines and patterns

Take your camera for a walk around your neighborhood and look for patterns and angles. Don't worry as much about getting great shots as about developing an eye for details.

The ABCs of composition

Here's a great exercise that was given to me by my friend Vincent Versace: Shoot the alphabet. This will be a little more difficult, but with practice you will start to see beyond the obvious. Don't just find letters in street signs and the like. Instead, find objects that aren't really letters but that have the shape of letters.

Finding the square peg and the round hole

Circles, squares, and triangles. Spend a few sessions concentrating on shooting simple geometric shapes.

Using the aperture to focus attention

Depth of field plays an important role in defining your images and establishing depth and dimension. Practice shooting wide open, using your largest aperture for the narrowest depth of field. Then find a scene that would benefit from extended depth of field, and use very small apertures to give sharpness throughout the scene.

Leading them into a frame

Look for scenes where you can use elements as leading lines, and then look for framing elements that you can use to isolate your subject and add both depth and dimension to your images.

Share your results with the book's Flickr group!

 ${\it Join the group here: flickr.com/groups/nikond 3200_froms napshots to great shots}$

D3200 Video: Beyond the Basics

VIDEO AND THE D3200

Probably one of the reasons you purchased the D3200 over competing cameras is its ability to capture video—and not just regular video, but high-definition video. As I discussed in the introduction, the focus of this book is the photography aspects of the camera, but that doesn't mean I am going to ignore the video functions completely. First, let's cover some of the basic facts about the moviemaking features.

Video recording is a feature of the Live View capabilities of the camera. You have to put the camera into Live View mode to even begin to capture video. This is accomplished by pressing the Live View button on the rear of the camera, which activates the live video on the rear display. If you want to control the aperture, you should set the aperture value (while in either Manual mode or Aperture Priority mode) before switching to Live View. Otherwise, switch to one of the other modes and let the camera adjust the aperture automatically.

Once Live View is active, press the i button and choose a focus mode. It is possible to use the full-time-servo (AF-F) mode while recording video, and you should try it out to see how it works, but I strongly urge you to refine your manual focus skills. Using manual focus not only gives you creative control of what is in focus, it also eliminates the sound of the lens trying to maintain autofocus.

Once your subject is in focus, push the Record button located on the top of the camera to begin the recording process (Figure 10.1). When the camera begins recording, you will notice that a few new icons show up on the LCD (Figure 10.2). At the top left will be a blinking red Record icon to let you know that the camera is in active record mode, and just below that is the audio recording indicator (press the info button on the top of the camera to show the audio level). In the upper right, you will notice a timer that is counting down your remaining recording time. This number is directly related to the quality you have selected for your video, which is also displayed in the upper-right corner of the screen. To stop the video recording, simply press the Record button a second time. This will take you back to Live View mode. To turn off Live View, simply press the Live View button once more or turn the camera off.

FIGURE 10.1 Recording a movie is a fairly straightforward process.

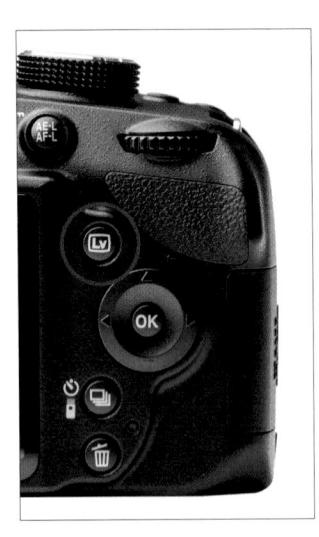

Press the Live View button to activate Live View.

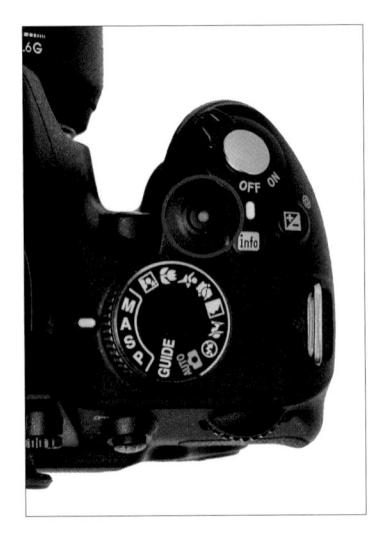

Press the Record button to start or stop recording.

FIGURE 10.2 New icons appear on the LCD when the camera is recording.

VIDEO QUALITY

The highest quality video setting on your D3200 will render high-definition video with a resolution of 1920x1080 pixels. This is also referred to as 1080p. The 1080 represents the height of the video image in pixels; the p stands for progressive, which is how the camera actually records/draws the video on the screen. You can select lower-resolution video depending on your needs. The other two video resolutions are 1280x720 and 640x424. For high-definition TV and computer/media sta-

Manual Callout

For more information on all aspects of the video recording, playback, and editing functions of your D3200, check out pages 88–96 of your PDF manual.

tion viewing, you will be served best using the 1920x1080 recording resolution. If you plan on recording for the Internet and iPods or portable video players, you might want to consider using the low-resolution choice. The benefit of this low resolution is that lower-resolution videos require less physical storage since they have a smaller pixel count. This means that you can record more video sequences on your storage card, and it will also take less time to upload the video to the Internet.

SETTING THE MOVIE QUALITY

- To change the quality of your video recording, start by pressing the Menu button and navigating to the Shooting Menu. You can do this while you are in regular or Live View shooting modes.
- 2. Using the Multi-selector, move the cursor to the Movie settings option and press the OK button (A).

- **3.** With Frame size/frame rate highlighted (**B**), press OK to choose your desired frame rate (**C**).
- 4. Press the Live View button on the rear of the camera to change to Live View mode.

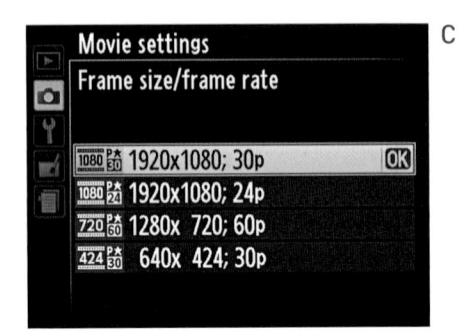

PROGRESSIVE SCAN

When it comes to video, there are usually two terms associated with the quality of the video and how it is captured and displayed on a monitor or screen: *progressive* and *interlaced*. The two terms describe how the video is drawn by line for each frame. Video frames are not displayed all at once like a photograph. In progressive video, the lines are drawn in sequence from top to bottom. Interlaced video draws all of the odd-numbered lines and then all of the even-numbered lines. This odd/even drawing can present itself as screen flicker, which is why the progressive video standard is preferred, especially when viewing higher-definition images.

SOUND

The D3200 can record audio to go along with your video, but there are a couple of things to keep in mind when using it. The first is to make sure you don't block the microphone on the front of the camera. If you look closely at the front of the camera body, you will notice three small holes right above the silver D3200 nameplate, located just above the lens release button. This should not be a problem if you are holding the camera as instructed in Chapter 1.

The next thing you need to know about the sound is that the built-in microphone records in mono, not stereo. This means that when you are watching the recorded video on your TV or computer, you might only hear the sound coming from one speaker. The D3200 does have an external microphone jack on the side panel (**Figure 10.3**),

so you might want to consider investing in an external mic that is capable of recording in stereo, as well as of producing higher-quality audio recordings (more about this later).

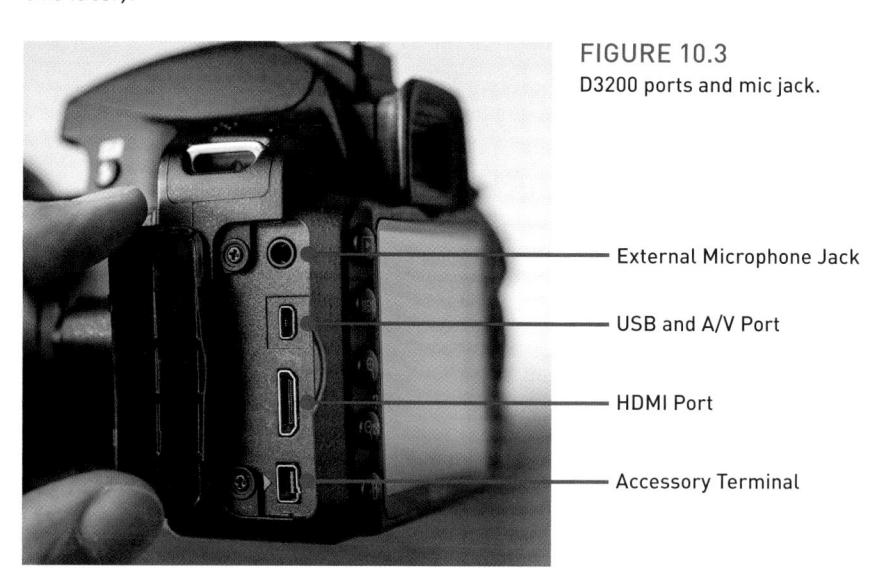

TURNING OFF THE SOUND

- Following the previous directions for setting the movie quality, locate the Movie settings menu and press the OK button (A).
- 2. Highlight the Microphone option and press OK again (B).
- 3. Select the Microphone off option and press OK to lock in the change (C). Press the Menu button twice to return to shooting mode.

FOCUSING THE CAMERA

Once the video is recording, you have a couple of focusing options to choose from. To manually focus, simply slide the focus switch on the lens to the M position and then rotate the focus ring while recording. If your subject moves closer to or farther from the camera position, it will be necessary for you to turn the focus ring on the lens in order to maintain sharp focus.

As mentioned, you can also use the camera's autofocus during recording to keep your subjects in focus, but I don't recommend it. It is a good idea on paper, but it has a long way to go in real life. You can certainly give it a try, but I think you'll find that it's a bit too jarring (and noisy) as it hunts back and forth trying to keep even a slow-moving subject in focus.

Another option is to leave the focus mode in AF-S, then simply press the shutter release button to focus on your subject. Note, though, that if you are recording sound with your video, the autofocus and vibration reduction functions will be audible in your video—and it sounds terrible. I usually let the AF lock focus first, and then I slide the focus switch to M and take over from there.

IT'S ALL ABOUT THE LENSES

Video cameras have been around for a long time, so why is it such a big deal that you can now use your DSLR camera to record video? The answer is simple: It's all about the lenses. If you have any experience using a video camcorder, you know that it always seems like everything is in focus. While this isn't always a bad thing, it can also be pretty boring. Using DSLR video allows you to use faster lenses (larger apertures), which can give you more shallow depth of field in your videos. This shallow depth of field can add a sense of dimension and depth that is normally lacking in most standard video cameras. The truth is that many videographers are turning their attention from video cameras costing many thousands of dollars to the much more affordable DSLR cameras to produce similar high-definition results.

The D3200 will not only allow you to capture video with a more shallow depth of field, it will also allow you the flexibility of using different lenses for different effects. While you may own only one lens right now, you have the ability to buy specialty lenses to enhance your video as well as your still capture. Any lens that you can use for still photography on your D3200 can also be used for video, including an ultra-wide lens such as the AF DX Fisheye-Nikkor 10.5mm f/2.8 ED, the AF-S VR Zoom-Nikkor 70–300mm f/4.5–5.6G IF-ED, or even the AF Micro-Nikkor 60mm f/2.8D for getting extreme close-up videos.
USING ACCESSORIES

CLOSE-UP

In the bonus chapter, "Pimp My Ride," you will find a section on close-up accessories, such as close-up filters and extension tubes. Well, guess what? You can use those same accessories for getting great close-up video of tiny little subjects such as insects or flowers

POLARIZING FILTERS

The polarizing filter will offer the same benefits to your videos as it does to your photographs. By utilizing this filter, you can eliminate the bluish color cast that can happen on those blue-sky days, bring accurate color and contrast to vegetation, reduce annoying reflections from water and glass, and darken your blue skies, giving them more depth and character. (See the bonus chapter, "Pimp My Ride" for more on the polarizing filter.)

NEUTRAL DENSITY FILTERS

Shooting in bright daylight conditions can sometimes overwhelm any attempts at using a larger aperture and achieving a shallow depth of field. To help combat this problem, you might want to employ a neutral density filter to darken the scene. The filters come in varying densities or darkness values, so you will need to determine how much light you need to cut down to get the effect you desire. A great filter for this is the Singh-Ray Vari-ND filter, which lets you vary the amount of density by up to eight stops. The problem with this filter is that it only comes in 77mm and 82mm sizes, and they are pretty expensive. You can create your own variable ND filter by purchasing a linear polarizing filter and a circular polarizer, which cost much less. Place the linear polarizer on your lens and then the circular on top of that. Then just rotate the circular polarizer and watch the scene get darker and darker. Dial in the amount of density you want and then start filming.

TRIPODS

The use of a tripod for video is not quite the same as for still image applications. When you are shooting video, you want to present a nice, smooth video scene that is fairly free of camera shake. One particular case for this is the pan shot. When you are following a subject from side to side, you will want the viewer's attention to be focused on the subject, not the shaky look of the video. To help in this cause, your

preferred weapon of choice should be a tripod with a fluid head. A fluid head usually has one long handle for controlled panning, and the head uses a system of small fluid cartridges within the panning mechanisms so that your panning movements are nice and smooth. For around \$80 you can get a nice fluid pan head, which will mount on your existing tripod legs (if your existing tripod has a removable head).

CAMERA STABILIZERS

Aside from using a boom arm, there's really only one way to get jitter-free video on your camera while moving around: use a steady device. You have probably heard of Steadicam rigs, but they can be cumbersome, expensive, and frankly a little bit of overkill for the normal video experience. But there are smaller handheld rigs that provide the same benefit without the cost and bulk, like the ModoSteady from Manfrotto (www.manfrotto.com). One of the big advantages of this rig is that it has three different setups to choose from. The steady mode hangs a counterbalance under the camera to allow you to capture fluid-looking video movement. You can also move the balance arm to a different position and then use it as a shoulder rig, much like the stock of a rifle. Finally, you can open the handle and turn it into a small tabletop tripod. That's a lot of functionality for under \$100.

EASIER LCD VISION

I have one problem with shooting video on the D3200 (or any DSLR camera): I can't use the viewfinder as I record. Instead, I am forced to use the rear LCD screen, and while it is very large and sharp, my old eyes tend to make me hold the camera fairly far away from my body to see the screen. But there is another way, and it is perfect for old eyes like mine.

In "Pimp My Ride," I introduce you to the Hoodman loupe for viewing your rear LCD screen. This small device allows you to get a great, crisp view of your LCD screen thanks to the built-in diopter. The only problem is that you have to handhold the loupe against the screen, which ties up one of your hands. That's why Hoodman came out with a great little device called the Cinema Strap, which allows you to attach your Hoodman loupe to the camera for hands-free operation. If you are going to be doing a lot of video recording, you will most certainly want to look into a device like this. Not only is it great for getting a better look at the LCD screen while recording, it also helps avoid glare on the screen while working outdoors. To check out all of the Hoodman accessories, head to www.hoodmanusa.com.

GETTING A SHALLOW DEPTH OF FIELD

As I said earlier, getting the look of a production cinema camera means working with shallow depth of field. The problem you might encounter when trying to get a large aperture in your video will be that the camera wants to use an auto-exposure mode to establish the correct camera settings for recording video. To get the benefit of a large aperture, you need to start in Manual or Aperture Priority mode and set your aperture before switching to Live View. To illustrate what I am talking about, I uploaded two video clips for comparison. One clip was shot with the aperture set to f/2.8 (Figure 10.4), and in the other I changed the aperture to f/22 (Figure 10.5).

- Video clip at f/2.8: http://vimeo.com/45020462
- Video clip at f/22: http://vimeo.com/45002759

Can you see the difference in the depth of field in the two clips? Deciding what is in focus is a very powerful cinematic technique, and controlling the depth of field is a great way to home right in on the most important part of the scene.

FIGURE 10.4 Frame of video shot at f/2.8 showing narrow depth of field.

FIGURE 10.5 Frame of video shot at f/22 showing wider depth of field.

GIVING A DIFFERENT LOOK TO YOUR VIDEOS

PICTURE CONTROLS

Something that a lot of people don't realize is that you can use the picture controls to give your video a completely different look. Sure, you can use the Standard control for everyday video, but why not add some punch by using the Vivid setting? Nothing says HD like bright, vivid colors. Or maybe you want to shoot a landscape scene. Go ahead and set the picture control to the Landscape setting to improve the look of skies and vegetation. If you really want to get creative, try using the Monochrome setting and shoot in black and white. The great thing about using the picture controls is that you will see the effect right on your LCD screen as you record, so you will know exactly what your video is going to look like. Want to take things up a notch? Try customizing the picture controls and do things like shoot sepia-colored video. Check out the "Classic Black and White Portraits" section of Chapter 6 to see how to customize the look of your Monochrome picture style.

WHITE BALANCE

Another great way to change the look of your video is to select a white balance that matches your scene for accurate color rendition—or better yet, choose one that doesn't match to give a different feel to your video. You can completely change the mood of the video by selecting a white balance setting that is different from the actual light source that you are working in. Don't be afraid to be creative and try out different looks for your video.

TIPS FOR BETTER VIDEO

SHOOT SHORT CLIPS

Even though your camera can record fairly long video sequences, you should probably limit your shooting time to short clips and then edit them together. Here's the deal: Most professional video shot today is actually made up of very short video sequences that are edited together. If you don't believe me, watch any TV show and see how long you actually see a continuous sequence. I am guessing that you won't see any clip that is longer than about 10 seconds in length. You can thank music videos for helping to shorten our attention spans, but the reality is that your video

will look much more professional if you shoot in shorter clips and then edit them together, which brings me to another point.

Shooting small clips will also give the camera a chance to cool down. It really heats up inside the camera when recording video, so keep an eye on the LCD screen to see if you get a temperature warning. I had this happen a few times while recording my son's baseball games. Having that black camera sit in the full sun didn't help, so I draped a light-colored lens cloth over the body for a little shade.

STAGE YOUR SHOTS

If you are trying to produce a good-looking video, take some time before you begin shooting to determine what you want to shoot and where you want to shoot it from. You can mark the floor with tape to give your "actors" a mark to hit. You can also use staging to figure out where your lens needs to be set for correct focus on these different scenes.

FOCUS MANUALLY

This will be difficult to do at first, but the fact is that if you want to change the point of focus in your video while you are recording, then you should learn to manually focus the lens. The autofocus system will work while you are recording, but it can be a little slow to react to changes in the scene. Manually focusing the camera is much faster, but it's not uncommon to "overshoot" your subject, so a little practice is always a good thing.

To manually change your focus, set the camera lens to manual focus and then use the focus ring on the front of the lens. This will be difficult at first, especially if you have never had to manually focus in the past, but with a little practice you can become fairly adept at the process.

AVOID THE QUICK PAN

While recording video, your camera uses something called a rolling shutter, which, as the name implies, rolls from the top to the bottom of the frame. If you are panning quickly from one side to another, you will see your video start to jiggle like it is being shot through Jell-O. This is something that can't be overcome except by using a slower panning motion. If you are going to be shooting a fast subject, consider using Shutter Priority mode and a fast shutter speed. It won't eliminate the problem completely, but it should improve it a little.

USE A FAST MEMORY CARD

Your video will be recording at up to 60 frames per second, and as it is recording it's placing the video into a buffer, or temporary holding spot, while the camera writes

the frames to your memory card. If you are using a slower memory card, it might not be able to keep up with the flow of video—with the result being dropped frames. The camera will actually not record some frames because the buffer will fill up before the images have time to be written. This will be seen as small skips in the video when you watch it later. You can prevent this from happening by using an SD card that has a speed rating of class 6 or higher (Figure 10.6). These cards have faster writing speeds and will keep the video moving smoothly from the camera to the card.

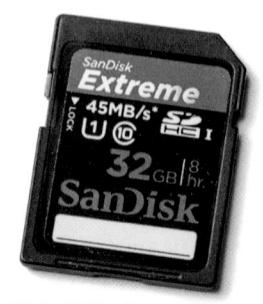

FIGURE 10.6
A fast card, such as this SanDisk
SDHC Class 10, will help capture
more of your video frames.

GET YOURSELF A MINI-HDMI CABLE

When you are ready to play back your video, you can run the video directly from your camera to your TV. To get the best-quality picture on your TV, use a TV capable of displaying high-definition video, which also means that you will want to use an HDMI cable to connect the camera to the TV. HDMI (High Definition Multimedia Interface) cables will carry your uncompressed video to your HD TV in all its glory. The only problem is that your camera didn't have an HDMI cable included in the box when you bought it. This means that you will have to purchase one to take advantage of the HD playback. If you are thinking that you already own an HDMI cable for connecting your other media components to your TV, you might want to take another look. Your camera uses a mini-HDMI connection, so most standard cables designed for video components won't work. If you do decide to purchase one, make sure you get a mini-HDMI-to-HDMI cable. You can find them at most electronics stores where HD cameras and TVs are sold. (Here's a little hint for purchasing a mini-HDMI cable: Search the Internet for the best prices. Most electronics stores have huge mark-ups on cables, and you can usually find a suitable one online for about a third of the price of those that you would find in your local store.)

TURN OFF THE SOUND

Earlier I told you how to turn off the audio option while recording your video. The truth is that the built-in microphone does not produce audio that is up to the quality of the video. To make your videos stand out, try turning off the mic and then adding a music soundtrack. You will be amazed at how the right music can really enhance a video. Of course you will need to do this on your computer, which will require special video editing software (see the "Editing Video" section that follows).

GET AN EXTERNAL MICROPHONE

If you want or need to have sound recorded with your videos, then I highly recommend you look into getting an external mic that you can plug into the mic jack on the side of the D3200. Nikon released the ME-1 external microphone a while back, and it is a nice step up from the built-in mic if for no other reason than that it records in stereo. You can watch and listen to a thorough review of the ME-1, along with some comparisons to other external mic choices, at http://bit.ly/d5100Mic (a D3s is used in the review).

WATCHING AND EDITING YOUR VIDEO

WATCHING VIDEO

There are a couple of ways for you to review your video once you have finished recording. The first is probably the easiest: Press the Image Review button to bring up the recorded image on the rear LCD screen, and then use the OK button to start playing the video. The Multi-selector acts as the video controller and allows you to rewind and fast-forward as well as stop the video altogether.

If you would like to get a larger look at things, you will need to either watch the video on your TV or move the video files to your computer. To watch on your TV, you can use the A/V cable that came with your camera (the one with the yellow and white jacks) and plugs into the small port on the side of the camera body. This will let you watch low-resolution video on your TV. To get the full effect from your HD videos, you will need to purchase a mini-HDMI cable (as discussed previously); your TV needs to support at least 720p and have an HDMI port to use this option. Once you have the cable hooked up to your TV (tune your TV to the channel used for HDMI input), simply use the same camera controls that you used for watching the video on the LCD screen.

If you would like to watch your video on your computer, you will first need to download the files or access them using an SD card reader. For Apple owners, you can use Apple's QuickTime Player to watch the video. If it is too large for your screen, try pressing Command-0 (zero) to make the video half-size, or Command-3 to fit the video to your screen. For Microsoft Windows users, it is possible to use the Windows Media Player, but you may need to download a special codec. Instead, try downloading the Apple QuickTime Player (www.apple.com/quicktime). The basic player is free and will allow you to view your movie files without any problems.

EDITING VIDEO

If you own a Mac, you can edit your HD video using the iMovie application. The latest version is chock full of new video editing features, including the ability to work with audio.

Windows XP users will have to purchase an editing program for editing HD video since the Windows Movie Maker application doesn't do a very good job of handling HD video resolutions. If you are using Windows 7, try Windows Live Movie Maker for a nice, basic video editing application.

There are also many other applications for Windows and Mac editing, such as Adobe Premiere Elements; you can find more information and download a trial version at www.adobe.com/products/premiereel. If you have Adobe Photoshop CS6, you should definitely take advantage of the improved video editing features that are now included in the Standard edition.

EXPANDING YOUR KNOWLEDGE

I have given you a couple of quick tips and suggestions in this chapter to get you started with your moviemaking, but if you really want to get serious there is a lot more you need to know. Videography can be a complex endeavor, and there is much to learn and know if you want to move beyond the simple video capture of the kids in the backyard or the trip to the amusement park. If you really want to explore all that your camera has to offer in the way of video moviemaking, then I suggest you check out *Creating DSLR Video: From Snapshots to Great Shots* (Figure 10.7). It is packed solid with everything you need to know about taking your DSLR videography to the next level and beyond.

FIGURE 10.7
A great book for taking your video work to the next level.

Chapter 10 Assignments

The video function of the D3200 is pretty impressive and can add a whole new dimension to your photographic experience. Take some time to capture some video the next time you are out taking photos.

Play with depth of field in your video

You can experiment with narrowing or widening the depth of field of your video to see how it affects the outcome. Start in Aperture Priority mode and set the aperture to the widest f-stop possible on the lens you are using (for example, f/3.5 on the kit lens) before engaging Live View. Focus on a subject that is somewhat close to you, but is also separated from a more distant background. Press the Record button to capture a few seconds of video. Stop recording (press the Record button again) and exit Live View. Now set your aperture to a small f-stop (such as f/22), focus on the subject, engage Live View and record a few more seconds. Compare the look of the two video clips to see the difference.

Refine your manual focus skills

The better you can get with manually focusing the lens while recording video the happier you will be with both the visual and audio results. Slide the focus switch on the lens to M and use the focus ring to lock in on your subject. Start with a slow moving subject. The wider your depth of field the easier this is to do.

Share your results with the book's Flickr group!

Join the group here: flickr.com/groups/nikond3200_fromsnapshotstogreatshots

Advanced Techniques

IMPRESS YOUR FAMILY AND FRIENDS

We've covered a lot of ground in the previous chapters, especially on the general photograp hic concepts that apply to most, if not all, shooting situations. There are, however, some specific tools and techniques that will give you an added advantage in obtaining a great shot.

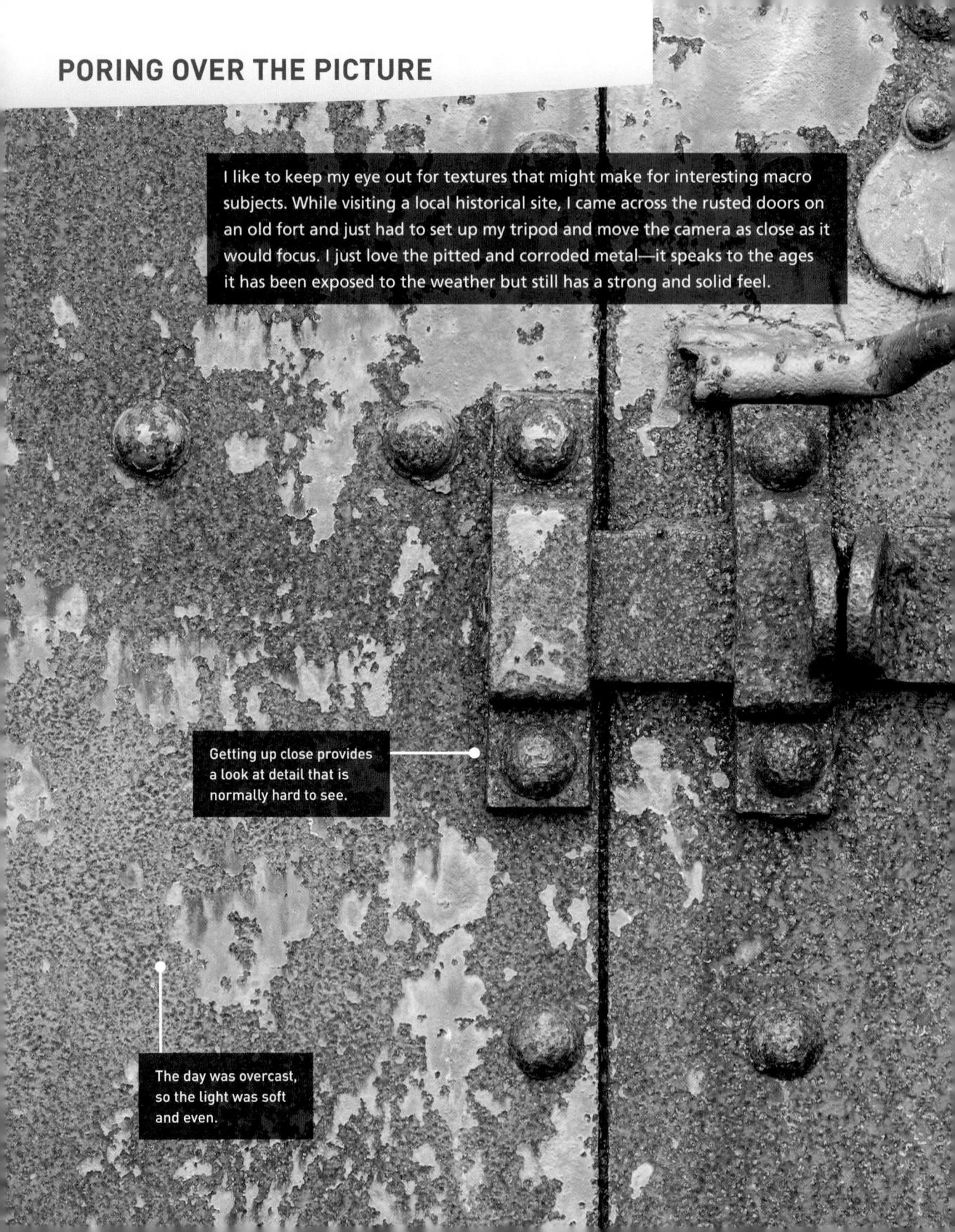

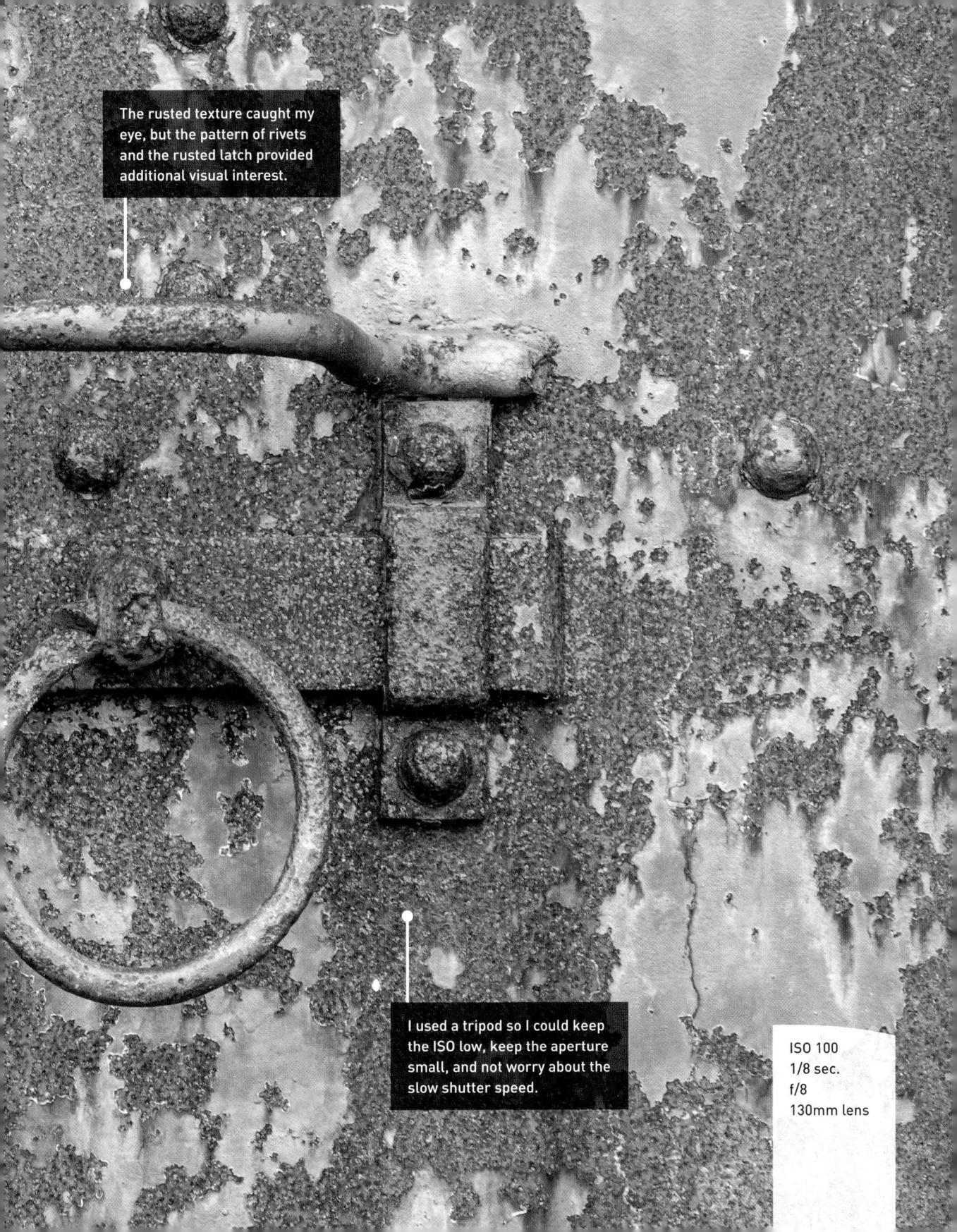

SPOT METER FOR MORE EXPOSURE CONTROL

Generally speaking, Matrix metering mode provides accurate metering information for the majority of your photography. It does an excellent job of evaluating the scene and then relating the proper exposure information to you. The only problem with this mode is that, like any metering mode on the camera, it doesn't know what it is looking at. There will be specific circumstances where you want to get an accurate reading from just a portion of a scene and discount all of the remaining area in the viewfinder. To give you greater control of the metering operation, you can switch the camera to Spot metering mode. This allows you to take a meter reading from a very small circle while ignoring the rest of the viewfinder area. If you are using the Auto-Area AF focus mode, the Spot meter will use the center spot in the viewfinder. Otherwise, the meter location is based on whichever focus point you are using.

So when would you need to use this? Think of a person standing in front of a very light wall. In Matrix metering mode, the camera would see the entire scene and try to adjust the exposure information so that the background is exposed to render a darker wall in your image. This means that the scene would actually be underexposed and your subject would then appear too dark (Figure 11.1). To correct this, you can place the camera in Spot metering mode and take a meter reading right off of—and only off of—your subject, ignoring the white wall altogether. The Spot metering will read the location where you have your focus point, placing all of the exposure information right on your point of interest (Figure 11.2).

Other situations that would benefit from Spot metering include:

- Snow or beach environments where the overall brightness level of the scene could fool the meter
- Strongly backlit subjects that are leaving the subject underexposed
- Cases where the overall feel of a photo is too light or too dark

SETTING UP AND SHOOTING IN SPOT METERING MODE

- 1. Press the i button to activate the cursor in the information screen, then move it to the current metering method.
- 2. Press the OK button, and then use the Multi-selector to select the Spot metering option.
- 3. Press the OK button to lock in your change.
- **4.** Now use the Multi-selector to move the focus point onto your subject, and take your photo. The meter reading will come directly from the location of the focus point.

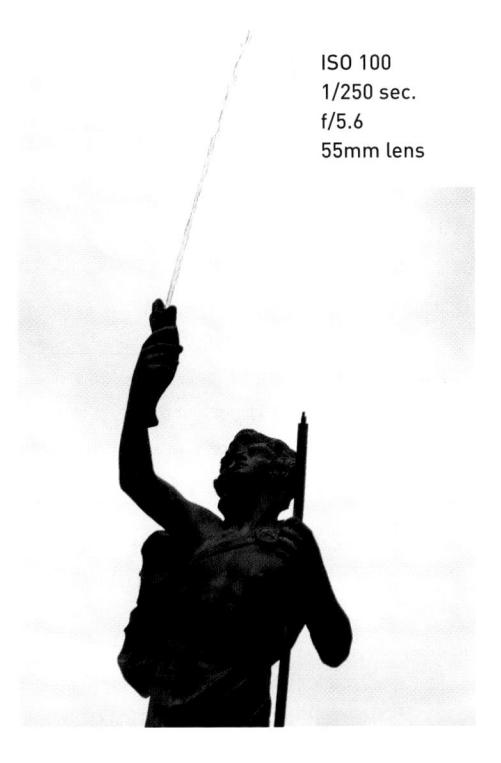

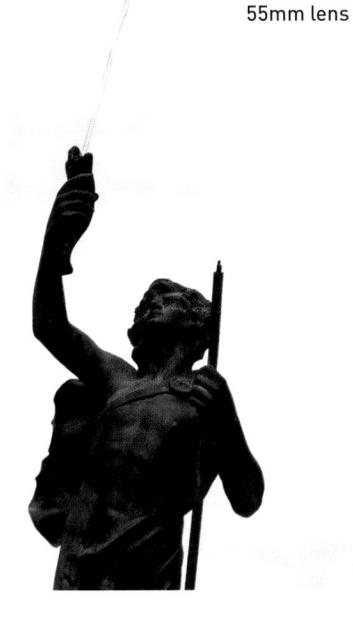

ISO 100

f/5.6

1/200 sec.

FIGURE 11.1 (left) A bright background can throw off your exposure. Using the Spot meter can help you zero in on great exposures.

FIGURE 11.2 (right) By switching to Spot metering I was able to get a more accurate exposure for the darker statue.

Note that if you are using the Auto-Area AF focus mode, the camera will use the center focus point as the Spot metering location.

When you're using Spot metering mode, remember that the meter believes it is looking at a middle gray value, so you might need to incorporate some exposure compensation of your own to the reading that you are getting from your subject. This will come from experience as you use the meter.

METERING FOR SUNRISE OR SUNSET

Capturing a beautiful sunrise or sunset is all about the sky. If there is too much foreground in the viewfinder, the camera's meter will deliver an exposure setting that is accurate for the darker foreground areas but that leaves the sky looking overexposed, undersaturated, and generally just not very interesting (Figure 11.3). To gain more emphasis on the colorful sky, point your camera at the brightest part of it and take your meter reading there. Use the AE Lock to meter for the brightest part of the sky, and then recompose. The result will be an exposure setting that underexposes the foreground but provides a darker, more dramatic sky (Figure 11.4).

FIGURE 11.3 By metering with all the information in the frame, you get bright skies and more detail in the ground.

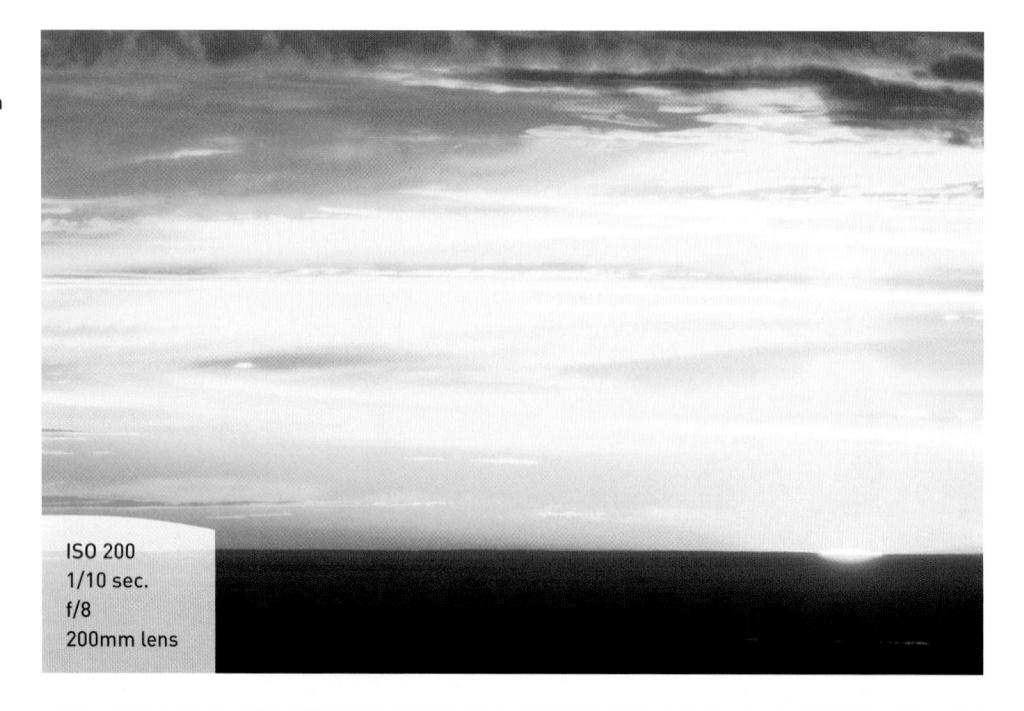

FIGURE 11.4
By taking the meter reading from the brightest part of the sky, you will get darker, more colorful sunsets.

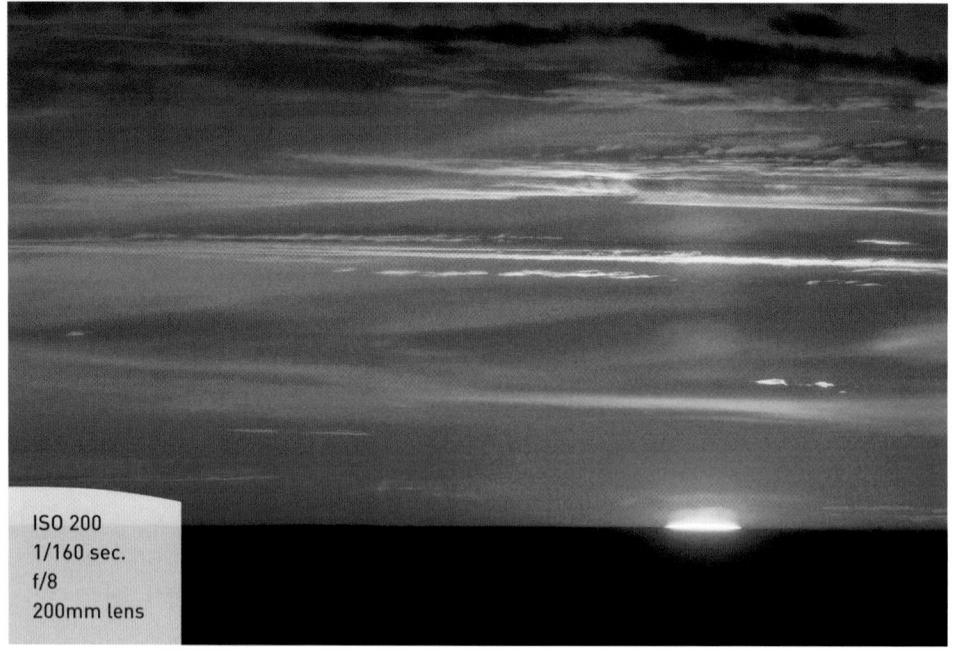

USING THE AE LOCK FEATURE

- 1. Point your camera toward a bright portion of the sky.
- 2. Press and hold the AE-L button with your thumb to activate the meter and lock the exposure.
- 3. While holding the button, recompose your photo and then take the shot with the shutter release button. As long as you keep the AE-L button pressed, your exposure will not change.

MANUAL MODE

Probably one of the most advanced and yet most basic skills to master is shooting in Manual mode. With the power and utility of most of the automatic modes, Manual mode almost never sees the light of day. I have to admit that I don't select it for use very often, but there are times when no other mode will do. One of the situations that works well with Manual is studio work with external flashes. I know that when I work with studio lights, my exposure will not change, so I use Manual to eliminate any automatic changes that might happen from shooting in Program, Shutter Priority, or Aperture Priority mode. In fact, every picture of the D3200 camera in this book was taken using Manual mode.

Since you probably aren't too concerned with studio strobes at this point, I will concentrate on one of the ways in which you will want to use Manual mode for your photography: long nighttime exposures.

BULB PHOTOGRAPHY

If you want to work with long shutter speeds that don't quite fit into one of the selectable shutter speeds, you can select Bulb. This setting is only available in Manual mode, and its sole purpose is to open the shutter at your command and then close it again when you decide. I can think of three scenarios where this would come in handy: shooting fireworks, shooting lightning, and painting with light.

If you are photographing fireworks, you could certainly use one of the longer shutter speeds available in Shutter Priority mode, since they are available for exposure times up to 30 seconds. That is fine, but sometimes you don't need 30 seconds' worth of exposure and sometimes you need more.

If you open the shutter and then see a great burst of fireworks, you might decide that that is all you want for that particular frame, so you click the button to end the exposure (Figure 11.5). Set the camera to 30 seconds and you might get too many bursts, but if you shorten it to 10 seconds you might not get the one you want.

FIGURE 11.5 A great use for the Bulb setting is when you're capturing fireworks.

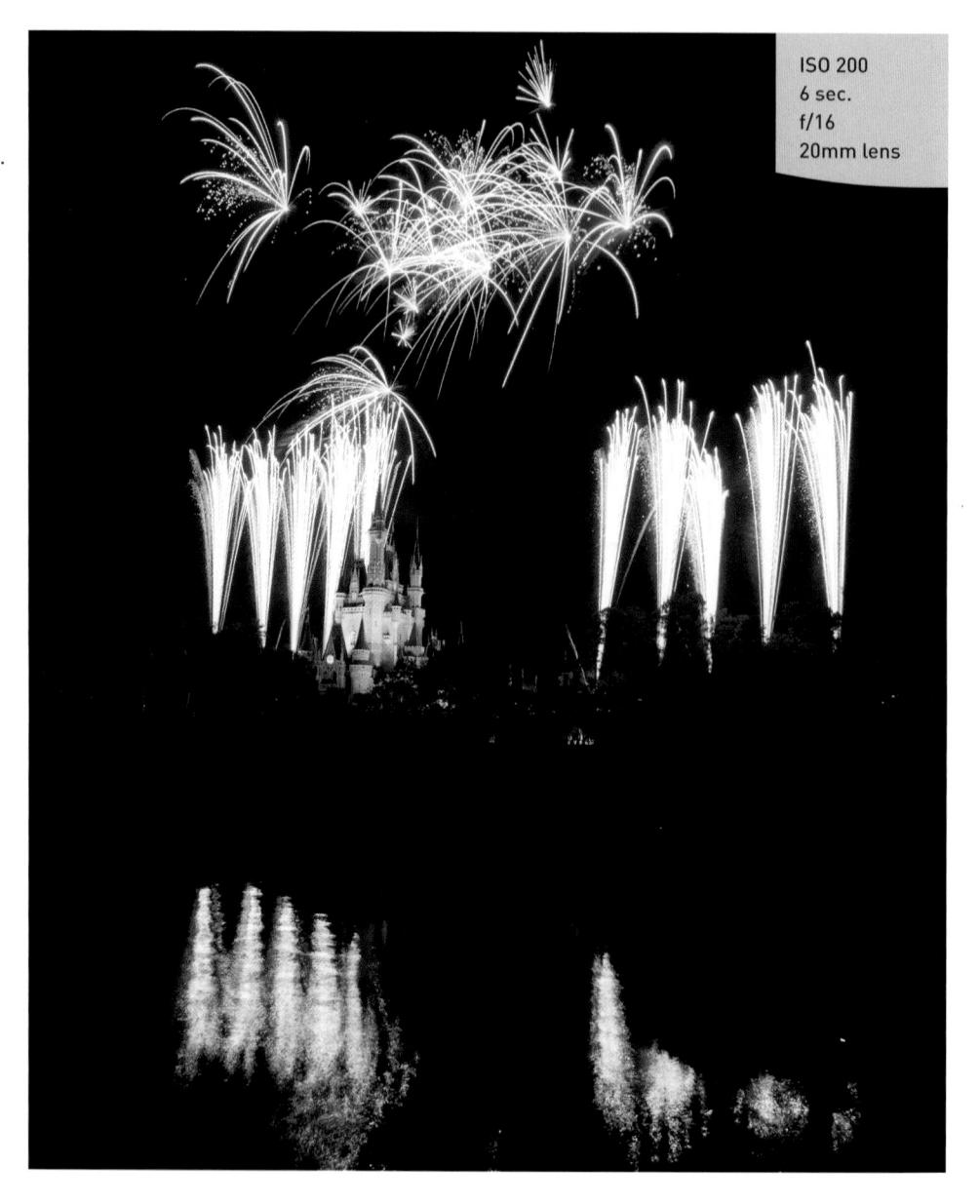

The same can be said for photographing a lightning storm. I have a friend who loves electrical storms, and he has some amazing shots that he captured using the Bulb setting. Lightning can be very tricky to capture, and using the Bulb setting to open and then close the shutter at will allows for more creativity, as well as more opportunity to get the shot.

Painting with light is a process where you set your camera to Bulb, open the shutter, and then use a light source to "paint" your subject with light. This can be done with a handheld flash or even a flashlight.

To select the Bulb setting, simply place your camera in Manual mode and then rotate the Command dial to the left until the shutter speed displays Bulb on the rear LCD screen.

When you're using the Bulb setting, the shutter will only stay open for the duration that you are holding down the shutter button. You should also be using a sturdy tripod or shooting surface to eliminate any self-induced vibration while using the Bulb setting.

BULB

If you are new to the world of photography, you might be wondering where in the world the *Bulb* shutter function got its name. After all, wouldn't it make more sense to call it the Manual Shutter setting? It probably would, but this is one of those terms that harkens back to the origins of photography. Way back when, the shutter was actually opened through the use of a bulb-shaped device that forced air through a tube, which, in turn, pushed a plunger down, activating the camera shutter. When the bulb was released, it pulled the plunger back, letting the shutter close and ending the exposure.

I want to point out that using your finger on the shutter button for a bulb exposure will definitely increase the chances of getting some camera shake in your images. To get the most benefit from the bulb setting, I suggest using a remote cord such as the Nikon MC-DC2 or a wireless remote such as the Nikon ML-L3 (see the bonus chapter, "Pimp My Ride" for more details). You'll also want to turn on the Noise Reduction, as covered in Chapter 8. With the wireless remote, you press the button on the remote once to open the shutter and then a second time to close it.

SHOOTING LIGHTNING

If you are going to photograph lightning strikes in a thunderstorm, please exercise extreme caution. Standing in the open with a tripod is like standing over a lightning rod. Work from indoors if at all possible.

AVOIDING LENS FLARE

Lens flare is one of the problems you will encounter when shooting in the bright sun. Lens flare will show itself as bright circles on the image (Figure 11.6). Often you will see multiple circles in a line leading from a very bright light source such as the sun. The flare is a result of the sun bouncing off the multiple pieces of optical glass in the lens and then being reflected back onto the sensor. You can avoid the problem using one of these methods:

- Try to shoot with the sun coming from over your shoulder, not in front of you or in your scene.
- Use a lens shade to block the unwanted light from striking the lens. You don't have to have the sun in your viewfinder for lens flare to be an issue. All it has to do is strike the front glass of the lens to make it happen.
- If you don't have a lens shade, just try using your hand or some other element to block the light.

USING THE SUN CREATIVELY

Have you ever seen photographs where the sun is peeking through a small hole and it creates a very cool starburst effect? There is actually a little trick to pulling it off, and it's fairly easy. The real key is to be shooting at f/22 (or whatever your smallest aperture is). Then you need to have just a small bit of the sunlight in your frame, either peeking over an edge or through a small hole. The other thing you need to do is make sure that you are properly exposing for the rest of your scene, not for the bright bit of sunlight that you are allowing in. With a little practice, you can really make some very cool shots (Figure 11.7).

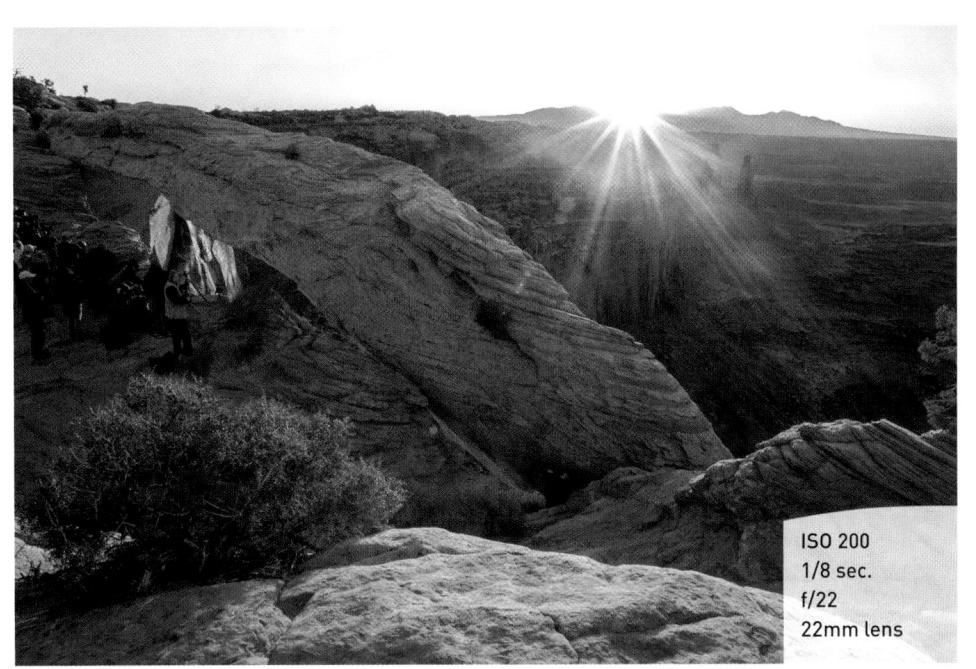

FIGURE 11.6
While out at Mesa
Arch, I took in the
view of the sunrise
while everyone else
shot the classic
shot through the
arch itself.

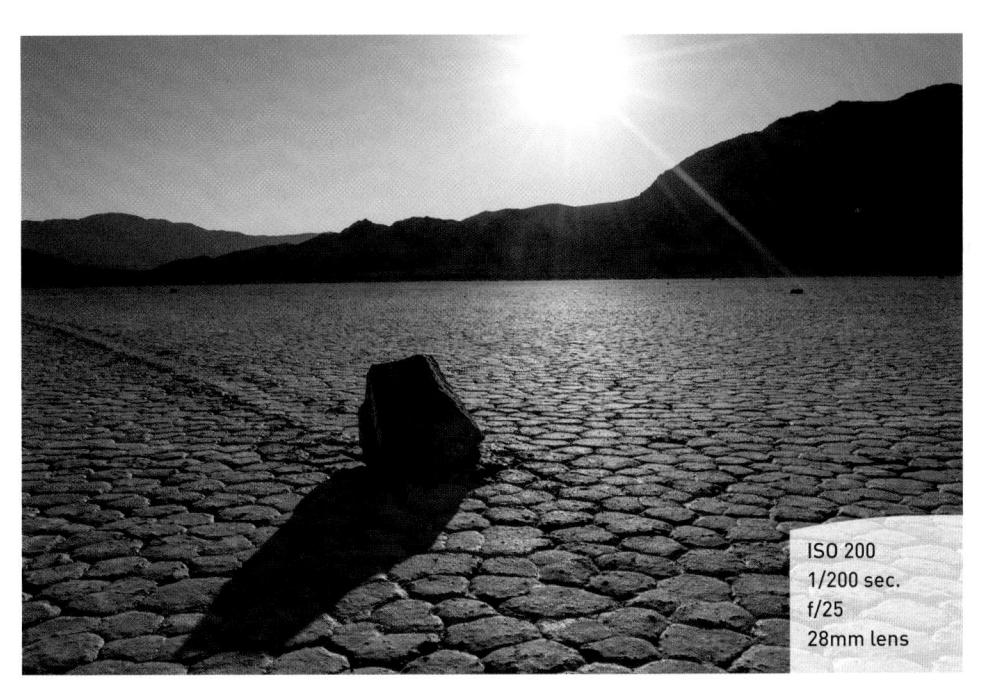

FIGURE 11.7 In the desert, it's hard to escape the feeling of the sun beating down on you—I wanted to bring that feeling into this photo.

MACRO PHOTOGRAPHY

Put simply, macro photography is close-up photography. Depending on the lens or lenses that you got with your camera, you may have the perfect tool for macro work. Some lenses are made to shoot in a macro mode, but you don't have to feel left out if you don't have one of those. Check the spec sheet that came with your lens to see what the minimum focusing distance is for your lens.

If you have a zoom, you should work with the lens at its longest focal length. Also, work with a tripod, because handholding will make focusing difficult. The easiest way to make sure that your focus is precisely where you want it to be is to use Manual focus mode.

Since I am recommending a tripod for your macro work, I will also recommend using Aperture Priority mode so that you can achieve differing levels of depth of field. Long lenses at close range can make for some very shallow depth of field, so you will need to work with apertures that are probably much smaller than you might normally use. If you are shooting outside, try shading the subject from direct sunlight by using some sort of diffusion material, such as a white sheet or a diffusion panel (see the bonus chapter, "Pimp My Ride"). By diffusing the light, you will see much greater detail because you will have a lower contrast ratio (softer shadows), and detail is often what macro photography is all about (Figure 11.8).

FIGURE 11.8 Flowers provide a great opportunity for moving in close and shooting macros.

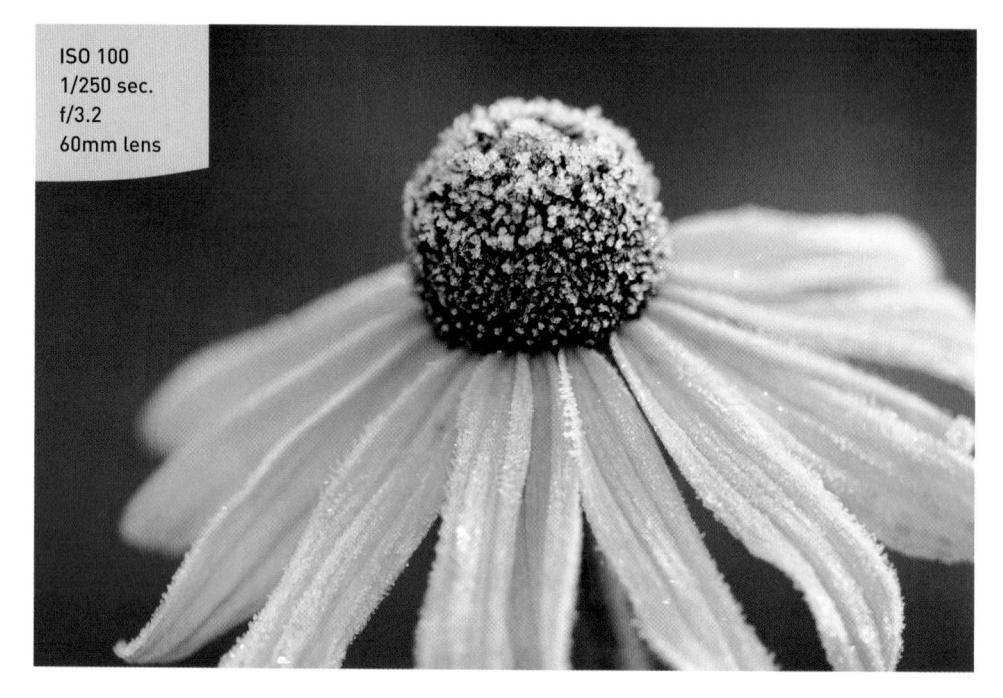

ACTIVE D-LIGHTING

Your camera has a function that can automatically make your pictures look better: Active D-Lighting. It works this way: The camera evaluates the tones in your image and then underexposes for the highlight areas while lightening any areas that it believes are too dark or lacking in contrast (Figures 11.9 and 11.10). The Active D-Lighting feature must be turned on using the Menu button. It will take slightly longer to process your images, so you will notice a bit of a lag from the time you take the shot to the time it shows up on your LCD.

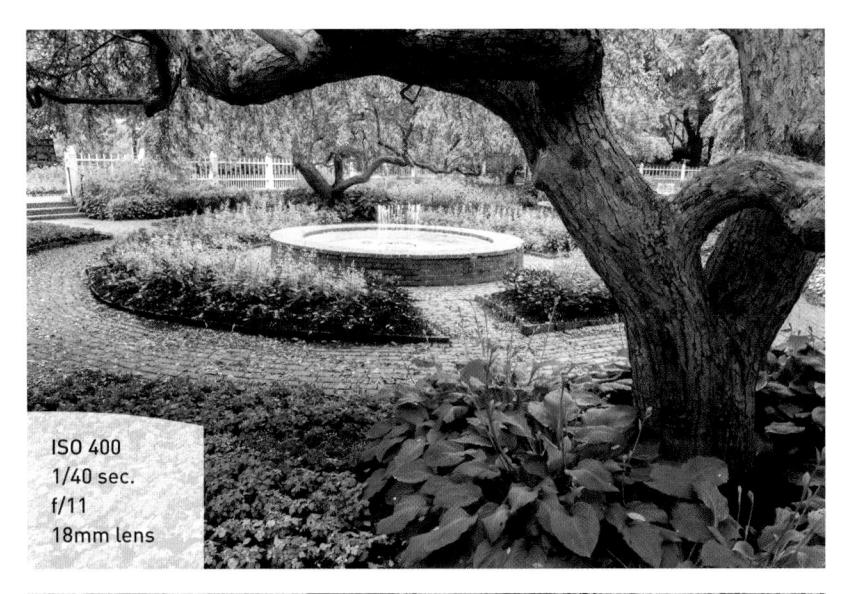

FIGURE 11.9 Without the Active D-Lighting, the shadows in the image are darker and more contrasty.

FIGURE 11.10 Although the exposure hasn't changed, the shadows are brighter after turning on the Active D-Lighting.

SETTING UP ACTIVE D-LIGHTING

- 1. Press the Menu button, navigate to the Shooting Menu by using the Multi-selector, and highlight Active D-Lighting (A).
- 2. Press the OK button, and then select On to activate Active D-Lighting (B).
- 3. Press the OK button to lock in your changes, and resume shooting.

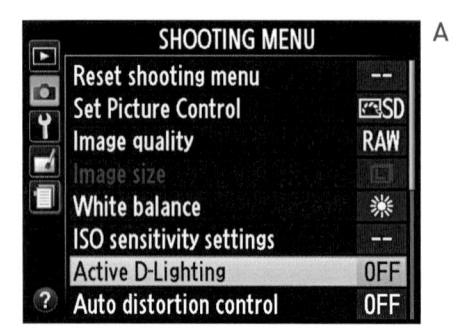

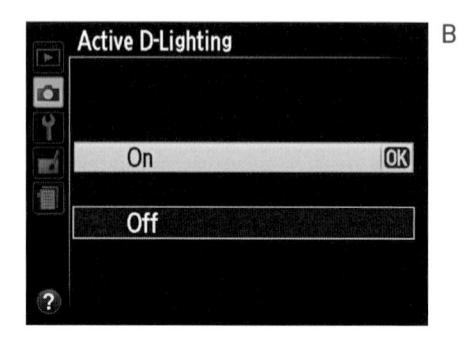

Active D-Lighting can also be applied to an image after shooting by using the Retouch menu.

APPLYING D-LIGHTING AFTER YOU SHOOT

- 1. To apply Active D-Lighting to an image, press the Image Playback button and navigate to the image that you want the effect applied to.
- 2. Press the OK button on the Multi-selector to enter the Retouch Menu.
- 3. Select D-Lighting and press OK (C).
- **4.** A before-and-after shot will appear on the screen. Use the up/down function on the Multi-selector to apply the amount of D-Lighting you desire (Low, Normal, or High), and press OK (**D**).
- **5.** When you are done, you will notice that there are now two images saved to the memory card: the original and a copy with the D-Lighting applied.

CUSTOMIZE YOUR WHITE BALANCE

Previous chapters have addressed the issue of setting your white balance, but what if you are in a situation that doesn't really fall neatly into one of the existing categories like Daylight or Tungsten? You might want to consider creating a custom white balance. This is especially helpful if you are working in a mixed lighting scenario where you have more than one kind of light source shining on your subject. A perfect example might be inside with fluorescent lighting fixtures overhead and daylight coming in through a window. To ensure that you are getting the best possible results in a situation like this, you can perform a quick white balance customization by using the Preset Manual option. Don't worry, though; it's easier than you might think. All you really need is a white piece of paper and a few seconds in your camera menu.

SETTING UP A PRESET MANUAL WHITE BALANCE

- 1. Press the Menu button, navigate to the White balance option found in the Shooting Menu, and press OK (A).
- 2. Scroll down to the Preset manual option, and press the right arrow on the Multi-selector (B).
- 3. Highlight Measure, and press the right arrow again (C). Then highlight Yes to overwrite the pre-existing data, and press OK (D). (The camera can store only one preset white balance, so you will need to overwrite any existing setting.)

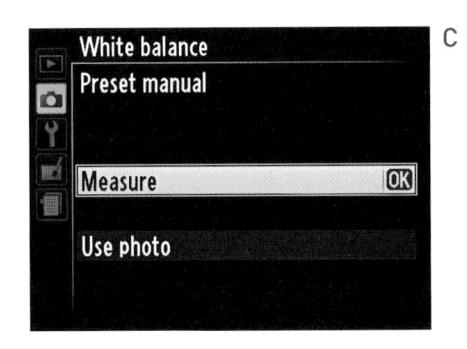

- The display will then direct you to photograph a white or gray object to use for measuring the color temperature (E).
- 5. Have your subject hold the white piece of paper in the same light that they will be standing in, or place it in the scene where the light will fall. Fill the frame with the paper and take a picture.

Your new white balance is now recorded and will be used until you change the white balance to something else.

CONCLUSION

As you'll see, the online bonus Chapter 12, "Pimp My Ride" (see Introduction for download information) covers a lot of gadgets, filters, and accessories that will make your photography easier and better. It can become an obsession to always have the latest thing out there. But here's the deal. You already have almost everything you need to take great pictures: an awesome camera and the knowledge necessary to use it. Everything else is just icing on the cake. So, while I introduce a few items in bonus Chapter 12 that I do think will make your photographic life easier and even improve your images, don't get caught up in the technology and gadgetry.

Use your knowledge of basic photography to explore everything your camera has to offer. Explore the limits of your camera. Don't be afraid to take bad pictures. Don't be too quick to delete them off your memory card, either. Take some time to really look at them and see where things went wrong. Look at your camera settings and see if perhaps there was a change you could have made to make things better. Be your toughest critic and learn from your mistakes. With practice and reflection, you will soon find your photography getting better and better. Not only that, but your instincts will improve to the point that you will come upon a scene and know exactly how you want to shoot it before your camera even gets out of the bag.

Chapter 11 Assignments

Many of the techniques covered in this chapter are specific to certain shooting situations that may not come about very often. This is even more reason to practice them so that when the situation does present itself you will be ready.

Adding some drama to the end of the day

Most sunset photos don't reflect what the photographer saw, because they didn't meter correctly for them. The next time you see a colorful sunset, pull out your camera and take a meter reading from the sky and then one without and see what a difference it makes.

Making your exposure spot on

Using the Spot meter mode can give accurate results, but only when pointed at something that has a middle tone. Try adding something gray to the scene and taking a reading off it. Now switch back to your regular meter mode and see if the exposure isn't slightly different.

Using the Bulb setting to capture the moment

This is definitely one of those settings that you won't use often, but it's pretty handy when you need it. If you have the opportunity to shoot a fireworks display or a distant storm, try setting the camera to Bulb and then play with some long exposures to capture just the moments that you want.

Moving in for a close-up

Macro photography is best practiced on stationary subjects, which is why I like flowers. If you have a zoom lens, check the minimum focusing distance and then try to get right to that spot to squeeze the most from your subject. Try using a diffuse light source as well to minimize shadows.

Share your results with the book's Flickr group!

Join the group here: flickr.com/groups/nikond3200_fromsnapshotstogreatshots

3D-tracking AF mode, 113 12- or 14-bit RAW images, 38	situations for using, 83–87, 92 wildlife photography and, 83 aperture settings depth of field and, 48, 50, 82, 86 exposure and, 46, 47–48
_	aperture settings depth of field and, 48, 50, 82, 86
_	depth of field and, 48, 50, 82, 86
0	
	exposure and, 46, 47-48
A	
accessories, 241-242, 266	f-stops and, 86
action photography, 99-122	landscape photography and, 84
3D-tracking mode for, 113	light levels and, 86
annotated example of, 100-101	portrait photography and, 128-129
assignments on shooting, 122	prioritizing, 82–88, 92
automatic mode for, 61-62	zoom lenses and, 45, 88
composing shots in, 118-121	architectural photography, 83, 85
continuous shooting mode for, 115–116	audio recording, 238-239, 247
conveying motion in, 116-118	Auto Cleaning feature, 36
depth of field in, 108-109	Auto Exposure Lock (AE-L) feature, 133–134
factors to consider for, 102-105	Auto ISO Sensitivity feature, 110-111
focus modes for, 111-114, 122	Auto ISO setting, 9, 10, 109
freezing motion in, 48, 49, 78, 102	Auto mode, 56-57, 68
ISO settings and, 107-108, 109-110	Auto off timer setting, 6
isolating subjects in, 108-109	Auto white balance setting, 13
portraits as, 143	autofocus system, 17, 199
shutter speed and, 78, 79, 93, 102,	Automatic Focus (AF) points, 113
105–106, 143	automatic scene modes, 14, 53-69
telephoto lenses and, 43	assignments on using, 68–69
tips for shooting, 118-121	Auto mode, 56–57
See also motion	Child mode, 60
Active D-Lighting feature, 67, 263-264	Close-up mode, 62–63
additive color, 16	Flash Off mode, 64-65
Adobe RGB color space, 16	Landscape mode, 59
AE Lock feature, 133-134, 255, 257	limitations of, 66–67
AF Assist feature, 200	Night Portrait mode, 63-64
AF-area mode, 112-113, 136	Portrait mode, 57–58, 128
AF-C focus mode, 67, 111-112, 143	Program mode vs., 74
AF-S focus mode, 11, 12-13, 25, 67, 134-135	Sports mode, 61–62
angles, shooting, 224, 225	See also professional modes
animal photography, 30-31, 83	D
Aperture Priority (A) mode, 82–88	В
assignment on using, 97	backgrounds
close-up photography and, 83, 84, 262	blurring, 48, 50, 57, 108, 128, 129
flash sync speeds in, 205	isolating subjects from, 108–109
isolating subjects using, 108-109	portrait, 128, 129, 150
landscape photography and, 83, 84, 171, 176	backlit subjects, 132, 254
photo examples using, 83-85, 87	backup battery, 5
portrait photography and, 83, 128-129	battery, charging, 5

beach scenes, 254	color space settings, 16-17
Black, Dave, 192	color temperature, 15, 170
black and white images	color theory, 16
landscape photos as, 169-170	Command dial, 75
portraits as, 137-139	composition, 219-233
blinkies, 94-95, 166, 176	action photo, 118-121
blur	angles and, 224, 225
background, 48, 50, 57, 108, 128, 129	annotated example of, 220-221
motion, 48, 49, 78, 79, 117-118	assignments on, 233
bonus chapter, xi, 266	color and, 226-227
brightness, 22, 178	contrast and, 228-229
Bulb setting, 257–259, 267	creating depth through, 180-181
"bull's eye" composition, 178	depth of field and, 222-223
, ,	framing and, 230-232
C	landscape, 178-181
camera shake, 65, 158, 197-198, 215	leading lines and, 230
camera stabilizers, 242	patterns and, 226
catchlight, 141, 142	point of view and, 224, 225
Center-weighted metering mode, 131–133	portrait, 144–152
charging the battery, 5	rule of thirds and, 178-180, 230, 231
Child mode, 60	continuous shooting mode, 115-116
children	Continuous-servo (AF-C) mode, 111-113, 143
action portraits of, 143	contrast, 228–229
automatic mode for shooting, 60	cool colors, 15, 170
shooting at their level, 151	Creating DSLR Video: From Snapshots to
Cinema Strap, 242	Great Shots (Harrington), 248-249
Clean now feature, 36, 37	
cleaning the sensor, 36-37, 51	D
Cleaveland, Dave, 114	Daylight setting, 14, 162
clipping, 22-23	default display mode, 18, 19
Close-up mode, 62-63, 68	deleting images, 21
close-up photography, 262	depth, creating, 180-181
accessories for, 241	depth of field
annotated examples of, 54-55, 252-253	action photography and, 108-109
Aperture Priority mode for, 83, 84, 262	aperture settings and, 48, 50, 82, 86, 92
assignment on shooting, 267	close-up photography and, 262
automatic mode for, 62-63	composition and, 222-223
Cloudy setting, 14, 162	landscape photography and, 171-172, 189
CMYK colors, 16	portrait photography and, 128, 129, 153
color	telephoto lenses and, 43
additive vs. subtractive, 16	video recording and, 243
contrast added through, 228	wide-angle lenses and, 41
viewing in photographs, 178	direction of travel, 102-103
warm vs. cool, 15, 170	display modes, 18-21
color composition, 226–227	display screen. See LCD display

distance	fireworks, 257–258
flash range and, 204	firmware updates, 34-35, 51
hyper focal, 172, 189	flash
subject-to-camera, 104-105	built-in, 203-206
distance compression, 43, 44	disabling, 64-65, 200-201
distortion, 129, 145	external, 214-215
D-Lighting function, 264	fill, 141–142
drive modes, 115	hot shoe bracket, 14
DSLR cameras, 24, 40	manual power mode, 205-206
dual image formats, 39-40	range/distance, 204
Dynamic AF-area mode, 112-113	Rear Curtain Sync mode, 211-213
dynamic range, 38, 187	red-eye reduction, 209-211
	reflections from, 213-214
E	shutter speed and, 202, 205
editing video, 248	Flash Exposure Compensation feature, 67,
environmental portraits, 129-130	142, 206-208
exposure, 45-48	Flash Off mode, 64-65
calculating, 46-48	flash synchronization
factors of, 45-46	Rear Curtain Sync mode, 211-213
histograms and, 22-23	shutter speed and, 202, 205
long, 78, 79, 201-202, 257-259	Flash white balance setting, 14
reciprocal settings for, 47-48	Flickr group for book, 26
Exposure Compensation feature, 94	flower photography, 54-55, 262
automatic scene modes and, 67	Fluorescent setting, 13, 162, 163
flash compensation and, 206-208	focal lengths, 40-45
HDR images and, 187	focus modes, 67, 122
highlight warning and, 95, 166	3D-tracking, 113
landscape photography and, 166-168, 176	AF-area, 112-113, 136
portrait photography and, 131	AF-C, 111-112, 143
shooting modes and, 168	AF-S, 11, 12-13, 134-135
exposure triangle, 45, 46	manual, 17-18, 114, 173-174, 199, 245
exposure value (EV), 45	focus points, 11, 12-13, 113
external flash, 214–215	focusing
eyes	for action photography, 111-114
catchlight in, 141, 142	for landscape photography, 171-174
focusing on, 134-135	for low-light photography, 199-200
red-eye reduction, 209-211	for portraits, 134-136
	for video recording, 236, 240
F	focusing system, 11-13, 199
Face Priority mode, 139-140	formatting memory cards, 33-34, 51
"fake" panoramas, 182-183	framing images
fast lenses, 86	action photos, 118-119
fill flash, 141-142	composition guidelines for, 230-232
filters	portraits, 144, 146-147, 150
Monochrome picture control, 138, 169-170	freezing motion, 48, 49, 78, 102
polarizing and neutral density, 176, 177, 241	

f-stops, 46, 47-48, 86	ISO settings
See also aperture settings	action photos and, 107-108, 109-110
Function button, 11, 164	Auto option, 9, 10, 109
	changing on the fly, 11, 107-108
G	expanded settings, 196-197, 215
glass reflections, 213–214	explained, 9
grid overlay feature, 180	exposure and, 46, 47-48
Guide mode, 66	flash range and, 204
	landscape photos and, 160-161
H	low-light photos and, 194-197
hand portraits, 152	noise and, 10, 160-161
handheld photography, 197-198, 215	prioritizing, 74-75, 92
HDMI cable connection, 246	starting points for, 75
High Capacity (SDHC) cards, 32	steps for selecting, 10
high dynamic range (HDR) images, 187-188	
high-definition video, 237	J
high-key images, 167	JPEG file format
Highlight Alert feature, 94-95, 166, 176	explained, 7, 37
highlights	quality settings, 7-9
overexposure warning for, 94-95, 166, 176	RAW+JPEG option, 39-40
regaining detail in, 168	reasons for using, 37
Highlights display mode, 19, 20	
histograms, 22-23	K
holding your camera, 24-25, 26	Kelvin temperature scale, 15
Holographium app, 211	
Hoodman loupe, 242	L.
Hoodman loupe, 242 horizon line, 180, 189, 230, 231	Landscape mode, 59, 68
-	Landscape mode, 59, 68 landscape photography, 155–189
horizon line, 180, 189, 230, 231	-
horizon line, 180, 189, 230, 231 hot shoe, 14	landscape photography, 155-189
horizon line, 180, 189, 230, 231 hot shoe, 14	landscape photography, 155-189 annotated example of, 156-157
horizon line, 180, 189, 230, 231 hot shoe, 14	landscape photography, 155–189 annotated example of, 156–157 aperture settings and, 84
horizon line, 180, 189, 230, 231 hot shoe, 14 hyper focal distance (HFD), 172, 189	landscape photography, 155–189 annotated example of, 156–157 aperture settings and, 84 assignments on shooting, 189
horizon line, 180, 189, 230, 231 hot shoe, 14 hyper focal distance (HFD), 172, 189 i button, 8	landscape photography, 155-189 annotated example of, 156-157 aperture settings and, 84 assignments on shooting, 189 automatic mode for, 59
horizon line, 180, 189, 230, 231 hot shoe, 14 hyper focal distance (HFD), 172, 189 i button, 8 image formats	landscape photography, 155–189 annotated example of, 156–157 aperture settings and, 84 assignments on shooting, 189 automatic mode for, 59 black and white, 169–170
horizon line, 180, 189, 230, 231 hot shoe, 14 hyper focal distance (HFD), 172, 189 i button, 8 image formats dual, 39-40	landscape photography, 155–189 annotated example of, 156–157 aperture settings and, 84 assignments on shooting, 189 automatic mode for, 59 black and white, 169–170 composition in, 178–181
horizon line, 180, 189, 230, 231 hot shoe, 14 hyper focal distance (HFD), 172, 189 i button, 8 image formats dual, 39-40 exploring, 51 JPEG, 7-9, 37 RAW, 38-39	landscape photography, 155–189 annotated example of, 156–157 aperture settings and, 84 assignments on shooting, 189 automatic mode for, 59 black and white, 169–170 composition in, 178–181 Exposure Compensation for, 166–168, 176
horizon line, 180, 189, 230, 231 hot shoe, 14 hyper focal distance (HFD), 172, 189 i button, 8 image formats dual, 39-40 exploring, 51 JPEG, 7-9, 37	landscape photography, 155–189 annotated example of, 156–157 aperture settings and, 84 assignments on shooting, 189 automatic mode for, 59 black and white, 169–170 composition in, 178–181 Exposure Compensation for, 166–168, 176 focusing for, 171–174
horizon line, 180, 189, 230, 231 hot shoe, 14 hyper focal distance (HFD), 172, 189 i button, 8 image formats dual, 39-40 exploring, 51 JPEG, 7-9, 37 RAW, 38-39	landscape photography, 155–189 annotated example of, 156–157 aperture settings and, 84 assignments on shooting, 189 automatic mode for, 59 black and white, 169–170 composition in, 178–181 Exposure Compensation for, 166–168, 176 focusing for, 171–174 HDR images and, 187–188
horizon line, 180, 189, 230, 231 hot shoe, 14 hyper focal distance (HFD), 172, 189 i button, 8 image formats dual, 39-40 exploring, 51 JPEG, 7-9, 37 RAW, 38-39 image quality settings, 7-9	landscape photography, 155–189 annotated example of, 156–157 aperture settings and, 84 assignments on shooting, 189 automatic mode for, 59 black and white, 169–170 composition in, 178–181 Exposure Compensation for, 166–168, 176 focusing for, 171–174 HDR images and, 187–188 hyper focal distance for, 172, 189
horizon line, 180, 189, 230, 231 hot shoe, 14 hyper focal distance (HFD), 172, 189 i button, 8 image formats dual, 39-40 exploring, 51 JPEG, 7-9, 37 RAW, 38-39 image quality settings, 7-9 image resolution, 38	landscape photography, 155–189 annotated example of, 156–157 aperture settings and, 84 assignments on shooting, 189 automatic mode for, 59 black and white, 169–170 composition in, 178–181 Exposure Compensation for, 166–168, 176 focusing for, 171–174 HDR images and, 187–188 hyper focal distance for, 172, 189 ISO settings for, 160–161
horizon line, 180, 189, 230, 231 hot shoe, 14 hyper focal distance (HFD), 172, 189 i button, 8 image formats dual, 39-40 exploring, 51 JPEG, 7-9, 37 RAW, 38-39 image quality settings, 7-9 image resolution, 38 Image Review button, 95, 247 Incandescent setting, 13 information screen, 5	landscape photography, 155–189 annotated example of, 156–157 aperture settings and, 84 assignments on shooting, 189 automatic mode for, 59 black and white, 169–170 composition in, 178–181 Exposure Compensation for, 166–168, 176 focusing for, 171–174 HDR images and, 187–188 hyper focal distance for, 172, 189 ISO settings for, 160–161 noise reduction for, 161–162 panoramas and, 181–186 picture control for, 165–166
horizon line, 180, 189, 230, 231 hot shoe, 14 hyper focal distance (HFD), 172, 189 i button, 8 image formats dual, 39-40 exploring, 51 JPEG, 7-9, 37 RAW, 38-39 image quality settings, 7-9 image resolution, 38 Image Review button, 95, 247 Incandescent setting, 13 information screen, 5 interlaced video, 238	landscape photography, 155–189 annotated example of, 156–157 aperture settings and, 84 assignments on shooting, 189 automatic mode for, 59 black and white, 169–170 composition in, 178–181 Exposure Compensation for, 166–168, 176 focusing for, 171–174 HDR images and, 187–188 hyper focal distance for, 172, 189 ISO settings for, 160–161 noise reduction for, 161–162 panoramas and, 181–186 picture control for, 165–166 sunrise/sunset in, 170–171
horizon line, 180, 189, 230, 231 hot shoe, 14 hyper focal distance (HFD), 172, 189 i button, 8 image formats dual, 39-40 exploring, 51 JPEG, 7-9, 37 RAW, 38-39 image quality settings, 7-9 image resolution, 38 Image Review button, 95, 247 Incandescent setting, 13 information screen, 5	landscape photography, 155–189 annotated example of, 156–157 aperture settings and, 84 assignments on shooting, 189 automatic mode for, 59 black and white, 169–170 composition in, 178–181 Exposure Compensation for, 166–168, 176 focusing for, 171–174 HDR images and, 187–188 hyper focal distance for, 172, 189 ISO settings for, 160–161 noise reduction for, 161–162 panoramas and, 181–186 picture control for, 165–166 sunrise/sunset in, 170–171 tripods used for, 158–159, 171, 173
horizon line, 180, 189, 230, 231 hot shoe, 14 hyper focal distance (HFD), 172, 189 i button, 8 image formats dual, 39-40 exploring, 51 JPEG, 7-9, 37 RAW, 38-39 image quality settings, 7-9 image resolution, 38 Image Review button, 95, 247 Incandescent setting, 13 information screen, 5 interlaced video, 238	landscape photography, 155–189 annotated example of, 156–157 aperture settings and, 84 assignments on shooting, 189 automatic mode for, 59 black and white, 169–170 composition in, 178–181 Exposure Compensation for, 166–168, 176 focusing for, 171–174 HDR images and, 187–188 hyper focal distance for, 172, 189 ISO settings for, 160–161 noise reduction for, 161–162 panoramas and, 181–186 picture control for, 165–166 sunrise/sunset in, 170–171

Landscape picture control, 59, 165-166 LCD display	self-timer used for, 198 Vibration Reduction lenses for, 197–198
reviewing photos in, 18–23, 26	luminance, 22
reviewing videos in, 247	idiffication, 22
zooming in on, 106	M
leading lines, 230	macro photography. See close-up
lens flare, 260, 261	photography
lenses, 40-45	Manual flash mode, 205-206
explained, 40–41	
exploring, 51	manual focus mode, 17-18, 26, 114, 122, 173-174, 199, 245
normal, 41–43	Manual (M) mode, 88–92, 257
portrait, 57, 145	
telephoto, 43–44	assignment on using, 97
Vibration Reduction, 65, 159, 197–198	Bulb setting in, 257–259
	Exposure Compensation in, 168
video recording and, 240	photo examples using, 89-91
wide-angle, 41, 42	setting up and shooting in, 91–92
zoom, 45	situations for using, 89–91, 121, 257
light meter, 89, 90, 131	Matrix metering mode, 66, 131
lighting	megapixels (MP), 38
Active D-Lighting feature and, 67,	memory cards, 32–34
263-264	choosing, 32
red-eye reduction and, 210	formatting, 33–34, 51
See also flash; low-light photography;	updating firmware from, 35
sunlight	video recording and, 246
lightning storms, 259, 260	metering modes, 131–133, 153
Live View feature, 139–140, 180, 236	Center-weighted, 131–133
long exposures, 78, 79, 201–202, 216,	Manual flash, 205-206
257-259	Matrix, 66, 131
lossy compression, 7	Spot, 131, 254-255
low-key images, 167	TTL, 205
low-light photography, 191–216	microphones, 238-239, 247
annotated example of, 192-193	mini-HDMI cable, 246
assignments on shooting, 215–216	mirror reflections, 224
built-in flash for, 203-206	Mode dial, 14
disabling the flash for, 64-65, 200-201	Monochrome picture control, 137–139,
eliminating flash reflections in, 213-214	169-170
external flash for, 214-215	motion
flash compensation for, 206-208	assignments on shooting, 122
focusing for, 199-200	automatic mode for, 61-62
ISO settings for, 75, 194-197	blurring, 48, 49, 78, 79, 117-118
long exposures for, 201-202, 257-259	continuous shooting mode for, 115-116
Night Portrait mode for, 63-64	focus modes for, 111-114
noise reduction for, 195, 201-202	freezing, 48, 49, 78, 102
Rear Curtain Sync mode for, 211-213	panning, 116-117, 122
red-eye reduction in, 209-211	shutter speed and, 48, 102, 105-106

techniques for conveying, 79, 116-118	Playback display options, 19
tips for shooting, 118–121	Playback menu, 19, 94
See also action photography	point of view, 224, 225
Movie settings menu, 238, 239	polarizing filter, 176, 241
multiple-image panoramas, 184-186	pop-up flash, 203-206, 216
	Portrait mode, 57-58, 68, 128
N	portrait orientation, 147
natural light, 153	Portrait picture control, 57, 139, 153
neutral density filter, 176, 177, 241	portraits, 125–153
Night Portrait mode, 63-64, 69, 205	action shots as, 143
nighttime photography. See low-light	AE Lock feature for, 133-134
photography	annotated example of, 126-127
Nikon D3200 camera	Aperture Priority mode for, 83, 128-130
features illustration, 2-4	assignments on shooting, 153
firmware updates, 34-35	automatic mode for, 57-58, 128
Guide mode for using, 66	backgrounds for, 128, 129, 150
memory cards approved for, 32	black and white, 137-139
properly holding, 24–25, 26	composition of, 144-152
Nikon SB-700 Speedlight, 215	depth of field in, 128, 129, 153
Nikon ViewNX software, 39	environmental, 129–130
noise in images, 10, 62, 160-161, 195, 196	Face Priority mode for, 139-140
Noise Reduction feature, 92, 161–162, 195,	fill flash for, 141–142
196, 201–202, 215	focusing for, 134-136
normal lenses, 41-43	lenses used for, 57, 145
,	metering modes for, 131–133, 153
0	nighttime, 63-64
online bonus chapter, 266	picture controls for, 137–139, 153
overexposure warning, 94–95, 166, 176	tips for shooting, 144-152
Overview display mode, 20, 21	Pre white balance setting, 14
, , , , , ,	pre-focusing cameras, 114
P	prime lenses, 45
painting with light, 259	professional modes, 14, 71-97
panning, 116–117, 122, 245	Aperture Priority mode, 82-88
panoramas, 181–186	assignments on using, 96–97
creating "fake," 182-183	Manual mode, 88-92
multiple-image, 184–186	Program mode, 74-77
patterns, 226	Shutter Priority mode, 77–82
perspective, changing, 224, 225	See also automatic scene modes
photowalkpro.com website, 188	Program (P) mode, 74-77
picture controls, 66	assignment on using, 96
Landscape, 59, 165–166	automatic scene modes vs., 74
Monochrome, 137-139, 169-170	flash sync speed in, 205
Portrait, 57, 139, 153	photo examples using, 76
video recording and, 244	setting up and shooting in, 77
pixel resolution, 38	situations for using, 74–76
Playback button, 106	progressive video, 238
,	1 5,

Q	sharpening RAW images, 38
quality settings	sharpness of photos, 173, 178
JPEG format, 7–9	Shooting data display mode, 19, 20
video recording, 237-238	Shooting Menu, 110, 162, 166, 237
QuickTime Player, 248	shooting modes
2	automatic scene modes, 53-69
R	comparison table of, 74
RAW file format, 38-40	dial for selecting, 14, 53, 71
advice on shooting in, 39	professional modes, 71-97
HDR images and, 187	Shutter Priority (S) mode, 77-82
RAW+JPEG option, 39–40	action photos and, 78, 79, 105-106, 143
reasons for using, 38	assignment on using, 96
Rear Curtain Sync mode, 211-213, 216	flash sync speeds in, 205
reciprocal exposures, 47–48	photo examples using, 78-80
Record button, 236	setting up and shooting in, 82
Red-Eye Reduction feature, 209-211, 216	situations for using, 78-81, 92, 176
reflections	shutter speed
eliminating flash on glass, 213-214	action photography and, 78, 79, 93, 102,
photographing, 223, 224	105-106, 143
Release Mode button, 116	exposure and, 46, 47-48
remote switch, 201, 259	flash synchronization and, 202, 205
resolution	handheld photography and, 197-198, 215
image, 38	lens limitations and, 81
video, 237	motion and, 48, 49, 102, 105-106
Retouch Menu, 264	prioritizing, 77-82, 92, 105-106
reviewing photos, 18-23	silky waterfall shots and, 175, 176
assignment on, 26	slow vs. fast, 78
display modes for, 18-21	tripod use and, 158
histograms used for, 22-23	VR lenses and, 197-198
timer setting for, 6	silhouetted subjects, 89, 91
zooming in for, 106	Single frame mode, 115
reviewing recorded videos, 247–248	single-point focusing, 11, 12-13, 25, 136
RGB histogram display mode, 19, 20	sky exposures, 166-168
rule of thirds, 178-180, 230, 231	snowy scenes, 90, 254
	sound recording, 238-239, 247
S	speed of subject, 103-104
scene modes. See automatic scene modes	Speedlight flashes, 215
screen display. See LCD display	Sports mode, 61-62, 68
SD memory cards, 32, 35, 51, 246	sports photography. See action photography
self-timer, 198	Spot metering mode, 131, 254-255, 267
semiautomatic modes, 81, 82	sRGB color space, 16
sensor cleaning, 36-37, 51	staging video shots, 245
Setup Menu, 33, 35, 37	subject-to-camera distance, 104-105
Shade setting, 14, 162	subtractive color, 16

sunlight	video recording, 235-249
creative use of, 260-261	accessories for, 241-242
ISO settings and, 75	book recommendation, 248
lens flare from, 260, 261	depth of field for, 243
portrait photography and, 148, 149, 153	DSLR lenses for, 240
white balance setting for, 14	focusing for, 236, 240
sunny 16 rule, 47	picture controls for, 244
sunrise/sunset photos, 170-171, 255-257, 267	quality settings, 237-238
synchronization, flash, 202, 205, 211-213	reviewing/editing videos, 247-248
	sound settings, 238-239, 247
T	starting/stopping, 236
tack sharp images, 173	tips for improving, 244-247
telephoto lenses, 43-44	white balance settings, 244
temperature warning, 245	
textures, 252-253	W
timers	warm colors, 15, 170
Auto off timer, 6	water
self-timer, 198	misty look for, 80
tonal range, 22-23	shooting reflections on, 223
tonemapping process, 187	waterfall photography, 78, 81, 87, 175-177
tripods, 158-159, 171, 173, 187, 241-242, 262	white balance settings, 13-15
TTL metering, 205	assignment on using, 25
TV connections, 246, 247	automatic scene modes and, 66
	choices available for, 13-14
U	color temperature and, 15
underexposed images, 23, 94	creating custom, 265-266
updating the firmware, 34-35, 51	landscape photography and, 162-164
user manual	steps for selecting, 14-15
AE-L button info, 133	video recording and, 244
external flash info, 214	wide-angle lenses, 41
flash range/settings chart, 204	depth of field and, 41
image quality settings chart, 9	distortion caused by, 129, 145
Live View mode info, 140	environmental portraits and, 129-130
Nikon memory cards list, 32	tight spaces and, 41, 42
picture control settings info, 165	wildlife photography, 30-31, 83
shooting modes comparison table, 74	wireless remote, 259
video function info, 237	
	Z
V	Zoom In/Out buttons, 106
Versace, Vincent, 233	zoom lenses, 45, 88
Vibration Reduction (VR) lenses, 65, 159,	
197-198	